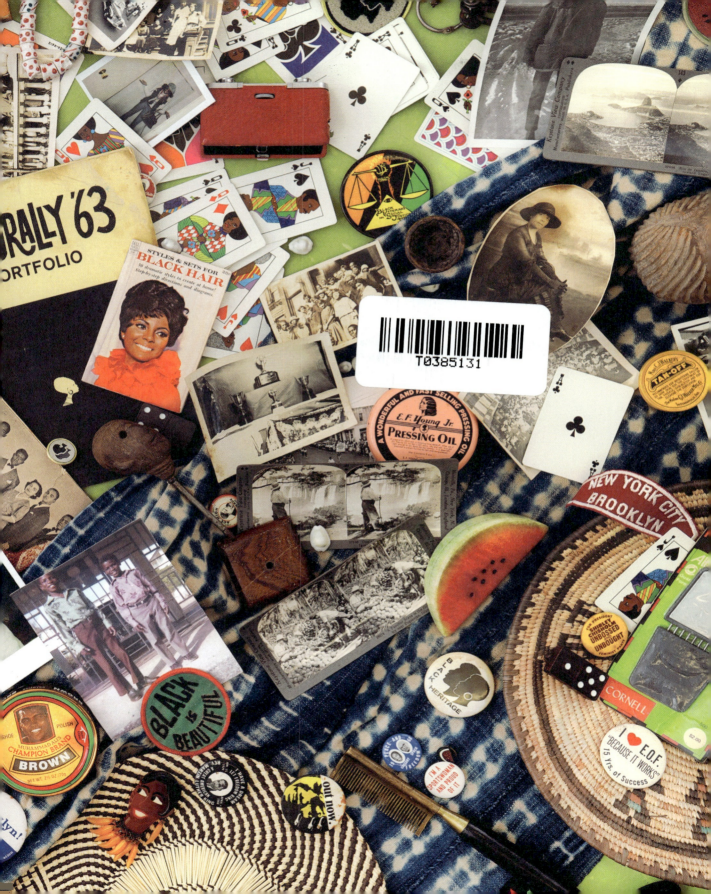

BLK MKT

VINTAGE

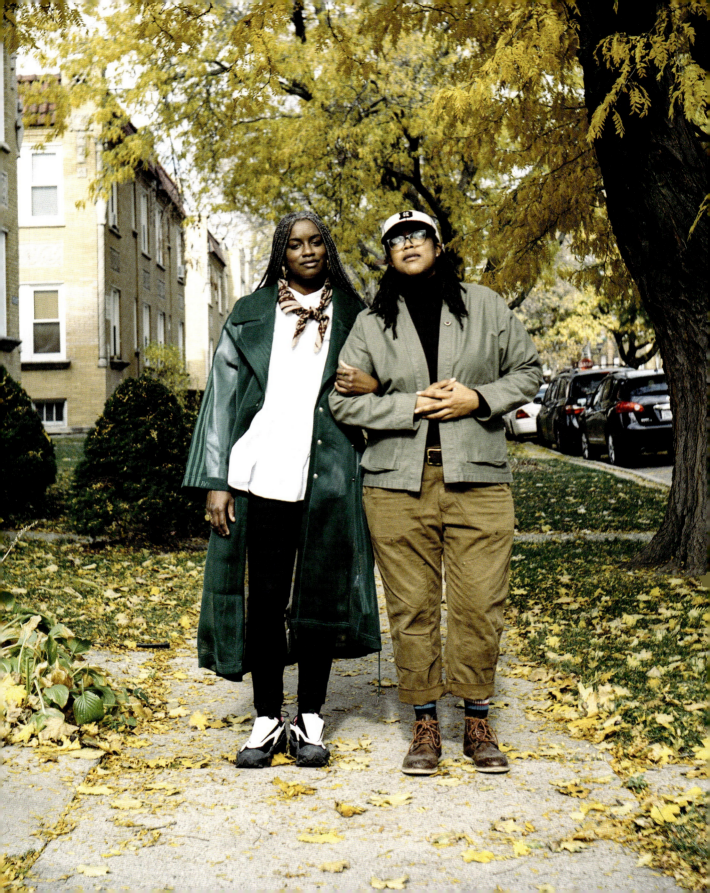

BLK MKT

*Reclaiming Objects
and Curiosities That Tell
Black Stories*

Kiyanna Stewart and Jannah Handy

BLACK DOG
& LEVENTHAL
PUBLISHERS
NEW YORK

VINTAGE

HAMPTON INSTITUTE

Clark College — Atlanta, Georgia — 1984

FISK UNIVERSITY OVAL 1979

HAMPTONIAN 1978

1992 Clark Atlanta University

PANTHER

FISK UNIVERSITY OVAL 1979

1965

AYANTEE

OVAL 1973 · Fisk University · Nashville, Tennessee

COLLEGE 1992 · Torch

CLARK COLLEGE · PANTHER

Clark College · Panther · Vol. 116

1985 · Fair Lawn High School · 2010 · VOLUME 101

CLARK COLLEGE · 1979 · Vol 110

OVAL 1972

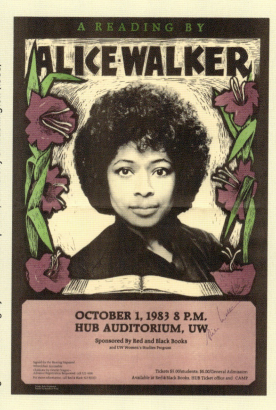

Signed "A Reading by Alice Walker" poster, University of Washington (1983)

Vintage church advertising fans

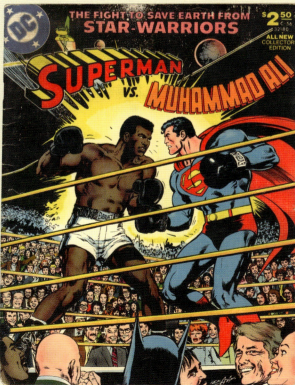

Superman vs. Muhammad Ali comic book

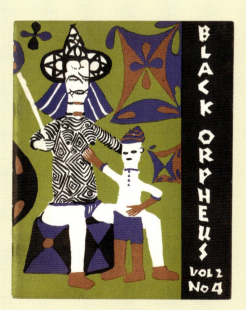

Black Orpheus: A Journal of the Arts from Africa publication, Lagos, Nigeria (1968–1970)

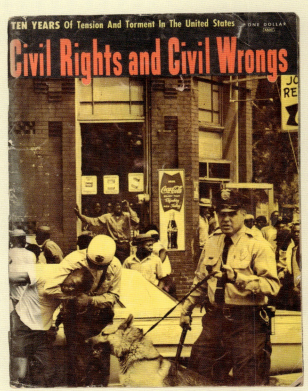

Civil Rights and Civil Wrongs Magazine

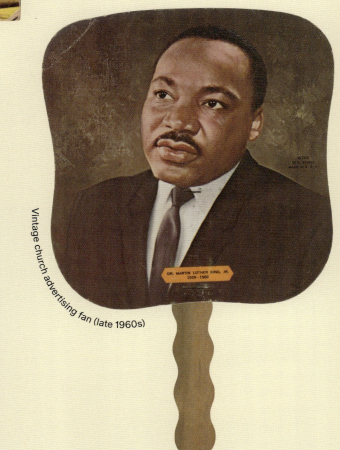

Contents

x Foreword by Spike Lee

xiv Introduction

1 CHAPTER 1: ORIGIN STORY

2 About the Biz

8 Who Is in the Frame?

11 Nostalgic Dissonance

17 Representation

18 Reclamation

Harry Belafonte from *A Time for Laughter* press release (1967)

23 CHAPTER 2: BLK MKT VINTAGE TODAY

24 Who We Are and What We Do

26 Curating a Collection We Love

28 Helpful Questions and Prompts to Consider When Starting/
 Curating a Collection

29 Snapshot of BLK MKT Vintage as an Organization

37 The BLK MKT Vintage Picking Process

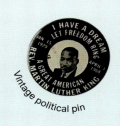

Vintage political pin

45 CHAPTER 3: INSIDE THE INDUSTRY

47 Value Is in the Eye of the Beholder

49 Who Are the Players?

53 Where Are the Players?

57 How the Players Play: Value on the Open Market

60 Value in the (Profit) Margins

63 Doing the Dance: Haggling

66 Buying What We Value: A Parable in Three Acts

70 The Reclaim Game: Why We Are in This Industry

74 Industry FAQs

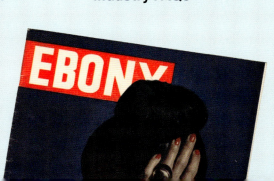

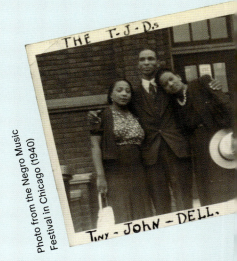

Photo from the Negro Music Festival in Chicago (1940)

77 **CHAPTER 4: THE VAULT**

78 **Preservation at Home**

82 **The Stewart-Handy Collection**

159 The Holy Grail List

161 **CHAPTER 5: COLLECTING WHILE BLACK**

164 **On Collecting**

174 **Collecting While Black: A Series**

176 Megan Dorsey, Everthine Antiques

179 Steven D. Booth, Johnson Publishing Archive

183 Carla Williams, Material Life and House of Black Style

188 Renata Cherlise, Black Archives

192 Matthew Jones, SOUL Publications

196 Syreeta Gates, Collector, Archivist, and Cultural Worker

203 **CHAPTER 6: SEEING BEYOND**

204 **What Is Imagination? The Science of Seeing Beyond**

204 **Looking Back to See Beyond: Vintage as Inspiration**

212 **Juneteenth Capsule Collections**

222 **Creating from the Source (Material)**

234 **Tapping into Your Black Imagination**

243 **CHAPTER 7: WHAT'S NEXT**

245 **Look Out, Shorty! AI's Gon' Get Your Mama!**

250 **When Your Things Outlive You**

251 **At the End of the Day . . .**

256 **Notes**

257 **Index**

261 **Photo Credits**

262 **Acknowledgments**

262 **About the Authors**

Willie Mays New York Mets baseball card (1973)

WILLIE MAYS NEW YORK METS

Vintage political pin BLACK POWER

Free Angela Davis: Hero of the Other America by Klein Steiniger (1972)

Free Angela Davis Hero of the Other America

I'M BLACK AND I'M PROUD PRIDE INC.

Vintage political pin

FOREWORD

See that poster over there? That's *Goldfinger*. My mother loved Sean Connery and she took me to see it as a young kid. We must have gone the first week it came out; and that day, the theater was packed. And you know, in James Bond films, no matter who's playing James Bond, there's going to be guns, explosions—but there was a lull in the movie, and it got really quiet as we all waited for the next explosion. I said to my mother, "Mommy, why is that lady named Pussy Galore?" HAHAHA! It was quiet, and everybody in the theater heard it. My mother was so embarrassed!

"Don't you say anything boy, shut up! Not a word." HAHAHA! It's 1964, so I'm like six years old.

I didn't know, but I learned.

Sitting here in the 40 Acres and a Mule studio, surrounded by these relics in my collection, I can recall so many influences that have made this all possible. Photography, sports, the Knicks, political material, cinematic historic pieces. Did I say music already? Music for sure.

If I trace my interests and connection to a lot of the ephemera in my collection, it started with my parents. Seeing my father play at the Newport Jazz

Festival left a mark on me. My mother taking us to the theaters and museums did too. I was talking with my students about this not too long ago.

My mother took me to see the *Bye Bye Birdie* Easter show one year. And it wasn't until many years after I made *Do the Right Thing* that something hit me: That opening-credit scene with Rosie Perez dancing, that's Ann-Margret at the beginning of *Bye Bye Birdie*! That [scene] stuck in my mind [from the 1960s], then came out again in my filmmaking in the eighties. It's all cyclical.

And that's what Jannah and Kiyanna's work is about.

As for the first collectors I knew, they were my grandparents. Like for a lot of northern Negroes, summer came and my ass got shipped down south. My parents were like, "Have a nice time with your grandparents." My mother's side lived in Georgia and my father's side was in Alabama. I just remember all the family photos. Family portraits on the walls and on the furniture. I don't know where those photographs are now, but I recall the family members throughout the crib, alongside blue-eyed, blonde-haired Jesus. Ha!

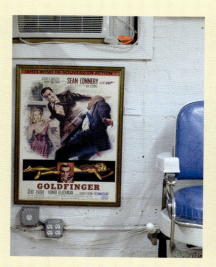

A *Goldfinger* poster hangs in Spike Lee's Brooklyn studio, 40 Acres

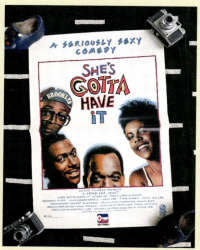

She's Gotta Have It poster

Love Supreme script: "I hope somebody got a lot of money for this."

Personally, I didn't start my cinema poster collection until I had my own poster—*She's Gotta Have It*. That's when I really started my collection. I knew I had to be the librarian and archivist for my own cultural creations and I wasn't waiting for anyone else to do it. All of my personal papers and scripts, I keep all that.

Mo' Better Blues was originally called *Love Supreme*, but Alice Coltrane objected to the sex, violence, and profanity in the film. So I said, "If I change the title, can you still let me use 'A Love Supreme' [in the soundtrack]?" And she said yes. I'm so grateful that Alice Coltrane gave me permission to use "Love Supreme," which plays in the ending montage of the film.

One of my favorite items in my personal collection is the ANC (African National Congress) flag signed to me by Winnie and Nelson Mandela. They signed it while still under the tyranny of apartheid, and it happened entirely because Nelson Mandela appeared [in a cameo] at the end of my film *Malcolm X*. We shot that scene in Soweto, South Africa.

A story most folks don't know: We began to shoot, and Mr. Mandela [acting as a Soweto schoolteacher] said, "Spike, I cannot say *by any means necessary*." I understood why [he wanted to change the script], because I knew he was going to run for the presidency of South Africa. Afrikaners would have taken that clip and insinuated that Mandela wanted to, or was in support of, killing all them white folks. But I knew we had the archival footage of Malcolm saying that; so in the film, we cut to Malcolm saying it instead.

The executives at Warner Bros. didn't understand. I had to explain to them why Nelson Mandela was in a film about Malcolm X in the first place. I told them, Nelson Mandela was on record sharing that the book *The Autobiography of Malcolm X* kept him alive for twenty-seven years while he was a political prisoner. So that's why Mandela was in the film and subsequently how the ANC flag came to be in my collection.

My collection here at 40 Acres serves as my personal pantheon. When I'm in the editing room, I'm often looking at all these heroes and heroines—and they're looking back at me. I feel their presence as we're editing. My collection is my personal

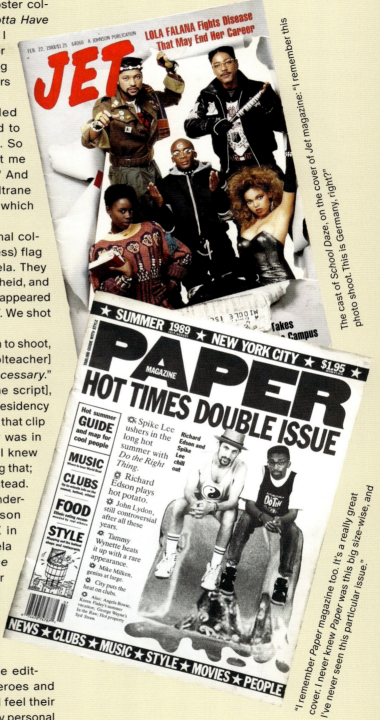

"I remember this photo shoot. This is Germany, right?" The cast of School Daze, on the cover of Jet magazine: "I remember this

"I remember Paper magazine too. It's a really great cover. I never knew Paper was this big size-wise, and I've never seen this particular issue."

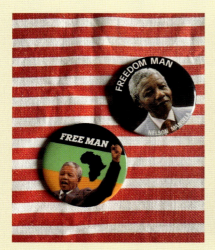

Vintage Nelson Mandela and African National Congress pinbacks

"Stevie Wonder promised me a clarinet that he played on *Innervisions*. Stevie, I'm still waiting on that."

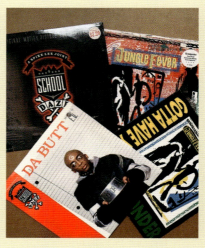

Vinyl records for the soundtracks *School Daze*, *Jungle Fever*, and *She's Gotta Have It*, plus the single "Da Butt" by the band E.U. from the *School Daze* soundtrack.

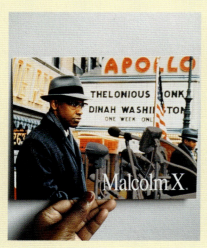

Malcolm X studio stills

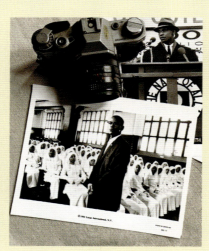

shrine to people who have made a difference in my life. All these people up here have busted their asses through so much challenge and circumstance. They keep my imagination fired up and they motivate me to not get lazy. One of the ways I pay tribute to them is by working amongst their legacies while building my own. It's powerful. And I've had the privilege to acquire so many personal items through those relationships.

TO MY SISTAS

What you ladies do is powerful. We, as Black people, were stolen from Mother Africa, robbed of our religion, language, history, you know. And here y'all are with a business and practice to help assist us get closer to all the ways we and our ancestors have existed through-out history. Before slavery. Throughout the diaspora.

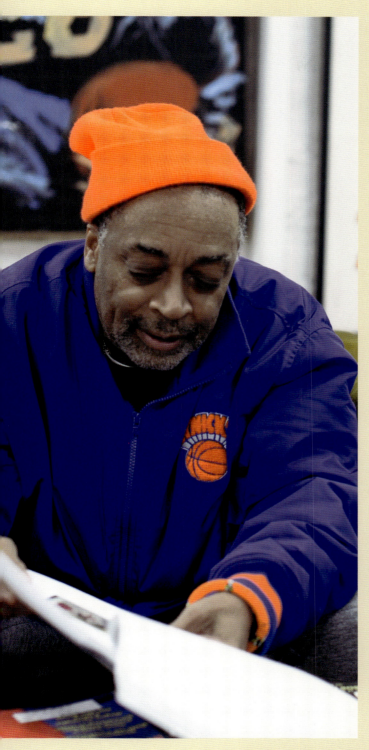

Everybody didn't have the same access that Alex Haley and his family did to genealogical tracing back in the day. I recently had my genealogical tracing done, and it was powerful for me to know from where I descended. And while I'm on the subject of genes and biology and ethnicity right now, your work is also about the cultural. Placing and locating *us*, culturally. We need to connect with our ancestors, and you don't have to go back to Africa for that. We've been here since 1619!

I know you educate folks in your store and in your broader work. Like you've told me several times, people come to you with stuff and they just think it's some junk. They don't know what they have or the context in which it came to be. I got to applaud you for exposing us to so much of ourselves. Back in the day, we said, "Knowledge is power," and that wasn't a cheesy slogan. It's a way of life and of honoring our histories. We don't all know our power because we're not all connected to the power of our ancestors. So, I congratulate you sistas again and thank you for the work you do. And for connecting me to pieces of material culture that help me strengthen my own ancestral awareness.

We don't all know our power because we're not all connected to the power of our ancestors.

TO THE READERS

Start going through your attic and basement. Get that box with the family photographs. What you have is very valuable.

To me, that's the most important materials: the personal heirlooms we have—the photographs, birth certificates, and documents. They are irreplaceable. Display it and put it up in the house. You don't have to pay a lot of money for a frame. But you have to be intentional about preserving those original copies.

Don't condemn what you have to an attic or basement and bury them amongst actual junk. They deserve to live amongst you. That's how these Brooklyn sistas changed the game—knowing that we as a people have always had value and that our ancestors and histories do too. That's where our value is rooted, in fact! Let's live like it.

Spike Lee signing *out*! Sho nuff, ya digg!

—Spike Lee

INTRODUCTION

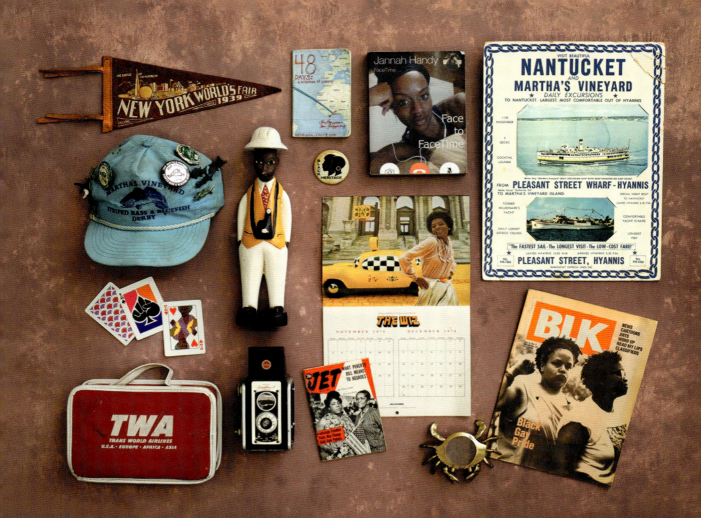

From left → 1. Vintage New York World's Fair pennant (1939); 2. Vintage Martha's Vineyard fishing derby hat with pins; 3. Soul cards (1970s); 4. Midcentury TWA mini luggage; 5. Vintage colon statue from Côte d'Ivoire; 6. Kodak duaflex camera (1940s); 7. *48 Days: A Collection of Poetry*, handmade book by Kiyanna (2014); 8. Black Heritage pinback (1960s); 9. *Face to FaceTime*, handmade book by Jannah (2014); 10. Vintage *The Wiz* promotional calendar; 11. *Jet* magazine (1964); 12. Brass magnifying glass crab paperweight; 13. Nantucket and Martha's Vineyard steamboat service notice (1940); 14. Vintage *BLK: The National Black Lesbian and Gay News magazine* (1990)

WRITTEN BY

Kiyanna and Jannah

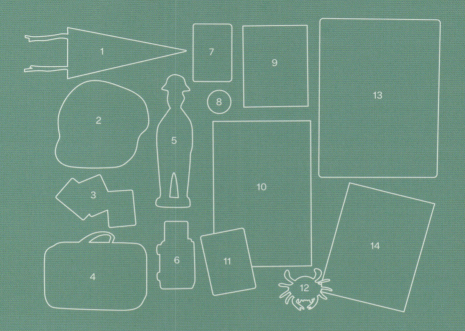

After two-plus hours in the car heading from Central New Jersey to Staten Island, we pulled up to our third-ever estate sale. It was **2014**. We were still feeling out how the estate sale scene fit into our individual sourcing and picking routines because we approach these things a little differently than one another. It can be a little scary. Not in an intimidating way, but in the **BLACK COLLOQUIAL WAY**. I [Jannah] don't like scary movies or going to hospitals or funeral homes. Death is tough and life is, honestly, scary enough. Going into a recently departed person's home and picking through their belongings is an eye-opening and humbling experience. There are price tags on framed portraits of their family and friends still on the walls, clothing hung in the closets and the scent and energy of the deceased wafting through the hallways. There is a very interesting air at estate sales, both **PHYSICALLY** and **SPIRITUALLY**. Kiyanna and I often ruminate over what our estate sale might be like if there was a public sale in our home after our passing . . . See. It's morbid and scary on the first page. **ALREADY**.

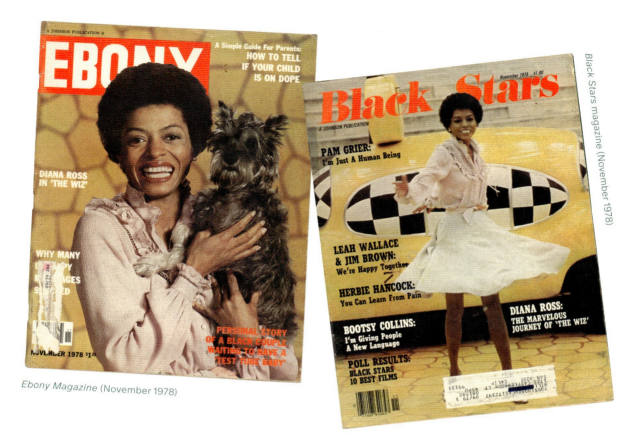

Ebony Magazine (November 1978)

Black Stars magazine (November 1978)

When we pulled up, we were greeted by a line of folks outside the residence—a telltale sign that the items at this estate sale were enticing. We hopped in line, grabbed a buyer number, and began chatting with the shoppers around us. "What are you here for?" "Did you see the collection of Wedgwood china?" "I'm here for the garage; the owner was definitely into tools." The early birds made their way out the front door with boxes. One departing shopper shouted, "All of the midcentury furniture is gone." The crowd around us groaned and returned to their chatter.

In the beginning of our time picking together, most of the items we collected weren't "raced." We hadn't yet devoted ourselves to sourcing Black ephemera and material culture to the same extent as we do now. At that point we would buy Black ephemera for our private collection, not yet aware of the public demand for it as well. We were (and still are) garage hounds, drawn to rusty tools, dented street signs, and automobiliana.

Once we were finally inside, we decided to divide and conquer. From room to room, we searched. The kitchen for some midcentury glassware. In the study, vintage NYC museum posters. In the bedroom, wool fedoras and belt buckles. Meeting back at the living room to add to our pile and regroup, we asked someone where the garage was and made a beeline for the side door that led to the garage patio. As soon as we opened the screen door, we were dumbfounded and almost moved to tears. In the driveway sat an original taxi from the movie *The Wiz*. It was instantly recognizable for us—two Black women, who were once girls raised on that iconic film. Nothing inside the house pointed to the wild discovery that there was a *Wiz* taxi sitting outside the garage. No paper ephemera or production/crew jackets or photographs or magazine covers of Diana Ross or Michael Jackson. None of the other shoppers in line or leaving the house mentioned it. As we stood outside, in front of this piece of Black cinematic history,

Vintage toolbox with assorted tools (2014)

An early BLK MKT Vintage estate sale haul

time stood still. We went into strategy mode and ran down all the factors we would have to consider to bring this iconic piece home with us.

How much would they charge for something like this? Collecting was still just a hobby for us and our most expensive single-item purchase at that point was $200. There was no way we could afford this. They had to be asking at least $1,000. At least $5,000? We didn't have $1,000 for one item that we likely wouldn't even sell.

Where would we put it? We were both still living in our apartment on a college campus with no additional parking options for non-operational vehicles. We couldn't park it on a city street with alternate-side-parking rules. Kiy's folks actively use their garage, so that option was out. Storage for vehicles is more expensive than a standard storage unit, so that wasn't an option, either.

How do we even get the taxi off the property today without a plan? The first questions the towing company will ask are "Where is the vehicle located?" and "Where will it be going?" We had no answer for the latter. The taxi was a piece of history—non-operational, propped on cinder blocks, and it needed some repairs. Was it even possible or smart to move it?

We left that conversation confident in our decision; there was no way to make it work, and the taxi had to be left behind. After snapping some pictures and letting the buzz of the excitement wear off, we made our way back to the living room to cash out our

other purchases—adding vintage license plates, some tools, and wooden advertising crates from the garage. We'd found an original taxi from *The Wiz*, touched it, but weren't in a position to take it home. The pang of disappointment still boils to the surface as we write about it almost ten years later.

After leaving the estate sale, we obsessed over the taxi. We did some Google searching but that didn't yield anything fruitful. So we left it alone; it was a missed opportunity that we would just have to live with. As time went on, our collecting evolved and so did our resources. A lot can shift in a year and by 2015 we had established a network of other collectors who had access to space, tow trucks, and flatbeds. The logistical challenges we were faced with a year earlier could now be approached differently. If only we could find that taxi's whereabouts. So, we tried to make that happen. We emailed and called the estate sale company to see if our taxi (*See how manifestation works?*) had been purchased, and, if not, what became of it. No response. But we found the contact information for the owner. SCORE! The taxi was left at a home they had purchased in Atlantic Beach, New York. When they bought the home, the car came with it. We dug up this info from a car enthusiast discussion board after some strategic key-word searches. We followed up with the email in the post and even joined the group to try to engage the poster. Jannah reached out on

August 27, 2016, more than two years since we had encountered the taxi at that estate sale. The owner responded about an hour later.

> *After the estate sale the charity came in and mistakenly went through a lot of effort and took the taxi. We called the charity and they offered to turn around. It's my taxi, and I live in Colorado. I decided to let it go. That was my error. The charity put it in front of their facility in Brooklyn, and that night an "artist" intentionally ran it over, smashing it to smithereens.*

Aargh, Tom

Once we read the word *smithereens*, we chalked it up to a loss and finally closed that chapter. We talked about it occasionally and shared a photo on Instagram with our lil' community of customers. Misery loves company.

Fast-forward to 2018. We were hired to prop and style the set of a short film called *In Our Mothers' Gardens* by Shantrelle Lewis. The film pays homage to the matrilineal line of trailblazing Black women and femmes. Those in the industry know how long production days can be, as well as how monotonous and slow

The Wiz taxi at a 2014 estate sale

the process can all seem. This was our second time styling a production set. As is customary, everyone breaks for lunch, so we were preparing for some grub and an hour of small talk with the other folks on the set. A PA (production assistant) I befriended asked if I wanted to join him for a quick smoke. Why, yes! He took me up to the roof via a hidden staircase. It was nice up there, a very unexpected view of Brooklyn with a sweeping aerial shot of the bustle below.

As I sparked up, we chatted about the day, how exciting it was to be a part of a Black women–led production and how the set felt different from other productions we'd been on. I finished up, thanked the PA, and prepared to descend back into the building, when something caught my eye—*The Wiz* taxi. Parked on a roof. On an adjacent building. I was flabbergasted, amazed, and exhilarated. *The Wiz* taxi had found its way back to us! I immediately searched for pictures in my phone from the estate sale to see if it was the same car. It was. Same dents, markings, and a faint sign of someone having scratched their initials or graffiti into the side of it. I knew immediately that this was a second chance gifted from our ancestors and I was certain that this time, the taxi was coming home with us.

After telling Kiy about this miracle and assuring her that I wasn't hallucinating, I took her up to the roof. She was speechless. Once again, we went into strategy mode.

What building is that, exactly, and how could we get the taxi off a roof? Not being able to determine the exact location from our vantage point on the roof, we did a Google Maps search of the block and found a vintage prop shop just around the corner.

We were on set for the next few hours. How could we even make this happen? That was an easy one—divide and conquer. One of us would stay for prop styling, and the other would walk around the block to the vintage store.

How much were they asking for it? Where would we store it? What happened to the smithereens? How did they get it on the roof?

I went to the vintage shop with our strategy, hopes, and resentments on my shoulders. Adrenaline pumping, I approached the owner and told him I'd seen the taxi on their roof from a few buildings away. I explained that I had been at the estate sale in Staten Island where it was initially put up for sale, but it got away. The owner mentioned that he, too, had gone to that estate sale and sent his staff back to pick up the taxi and store it at one of his facilities until he was able to get it on the roof of his existing store. He told

me about the impact *The Wiz* had on him and how sentimental it was, proclaiming that he would never sell it because of said value. He then pointed out the schoolyard across the street from his building that had a perfect view of his roof. He said that he loved being able to spread the joy of *The Wiz* to schoolkids, who could look up and see this piece of history. We learned our lesson from 2014 and came in ready to offer coin, regardless of his unwillingness to sell.

Would you take $2,000 for it? No? $3,000? OK. Final offer, $10,000.

We did not have $10,000 to drop on this prop, but that didn't matter. He then said again, in no uncertain terms, "I love this piece and I will never sell it." I recognized in him that same fervor and passion I had for the taxi, so I yielded. I thanked him and walked back over to the shoot to bring Kiyanna the news. I was deflated by our exchange, but still overjoyed by the reminder that we were in the right place at the right time. And, at the very least, we knew where it was and that it was being enjoyed.

Fast-forwarding again, to 2020. We don't know what it was about the dumpster fire that was the year 2020 that had us ruminating over missed opportunities and connections. One of them being *The Wiz* taxi. Perhaps, it was the

The Wiz taxi on a rooftop in Bushwick, Broolyn

changing landscape in Brooklyn where small businesses were closing en masse due to pandemic restrictions.Or, more specifically, the collective "Fuck this shit!" attitude of us all, as we seemed to be in our "end of times" era. We felt emboldened to check back in with folks and collectors we had lost touch with or never circled back to. So we looked up the vintage prop shop from all those years ago and sent an email. It bounced back. We googled the vintage shop and the site read, **PERMANENTLY CLOSED**. Dread set in for the both of us. We searched the store's address and found that the building was up for sale and had recently been purchased. *Enter frantic strategy mode.*

Okay, the vintage store is permanently closed, but where is the taxi? We reached out to the store's email, Instagram, and Facebook. As well as the owner's personal social media accounts. Nothing. If the building had been sold, where had the tenants gone? Did they change locations or close their business for good? We reached out to the listing agent to see if the taxi was on the roof for showings. They responded, "No. The taxi wasn't there, and the entire premises was vacant." They had "no clue what happened to the taxi."

If the owners respond, what price are we offering? We'll cross that bridge when we get there, but we will do what it takes to own it. Although we were in the midst of a pandemic, we were in a different financial position than we had been in 2014 and 2018. We could make this happen.

With a lot more time on my hands as the pandemic quarantine wore on, I decided to continue to message the former owners until I got word back. We were desperate and stayed the course. One of my last messages offered over $10,000 and guaranteed that we'd cover all the expenses to have it removed within twenty-four hours. After that email went unanswered, I hit them with the NAME YOUR PRICE email. It was getting to be a bit like cyberstalking, so I knew this would likely be my last shot at this. Kiy and I anxiously awaited a response for another two weeks. Then, a reply came

Hello, I no longer have the taxi. Thank you.

That was it. No explanation about what happened to it. No follow-up lead or opportunity to see or purchase it. No response to the cash offers. Just—

Hello, I no longer have the taxi. Thank you.

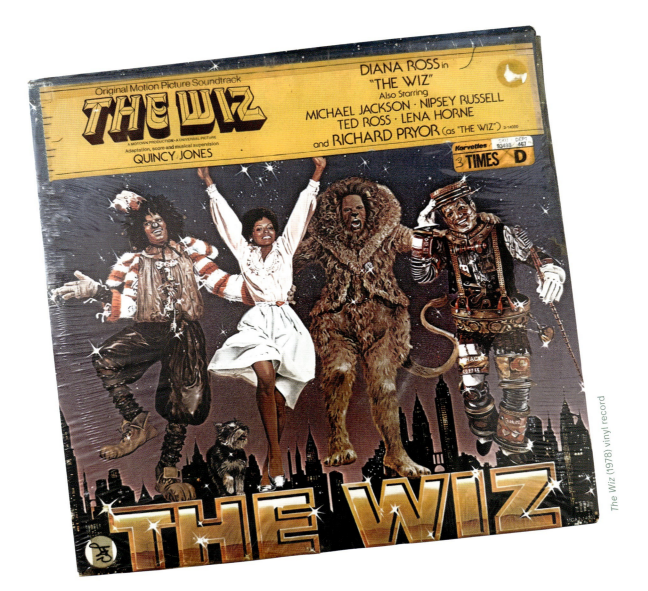

The Wiz (1978) vinyl record

It's 2024 and the saga of *The Wiz* taxi prop may have come to a close, although we prefer to call it an impasse. Perhaps there's a little part of us that hopes that by sharing our *Wiz* taxi allegory, it may cosmically find us again. The universe and our ancestors work in magical ways, but even if we never see that taxi again, we were given a gift. As we reflect on the utter serendipity of place, time, and memory, we're emboldened on our path as entrepreneurs, memory workers, and stewards. The gift of *The Wiz* taxi saga is and was the

gift of affirmation. That Black cultural production has staying power, cultural relevance, and is inextricably linked to the cultural consciousness of the moment. In the words of Kenya Moore, it is "the moment." We're approaching the fifty-year anniversary of *The Wiz* in 2028. In another fifty, it will still be the moment. The work of BLK MKT Vintage is not simply the transaction of buying and selling goods. Our work rests in the magic we experienced back in 2014, 2018, and 2020, and still feels like today in all our encounters with Black

"You Can't Win," from *The Wiz* sheet music (1978)

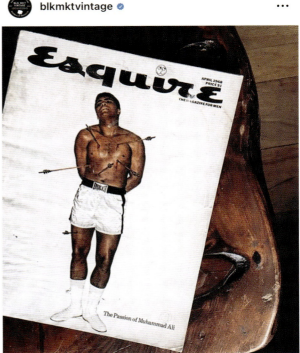

Esquire Magazine (April 1968)

vintage materials. The awe. The wonder. The quest. The adventure. Our favorite places are antiques stores, thrift shops, flea markets, swap meets, and dusty attics. We are drawn to oddities left on the side of the road, dumpsters behind auction houses and barns in obscure rural towns across the country. We scour piles, stacks, bookshelves, and dilapidated boxes in a devoted and diligent search for ourselves and our history, Black history.

This book is the physical manifestation of our love for one another and for this history. In *BLK MKT Vintage*, we'll take you on a few journeys with us—sharing peeks into our daily processes and rituals, into the earlier parts of our lives and career, and finally, into the moments that have brought us to rest at the feet of thousands of objects that tell Black stories and allow us to listen, learn, remember, and bring those lessons to the present and the future. We've been thinking about this book for almost a decade and knew that when the time came, we would write a book that placed us, two Black queer women from Brooklyn at the center, as means to show

how Black folks have been doing the work of archiving, collecting, and preserving for as long as we've existed. That our business, while doing important and fulfilling work, is the product of and response to generations of Black folks' intimate relationship to memory work. We may be doing our work uniquely, creatively, and with a huge audience, but our work is rooted in a *long* tradition. *BLK MKT Vintage* explores our work of uncovering what Black folk have created—from pennants, dolls, political campaigns, and family photo albums—and how our work exists because Black vintage and antiques do.

Our goal with this book is to explore Black material culture in contemporary life. There's a lot packed in here. It's like opening a Danish cookie tin at your mom's house, dismayed to find mints, bobby pins, and curlers instead of the damn cookies you know you shouldn't have been sneaking anyway.

We hope you are down for the adventure and surprise of what lies under the lid.

In the next seven chapters, you can expect us to do the following:

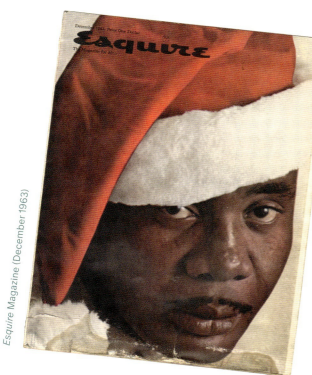

Esquire Magazine (December 1963)

❶ Democratize Black cultural ephemera. There's value here for everyone.

❷ Peel back the curtain on our process and share a bit about ourselves.

❸ Provide a theoretical and contextual grounding for our work.

❹ Reveal some wild stories and encounters from our picking adventures.

❺ Introduce and highlight the community that makes this industry go 'round.

❻ Dish industry tips and tricks, so you can engage in this work in your own lives, spaces, and communities. Black material culture is everywhere!

Each chapter is anchored by a long-form essay and cushioned by other narrative forms, like lists, dialogues, cartoons, handwritten annotations, and streams of consciousness. And the images? We've curated an assortment of visuals that are heavily influenced by our own aesthetic. We're deeply inspired by the tradition of still-life photography, layered tableaus, and the texture of vintage photography on film. So much so that we enlisted the expertise of image-maker and visual artist Nakeya Brown to create still-life images for each chapter, using the objects we feature. The inspiration for these tableaus was the December 1963 issue of *Esquire* magazine (with Sonny Liston on the cover). In the eight-page editorial, clothing, housewares, and décor were staged in these sexy, stately, quintessentially 1960s vignettes, with a numbered key at the bottom for crediting.

Nakeya's work incorporates vintage objects and materials related to the beauty industry and Black women's hair-care practices. Memory is a critical theme in her work and the color, staging, and material objects together elicit a sense of nostalgia that immediately takes viewers into a particular time and place. Other supplementary images in the book come from primary sources, our personal archive of images taken over the years, and from our lens. Evoking the legacy and spirit of African American quiltmakers, we've created a tapestry between these pages. An heirloom quilt of our experiences, questions, expertise, musings on the Black aesthetic, material culture, the archives of our future, and so much more. May this book serve as documentation of the world and the work of BLK MKT Vintage—curating and reclaiming Black history through our physical objects. May this book also continue the conversation about how, in a world plagued by capitalism, anti-Blackness, homophobia, sexism, and ableism, we can see value in ourselves and in one another, and treasure that. That we can be, in the words of Gwendolyn Brooks, "each other's harvest . . . each other's business . . . each other's magnitude and bond."

Jannah + Kiyanna

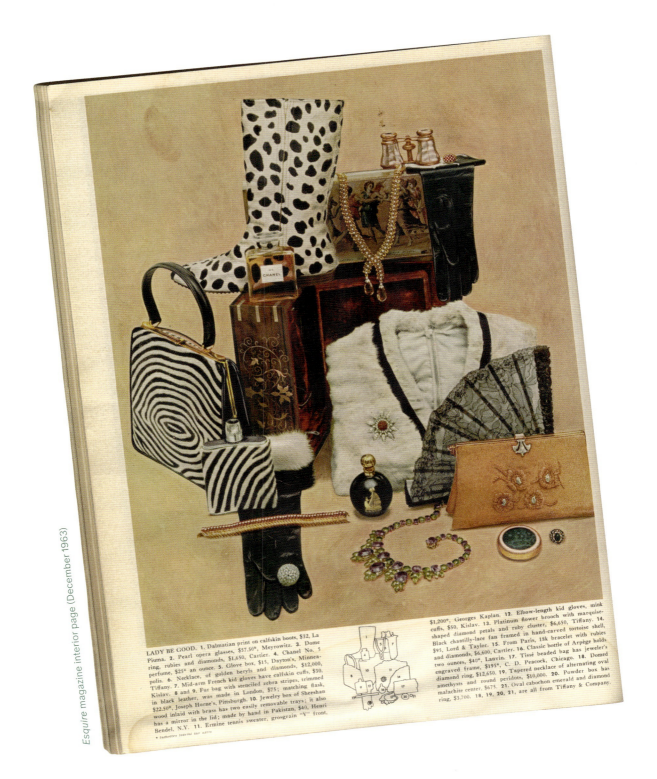

Esquire magazine interior page (December 1963)

LADY BE GOOD. 1. Dalmatian print on calfskin boots, $32, La Piuma. 2. Pearl opera glasses, $57.50*, Meyrowitz. 3. Dome ring, rubies and diamonds, $1,650, Cartier. 4. Chanel No. 5 perfume, $25* an ounce. 5. Glove box, $15, Dayton's, Minneapolis. 6. Necklace, of golden beryls and diamonds, $12,000, Tiffany. 7. Mid-arm French kid gloves have calfskin cuffs, $30, Kislav. 8 and 9. Fur bag with stenciled zebra stripes, trimmed in black leather, was made in London, $75; matching flask, $22.50*, Joseph Horne's, Pittsburgh. 10. Jewelry box of Sheeshan wood inlaid with brass has two easily removable trays; it also has a mirror in the lid; made by hand in Pakistan, $40, Henri Bendel, N.Y. 11. Ermine tennis sweater, grosgrain "V" front,

$1,200*, Georges Kaplan. 12. Elbow-length kid gloves, mink cuffs, $50, Kislav. 13. Platinum flower brooch with marquise-shaped diamond petals and ruby cluster, $6,650, Tiffany. 14. Black chantilly-lace fan framed in hand-carved tortoise shell, $95, Lord & Taylor. 15. From Paris, 18k bracelet with rubies and diamonds, $6,600, Cartier. 16. Classic bottle of Arpège holds two ounces, $40*, Lanvin. 17. Tissé beaded bag has jeweler's engraved frame, $195*, C. D. Peacock, Chicago. 18. Domed diamond ring, $12,650. 19. Tapered necklace of alternating oval amethysts and round peridots, $10,000. 20. Powder box has malachite center, $675. 21. Oval cabochon emerald and diamond ring, $3,700. 18, 19, 20, 21, are all from Tiffany & Company.

*Indicates federal tax extra

ORIGIN STORY

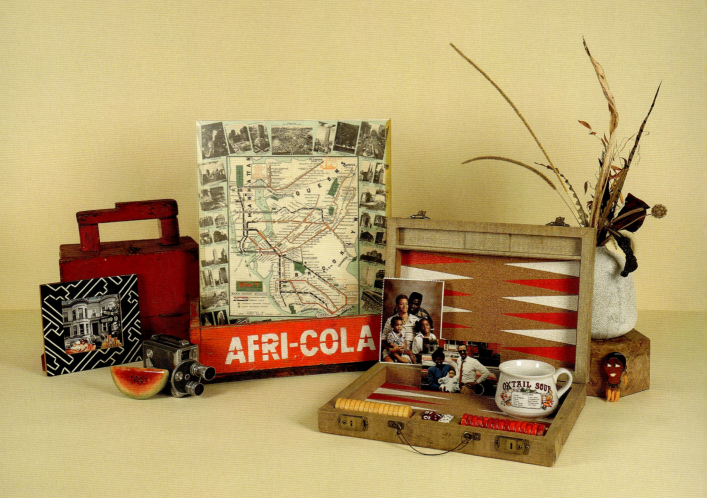

From left → 1. Vintage showshine box; 2. Framed collage, made by Kiyanna; 3. Glazed ceramic watermelon (1980s); 4. Vintage film camera; 5. Brooklyn–Manhattan Transit Line map (1924); 6. Midcentury Afri-Cola crate from Germany; 7. Childhood photo of Kiyanna and her family; 8. Vintage backgammon board; 9. Childhood photo of Jannah and her family; 10. Vintage oxtail soup mug (1970s); 11. Josephine Baker Bakelite pin (1940s)

WRITTEN BY

Jannah

Literary mother and ancestor **TONI MORRISON** famously said, "If there's a book that . . . hasn't been written yet . . . **YOU** must write it," (from a 1981 speech to the Ohio Arts Council). In many ways, we have carried and embodied that ethos throughout our individual paths and journey as **PARTNERS** in life, love, and **VINTAGE™**. This humble phrasing of a very complex paradigm is a call to action in a world of absences; a call to **DO** when others haven't. The **DESIRE** and **DRIVE** to create in a world, that operates in spite of us, was role-modeled and encouraged from an early age as our parents and familial villages were made up of entrepreneurs, civil servants, advocates, and community leaders in our **BLACK** Brooklyn neighborhood. We founded the business we wanted so deeply for ourselves; born out of marginalization and necessitated by the **RIGHTING** and **REWRITING** of historical **"ALTERNATIVE FACTS"** and convenient omissions.

In a nutshell, our business started because we wanted to create the **BLACKEST ANTIQUES STORE EVER**. It started with all-night conversations. Musings and daydreams. Ideation cyphers. Trial and error. Disagreements and developments. BLK MKT Vintage's origins are positioned squarely in the desire for two Black, queer women from Brooklyn to want to be seen and to have our history acknowledged. Rooted in a deep love for Black people, each other, and our shared history, BLK MKT Vintage is not only a labor of love but a duty of legacy.

In this chapter we will lift the curtain of the alchemy that has led us here, to these pages; from 2014 ruminations to the business you see in 2024. Together, we'll explore the concept of nostalgic dissonance, the importance of representation, and the act of reclamation, and how these themes are the major throughlines in our lives and our work. The last ten years are a direct result of not wanting to wait to be acknowledged by others or the "mainstream," but creating the space to center us, center our contributions to the American project(s), and honor those who came before us.

ABOUT THE BIZ

If you've been following us for some time, you have likely heard the story of our courtship and how it is inextricably linked to our business origin story. Kiyanna, an avid thrift-store shopper and collector brought me into her world of secondhand. A world toward which I, a sibling

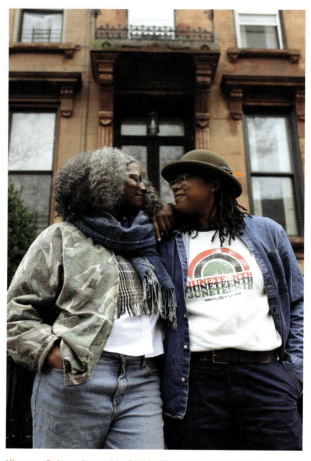

Kiyanna & Jannah outside BLK MKT Vintage in Brooklyn. (Photograph by Dee Williams, 2020)

2013–2014
Courting @ the thrift store

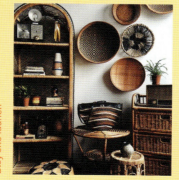

2015
Etsy site launch

2014–2016
Amassing a collection

The Timeline

of four who had their fair share of unwanted hand-me-downs, did not have fond proclivities. Kiyanna's use of thrifted items to express her creativity was so impressive and inspirational, not only was I hooked on thrifting, but I was hooked on her . . . (blushes in gay). What the thrift store offered us in the beginning of our life together was a place to dream, imagine, and play.

Prior to 2014, when we officially became BLK MKT Vintage LLC, we were two people who were content in newfound love but longing in our careers. We would spend extra-long (unapproved) lunch breaks at the local thrift store, competing to see who could discover the most interesting piece for under $10. Early on, we found ourselves to be equally yoked in passion, ambition, and supporting our communities. As such, it's fitting that we met at work, on a college campus while working in Student Affairs. In our daily lives we were accustomed to carving out space for marginalized students, providing resources, and investing in the futures of countless employees and mentees alike. Our work came from a deep place of passion and commitment to uplifting and supporting individuals by meeting them *where they are* to get them where they are going.

We found respite in each other. We found solace, affirmation, and support in our imagining of worlds and realities beyond our day-to-day grind in the bureaucratic landscape of higher education at a predominantly white institution. The tremendous personal investment made for our students began to be weighed down by the realities of "scarce" resources, institutional bias, and ideological hypocrisies of profit over students. How

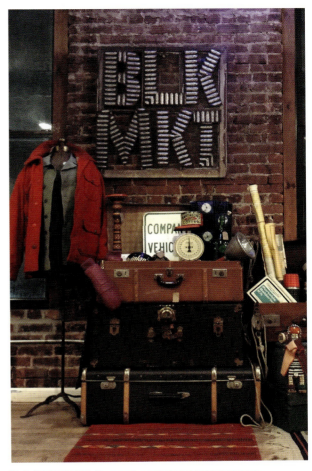

Early BLK MKT Vintage pop-up in Newark, New Jersey

2015–2017
Fleas + Festivals

2017
Jay leaves full-time job

2017–2018
Stoop sale era

 blkmktvintage ✓ • • •

 🔖

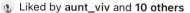 Liked by **aunt_viv** and **10 others**

blkmktvintage Gearing up for our first weekend at @artistsandfleas in Williamsburg! Come see us Nov 1st + Nov 2nd from 10am - 7pm! // #vsco #vscocam #blkmktvintage

October 15, 2014

BLK MKT Vintage's first Instagram post

could I continue to work long and taxing hours for an institution that paid coaches millions while there were actual students in the campus community who were food insecure or houseless? Together, we yearned for spaces that we could control, and that would unequivocally address the ills of society and obstacles facing regular people. Spaces that allowed us to create in the ways we deemed necessary for survival and growth while being true to the values we espoused.

Born out of this necessity to be more in control of our futures, more specifically the tremendous amount of energy and bandwidth devoted to work in comparison to our passion, we both set out to make the time we have on Earth more meaningful. Our joys, interests, and hobbies didn't have to be relegated to the weekend, or nonwork hours. One key lesson we'd learned as Student Affairs practitioners and classroom instructors was that when you made room for your authentic self, you end up making room for others. The crux of our business model has always been to center, preserve, and make accessible vintage objects that tell Black stories—starting with our own. Our very personal desire to see our faces, families, or experiences reflected back to us has been a throughline that sustains us as individual people but also as a business and a brand.

But ain't nothing going on but the rent . . .

For more than half of our journey, we had to keep working a conventional nine-to-five. Steady paychecks, health insurance, the commitment to our students,

2018
Kiy leaves full-time job

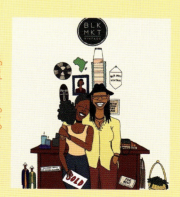

2018
Here we (Indigo) go campaign

The Timeline

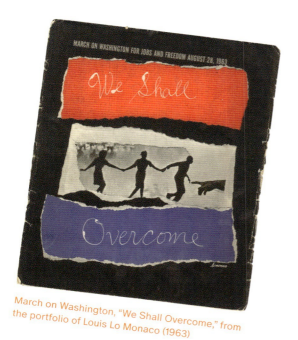

March on Washington, "We Shall Overcome," from the portfolio of Louis Lo Monaco (1963)

and an overall love for academia made the transition to being self-employed business owners very hard.

One of the questions we get the most about our journey is *When did you know it was the right time to leave your full-time job?* The answer for us both is simple: We didn't. If we waited for the time to be right, I guarantee you we would likely still be working away on someone's college campus and our store would not exist. For us, it wasn't a question of the timing being right, but what was right for us. When counseling students, I would often try to help reframe their thinking; "adulting" isn't about seeking the right or wrong answer, but about making an informed decision. Thinking in terms of *right* and *wrong* will have you stuck, paralyzed by a future yet to unfold. Sometimes the *wrong* decision leads to the *right* outcome. Outside of questions of morality, right and wrong are an invention of retrospect.

Despite taking this leap of faith and jumping off into the great unknown, we're still two detail-oriented folks. We knew we needed a plan to get us where we wanted to go. We came up with a scheme to stagger our departures, with me going first. This was ideal in that we were able to get proof of concept with someone at the helm of the business 24/7. A short test period to see if we could survive on our own, as first-time entrepreneurs and freelancers. Then, after a year and a half of saving and prepping for the full transition, Kiyanna left her position, and we were off to the races.

Once we'd committed to the full-time business, we implemented a very measured approach to its formation and goals. At each step of the way, we outlined our desired outcomes and metrics of success. In 2016, could we sustain an Etsy page with over ten visitors a day, and weekly sales above $500? Could we expand our physical presence to in-person flea markets and clear at least $1,500 a weekend? Did we have enough of a following to start stoop sales, where we were the only vendor and the main draw? People kept suggesting that we have a physical store. Could we sustain that kind of investment, in Brooklyn no less?

2019
Opening the brick-&-mortar

2020–2022
Surviving the pandemic

2024
A decade in the game

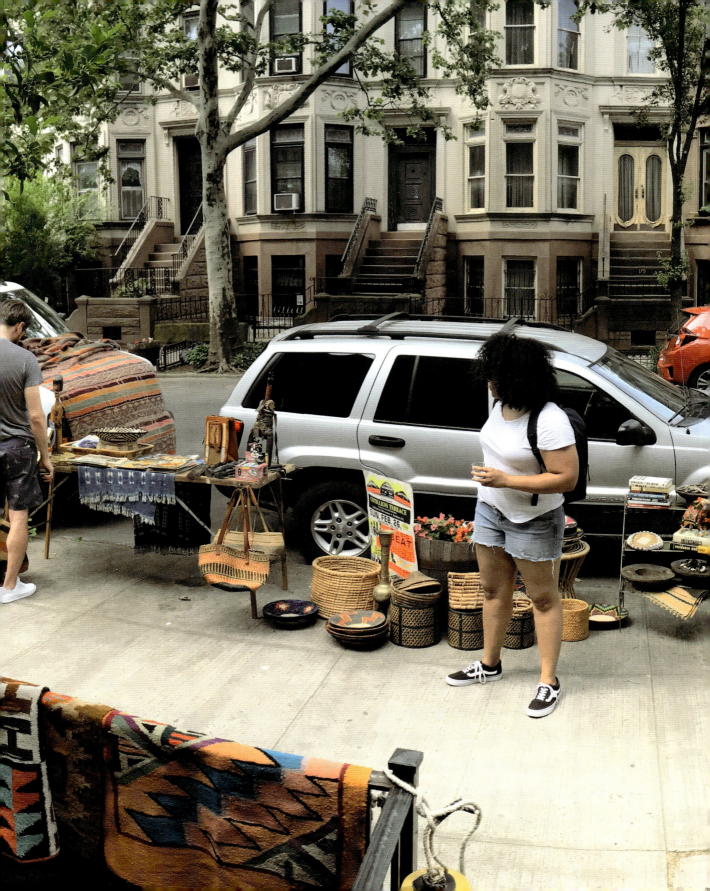

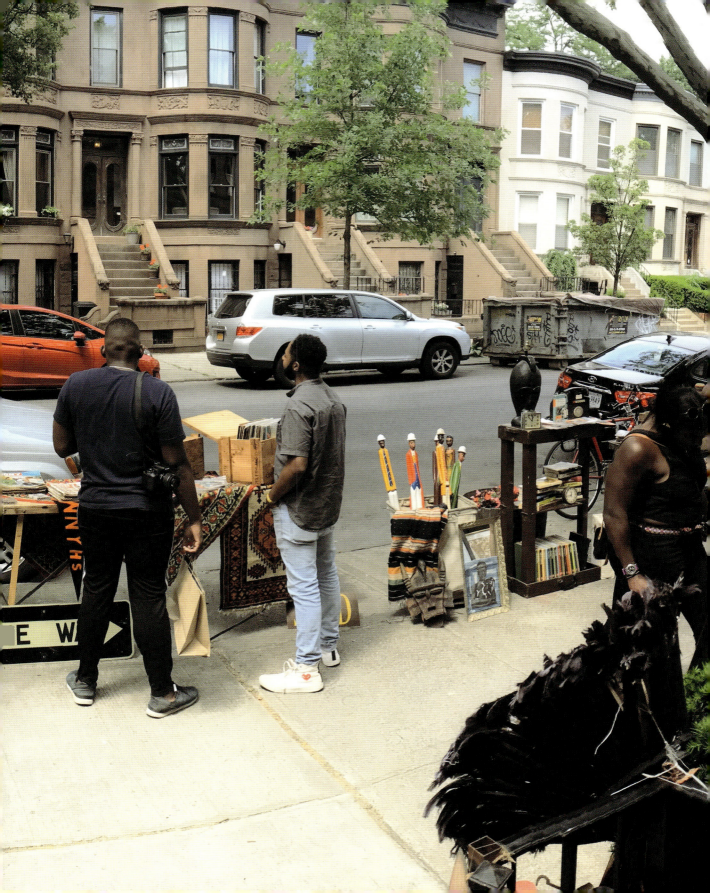

We learned, too, that our origins are also nothing without the support of the community. A lot of our firsts and biggest opportunities came from community members and clients who answered yes to our calls. They saw something in us and chose to invest in our burgeoning business not only as customers but by spreading the word to their own networks.

This love we get back from our community has continued to be the driving force of our work and our commitment to our practice. While the impetus of this work starts with us, the point of it all is to celebrate and acknowledge Black people and their lived experiences. When we first launched our Instagram account on October 15, 2014, it wasn't about follower count or blue checks but about engagement—would people get what we were trying to do and become invested in our work? Did people think this history was as cool or valuable as we did? Now, 270K+ followers later, the answer is a resounding YES. Our community continually affirms that showing up authentically and unapologetically is a viable business model. When the work gets hard, we soldier on because we know our community has got us, and we have got them. By centering Black cultural artifacts via thoughtful curation and varying modes of accessibility, we're communicating very explicitly to Black folks that *not only do we see you, but we love you as well. You're worthy. What you've created is worthy. You are important here.*

Negro History Bulletin issues (1970s)

WHO IS IN THE FRAME?

As Carter Godwin Woodson states in *Miseducation of the Negro*:

If you teach the Negro that he has accomplished as much good as any other race he will aspire to equality and justice without regard to race. Such an effort would upset the program of the oppressor in Africa and America. Play up before the Negro, then, his crimes and shortcomings. Let him learn to admire the Hebrew, the Greek, the Latin and the Teuton. Lead the Negro to detest the man of African blood—to hate himself.

It all started with a spark—not hyperbole by any means. The journey that brought me to BLK MKT Vintage starts at my first elementary school, Sparks of African Genius. Sparks was a space that centered the Afro-diasporic experience. In addition to the compulsory rigors of reading and arithmetic, we were taught how to count, how to give thanks, and common phrases in Swahili.

That's really where I first tapped into the idea of the Black identity as a dynamic experience across continents, countries, and, in some communities, across the street. My family heritage is Black American. My mother's people can trace their lineage to Texas and my father's to Louisiana, both by way of Jamaica, Queens, New York—anticlimactic, I know. My parents were unapologetically Black before the hashtag. Dashiki-wearing, natural-hair-repping people who dedicated their lives to improving the experience of the folks around them. My dad, Michael J. Handy, a

Jannah's class photo, Sparks of African Genius School, Jannah is in the top row, fourth child from the left (1991)

civil servant and Vietnam war veteran, advocated for veterans returning home in need of resources and support throughout their transition. Mom, Edna Wells Handy Peeples, an attorney and career civil servant, has, to this day, dedicated her life to *being the change* and investing in those around her. My sisters and I were encouraged to ". . . see a need and fulfill it." And to always be proud of our heritage as Black people, women, New Yorkers, and engaged American citizens.

Afrocentric schools and Black-centered curricula of study have been a staple in the Black community that predates the formation of Historically Black Colleges and Universities in 1852, the Black cultural and educational enlightenment of the Harlem Renaissance in the 1920s and '30s, and the separate but equal doctrine of the 1950s. Popularized in the 1960s through to the '90s, due to increased school segregation and inequitable allocation of resources, Afrocentric and community schools have fluctuated in their popularity.

Afrocentricity in schools is a pedagogical method that approaches education through the lens of the African diaspora. While there is no standardized curriculum or course of study, Afrocentric schools utilize the core tenets of knowledge of heritage, communal pride, academic excellence, and Black empowerment. Afrocentric education seeks to provide culturally specific lessons, diverse and inclusive source materials, and overall rigorous academic training. Whether explicitly called Afrocentricity or not (or Critical Race Theory or not), the idea of a more balanced and inclusive account of history—and education more broadly—is one that more people should be proponents of.

As a little Black girl in 1991, I was exposed to what amounts to the Kid's Bop edition of the 1619 Project. At that age I had inklings of the need to dig deeper to get more of the story than what was being told. At Sparks of African Genius, the "more" was the point. Who invented the system of counting that we still use

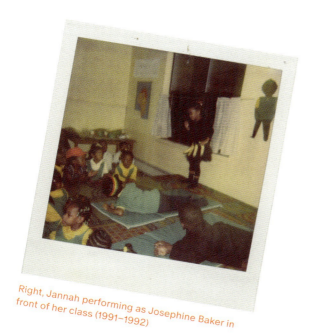

Right, Jannah performing as Josephine Baker in front of her class (1991–1992)

designed to subjugate her to her advantage and help the "greater good." All while entertaining flawlessly in finger waves and pearls. Naturally, all the projects and presentations I was assigned concerned Josephine. I donned a banana skirt and learned a couple of her signature dance moves. I parroted a horrible French accent and dreamed of being a spy. I cannot confirm or deny if the latter has ever come to fruition.

At Sparks, I learned that historical significance was not only for dead white men in gilt-framed portraits with the realities of people who looked like me conveniently just outside the frame. Those people, my people and my ancestors, had just as much of a hand in the forming of this nation and this world as the folks who get statues, federal holidays, and libraries named after them. In that space I learned that it was on all of us, individually, in our own spheres of influence, to bring more people into the "frame" not only to appreciate the contributions of those before us, but to be sparked by their genius to lean into our own.

today? Who were the great rulers before the empires of Greece and Rome? Who was the woman leader who defeated Napoleon? Who were the Black spies who aided the United States in fighting the Civil War and World War II? At these schools, our contributions as a people were not relegated to footnotes or erased completely; they were the crux of lesson plans and pedagogy that the teachers employed. This representation and centering of our Blackness showed us that the same greatness was in us. Within me. I was able to see myself in Harriet Tubman and Shirley Chisholm, real-life Black women who made tangible impacts on history. Black trailblazers, who weren't just Malcolm X or Martin Luther King Jr., who had a hand in shaping the world I occupied back in the '90s and even today.

In addition to coming to that rather profound realization at the prescient age of six, I experienced my first girl crush—Josephine Baker—during a lesson on spies, rebels, and maroons of history. (Yes, even then I had a proclivity for strong Black women). Not only was I crushing on her, I wanted to *be* her. I was enamored not only of her bravery, but of how she subverted the white gaze as a means of liberation. My teachers—"Mamas," to be precise—shared with us the stories of how Josephine used stereotypes and systems

Jannah's school portrait (1991)

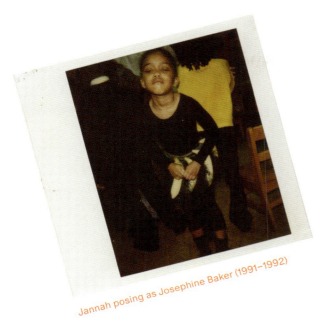

Jannah posing as Josephine Baker (1991–1992)

left out of the canon and conversations, a skewed narrative of our ancestors inevitably fills the void or, worse, erases them completely. This sentiment gets directly to a phrase we coined in our work, *nostalgic dissonance*. Don't try to google it because you'll fetch a bunch of random tweets and SoundCloud pages. The term is specific to our work in historical artifacts and is the heady brainchild of two former collegiate co-adjuncts with master's degrees who traverse the pages and places of history. Here are some examples:

Make America Great Again
States' Rights
Celebrating Thanksgiving
Commemorating Christopher Columbus

For those of us whose histories and experiences are left out of the curricula and marginalized, the

At Sparks they lifted the proverbial veil for us on the truth that those in charge get to set the narrative; sociopolitically, economically, and historically. The jig was up before the music started and this knowledge taught me to question everything. I took the red, black, and green pill and was able to see through the *matrix of propaganda* that is anti-Black, anti-woman and anti-femme, anti-queer, anti-Indigenous, immigrant, and poor.

NOSTALGIC DISSONANCE

Throughout time, marginalized peoples have been called to create, thrive, and live full lives in the face of oppression and uncertainty. The stories of these ancestors' struggles and triumphs illuminate their experiences due to race, class, gender, and sexual orientation in a white supremacist, capitalistic, neo-colonial system. It's our belief that the primary sources and artifacts we collect serve as oral histories and written stories—both contextualizing our existence by demonstrating our humanity, creativity, and genius, and also showcasing our beauty and brilliance. When our contributions are

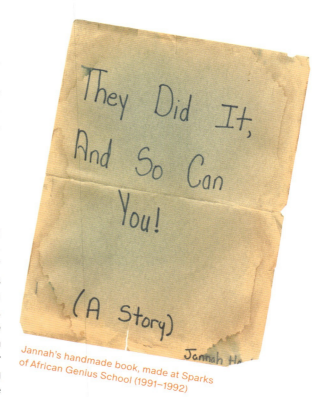

They Did It, And So Can You!

(A Story)

Jannah H

Jannah's handmade book, made at Sparks of African Genius School (1991–1992)

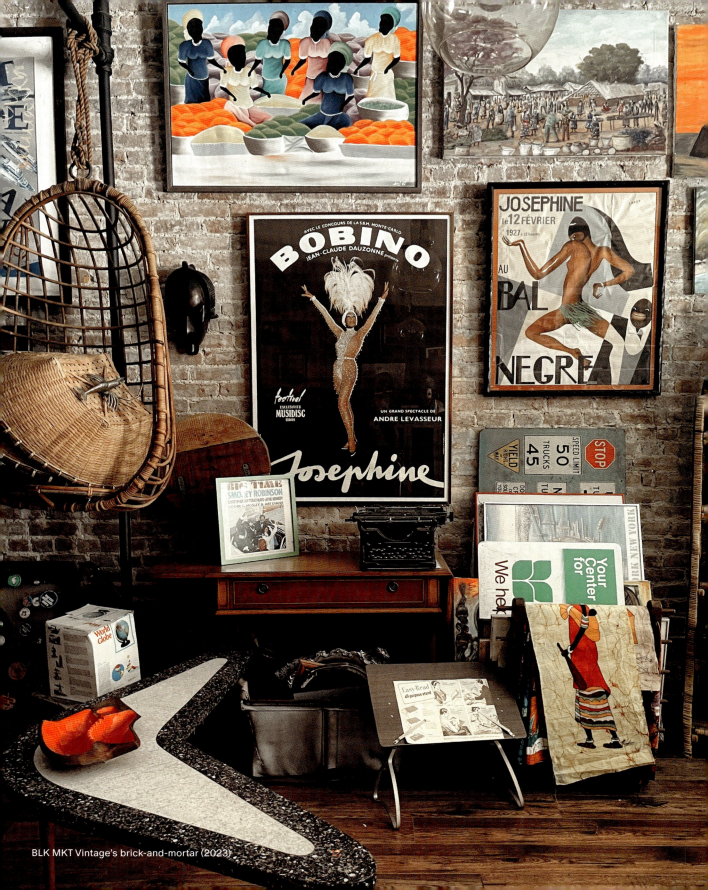

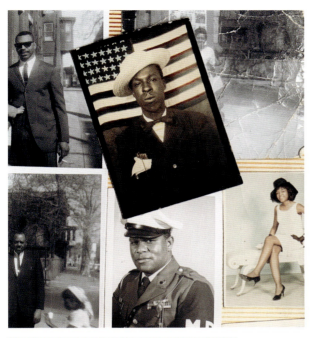

in their conceptions of the world and of themselves. The concept was developed in the 1950s by American psychologist Leon Festinger.

As a Black woman with familial roots in the American South, I struggle with nostalgia. I want to see my history "fondly" and "long" for it. I am thankful for my parents, community, and the work of BLK MKT Vintage because I genuinely do look upon Black history with immense pride. Even for the more mundane vintage items we engage with, I often can't control the flood of nostalgia when seeing a brass hot comb (trigger warning) and pink foam hair rollers. But there is no mistaking that aspects and artifacts of our history are dark. Childhood Easter Sunday memories are one thing, but how can one *fondly* look back on the antebellum South? Can we be fond of a time when Black families were torn apart, individuals' personhood and bodies violated or mutilated at any white person's will and whim? Therein lies the *dissonance*; idyllic plantation wedding suggestions on Pinterest, happy slave narratives, or ten little nigger nursery-rhyme tunes blaring from ice cream trucks during the summer months.

What this sentiment essentially boils down to is the flattening of the duality experienced in folks marginalized by white supremacy. Rooted in the racial theories of noted Black historians, the idea of nostalgic dissonance is a derivative of W. E. B. Du Bois's theory of *double consciousness* and Richard Wright's reflections in *The Outsider*. In *The Souls of Black Folk*, Du Bois speaks of the:

> *peculiar sensation, this double-consciousness, this sense of always looking at one's self through the eyes of others, of measuring one's soul by the tape of a world that looks on in amused contempt and pity . . . two souls, two thoughts, two unreconciled strivings; two warring ideals in one dark body.*

Du Bois's phrasing is spot-on as it speaks to the unease or dis-ease that is reflected in nostalgic dissonance. The "peculiar sensation" of longing for a fraught history or having to search for yourself in the historical record and filling in the blanks of convenient omissions is a major throughline of the work we engage in daily. Being *of* history but not *in* history is a rather peculiar reality.

feeling of nostalgic dissonance is something you're likely familiar with. Reading this theory as "Nostalgic Cognitive Dissonance" will give you the best understanding of the crux of it.

nostalgic; adj: ❶ longing for or thinking fondly of a past time or condition; ❷ evocative of a longed-for past time or condition.

dissonance; n: ❶ lack of agreement, especially inconsistency between the beliefs one holds or between one's actions and one's beliefs; ❷ an instance of such inconsistency or disagreement; ❸ a mingling of sounds that strike the ear harshly, a mingling of discordant sounds.

cognitive dissonance; n: the mental conflict that occurs when beliefs or assumptions are contradicted by new information. The unease or tension that the conflict arouses in people is relieved by one of several defensive maneuvers: They reject, explain away, or avoid the new information; persuade themselves that no conflict really exists; reconcile the differences; or resort to any other defensive means of preserving stability or order

Our business model is to center and preserve objects

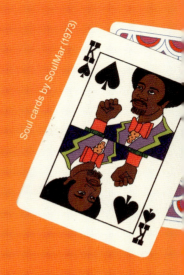
Soul cards by SoulMar (1973)

Vintage domino tile

Vintage pin

CATALYST FOR CHANGE
SHIRLEY CHISHOLM FOR PRESIDENT
Vintage pin

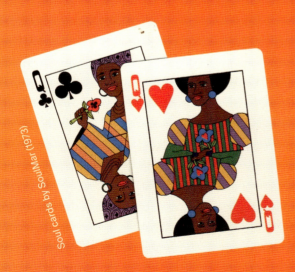
Soul cards by SoulMar (1973)

Lincoln Memorial church fan

that tell Black stories— including our own.

SAVE FLATBUSH TOWN HALL

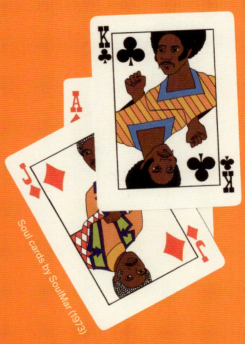

Soul cards by SoulMar (1973)

Beer advertisement, featuring singer Jerry Butler

Schmidt's
Quality Beer Since 1860

"To Taste it is to Love it!"

MALCOLM X
1925 – 1965

Boxed Malcolm X razor kit

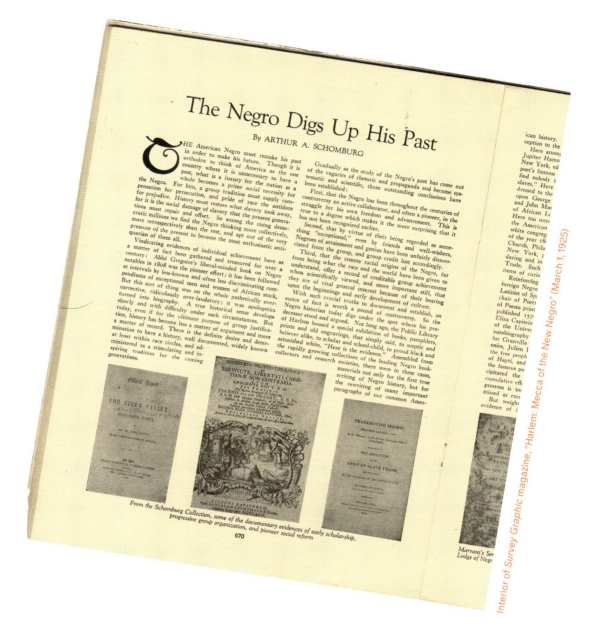

The Negro Digs Up His Past

By ARTHUR A. SCHOMBURG

From the Schomburg Collection, some of the documentary evidences of early scholarship, progressive group organization, and pioneer social reform.

670

Interior of Survey Graphic magazine, "Harlem: Mecca of the New Negro" (March 1, 1925)

Half a century after Du Bois's assertion of double consciousness, Richard Wright, in *The Outsider*, built upon the same sentiment:

[G]ifted with a double vision, for, being Negroes, they are going to be both inside and outside of our culture at the same time.

These words, spoken by a white attorney to the book's protagonist, Cross Damon, encapsulate the idea of being both an insider and an outsider simultaneously, which is the driving force behind the plot of Wright's novel *The Outsider*. What's intriguing is the idea of double vision being positioned here as a "gift." Standing in stark contrast to Du Bois's interpretation of "warring

ideals," the experience of duality can run the gamut from being useful, or a tool, to being debilitating, or a detriment. Regardless of the connotations ascribed to the idea, duality, double consciousness, double vision, and nostalgic dissonance are the result of real lived experiences and societal paradigms.

Not to be confused with revisionist history—that foggy veneer of pleasantries often transposed onto the past—nostalgic dissonance is the presentation of history as a complete narrative that willfully excludes diversity. How is it possible that today, on Nikole Hannah-Jones's internet, spaces can be dedicated to antiquity that only center one view, one lived experience? How, in 2024, can we still be commemorating Columbus Day, knowing the truth about Christopher Columbus's racist, murderous, and sadistic exploits? The same way on July 4th in 1776, American independence was celebrated while an entire race of men, women, and children were deemed subhuman and enslaved. Nostalgic dissonance thrives in these contradictions, and the intentional refusal to acknowledge well-documented truths, while elevating beliefs over facts.

Our coining of *nostalgic dissonance* was meant to articulate the feeling we kept experiencing early on in our journey of walking into a vintage store and seeing a singular narrative being told. The exasperation of looking through hundreds of magazines and finding maybe one with a person who looked like us on the cover. What words can describe the reality that, in our field, Black historical representation is relegated to the section labeled **BLACK MEMORABILIA**, which includes ephemera like Jolly Nigger banks, Mammy and Sambo iconography, and grotesque caricatures of Black people created by white people? As collectors, historians, business owners, women, and Black people, we no longer wish to accept this distorted view of our own history.

In order to move from nostalgic dissonance to liberation, we must take action in two powerful and important ways: Representation and Reclamation.

Nostalgic Dissonance: "Were we here?"
Representation: "I am here."
Reclamation: "We were here/here we are."

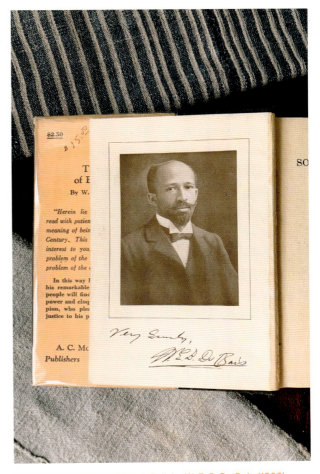

Interior of *The Souls of Black Folk* by W. E. B. Du Bois (1903)

REPRESENTATION

Some Sayings About Representation:

You can't be what you can't see.
Be the change you wish to see in the world.
Seeing is believing.

There are many ways you can say it, but it all shakes down to the same idea: *Representation not only matters; it is a cultural imperative.*

Arturo Schomburg, ancestor and trailblazing Black archivist and historian, states this fact precisely in *The Negro Digs Up His Past*:

The American Negro must rebuild his past in order to make his future. Though it is orthodox to think of America as the one country where it is unnecessary to have a past, what is a luxury for the nation as a whole becomes a prime social necessity for the Negro. For him, a group tradition must supply compensation for persecution, and pride of race the antidote for prejudice. History must restore what slavery took away, for it is the social damage of slavery that the present generation must repair and offset.

As asserted above, "History must restore what slavery took away" and the act of "repair and offset" are imperatives that lead us directly to the work we do of reclaiming primary sources and artifacts.

RECLAMATION

Naming what we do as *reclamation* emboldens a sense of ownership, rightful access, and deliberate engagement. Reclamation and the effort to "seek" are necessitated by an effort to hide. So our work inherently becomes an act of rejection of the tacit anti-Black, capitalist, hegemonic world, values, and traditions. As bell hooks notes in *Art on My Mind*:

> *It occurred to me then that if one could make a people lose touch with their capacity to create, lose sight of their will and their power to make art, then the work of subjugation, of colonization, is complete. Such work can be undone only by acts of concrete reclamation.*

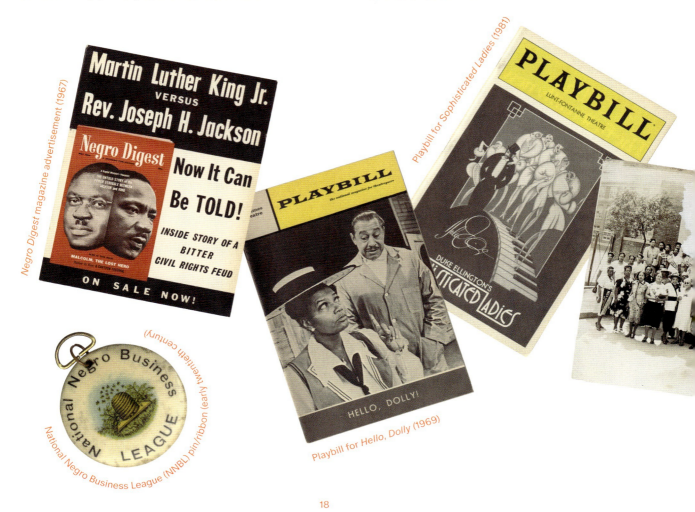

Negro Digest magazine advertisement (1967)

National Negro Business League (NNBL) pin/ribbon (early twentieth century)

Playbill for Hello, Dolly (1969)

Playbill for Sophisticated Ladies (1981)

Deliberate erasure must be met with deliberate centering; the obscuring of narratives begets the unearthing of primary accounts. The reclamation of cultural ephemera and artifacts is pivotal in the work of dismantling stereotypes, strengthening communities, and engaging with radical restorative justice as the historical record is corrected and contemporary repair occurs. It is likely that this paradigm has led to an increase in the number of folks interested in reclaiming aspects of our identities and histories. Some of these folks and institutions are:

Black Archives
Emmaline + Them
Project STAND
The 1619 Project
BLK MKT Vintage
ONE Archives
The Gates Preserve
The Blackivists
The Black Archives (Netherlands)
Community Archive Initiatives

There is an additional layer of how technology and information practices have established the need to (re) assert ourselves as we move from an analog world to a digital one and beyond. We are being left out of the textbooks, but we won't be left out of the metadata. In chapter 7 we will delve more deeply into how technology impacts the work of reclamation but more specifically the work we do here at BLK MKT Vintage.

Looking at how these three concepts—nostalgic dissonance, representation, and reclamation—interact, we not only get a better sense of the work that we do, but the very personal experiences that have brought us to this work. The thrust to reclaim our artifacts as a means to combat the lack of representation and subsequent nostalgic dissonance because we found value in our cultural production is the linchpin of all we do. For ourselves and for our community we yearn to be a spiritual and metaphysical respite. Our work sits at the intersection of possibility and probability models. Through primary historical sources, folks are not only inspired by what has happened, but by what else they can make happen NOW . . .

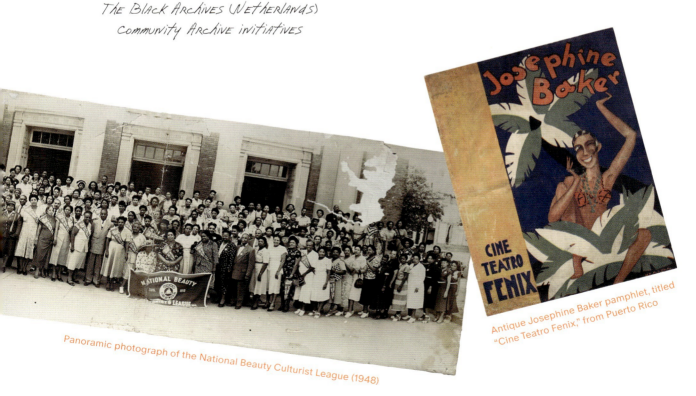

Panoramic photograph of the National Beauty Culturist League (1948)

Antique Josephine Baker pamphlet, titled "Cine Teatro Fenix," from Puerto Rico

DISSONANCE ⎯⎯⎯⎯

NOSTALGIC

RECLAMATION ←

REPRESENTATION

BLK MKT VINTAGE TODAY

From left → 1. Antique stool; 2. First edition of *Their Eyes Were Watching God*, by Zora Neale Hurston (1941); 3. E. F. Young Jr. Pressing Oil (1950s); 4. National Negro Business League pin (1900–1920); 5. Framed portrait of African National Memorial Bookstore in Harlem (1960s); 6. Vintage African seashell necklace; 7. Kings County Clubs of the National Association of Negro Business and Professional Woman's Clubs, Inc., framed dance poster from Brooklyn (1984); 8. Vintage bound *Ebony* magazines (1970s); 9. Can of Negro Head Oysters Vintage (1940s–1950s); 10. *Spirituals in Rhythm* by Sister Rosetta Tharpe, vinyl record (1961); 11. Philadelphia Odunde Festival T-shirt (1970s)

WRITTEN BY

Kiyanna

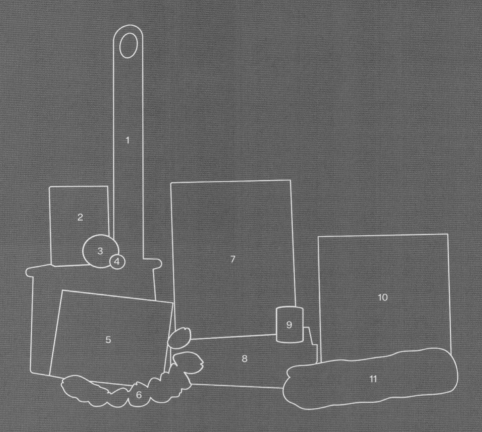

Entrepreneurship is a wild ride. Being entrepreneurs while holding multiple **MARGINALIZED** identities has often felt like choosing insanity. We founded BLK MKT Vintage in **2014**, back when both of us were working full-time jobs, looking to make some side coin at local markets, selling our wares on the weekends. **TODAY**, almost ten years in, I'm writing these pages before heading out to open up our brick-and-mortar shop—our flagship store in the historic neighborhood of **BEDFORD-STUYVESANT, BROOKLYN**. I've just responded to a text from our intern, checking in with us about his schedule, and I'm reflecting on where this unique journey has taken us in the last **NEAR-DECADE**. On the desk next to me is a short to-do list I wrote out for the weekend, to help me prioritize the myriad projects and tasks we're managing (read: juggling) and this list, too, sums up where our business stands in the year **2024**.

WHO WE ARE AND WHAT WE DO

BLK MKT Vintage operates as a vintage/antiques concept shop that specializes in the collecting and reselling of objects, ephemera, décor, and cultural production from across the African diaspora, with a focus on African American objects. That African American–*ness* is the lens through which we curate our collection as we search for pieces that awaken our cultural memory. But, even my (Kiyanna's) Caribbean heritage impacts our curation, shading my own sense of identity and cultural memory in the same way that Jannah's African American lineage and roots in the deep South (stand up, Louisiana and Texas!) also locate the coordinates from which she speaks and sees. BLK MKT Vintage's work rests in what and how we remember, as much as in what and who we are today.

And we are two Black, LGBTQIA-identified women who are partners in love and life, running a business that is very much about Black people's self-determination, visibility, value, and cultural production. I didn't always think that I'd be an entrepreneur. I'd like to think that I've lived many lifetimes in my young thirty-three years earthside. Adolescent Kiyanna was going to be a principal ballerina, teaching dance on the weekends. A few years later, I just knew I was going to be a writer or journalist. In high school and college, I learned all about cultural criticism and the field appealed to my curiosity (and cynicism) much more than hard news reporting.

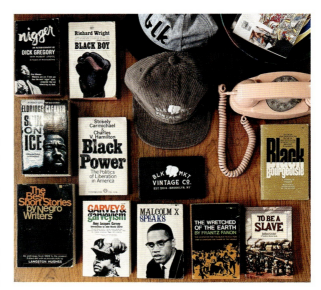

Books in BLK MKT Vintage shop (2022)

Then, after a series of internships in the fashion industry, I wanted to continue pursuing cultural criticism, but with a focus on fashion. I was obsessed with Robin Givhan of the *New York Times*, even before I could fully understand the complexity of many of the topics she was writing about. I knew that she had nurtured her voice and point of view, while building a body of work invested in the relationship between the personal and the political, from the historical to the present. I knew that there was something about the intersection of those themes—and here I am today, building a home

There is a storied relationship between Black bookstores and various resistance movements in their surrounding communities. I'm thinking specifically about Una Mulzac of the Progressive Labor Party (PLP) and her founding of Liberation Bookstore in Harlem in 1967 and the National African Memorial Bookstore in Harlem, owned and operated by Garveyite and Black nationalist Lewis Michaux since the 1930s. Also, Judy Richardson, Jennifer Lawson, and Daphne Muse of the Student Nonviolent Coordinating Committee (SNCC), who founded Drum and Spear Bookstore in Washington, DC, one of the best known and largest Black-owned bookstores of the Black Power era. Bibliophile and librarian Mayme Clayton established the Third World Ethnic Bookstore in 1973. The store's inventory later became the core of the Western States Black Research Center and, subsequently, the Mayme A. Clayton Library and Museum in Culver City, Los Angeles. Lastly and earliest, I'm thinking of David Ruggles, a Black abolitionist who opened the country's first Black bookstore and reading room in New York City in—get this—1834. Ruggles's shop was burned down by a white, racist mob.

The Black Bookstore

and a career on that very fertile land. According to Forbes.com, Black women are the fastest-growing group of entrepreneurs in the United States, totaling 42 percent of new women-owned businesses. We are part of a larger community of mission-driven Black women entrepreneurs managing businesses that are moving the culture forward, while acknowledging where we've been. That feels good to say.

Choosing to center Black cultural ephemera *and* Black people is a deliberate and radical commitment. We do the work we do so that one day (hopefully, in our lifetimes), it is no longer radical to do so. Antique, thrift, and vintage shops and resellers make up a significant part of the resale industry, which has been valued at $28 billion, according to an *IBISWorld* report. We don't know just how many formal businesses and shops share in the work of specifically collecting and making accessible Black vintage ephemera, but, in recent years, we've seen that number increase dramatically, predominantly with Black women at the helm. Anecdotally, we're seeing so many more Black women enter the resale industry, find or create a niche for themselves, then prop the doors open for other sisters to enter. Most antiques and vintage shops operate with three major functions—selling, purchasing, and appraising goods and collectibles. While BLK MKT Vintage covers those bases, we also ground ourselves and our work in another specific tradition. The Black bookstore.

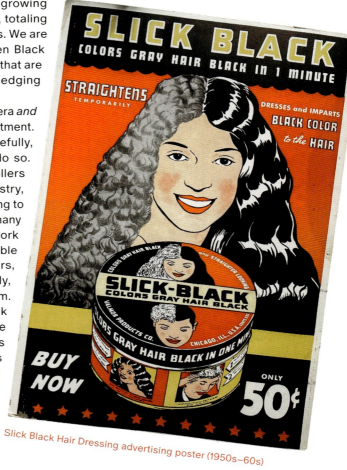

Slick Black Hair Dressing advertising poster (1950s–60s)

Black-owned-and-operated bookstores are inextricably linked to Black self-definition, resistance, and preservation. Simultaneously, they center education, are grounded in the notion of history as present, and support direct action aimed at ensuring the liberation of Black folks in their immediate communities. Joshua Clark Davis writes about the multi-nodal mission of Black bookstores in the Black Power era in his essay "Black-Owned Bookstores: Anchors of the Black Power Movement":

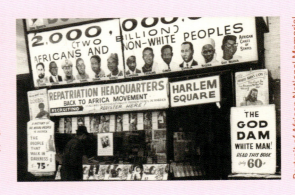

Portrait of African National Memorial Bookstore, Harlem, New York

CURATING A COLLECTION WE LOVE

Curate. Curator. Curatorial. There's certainly been an ascendance of the word *curate* over the last few decades, particularly as the visibility of curators in the art world has increased. However, its more recent proliferation stems from the internet and social media. The web has democratized many cultural spaces that have historically, and even to this day, been guarded by gatekeepers. I think that as access has widened and hegemonic structures have been interrupted and exposed for their dehumanizing exclusivity, we've witnessed a sort of cultural cachet that comes with self-authorship and authority. A curated menu. Curated playlists. In our case, a curated collection.

The word *curate* means "to restore to health or a sound state," from the Old French word *curer* and directly from the Latin word *curare*, meaning to "take care of." In my very Black household, the *cur* in *curate* also represents "curiosity." It's this etymological framing that should give you all you need to know about how we curate a collection of Black vintage ephemera. We approach every object we encounter with curiosity. When we enter folks' homes and sort through their goods, we actively listen to their stories and the stories of their belongings, knowing that each piece is freighted with memories that we try to preserve and pass along with the physical object. Now, that doesn't mean we buy, acquire, or take on every object we come across. For us, curating a collection of vintage and antique objects is about intentionally (re)telling stories about who Black folks are, what we've endured, who and how we've loved, and all the other ways we've showed up in the world. We can't possibly house every item; believe me, Jannah has tried! With limited space, resources, and capital, curating a collection that we love means being selective about the purpose of every item, thinking in advance about how it will need to be cared for, what stories each item holds or tells and who we can possibly connect that item to. You don't need to be a "capital C" curator in order to do that. You do need to have an intention that will ground your work. What is the story you're trying to tell? What or who is represented through your collection? What or who is missing?

I love when folks ask us how to start a collection of goods and wares. They'll usually share that they've been supporting our business for a few months or years, purchasing an assortment of thangs, but need help curating, scaling, and organizing their finds. Another common

"Black booksellers positioned their stores as a new generation of Black public spaces, welcoming a wide range of customers, activists, and curious community members. At Black-owned bookstores, customers talked with storeowners and each other about books, political issues, Black culture, and history. African American booksellers rejected the idea that Black businesses' primary goal was to accumulate capital. They argued that Black entrepreneurs instead had a responsibility to affirm racial pride, celebrate Black history and identity, and promote connections with Africa. These activist retailers unabashedly criticized capitalism in general as well as the tradition of Black business enterprise advocated by Booker T. Washington and the National Negro Business League . . ."

Michaux's legendary Harlem bookstore serves as another example of the rich legacy of book shops functioning as Black community centers, nurturing

The Black Bookstore

refrain is "How do you not keep everything?!" Just the thought of keeping every single item we encounter causes me quite a bit of anxiety. I tend to become overwhelmed by too much sensory stimulation, but I accept that I've chosen a line of work that is all about the relationship of the senses to collective memory and cultural consciousness. The smell of the bound pages of our 1948 first edition copy of Mother Zora's *Their Eyes Were Watching God*. The brown gradient toning along the edges of our 1950s Black Chamber of Commerce photograph. The cold, embossed relief on the face of a set of metal Madam C. J. Walker's "Wonderful Hair Grower" pomade tins. The distorted sound from the voice box from our vintage Flip Wilson/Geraldine pull string doll (circa 1972) and its muffled tenor: "If I had known you were coming, I'd have stayed at home!" These are just a few examples of the sensory details our objects impart. These details elicit something different for each of us.

I remember the very first apartment we lived in together; it was Jannah's and I'd recently moved in with her. Little time passed before we were confronted with the reality that our methods (or lack thereof) for picking, upcycling, and preserving items weren't sustainable in that space. More than just not having enough room for our collection, our strategy (such as it was), wasn't serving us,

the space we inhabited, or our goals (such as they were) for the collection.

In the beginning, we were buying cool shit that we thought was important and fit our tiny budget. The truth is, there were no goals for a collection early on; only imagining the things we might find and lamenting about the exorbitant pricing of the capital A "Antiques." There came a point shortly after the founding of our business when things shifted. As we interfaced with customers of all identities at various flea markets, we realized how important it was to have a public-facing collection of goods that felt reflective of our own identities and interests. The more we found and sold on the weekends, the more we wanted to hold on to a select assortment for ourselves. We were both coming into our own relationships with "things," while growing in our relationship with each other and flirting with the *collector* title. As our community and public-facing work expanded, so did our desire for a personal collection to adorn our home and reflect the immense love and respect we have for Black material culture.

We *eventually* created a collection we loved by identifying types of items that intrigued us personally. We researched and tapped into local resources, so we could grow the collection over time. Some of

Vintage hair tools

Black radical imagination and politics, while tending to the lived and material conditions of Black folks in its immediate community. It was called the National Memorial African Bookstore and also referred to as "the House of Common Sense and the Home of Proper Propaganda." I mean, if that tagline ain't the spirit of BLK MKT Vintage in 2024 embodied, I don't know what is.

Similar to other beloved community spaces, like churches, barbershops, and beauty salons, African American bookstores have been community hubs with Black nationalist roots and politics, forging space for other politically oriented public spaces that might exist beyond our notions of capitalism. These shops, and their owners and staffs, created the conditions for newly imagined Black public spaces that exist to serve and nurture Black people's survival, resistance, and existence.

those local resources were neighborhood thrift and vintage shops. You'd be surprised what a quick Google search can yield. We made friends with dealers and other collectors at local flea markets and estate sales. We invested time and money (lots of it) into regular acquisitions, trading objects we no longer wanted or that we had found duplicates of. We've polished, dusted, and disinfected thousands of objects, restoring them to their original glory. We'd be remiss if we left out the fact that we've been curating a collection that would evolve to serve many purposes—to be kept and enjoyed at home, to be sold and/or traded, and to be rented for production and events purposes. Those have been codified as various services our business offers, and we'll detail them later in this chapter, so you understand how BLK MKT Vintage is structured as a business entity.

HELPFUL QUESTIONS AND PROMPTS TO CONSIDER WHEN STARTING/CURATING A COLLECTION

❶ What am I looking for? ❷ What am I interested in? ❸ What do I want to collect? ❹ Who is this collection for? ❺ What purpose or whom is my collection serving? ❻ Who else (individuals or institutions) is collecting items/objects I'm interested in, and what

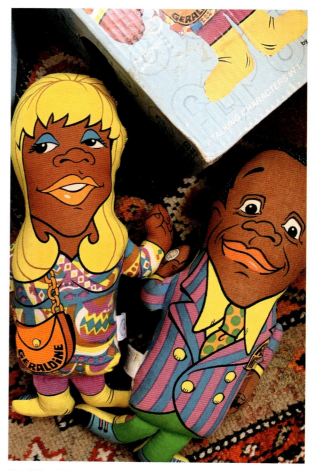

Flip Wilson/Geraldine doll by Shindana Toys (1970s)

BLK MKT Vintage Interiors celebrates the meeting of our pasts, presents, and aspirational futures with layered and narrative-driven design. As space maker, interior designer, and environmental curator, BLK MKT Vintage Interiors centers the reclaiming of vintage/antique objects in a collaborative effort to craft spaces that reflect the lived experiences of Black folks across the diaspora. We reference and design from a uniquely Black aesthetic, using color, texture, shape, light, memory, and history as parts of our alchemy of design.

There are so many memorable projects throughout our last five years offering interior styling and curation services—from full service design to smaller projects like gallery wall styling. One of our longest-standing projects is our own home, a charming Victorian just a few years shy of one hundred years old. We started the design process back in 2021 after purchasing it during the COVID-19 quarantine and have been slowly bringing it back to its glory. Built in 1930, it's something of the imagination of a Victorian Afrofuturist, with lots of original details in the home that require

Our Design Philosophy

can I learn from their processes? ❼ How will I store or display my collection? ❽ What is missing from my collection? ❾ What story or stories is my collection telling? ❿ What do I need to ensure that my collection is sustainable with room to grow? ⓫ What rituals or practices of care do I need to implement as I build this collection? ⓬ Do I want to insure my collection? And if so, for how much? ⓭ What do I want to happen to my collection when I'm no longer alive?

We've curated a collection and a business ethos and structure that reflect who we are, as well as our respect for and the value we place on Black lives, histories, and experiences. The stories told by our collection speak of an expansive existence dating back generations; of flawed and full, abundant humanity. That we are and have been all things. That we are a multitudinous people.

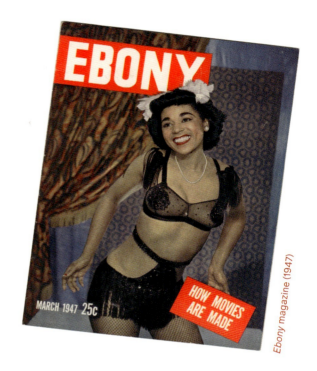

Ebony magazine (1947)

SNAPSHOT OF BLK MKT VINTAGE AS AN ORGANIZATION

In November 2024, BLK MKT Vintage turns ten. We're celebrating how, in this last near-decade, we've been able to sustain and scale this passion project of ours. Today, BLK MKT Vintage exists as a multifaceted business that encompasses an intentional ethos, built on the goals we established for ourselves in those early days. We've cultivated a thriving e-commerce platform, supported by social media platforms like Instagram and Facebook, and since 2019, have cultivated community (and sales) in our physical storefront. While the commerce component is a major part of our work, mission, and revenue generation, it's not the only thing we do. Like many successful, small businesses, we've found ways to capitalize on our individual strengths and interests by cultivating other avenues for our work to fill a void, respond to a problem, and address a need.

preservation—corbels, woodwork, plaster, etc.—warm, earthy tones with soft whites throughout and thoughtful art and décor choices that reflect our Afrocentric, midcentury, and eclectic sensibilities. As a Black queer family and first-time homeowners, it's truly been a joyful, collaborative, and spiritual assignment to dream up our first home together.

A recent client project we've been privileged to put our hands to is the design of Beaucoup Hoodoo in Germantown, Philadelphia—a shop and community space by Shantrelle Lewis that centers African spirituality traditions and healing. Lewis is a friend, sister, Jannah's soror, and one of our co-conspirators, so working together to design a space that teaches and aids in the spiritual work of our ancestors was a gift. Shantrelle, who hails from New Orleans, gave us our design anchor early in the process in the form of a question: What would it look like if Marie Laveau were practicing voodoo and owned a shop in 2024? This project called on us to bring the swamps, metropolitan flair, and inimitable character of old New Orleans to the historic Germantown neighborhood. Through incredible

THE BRICK-AND-MORTAR

On the corner of Marcus Garvey Boulevard and Decatur Street in Bed-Stuy, Brooklyn, sits our sunny thousand-square-foot flagship brick-and-mortar shop. We decided back in 2016–2017 that we would open a physical location to house our public-facing collection, entertain rental inquiries, and hold space for community. Building a digital footprint is no easy feat and there was something missing that we both knew could be cultivated if we had a physical home base to invite customers to. Brooklyn was the only and obvious location, but we were struggling to amass the capital needed to secure and build out a brick-and-mortar in a borough so depleted by violent anti-Black gentrification. So, we turned toward our community. It was 2019 and we'd just completed a successful crowdsourcing campaign to raise some funds for the brick-and-mortar. Folks generously donated about $25,000 to the cause—a gift that left us inspired by the possibilities of community and self-determination. Prior to 2019, we searched for nearly

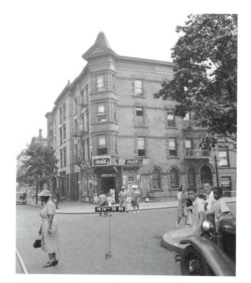

BLK MKT Vintage brick-and-mortar (circa 1939–1941)

a year for the right spot—checking out commercial spaces in Flatbush, Bushwick, Fort Greene, and other sections of Bed-Stuy to no avail. We finally landed on our corner space, with beautiful, exposed brick and other charming in-era details we loved. Importantly to us, it was formerly owned by the Garrett family, a Black family in the neighborhood who ran a dry cleaners and had established a long Black legacy in the community. With the violent realities of gentrification, we were touched by the possibility that we might be able to preserve that legacy and sustain it into the future.

Today, the shop acts as the physical, sensory, and immersive public-facing showroom for some of our collection. I say *some* because we selectively curate what is available for sale there. Not everything makes it to the physical shop. What does make it there are a ton of books; hundreds of records (updated weekly), two racks of vintage clothing; small, fragile housewares; and a lot of large furniture and décor that might be challenging to ship. Our shop is open to the public on Saturdays and Sundays, and, when doors are open,

found objects, reproduction antique furniture, and design elements like aged tile, built-in shelves, and incorporation of wall molding, we made a contemporary home for Marie Laveau that was aligned with the work of our client. We both really love the work of interior design and its influence on daily living for Black people. Narrative-driven design rests at our core and it's such a privilege and gift to be able to work with clients who understand our love for vintage and value the vulnerability that comes with bringing our full selves to the imaginative work of design.

Beaucoup Hoodoo completed project (2023)

Our Design Philosophy

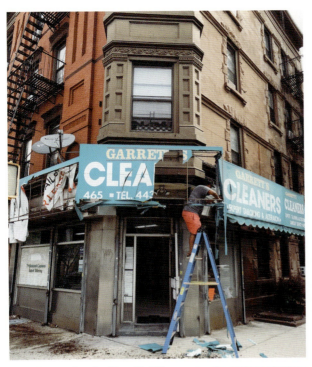

Jannah removing the Garrett's Cleaners awning preconstruction of BLK MKT Vintage brick-and-mortar, Brooklyn

BLK MKT Vintage brick-and-mortar, Brooklyn

it's often brimming with couples, families, and solo shoppers humming along to whatever Spotify playlist we're feeling that day.

It didn't take us long to establish relationships with a few regulars, folks in the neighborhood who collect and are intentional about supporting local businesses (even if it's to pop in on their way to or from the grocery store, do a lap around, and check on us). Some folks aren't necessarily coming in to shop with us; they're visiting the shop to bring us goods that they'd like appraised, consigned, or sold entirely. These are some of my favorite visits because they bring spontaneity to the shop, new items, new owners and new stewards of the cause, and new stories to be shared.

One of our regular clothing connects lives just a few houses away from our shop and brings us vintage tees once or twice a month. Last month, he brought in a vintage Morehouse College tee, a Black Betty Boop joint, and a vintage School of Hard Knocks tee (that Jay wound up keeping). Last week, he brought in a 1980s "We Are the World" tee (that I wound up keeping), an

early aughts Knicks NBA tee, and a vintage rasta-colored sweatshirt.

With any walk-in sales, we closely inspect the items for damage or signs of wear and tear; note any significant markings, dates, or authorship; and talk through value until we agree on a purchase price. Most times we're able to find a price that is mutually agreeable, but sometimes we don't and that's just the business. The internet has made it so that anyone can sell goods and dictate their own pricing, without a ton of experience or knowledge. So, while the internet has made our work possible, it also brings forth challenges to the industry when it comes to valuation of items, not to mention the encroachment of reproductions. More on this to come . . .

We liken our brick-and-mortar to visiting the "fun relative's" house. Y'all have a "fun auntie"? At Auntie's, you can touch the magazines, pull down the "good china" and inspect it (*okay, maybe this is a stretch*), smell the spines of books that sit at the very top of the bookcase, sing along to grown folks' music LOUDLY, try

Choosing to center

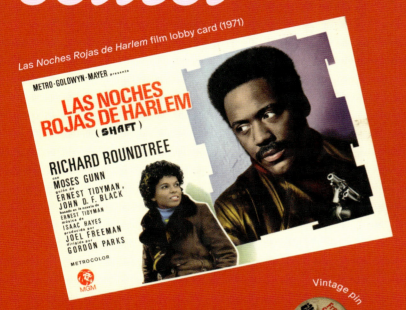

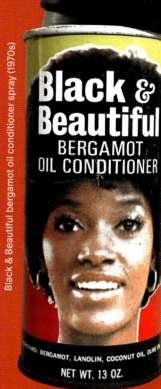

Vintage pin

Antique Ole Vir-gin-a cake pan with original label (1930s-40s)

Black cultural ephemera and Black people

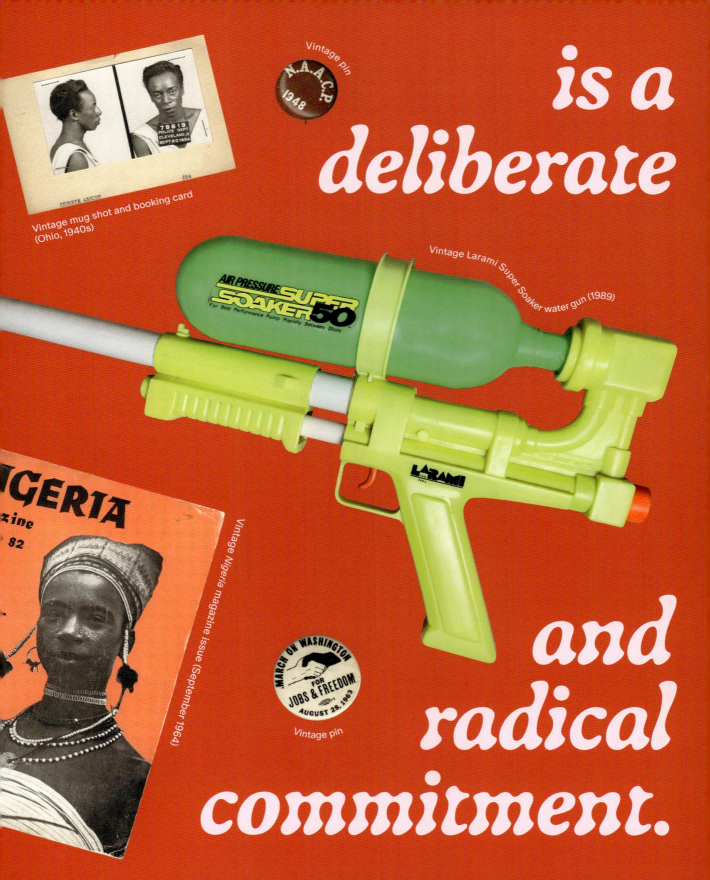

Vintage mug shot and booking card
(Ohio, 1940s)

Vintage pin
N.A.A.C.P.
1948

is a
deliberate

Vintage Larami Super Soaker water gun (1989)

AIR PRESSURE **SUPER**
SOAKER 50
For Best Performance Pump Rapidly Between Shots

LARAMI

NIGERIA
zine
82

Vintage Nigeria magazine issue (September 1964)

MARCH ON WASHINGTON
FOR
JOBS & FREEDOM
AUGUST 28, 1963

Vintage pin

and
radical
commitment.

Beacoup Hoodoo first site visit (2022)

and not owned) in a neighborhood that has undergone years of gentrification and whitewashing. It is a literal embodiment of our mission to reclaim space and center Black history and culture.

INTERIORS

One of our earliest sayings about the division of labor in our business is that Jannah "brings home the bacon" and I "cook it up." Jannah was (and still is) awake at 5:30 a.m. to spend early mornings at local antiques and flea markets two to three days a week. She packs our SUV full of incredible goodies from her favorite market vendors, bringing home "the bacon"—midcentury wall hangings, postmodern side tables, Victorian gilded mirrors, and more. If these incredible pieces are the bacon, interior styling is the cooking and BLK MKT Vintage is the kitchen! Once those items and others make it home (directly into our foyer), it is time to cook it all up—unwrapping the bubble wrap and butcher paper, dating objects, holding them up to the colors on our

on vintage hats and croc-skin kitten heels, put records onto the player, gently touch the patina along the edges of the family photos, and flip through memorabilia on the sofa (*which isn't covered in plastic, by the way*). Here, you can find yourself at play. Here you can explore the full sensory possibilities of Black ephemera, all while bumpin' to Roy Ayers and Big Mama Thornton and rubbing shoulders with other Black folks who are simultaneously seeing and experiencing . . . themselves.

We host public events here. We rent out the space for private gatherings and photo shoots—both personal and corporate. I've witnessed two wedding proposals in our shop, one was my own (blushes) and the other, a gorgeous young Black couple whose joy and palpable love held the shop captive for the moments after. The function of our brick-and-mortar is about community and about Black folks, *first and foremost*, having a space to come together in the name of shared heritage. It offers a physical space for us to truly see one another in a world that is primarily constructed and mediated in digital spaces. The function of our brick-and-mortar is to also reclaim space (even if it's rented

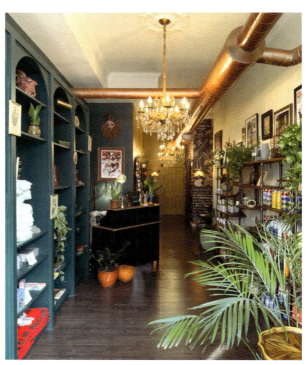

Beacoup Hoodoo project compeleted (2023)

Beacoup Hoodoo first site visit (2022)

SET DESIGN AND PROP RENTALS

Another arm of BLK MKT Vintage is our prop rental and set design service. It was a natural pivot from designing interiors, which is ultimately a form of narrative storytelling through space and environment. We'd always wondered about Black-owned prop houses and who was sourcing staple items in dramatic sets of Black households. We also knew a bit about prop styling from our early days as a mobile business. Each venue we visited with our pop-up shop required new and varied styling, but our goal was to always tap into the collective memory of Black folks and Black experience by creating a space that spoke viscerally and authentically to that shared memory.

Our set design and interior business are inextricably linked and we manage requests on a case-by-case basis. Requests for props and costumes are sourced from three places—our private collection, our rental inventory, and sometimes, the brick-and-mortar. We charge stylists, creative directors, and others a daily, weekly, or monthly rate for these props and costumes.

walls, wiping down the glass and moving them around to find the best placement in our crib. It's a beautiful metaphor for the ways our strengths and abilities have brought forth curious, playful, and unmistakably Black curated spaces.

For the past four years, we have been curating physical spaces for clients with vintage objects, aesthetics, and design elements at the center. I spearhead this aspect of the business with Jannah's input and support. We take on about four to six projects per year, of varying physical spaces, budgets, and types. Our clients are parents, couples, entrepreneurs, first-time homeowners and apartment-dwellers looking for interior design that reflects who they are and who they want to be. We've styled residential spaces and recently expanded to commercial spaces, an exciting growth area, considering our own positioning as business owners. Most of our clients come to us via a word-of-mouth recommendation and because our work appears on our website and social media. Thank you Ella Baker's internet for allowing us to showcase all the different iterations of our work and expand our reach!

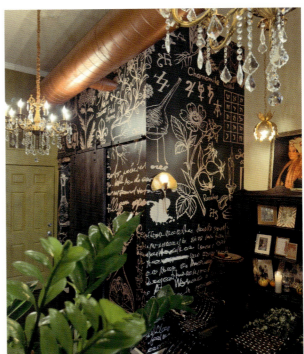

Beacoup Hoodoo project completed (2023)

These projects are fun for us because they challenge us to think 360 about the elements of storytelling—character, plot, era/time, place, and, most importantly, the role material culture plays in it all. Costume rental is especially fun for those reasons, particularly when we're pulling for characters we know, love, and are connected to.

Thanks to costume designer Shiona Turini, we sourced several tees for Issa Rae and Yvonne Orji that appeared on seasons two through five of *Insecure* on HBO. These were some of our favorites—the vintage 1970s United Negro College Fund ringer tee, the 1990s Martha's Vineyard color-block tee, the 1970s Angela Davis yellow tee, and, of course, the 1990s Dark & Lovely tee. We've also sourced tees that have appeared on *Saturday Night Live* and in various commercials, marketing and ad campaigns, and plays. The requests really do vary and it's always interesting to see the needs of the production side of our favorite on-screen content. Sometimes, props and wardrobe are needed. Other times, we pull for requests and are also asked to style the event or set. We've had to build out this arm of our business to allow for production needs, which are often varied, last minute, quickly changing, and particular. This isn't the section where we discuss the future of BLK MKT Vintage, but a prop house may be in the stars. Jannah has taken a liking to sourcing for wardrobe and we're expanding our offerings for the prop and wardrobe needs. Ya heard it here first!

ACTIVATIONS AND BRAND PARTNERSHIPS

The third major arm of the business includes our brand partnerships and activations. BLK MKT Vintage partners with brands and companies that are looking to market various projects and, sometimes, products. We take on a handful of these partnerships on an annual basis and only for partners or specific projects that are aligned with us in their values, aesthetic, community, and mission. Solange told us to "do nothing without intention" and that mantra undergirds all of our work, but especially collaborative endeavors. Capitalism has made it so that large corporations have extensive marketing coins and, as a brand with a large digital community, we're approached often to collaborate on initiatives that will bring visibility to a project and joy to our community. These collabs require our team to be discerning. Authenticity is important to us and we embrace opportunities to expand our reach and amplify Black culture and historical memory. We've partnered with companies to bring immersive experiences to communities as a way to market various initiatives, including film projects, TV shows, Black History Month celebrations, holidays, etc. Activations are *experiential marketing*. It's in the name—the experience is paramount. Whether we're curating our shop with 1970s film or TV ephemera for the release of a documentary about Black cinema or curating a mini–hair salon with vintage products and furniture for the release of a hair

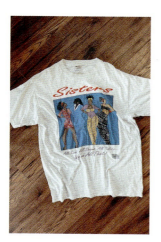

Vintage "Sisters" tee (1990s)

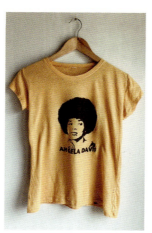

Vintage Angela Davis tee (1970s)

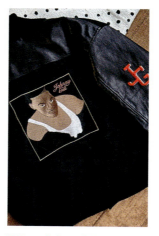

Vintage Johnny Gill crew jacket (1990s)

Vintage "Positive Women" sweatshirt (1990s)

care line, we're energized by opportunities to break out the ephemera from our private and rental inventories and create a unique, felt experience. Activations are especially fulfilling because they're in-person and as much as the digital community is about us and Black material culture, there's nothing quite like experiencing vintage/antique objects IRL. We've had the privilege of curating activations for Afropunk, Wieden+Kennedy, Facebook, the Apollo Theater, the Brooklyn Museum, AfroTech, and more—all with the intention of bringing Black historical memory to the present moment, in a full and sensory way.

THE BLK MKT VINTAGE PICKING PROCESS

There's a real desire and need to be clear about our intentions and to codify a process because, without one, we could literally buy up every single piece of Black ephemera we see on each outing to an estate sale or a vintage shop. That isn't our work or our ministry. In this section, we're going to share a bit more about the process and structure in which our decision-making and curatorial process is rooted. There's an immense

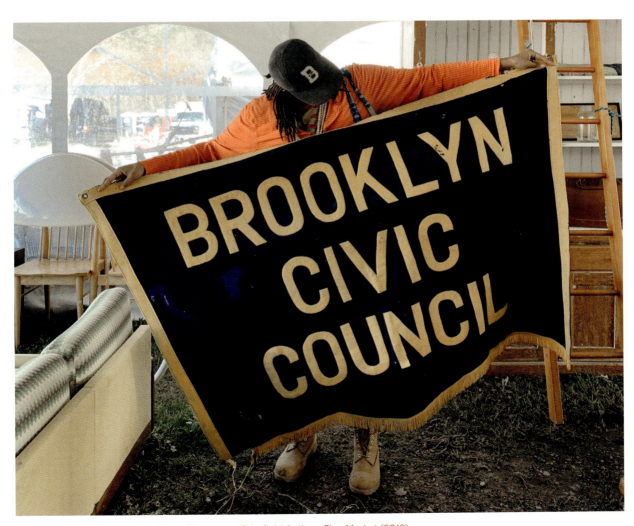

Jannah holding Brooklyn Civic Council banner at Brimfield Antique Flea Market (2019)

37

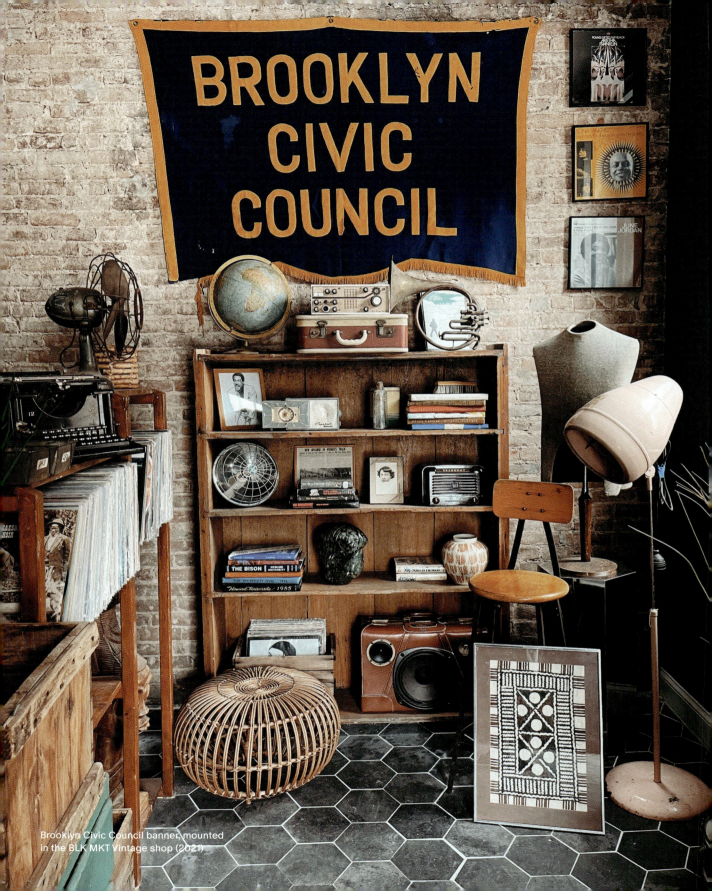

Brooklyn Civic Council banner mounted in the BLK MKT Vintage shop (2021)

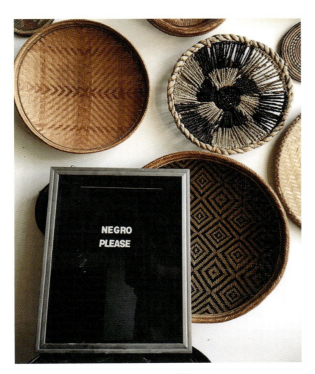

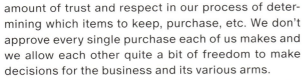

Vintage sign board, "Negro Please," (1970s)

Vintage Afro picks in original packaging (1970s)

amount of trust and respect in our process of determining which items to keep, purchase, etc. We don't approve every single purchase each of us makes and we allow each other quite a bit of freedom to make decisions for the business and its various arms.

Say we're driving in upstate New York for an afternoon of picking. We'll immediately split up and start pulling objects. Once we're both done scanning the space, we'll find each other and it's show-and-tell time. We normally show one another the goods we like and share pricing or any information that stands out about the purchase. Perhaps one of the legs on a nightstand is loose or there's an inscription by Patrick Kelly on the back of one of his T-shirts. Those are notes we share with one another prior to making final decisions and paying. I think it's fair to say that eight out of ten times, we agree on a purchase. Easy. Here's our business credit card. Those other two out of ten times are resolved differently, depending on the item, cost, provenance, seller, etc. There are so many factors that impact how we decide about an item and it's truly a case-by-case decision.

Jannah once found a set of four antique fold-up theater seats on Craigslist. She reached out to the owner to inquire about condition, negotiate the price, and set up the sale. I was open to them. They were beautiful, but they were HEAVY and would take up a considerable amount of space in our two-bedroom loft (this is before we had a storage unit). I expressed my dissent and after much discussion about the pros and cons, I deferred to Jannah. She purchased them and gave them a home in our second bedroom. When we moved, they went into storage and when we bought a house, all the seats but one remained in storage. One was brought into our garage, so Jannah could find the right person to restore and reupholster them. Today, those theater seats sit in the exact same place—one in the garage and three in storage. I truly believe that one day, she'll execute her vision for them by bringing them back to their fullest glory, but when I deferred to her purchase and, ultimately, her vision for them, I was also accepting that what happened might be a possibility. Instead of fussing about them, I choose to give grace and remember that different priorities come with the territory

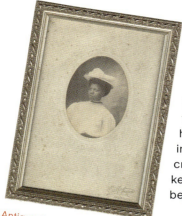

Antique framed portrait from the Stewart-Handy collection

of running a business with another person. We simply will not agree on every single purchase, but we do our best to advocate for the objects we see history and potential in, while honoring our creative desires and keeping the business' best interests in mind.

In terms of selling, we also employ trust, intuition, and communication to determine what should be sold, how, and where. The inventory in our brick-and-mortar is entirely different than the inventory stored for our online shop. Typically, we sell furniture and large décor pieces in-store and smaller, shippable items online—with a handful of exceptions, of course. There aren't many times we disagree about how, where, and if items should be sold. I've already noted that Jannah, more often than not, is interested in keeping items that I want to sell and also acquiring items I don't necessarily want to have. We work it out. Talk about it. Relinquish where we can and keep it moving. And sometimes it's not each other that we are at odds with, but, rather, the complicated histories of our ancestors, organizations, and elders, and even the material object itself.

You can't rummage through our assortment of vintage magazines and find a rich reserve of magazines with Bill Cosby on the cover. Maybe there's one, but it likely has the full cast of *The Cosby Show* on it. There are no R. Kelly vinyl records sold in our shop. I don't think we've ever bought

Ebony magazine (1949)

or sold one, to be honest. You can, however, find a rare vinyl record of the Honorable Minister Louis Farrakhan's speeches and an occasional copy of *Soul on Ice* by Eldridge Cleaver of the Black Panther Party. There are no press photos of Stacey Dash in *Clueless* but you might find a magazine where "old Kanye's" on the inside being featured. There was a Ben Carson biography collecting dust in the library section of the shop, a boxing magazine or two with Mike Tyson on the cover, and I remember seeing a *Time* magazine with a cover photo of Clarence Thomas in our $5 bin. Occasionally, we'll buy vintage Black erotic magazines with the raunchiest covers and headlines you've EVER seen. And, sometimes we purchase more mainstream publications like *Jet*, *Hep*, and *Bronze Thrills* with cover stories that employ violent, homophobic, transphobic, sexist, colorist, classist, and prejudicial language by today's cultural standards. We still have dozens of Alice Walker's books in the shop for sale today. We uphold the legacy of *Ebony* magazine today, despite its propagation of colorist beauty standards in its early days,

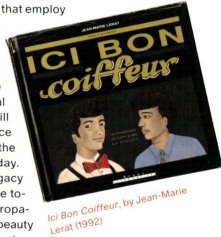

Ici Bon Coiffeur, by Jean-Marie Lerat (1992)

and plenty of NAACP memorabilia, despite dissent within the community about several of its founding members being white Americans. Lastly, hundreds of copies of the Black Panther Party newspaper have passed through our hands over the years and we consider them important, despite the rampant sexism, abuse, and misogynoir on the part of the Black male leadership, both in their private lives and within the ranks of the organization.

All that to say, we recognize that many of our historical figures, organizations, and ancestors led complicated lives and have therefore left us with complicated legacies. Some more than others. And the ways we come to remember those who have harmed others or have espoused problematic beliefs, while being mouthpieces of the patriarchy

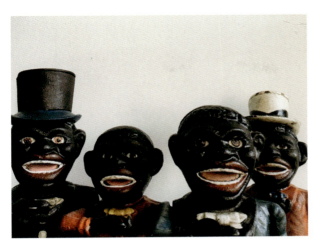

Jolly Nigger banks

and white supremacy (and sometimes white people) vary from person to person. Black folks are not a monolith and if there's one message we are intentional about spreading via BLK MKT Vintage, it is that we are an expansive, multitudinous community. We ain't flat. So, dissent, critique, and curiosity are welcome here. Customers have questioned our Farrakhan tees, Dr. Dre vinyl records, and amplification of Black Panther Party ephemera. We've had some spirited conversations in the comment section, in our Instagram DMs, and in our shop—those are valuable and at the end of the day, we are curating a selection of historical ephemera that is aligned with *our* values, *our* curiosities, *our* interests, and *our* desire for truth-telling. A different vintage shop has a selection that is aligned with theirs. As you've read, we're very much interested in facilitating opportunities for our community to get close to the materiality of our past and bring the lessons, data, and inspiration into the present moment. That doesn't mean that *anything* and *everything* finds its way into our shop with the intent to just "teach a lesson." Nah. We, as the founders of BLK MKT Vintage, are arbiters and stewards.We are two people, with biases, triggers, knowledge, responsibility, boundaries, and we hold all those parts of our human experience alongside our desire to see the most difficult and harmful parts of ourselves, our culture, and our beloved public figures in order to inspire a new way In this same vein, we're highly selective about some of the violent and racist ephemera that exists out there. Just googling Black

americana or Black memorabilia will yield thousands of examples of these racist caricatures and renderings. Occasionally, we'll acquire a collection that might have a handful of ephemera in it that doesn't fit our area of interest and expertise. Maybe there are small crumb brushes with Sambo-esque figures on top, some copies of early twentieth-century racist sheet music or kitchen décor with Mammy figure appliqués. We've made a few exceptions over the years, and when those items are listed for sale online, they're accompanied by a blurb about their embodiment of racist archetypes. We've even gone as far as to label the item "racist" in the description header. For example, "Vintage Mid-Century Racist Mammy Kitchen Textile" just so it's super clear. For us, selling and sharing objects like these in 2024 calls on an ethical and moral responsibility to contextualize the time in which they were made, and the white imagination in which they were conceived. Because these racist depictions actually have nothing to do with us. With Black people. They have more to do with those invested in racist aesthetics, folklore, and the upholding of whiteness, while invisibilizing real, human Black people. BLK MKT Vintage is interested in the material culture that represents real Black humans' lived experiences from each corner of the diaspora, particularly the Americas. We are not in the business of propagating dehumanizing caricatures. Nor tropes. Nor archetypes. Our work is about Black folks' shared and lived experience and the actual decentering of whiteness (and all its facilities) in order to make room for the fullness of who we are and who we've been.

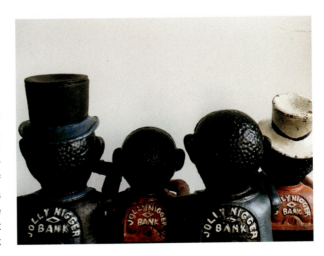

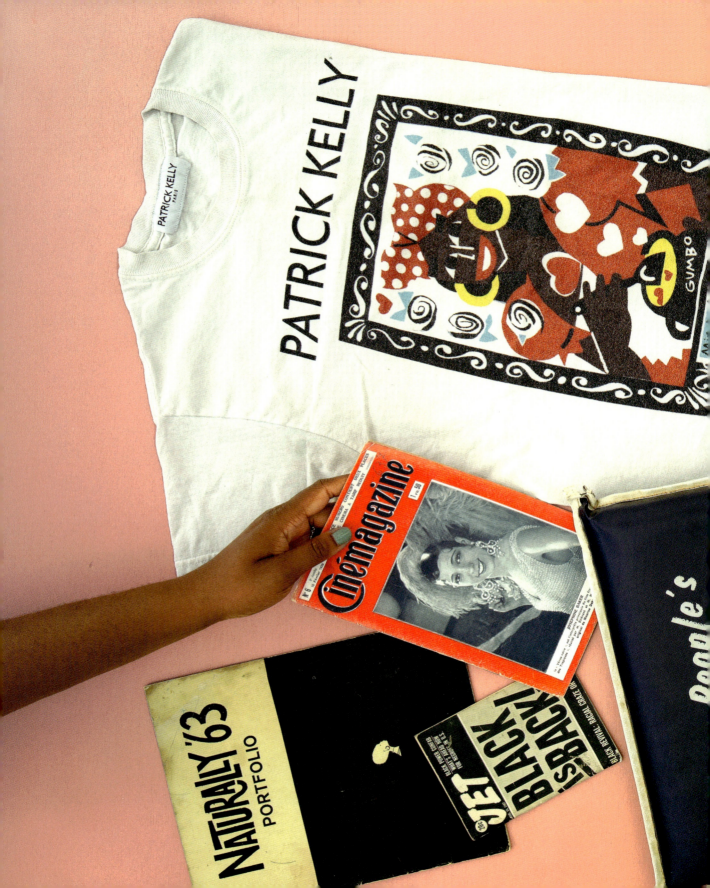

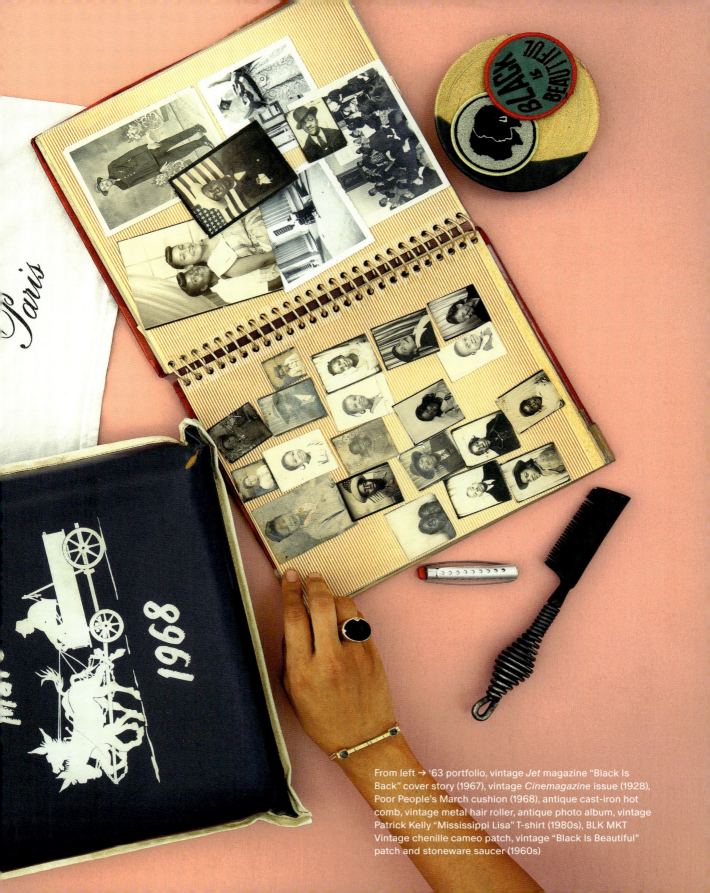

From left → '63 portfolio, vintage *Jet* magazine "Black Is Back" cover story (1967), vintage *Cinemagazine* issue (1928), Poor People's March cushion (1968), antique cast-iron hot comb, vintage metal hair roller, antique photo album, vintage Patrick Kelly "Mississippi Lisa" T-shirt (1980s), BLK MKT Vintage chenille cameo patch, vintage "Black Is Beautiful" patch and stoneware saucer (1960s)

INSIDE THE INDUSTRY

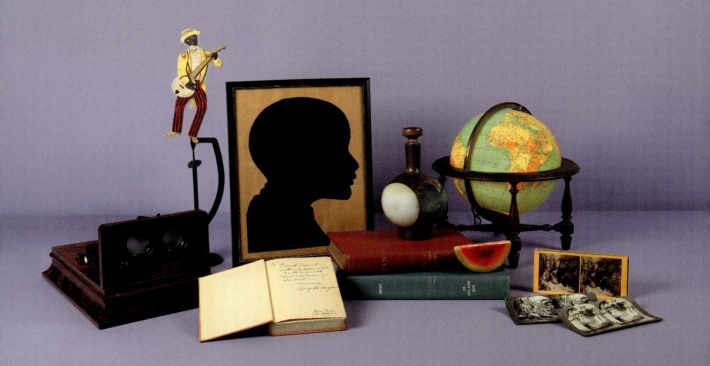

From left → 1. Midcentury banjo-playing figurine on stand; 2. Antique stereoviewer; 3. Framed cut silhouette portrait (1960s); 4. First edition of *The Ways of White Folks*, signed by Langston Hughes; 5. Stoneware decanter (1960s); 6. Bound *Tan* magazine issues (1960s) and bound *Ebony* magazine issues (1970); 7. Light-up globe and wood stand (1970s); 8. Glazed ceramic watermelon (1980s); 9. Antique stereoview photo cards

WRITTEN BY

Jannah

ONE MARKET MORNING...

At the market this morning, **6:30 A.M.**, after driving over an hour and for what will be a hundred miles round trip, haulers, junkers, and collectors alike **CONVERGE** in a random New Jersey town up the road from a nondescript Wawa. I'm having a familiar series of thoughts as I look over a box of vinyl records. Whose **BELONGINGS** was I sorting through? Which records were their favorites? How were they curating the vinyl mixtape to their lives? After the third box of approximately forty to fifty records, the flipping can almost become **MECHANICAL**. My trained eyes are searching for **BLACK** faces and familiar names with speed top of mind so as not to let the other early birds beat me to the next box.

REGGAE GOLD 1997

(PLAYABLE CONDITION—BUY PILE)

LENA HORNE JAMAICA

(JACKET IS DAMAGED,
DEEP SCRATCHES—FLIP)

JANET JACKSON CONTROL

(SEALED—BUY PILE)

BEETHOVEN SYMPHONY NO.5

(FLIP)

SOCA HITS OF TRINIDAD

(PLAYABLE CONDITION—BUY PILE)

DOLLY PARTON GREATEST HITS

(FLIP)

STEEL PAN COMPILATION

(DEEP SCRATCHES—FLIP)

JAMAICAN FOLK SONGS

(PLAYABLE CONDITION—BUY PILE)

MARY J. BLIGE SHARE MY WORLD

(NO VINYL, SLEEVE IN GOOD
CONDITION—BUY PILE)

I let my imagination take flight. Whoever they were, they must be of West Indian descent, maybe older immigrants. Some of the vinyl were pressed in the UK, or from Caribbean labels. Did they bring them with them when they came stateside?

But even before I came along to flip through these crates, the vendor made their own selection. What was it about this music, these artists—individually or collectively—that allowed these particular records to transverse time and end up together on a vendor's folding table? What records didn't make it to the public and into the vendor's "keep" pile, and which were deemed trash?

▲▲▲▲▲

The journey of our things is often obscure, but it's humbling, to acknowledge that for every pair of hands an item has passed through on its way to this market, a choice was made by another person to "flip or keep" it.

For us, the journey is often THE point. It's through the journey—through the experiencing of the object by many hands and many owners across time—that the object gains cultural significance in the first place. As stewards of the secondhand industry, we have to make decisions every day that will lead to the continued survival of a piece of material culture or its destruction at a landfill. Trust me, I'm not being dramatic. We are not a company with unlimited resources or space, so we have to make tough choices about what we acquire and what we keep or sell. Thousands of antiques dealers, collectors, resellers, and folks in the industry make these choices daily. YOU make these choices every day, whether you are in this industry or not. What you decide to keep or discard, and the means through which you make that happen, makes you a player in this industry as well.

In this chapter we will take a dive into the secondhand industry on the macro level. The who, the where, and the whys that are so vitally important to be aware of when traversing the scene. With each player comes a different value system, level of power or import, education, size and scale, and motive for selling or buying secondhand items. We'll also define some key terms and share our unique positionality with respect to the players and motives in the industry.

VALUE IS IN THE EYE OF THE BEHOLDER

How much do you value this book? It may be hard to answer at this point in, but if the question was posed to you, what would your answer be? The price you paid for the book? The potential appreciation of the book twenty years from now? Or the value you put on the knowledge and feeling of nostalgia gained from reading through these pages? The word *value* can be defined, but its meaning is still difficult to grasp, because value is always in the eye of the beholder.

value; n: ❶ the regard that something is held to deserve; the importance, worth, or usefulness of something. "Your support is of great value." ❷ a person's principles or standards of behavior; one's judgment of what is important in life. v: ❸ estimate the monetary worth of (something). "His estate was valued at $45,000."

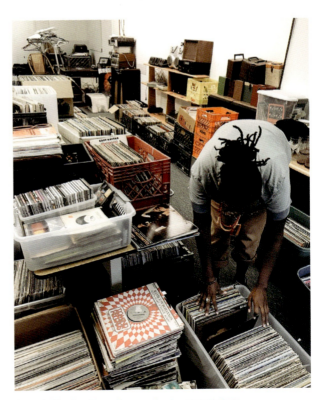

Jannah flipping through records at a record shop

In our capitalistic society, the first thing most of us think of when it comes to value is *monetary value*. But, there are so many other—arguably more powerful— forms of value that are too often, unfortunately, outpaced by monetary value.

When our default understanding of *value* is monetary, we risk missing the objects that will enrich us through other means. In a world where "money talks," it makes perfect sense to view objects for what they are monetarily worth, but the BLK MKT Vintage ethos is to consider multiple forms of value in our picking, buying, pricing, and selling practices.

In the same vein of prioritizing monetary value, rarity and scarcity are two additional concepts that are often unnecessarily associated with value. There is the assumption that an item's rarity or scarcity should be reflected in its price.

rarity; n: The state or quality of being rare. "The rarity of the condition"; a rare thing, especially one having particular value. "To take the morning off was a rarity."

scarcity; n: The state of being scarce or in short supply; shortage. "A time of scarcity."

While the terms are often used interchangeably, they have a key distinction; *rarity* centers value, whereas *scarcity* centers availability. What many folks do is make the inference that if something is scarce, then it should intrinsically have a higher value, which is not necessarily true. For example, blank floppy discs are

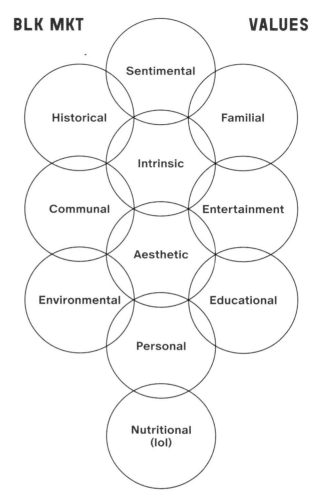

BLK MKT **VALUES**

Sentimental

Historical Familial

Intrinsic

Communal Entertainment

Aesthetic

Environmental Educational

Personal

Nutritional (lol)

We met Frank by accident back in 2014 and our relationship was rather short-lived for reasons that'll soon become evident. We were still at our full-time jobs and thrifting as a hobby, frequenting the same thrift stores on the discount days and during lunch breaks. Along the route to one such store I noticed a pretty nondescript junkyard behind a large rolling fence with a sign to "Call Frank," followed by a phone number. I thought nothing of the junkyard—it was on a back road near a truck depot with a gate that was usually closed—until one day it wasn't. I was flabbergasted driving by, not only by the size of the property the gate was masking but by what I saw inside. To this day I wish we had taken more pictures because you would not believe the number of items stored in piles, mounds, barns and makeshift buildings, trailers, and, mostly, just out in the open.

After seeing this for the first time I knew it was time to indeed "Call Frank." Outside of estate sales this would be our first "pick" of someone's collection. I remember the call being rather matter-of-fact as if Frank got these calls all the time. The tone changed

The Story of Frank and the Junkyard:

rather scarce nowadays, but that doesn't mean folks inherently will pay more for them.

Recognizing how folks use or misuse these terms is the first step in navigating the secondhand market. Understanding the nuances of these terms enables you to read a situation, decode language, and communicate across differences effectively to get the desired outcome—a successful purchase or sale. We did not have this understanding when we first set out to do this work. Over the past ten years there have been countless times where misalignment of terms and definitions has led to failed transactions, conflict, and missed opportunities.

Totius Africae Accuratissima Tabula, seventeenth-century map of Africa

WHO ARE THE PLAYERS?

It would be easy to fill this book with hundreds of industry anecdotes of how value and valuation are utterly subjective and inconsistent. Buyers, sellers, and traders all serve as gatekeepers who get to decide which type of value is counted and which others are quite literally discounted. One of the reasons we started BLK MKT Vintage is that we weren't seeing enough Black ephemera and artifacts being valued in the market.

The players in our industry are varied and no two folks have the same ethos, business model, or systems of valuation. Some folks—namely, institutions—have codified their valuation systems via algorithms and extensive market research. Small business folk, like us, use online analytics and anecdotal market research to delineate our valuation systems and methods. Others simply rely on intuition and the market principles of supply and demand.

Frank's salvage yard (2014)

A Lesson in Valuation

JUNKERS
SCRAPPERS
CLEANOUT folks
ESTATE SALE COMPANIES
ONLINE RESELLERS
COLLECTORS
AUCTION houses
VINTAGE SHOP OWNERS
INSTITUTIONAL buyers
MUSEUMS
ARCHIVISTS
CLOTHING RESELLERS
FINDERS AND flippers
VENTURE CAPITAL-backed companies
DUMPSTER-divers
CHARITY-DRIVEN thrift corporations
PROP AND SET designers
INTERIOR designers

As a society, our keeping and collecting habits can be traced along the same trajectory as industrialization, globalization, and technological advances. Societal sentiment and overall economic outlook inform one's propensity to engage with the resale market on the sell side. In the contemporary context, according to thredUP's 2021 Resale report, the global

secondhand market is expected to be valued at more than $77 billion by the year 2025. This shift is being linked to changing consumer sentiments. People want to spend their money with companies that engage positively or philanthropically with society. This era of quasi "corporate responsibility" has also shed a more positive light on the net good of the resale industry in terms of sustainability and the environment. Yet it is pivotal to remember that, at the end of the day, folks are in this industry because it's good business—$77 billion worth.

While those who make up this industry vary from two-person-run vintage shops to multinational thrift companies, our work is unequivocally grounded in the individual. As much as our business is about things, it all starts with *the who*. Shopping the resale industry, more often than not, means shopping small; supporting local, community-powered businesses. The landscape of folks who are on the sell side of the equation is ever changing. While there have always been institutional interests in the resale industry, it's time to *watch out for the big girls*! The venture capitalists with big money are coming on the scene. Since 2014, there has been a notable shift in the amount of money being pumped into start-ups in the resale industry. Businesses like Plato's Closet, thredUP, Poshmark, and The RealReal have entered the space to capitalize on the current public sentiment toward the industry. For the purposes of this discussion and our lens throughout the book, we are choosing to focus on the mid- to small-sized businesses and institutions.

once the day came for our visit. Don't get me wrong, the tone on the phone was not *not* welcoming. It was indifferent, but in person there was an air of reticent discomfort. Being in this work for almost a decade now, we know this feeling well; when people part with their belongings there are a whole host of emotions at play, but when a collector parts with their things there is often a palpable calculus and resentment toward the buyer. But that's not the point of this story . . . yet.

picker; n: A person in the profession or hobby of sourcing or looking for antiques and vintage items. *Picker* denotes the curation that goes into the process as well as the many places a picker may go to find their wares. Popularized by the TV show *American Pickers*, those who fit this term are unlike thifters, who frequent thrift stores, or antiquers, who stay in the antiques store and mall scene.

The Story of Frank and the Junkyard:

THE YOU OF IT ALL

One of the most important players in the secondhand industry is the layperson, as their role is twofold—functioning not only as a consumer on the "buy side" of the equation but ultimately as the supplier of the goods on the "sell side" as well. The life cycle for vintage items begins with individual people who are not hobbyists, entrepreneurs, sustainability advocates, or historians. The items we acquire come from individuals who make one-time donations to thrift stores, who sell used items to bookstores or clothing stores, or whose homes or spaces need a cleanout. *They set* the prices, trends, and tastes of the market.

cleanout; n: The clearing out of homes, commercial spaces, or construction sites of all materials. During cleanouts, folks are hired to clear the premises and are usually able to keep whatever items they want with all other items being discarded. Materials from cleanouts comprise household items and belongings.

Les Ballets Africains (1968) and A Raisin in the Sun (1959) theater playbills

During the height of the COVID-19 pandemic, what became abundantly clear was that the second-hand industry doesn't stop churning. While no designation was given on a governmental level, the industry proved itself to be "essential," even in the face of the quarantine and the shutdown of most traditional retail outlets. People still had things they no longer wanted and didn't want to send to the landfill. Open-air flea markets were the first to reopen but, even prior to that, online, person-to-person transaction sites like eBay, Etsy, and Facebook Marketplace were all still buzzing with commerce. Our email and DMs were swamped with folks wishing to sell or donate items to us for a plethora of reasons. The quarantine was a time where folks reevaluated the items around them and sought options to make additional funds through engaging with the secondhand industry. Additionally, due to the supply-chain interruptions of mass-produced, new items, a number of folks were seeking secondhand items as an alternative. On a real level, with more than 700,000 Americans who died from COVID in the years

estate sales; n: Usually prompted by a death or a move, an estate sale is the selling of all or most of one's belongings. Estate sales usually take place in the person's home, storage unit, or online. Everyday items to rare collectibles can be found at estate sales.

Frank's collection was mainly industrial, with a massive assortment of items from the early 1900s to the present day. We didn't have a sourcing list, or items we were seeking. We were purely there for the pick, the dig, the treasure hunt. To name everything we saw

Toilets in junkyard (2014)

A Lesson in Valuation

2020 and 2021, the estate sale industry was very active with its business as usual.

The importance of the collector to this industry cannot be overstated. Just by the simple accumulation of items, you all become the archivists that we source from. On our living room wall hangs a silhouette of a Black boy from the 1960s. We acquired the item back in 2016 at an estate sale by a family relocating to Atlanta from South Plainfield, New Jersey. The seller of the home, the subject of the silhouette, now a grown man, was perplexed as to why we would want to buy it. He hadn't priced it because he didn't think anyone would be interested in it and planned to put it in the donation pile. He remembered sitting for the portrait and attempted to place the exact year while talking with his brother in the garage. We explained that his portrait was in an antique style called "cut-paper silhouettes" that predated photography. At that point we were just starting our collection of Black portraiture, including cut paper, hand-tinted photographs, daguerreotypes, tintypes, and stereoviews. It was dope enough to have found the piece at all, but we were thrilled to have the opportunity to meet the subject. These are the interactions that bring us fulfillment.

source/sourcing; v: The act of sourcing is seeking out and acquiring a specific item utilizing a number of sources to track it down. When a client has a specific ask for an item, we go and source it.

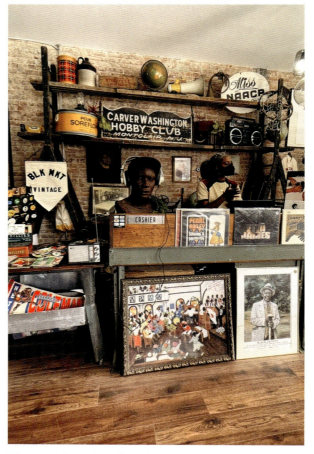

Kiyanna at the register of our brick-and-mortar store post-pandemic (2021)

would be impossible. Frank was a junker, someone who was in the business of tonnage and salvage. He had the benefit of having a large physical space in which to put everything. Frank's was the last stop for all the items that were unscrappable, nonrecyclable, unsellable, or just too cumbersome for most collectors or vendors to store. These items got dumped at Frank's. Architectural salvage, including toilets, doors, sinks, fire extinguishers, street signs, car parts, and bike frames were intentionally categorized but haphazardly strewn across a yard almost an acre in size. All the items were out in the open and exposed to the elements. Some piles were granted temporary "shelter" by decaying storage containers, broken hot dog cart umbrellas, or buried deep enough under other things to stay relatively unscathed by inclement weather.

architectural salvage; n: Pieces of physical structures that can be removed and reused, including doors, mantles, flooring, and antique plaster accents. Pieces are usually removed during a renovation process or prior to a demolition.

The Story of Frank and the Junkyard:

WHERE ARE THE PLAYERS?

The resale industry, across the globe, is one of the oldest means of entrepreneurship. Prior to the industrial revolution, which began in the last quarter of the 1700s, and the advent of mass production of goods and wares, everything was reused; nothing was thrown away. In the 1930s, recycle and reuse campaigns were instituted in support of World War II, in response to rededicated supply chains and the overall war effort. In the absence of the global supply networks and mass production, items were kept for longer periods of time and manufactured with longevity in mind. Reaching even further back, to the fifteenth-century souks and bazaars of Persian and Arabic empires in Africa and the Middle East, these spaces served not only as hubs of commerce but of culture as well. Vendors, traders, artisans, and craftspeople alike would sell, barter, and trade new and used items. As early as 3000 BCE these marketplaces became the precursors to urbanized cities and central business districts. Unlike then, in our contemporary setting, there is no simple answer to the question of "where" secondhand business takes place, as it is hyper-regional, culturally driven, and impacted by access and technology.

To best understand where to seek out folks who engage with the secondhand industry, it might be helpful to think about them in terms of the following categories:

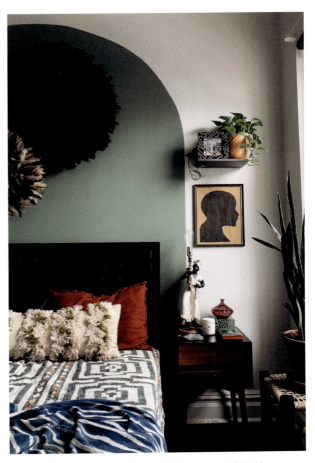

Hand-cut portrait, mounted in our former Jersey City, New Jersey home

There was one structure on the property, a barn, just barely visible from the street. Everyone in our business knows that the barn is *where it's at* for the best barn-fresh finds. Folks with large collections often keep things they value indoors, covered, closer to or even in their living spaces. Having been in the business for this long, this rule of thumb holds true every time! Even in a space like this, curation was at play. The barn had all the goods: old barbershop signs, décor, porcelain trolley signs, and Frank's 1930s automobile, sitting dusty and untouched. Frank was

holding out! Playing coy but still willing to part with some items. We knew that asking to buy things in the barn would be a tall task.

barn finds; n: Items found in barns, on farms, or in more rural settings. In urban settings, the term is used colloquially to denote items in a structure shielding them from the elements.

Then there it was . . . the point of the story? No, a turn-of-the-century traffic light. Truly a piece of

A Lesson in Valuation

❷ Informal

These spaces are characterized by hobbyist and semi-regular involvement in the industry.

Memorabilia shows/ auctions

Recurring IRL markets: flea markets, farmers' markets, swap meets

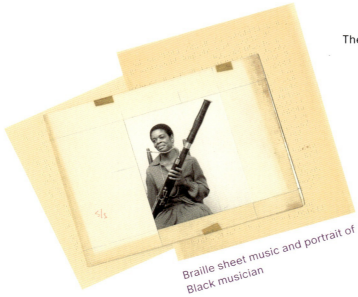

Braille sheet music and portrait of Black musician

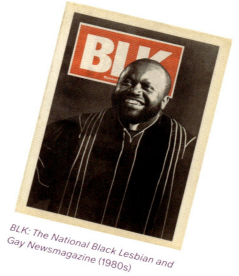

BLK: The National Black Lesbian and Gay Newsmagazine (1980s)

❶ Sporadic

Denotes spaces that pop-up or are not routinely involved in the secondhand industry.

Pop-up IRL markets: garage/stoop sales or sidewalk vendors

E-commerce: Etsy, eBay, Facebook Marketplace

architectural beauty in its unnecessary adornments and impractically heavy fabrication. Until that moment, I had only seen pieces that old, or, in that condition on TV appraisal shows and on Midwest architectural salvage websites. But here it was, perched by the door of the barn, partially covered by an overhang. The retail price, for an item like this, with original paint and colored lenses, was easily around $2,500. I knew I had to inquire, and since it was outside, becoming pitted and rusted due to water damage, it wouldn't be a hard deal to close.

After mustering my sweetest affect and tendering my most convincing offer, Frank uttered the three most deflating words in the industry: **NOT FOR SALE**. We honestly didn't get it in the moment, but, looking back, our naive presumptions were quite precious. We offered Frank well over what we were willing to pay and he stood firm. Finally, trying to level with him, I mentioned how the piece would be destroyed by the elements in his care and it should go to someone willing to preserve it. Frank was incredulous. If the adage were to hold true (and since I just told you it

The Story of Frank and the Junkyard:

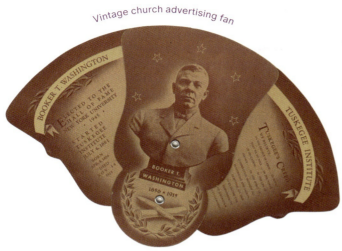

Vintage church advertising fan

❹ Corporate

The big players in the field. Multinational and national chains and retail outlets. New peer-to-peer platforms that monetize the buying and selling process while facilitating the transaction. Venture-backed organizations and charity-based thrift stores fall into this category.

Auction houses
E-commerce "big box" stores
Brick-and-mortar shops
Estate sale search engines

❸ Institutional

This designation is for the frequent participants in the industry. Small businesses, local enterprises, and family businesses fit into this category.

Brick-and-mortar shops
Storage units
Annual book fairs
Junkyards/salvage yards
Owners' estate sales

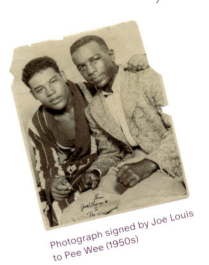

Photograph signed by Joe Louis to Pee Wee (1950s)

did), outside items = less value = easier to buy; inside items = more value and would be harder to bargain for. Wrong. Hopelessly wrong because we didn't take into account in the equation the *type* of value this item held for the owner. Frank shared with us that he couldn't sell the traffic light because he enjoyed it too much. Having the traffic light poised in front of his barn brought him joy, dare I say value. In my inexperience, I had prioritized monetary and historical value of the traffic light and completely discounted the personal or sentimental value he placed on it. This experience was

invaluable (see what I did there) because it helped us develop an ethic of care, a bedside manner that honors and respects the varied ways people connect to and place value on their things.

NFS (adj, not for sale): The dreaded three letters you'll sometimes come across in a vintage store or vendor booth. NFS is usually on a tag in place of a price for pieces the seller wants to keep personally.

A Lesson in Valuation

Magic Lantern glass slide at a local antique market

PICKING IN THE DIGITAL AGE: EBAY, ETSY, AND FACEBOOK MARKETPLACE—OH MY!

Like so many other aspects of modern society, the internet has granted us unprecedented opportunities for access to information and to each other. One of the greatest tools in our arsenal is the world wide web. Gone are the days where you have to physically shop at your local thrift, vintage, or antiques store to find a given piece of ephemera. Now the items are accessible via a simple search engine query. Titans of the space, eBay and Etsy, are the two sites that folks in the industry generally use to find, sell, and buy vintage items online. The peer-to-peer aspect of these sites gives collectors the opportunity to find niche and rare items that may not populate the tables of your local flea market or make it past the usual gatekeepers. Sites like these make collecting networks exponentially larger as individuals are no longer confined to the offerings of their local institutions.

ephemera; n: Ephemera is used to denote temporary or minor paper effects of one's life.

With newfound access come some drawbacks. Being an OG eBay user, I have had my fair share of counterfeit items sold to me under the pretense of authenticity or have outright been scammed. I am still hurt over the pair of Evisu jeans I bought in 2003, for which I mailed a certified check (funds earned from my NYC Summer Youth job at that) to Vietnam, and never received. Or a "vintage" folk art collage from the 1990s that wound up being a photocopy. Online sites, namely the peer-to-peer ones, also tend to skew the understanding of market value or pricing. Since these sites are a mix of folks engaging with this work on the *sporadic, informal, institutional,* and *corporate* levels, the understanding of market research and comparative pricing is not universal. Broader markets bring more market participation, which leads to more price variance (just makes sense, no?).

Lastly, with more regional options, like Craigslist or Facebook Marketplace, the potential for scamming IRL and interpersonal danger is also a possibility. Buying

Go to enough flea markets and estate sales, and you will start to see a trend. A fair number of the vendors are in this work with their partners, husbands, or wives. Some are like Kiy and me, who came to this work together, and others started with one partner in the field and the other joining in. While I don't have a strong hypothesis as to why so many partners are in the space together, my best guess is that it takes a lot of work and time to be in this business. Being in the secondhand industry as a small business can be grueling and time-consuming, with road trips, hours of researching items, and days of picking through just one person's collection. This work, with the long hours, offers space and time for connection between partners. Spending hours going from market to market is a lot less lonely when you have someone you love along for the ride. A smaller inkling of a thesis I have around partners being in this work together is that it takes tremendous balance. Not only do you need to go out and find the pieces, but you have to curate them and present them in a way

Life, Love & Vintage™

a Victorian pier mirror from a guy two towns over is convenient until that guy is a creep. However, if Marketplace is to thank for the mirror not ending up in a trash heap, then maybe said creep's mildly misogynistic jokes are worth it. Websites like Etsy, where we launched our first e-commerce shop, allowed for a more curated and less unregulated, "Wild Wild West" vibe than you may find on eBay and Craigslist. Despite the site being billed as a place for artisans and makers, antiques collectors have found space in that community, offering their pieces to buyers seeking unique gifts and items.

The internet is directly responsible for our ability to grow as a business. Connecting us to new players in the industry, including clients, fellow collectors, and dealers and institutions. Since we began our business in 2014, the landscape has changed tremendously, as algorithms and artificial intelligence influence so much of our online experiences these days, including our personal tastes, needs, and desires.

HOW THE PLAYERS PLAY: VALUE ON THE OPEN MARKET

Just as there's no one place to find the players in this industry, there's also no singular reason why folks engage in the secondhand industry. All kinds of reasons bring people to this space. Such a wide variance makes it impossible to talk about standard practices or generalized rules of the game. Someone managing the estate of a deceased relative and the scrapper who does cleanouts may have little in common in terms of motivation and goals. For example, the person managing the estate may be concerned with where the items end up, wanting them to be cared for or end up "in a good home," while the scrapper's main goal may be to turn metal into money, regardless of whether they must melt down heirlooms or antiques. What this means for a buyer is that

Antique framed portraits from the Stewart-Handy collection

that is pleasing to customers. Without traversing the slippery slope of gender roles, we find that the balance one seeks in their romantic relationship can also be reflected in their work partnership.

Kiyanna and I take tremendous pride in being partners in life, love, and vintage™ and find that our passion for vintage only enhances the other ways we are in relation to each other.

DISCLAIMER: This isn't a blanket call for you to go into business with your partner or spouse. We, individually, or as BLK MKT Vintage LLC (or our publisher, for that matter) are not willing to take on that liability! Folks tell us all the time that they could not fathom working with their significant other. For us, it's hard, and can be taxing on all of our forms of connection, but it's worth it. While we may not always work well together, we do work good together.

Doing this work saves pieces from ending up

Vintage "Black Is Beautiful" patch

Vintage brass compass

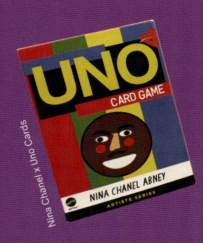
Nina Chanel x Uno Cards

Magazine scraps and clippings

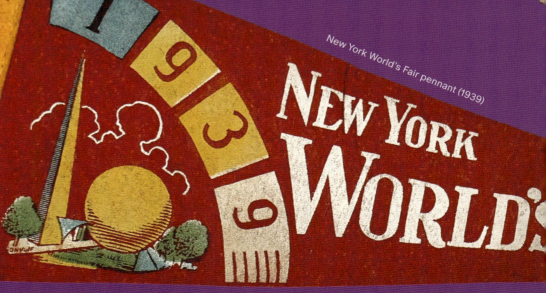
New York World's Fair pennant (1939)

Vintage Muhammad Ali shoe polish (1970s)

Vintage porcelain watermelon paperweight

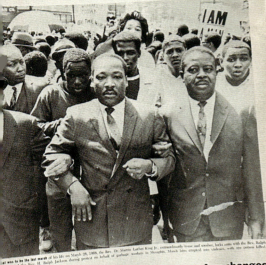

EARS AFTER:

GARBAGE WORKERS, PHIS AND DR. KING

I AM

al was to be the last march of his life on March 28, 1968, the Rev. Dr. Martin Luther King Jr., extraordinarily tense and somber, locks arms with the Rev. Ralph (r.) and the Rev. H. Ralph Jackson during protest on behalf of garbage workers in Memphis. March later erupted into violence, with one person killed.

nitation men make gains, but city sees few changes

BY JACK SLATER

Vintage ceramic catch-all

Vintage DIY collaged holiday ornament

Vintage pinback
Brooklyn!

FAIR

in the metaphorical wastebasket of history.

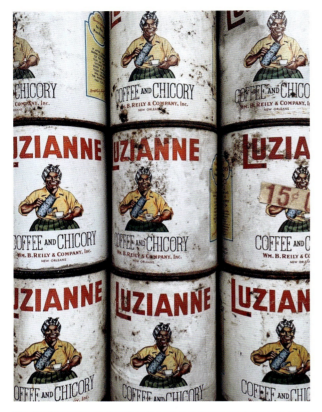

A collection of Luzianne tins, found at an estate sale in a garage

❸ Aesthetic Value Motive: Buys items regardless of age but based on beauty and style

❹ Personal/Familial/Sentimental Value Motive: Has a deep connection to, or nostalgia for, the past, and wants to engage with items that resonate personally

❺ Environmental Value Motive: Is sustainability conscious and wants to reuse the items around us to lessen their negative environmental impact

❻ Monetary Value Motive: Is in it to make a profit

VALUE IN THE (PROFIT) MARGINS

We would need to go into a full-on Econ 101 breakdown of opportunity costs and how supply and demand influence pricing structures to get the most robust picture of the secondhand market versus the retail market, but the one economic concept that we will dive into a little further is the concept of *profit margin*. Simply put, the *profit margin* on a product is the sale price minus the cost of inputs divided by the revenue. For example, Kim is a vendor who just purchased ten vintage Afro picks. The picks cost $10 each, for a total of $100 (inputs, or cost). Kim plans to sell the Afro picks at her shop for $25 each, for a total of $250 (sale price, or revenue). To get her profit margin, we must subtract cost from revenue, $250—$100, leaving Kim with $150 in profit. The concept of the "margin" comes in when we divide the profit by the total revenue, $150 ÷ $250. Kim is at an impressive 60 percent profit margin. Places like Target have a set profit margin for all their products, as well as a set profit margin for their overall business. But, small secondhand vendors like Kim have a volatile profit margin that will fluctuate and sometimes even dip into negative percentages. Why? With secondhand items the item itself doesn't conform to any standard in terms of condition, availability, or input costs. Each factor must be taken into account on every single transaction. The presence of varying profit margins makes haggling, negotiating, or bartering advantageous for the seller . . . and the buyer.

these different motivations and goals will have a strong impact on pricing and negotiation tactics.

scrapper; n: Someone who buys and sells vintage items, scrap metal, or contemporary metal objects to be sold for profit. Items are valued based on the metals they're composed of and melted down to their purest form.

This is where those qualified definitions of *value* that we talked about earlier become directly linked to motivation. Let's look at how this connection ends up playing out in the dollars and cents of it all.

❶ Communal Value Motive: Wants to be a part of the preservation of our collective history or be a part of the second-hand community

❷ Historical/Educational Value Motive: Wants to engage in this space to save pieces of history

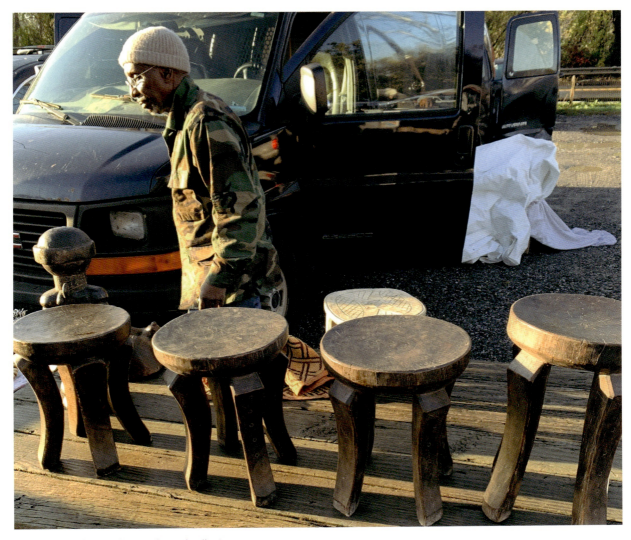

Mustafa Sano, flea market vendor and collector

Me: Good morning, sir. How you feelin' today?

Sano: I'm good, my friend. What are you buying from me today?

Me: Let me see what you got, Sano . . .

(I look at Sano's tables and items for sale)

Me: How much for the three colon statues?

Sano: How much you want to pay?

Me: Sano, what is your price for it?

Sano: How much you want to pay?

Me: $125

Sano: (Scoffs) No, that's too low!

Me: Sano, what is your price?

Sano: You can pay more, how much you want to pay? $275?

Me: No. Can't do that. I'm good. Have a nice morning, Sano.

(I start to walk away)

Sano: OK, my price is $125!

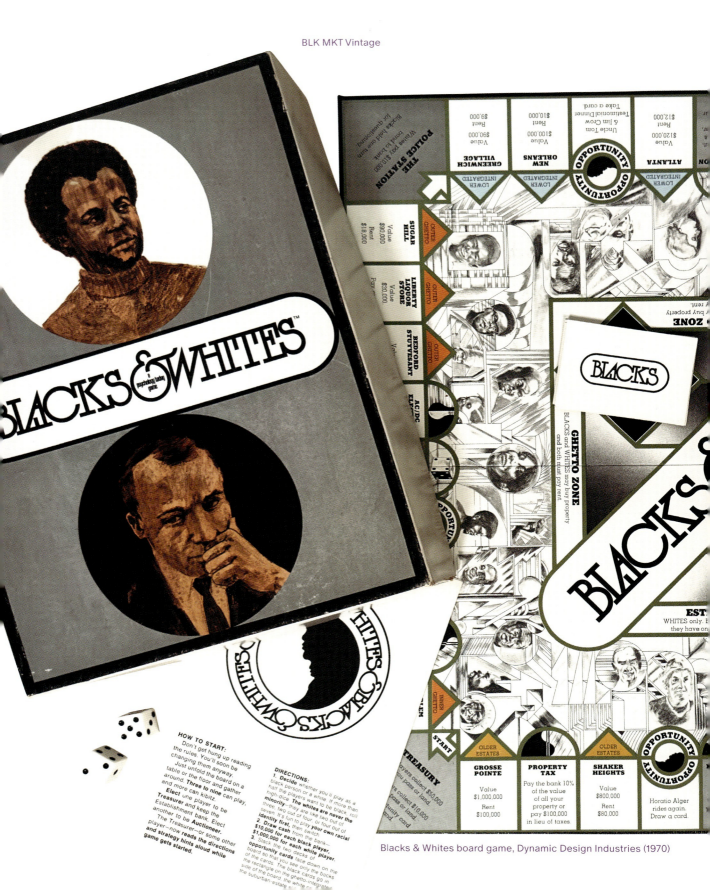

Blacks & Whites board game, Dynamic Design Industries (1970)

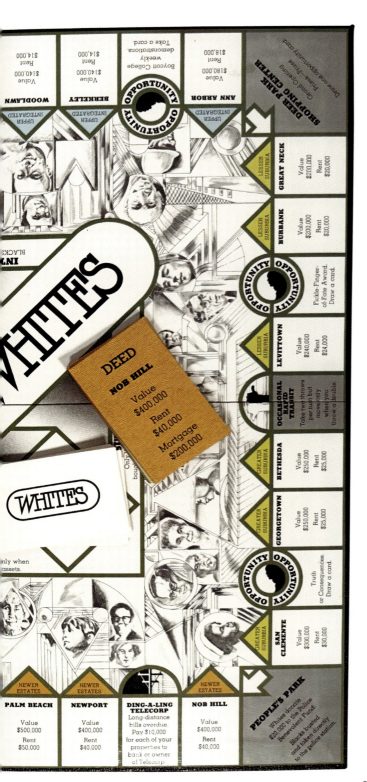

DOING THE DANCE: HAGGLING

Unless expressly stated as being firm, prices in the secondhand space are negotiable. The ultimate goal of the seller is to move an item. They would rather have more space for a new item than keep inventory for too long. The practice of negotiation and flexible pricing is the proverbial double-edged sword, affording the opportunity for the upper hand to both the buyer and the seller. This is a dynamic that can be experienced as varying levels of contention, or completely benign.

firm; adj: Sometimes written in product descriptions or on signs in a vendor booth, firm means the vendor does not want to haggle or negotiate. They are firm on the price as marked.

There are tips and tricks to the dance of haggling—some I can share (as long as you promise not to use them against us) and others you'll have to learn by experience. In full transparency, and as several dealers can attest, Kiyanna is the better haggler than I am. When traversing the market, I usually lean toward doing it quickly, whereas Kiyanna prefers to do it thoroughly. So, whereas she'll spend more time haggling, I am outta there once I hear a price too far from my desired price point. To give you the best chance at success, see her notes to my list.

Hand-painted NAACP parade float sign (circa 1960s)

❷ Don't give your price first. I still slip up on this one, as I can be impatient. Let the seller set the price range to ensure that you don't miss out on a bargain.

Kiyanna: This really is a balancing act because some sellers are also impatient and will want to cut to the chase. "What's your best on this?" Is often my go-to. If they ask you to make an offer first, ground that offer in something. Do research, ask them what the item typically sells for, etc. Let's not pull random numbers out of thin air.

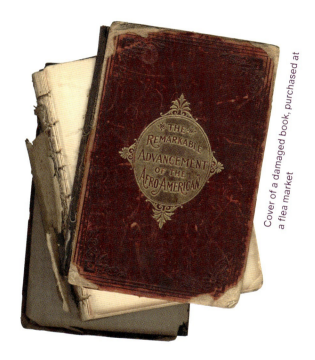

Cover of a damaged book, purchased at a flea market

❶ Put on your poker face. Try to keep an even-keeled demeanor. The more a vendor knows you are interested in an item, the more they may try to charge you. Play it cool and nonchalant to keep the upper hand.

Kiyanna: Totally agree with this one. Don't let 'em see you sweat!

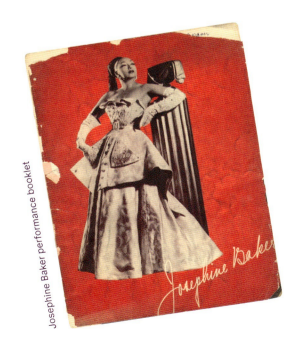

Josephine Baker performance booklet

❸ Be clear and firm. Vendors legitimately have "all day." Playing the haggle dance can be drawn out. To save time and get to the next find, be clear in your desire and firm in your pricing.

Kiyanna: True! True! And in doing this, be respectful as well. No one likes a nasty customer or seller. Kindness and generosity both go a long way.

"The Herbs of the Orisa" booklet (1970s)

❺ Perfect the walkaway (or at least the threat of it). Vendors understand that as long as you are in their booth or at their table they have your interest. As soon as you walk away, they've potentially missed their opportunity. Using the walkaway is key in showing you're serious and firm.

Kiyanna: I love a walkaway done right. This could mean walking away from the particular item to another table or walking out of the store, respectfully, and coming back in two weeks to inquire about the item's availability once you've taken some space. Remember, though: If you don't really want to take a chance on something being purchased by someone else, just buy it. There's nothing like "the one that got away" remorse.

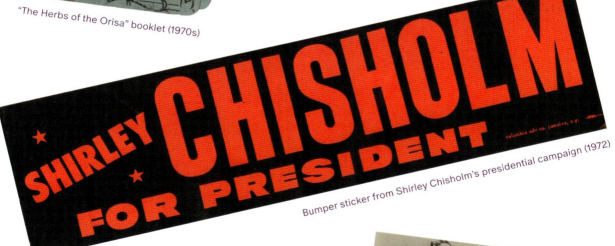

Bumper sticker from Shirley Chisholm's presidential campaign (1972)

❹ Bundle. This tip is the PRO TIP. Bundling allows you to reduce your unit/item cost. The more items, the cheaper the per-unit cost should become. Bundle in order to get a bargain.

Kiyanna: And remember to bundle the price with things you actually want. The point is to get a lower per item cost, not overall. And if you change your mind on an item you were quoted in the bundle—guess what? Your price is going back up.

Josephine Baker in *The Flame of Paris*, film stills (1953)

Hand-painted sign from a parade float (circa 1960s)

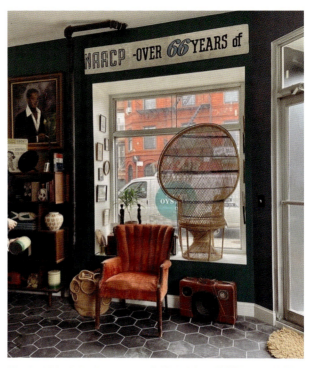

Hand-painted sign from a parade float (circa 1960s), mounted in our brick-and-mortar store

BUYING WHAT WE VALUE: A PARABLE IN THREE ACTS

At the end of the day, the goal is to both buy and sell items at our desired margin. However, in this business it is imperative to understand that meeting someone's desired price is not always the same thing as having the same understanding of value. Here's a *Parable of Parade Float Signs*, a drama in three acts, to show you better than I can tell you. Disclaimer: Please note some of the details of the stories have been changed or embellished to protect the identities of our sources so y'all don't go running up on them.

ACT ONE

I'm not exaggerating when I say I started hyperventilating—full-on chest heaving, runny nose, and tears running down my face. All I could see were the letters

NAACP hand-painted on a sign propped under a table. I don't remember how quickly I made it over to the older white man behind the table, but the yards felt like inches in a matter of seconds. I still had time to roughly calculate how much money was in our business checking account, how much I could spare from my savings, and if we had paid the rent yet. I was prepared to give this vendor whatever he wanted because this artifact needed to come home with me. I blurted out, "I need this sign. How much you asking?"

The vendor explained that the sign was from a parade float. He had purchased it from an auction house in the area. Again, impatiently, I asked, "How much?" utterly failing to keep my cards close to my chest. The older gentleman then proceeded to explain that he had had two other signs that belonged to the set, but they had been sold earlier that morning. My heart dropped. I remember it clear as day: He said, "But you got here right in time, kid. I was going to throw it away because I've already made my money on the lot. You can have it." I thanked him profusely, picked up my sign, and cried

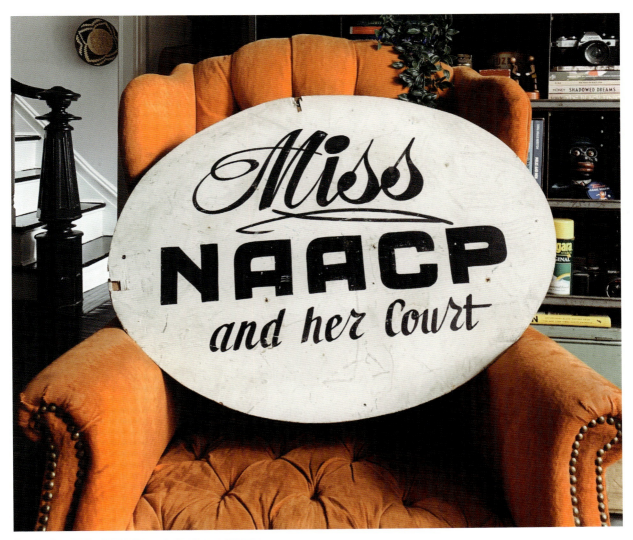

Hand-painted Miss NAACP Parade float sign at home

all the way back to the parking lot. I gave thanks for being right where I was supposed to be and verbalized my gratitude to the ancestors for making a piece that had survived and for sending it my way.

ACT TWO

Rob was a fellow collector, dealer, friend, and mentor in the field. As an African American man who has spent more time in the industry than we have, Rob would greet me with a sage smile and a story of yesteryear. We would often check in with each other prior to the market (around 4:00 a.m.) to see if we would both be there and if he had something specifically for me to buy. That morning was different because now I had a story for him: the story of my free NAACP sign. Rob knew exactly how much an item like this meant to me, as he would source for us and bring items from his private collection for us to sort through and purchase. Being the same age my dad would have been if he were still alive, he would talk about jazz greats he saw perform in person,

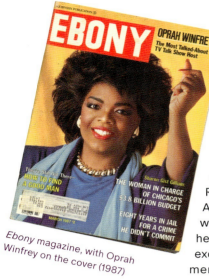

Ebony magazine, with Oprah Winfrey on the cover (1987)

or tell tales of navigating the secondhand industry and the crazy prices he used to pay for the things available now as *vintage*. As I recounted the story, Rob started to smile. At first, I thought he was just happy to hear the story or was excited by my excitement. But, he had a little something up his sleeve or, rather, in his trunk. Without saying anything he walked to the trunk of his car and said, "I bought one of the other ones at the auction." He then proceeded to pull out a wrapped board with another float sign inside. Rob explained that he was using it in his car to help protect the glass in the other pieces of frame art he had in the trunk. Before asking if it was even for sale, I offered him what I thought (at the time) was a high price—$250. He thought about it for a second and agreed. SOLD. After the transaction, he told me he would've taken a lot less, but I was so forward he just went with it. SMH.

RIP, Rob, thank you for the connection, and for being an elder and ancestor in this work we do. We cherish the role you played in inspiring and pushing us forward.

ACT THREE

Traditional auction houses are often considered the arbiters of provenance and valuation when researching a piece of material culture. Auction catalogs, both in print and online, serve as market, price, and value markers. There were more than twenty thousand auction houses in the United States as of 2021, with the oldest being Freeman's auction house, dating back to 1805.

provenance; n: The place of origin or earliest known history of something. The beginning of something's existence; something's origin. A record of ownership of a work of art or an antique, used as a guide to authenticity or quality. Provenance comes in many forms, from hard copies of certification documents to photographic evidence of authenticity or news articles that corroborate the existence of an item. Having provenance or what amounts to proof of authenticity usually impacts pricing positively, as a potential buyer can be assured that the piece is not a reproduction or counterfeit. Additionally, knowing the backstory of a piece helps illuminate the other forms of value inherent in the item.

We typically buy from auction houses in the United States and Canada a few times a year. Some are larger, more prominent players in the industry while others are lesser known operations with smaller audiences, name recognition, and marketing dollars. We can't knock the smaller auction houses, because they've been the source of a few rare and truly special finds over the years. In this case, we received a tip from a fellow dealer/collector that a Miss NAACP Parade float sign was up for auction at an auction house we'd never heard of. They didn't want to see the sign fall into the "wrong hands" and encouraged us to bid on it. We did our research about the auction house and signed up to bid the following week. Live bidding in traditional auctions is a stressful process and warrants a whole chapter in another book. The anticipation for this auction was amplified due to the presence of this piece and the possibility of expanding our collection of NAACP parade float signs According to the pre-auction estimates, the piece was projected to sell for $750 to $1,000. Keeping in mind that pieces routinely sell for over the estimate, plus the customary 20 to 25 percent buyer's premium and

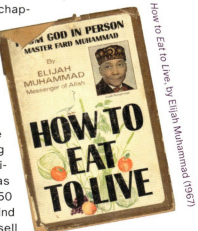

How to Eat to Live, by Elijah Muhammad (1967)

other taxes and fees, we figured we were in the game, as long as the winning bid stayed under $1,000.

buyer's premium; n: A percentage added to the sale price in traditional auction settings. Premiums range from 10 percent to 30 percent. The fee reflects the cost of the acquisition, research, and storage of the item for sale.

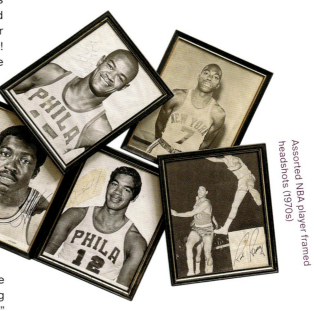

Vintage pinback (1980s)

pre-auction estimate; n: A projected range of what the winning bid on an item will be. Estimates are based on comparative pricing, condition, and the rarity of a given item. These estimates are educated guesses and come with no guarantees as items routinely sell outside of the pre-auction estimate range.

Like many aspects of the industry, auction houses have welcomed the twenty-first century into their operations—namely websites and apps that allow bidders to participate in live auctions remotely. Prior to the introduction of digital bidding, the most high-tech innovations in the auction space were three-way calling and fax machines. There we were, in front of the screen, the anticipation mounting as each lot was announced. As the auction proceeded, we realized that folks were not here to play. Each lot was either doubling or tripling their pre-auction estimates. YIKES!

By the time our lot came up for bidding, we were honestly ready for failure. If this lot followed the same trend, the parade float sign would be at least $3K when factoring in the buyer's premium. There was no way we could afford that. But we've learned, in some rather stunning ways (see *The Wiz* taxi in the introduction) that you must at least be in the game before accepting defeat. So, we entered our max bid of $600 and waited. As the auction commenced and the auctioneer began calling bids, the excitement started to ramp up. We weren't immediately outbid, which was different from most of the preceding lots. The auctioneer continued to the "Fair warning": "Any last bids," they called. "Going once . . . going twice . . . SOLD to paddle number 371!"

Waiting until the hammer was banged on the table to make sure it was true, we sat there looking at the phone, elated. We had won! With the buyer's premium and taxes, it came to a grand total of $850, under the $1,000 we had budgeted.

▲▲▲▲▲

Three different signs of similar origin, from three different vendors with varying motives that factored into their pricing and willingness to sell. As evident in this simple demonstration, establishing a baseline or industry standard is nearly impossible due to the ultra-subjective and value(s)-driven motives of sellers.

This is why we do the work—the three-year journey for these pieces to find their way to our private collection. Together. The over sixty-six years that these pieces have survived. The $1,100 we spent on all three signs. The reclamation of legacy, object, and history is the underlying barometer of value we consider in our journey in this industry. While the industry overall finds their business models rooted in scarcity, rarity, and profit margins, ours is rooted in honoring and monetizing all the forms of value and reclamation. Reclaiming a voice in a space that values Black cultural production but not Black people seems to be the tacit throughline of anti-Blackness in America and beyond.

Assorted NBA player framed headshots (1970s)

We aim to interrupt and interrogate this understanding by doing *the work*, finding, reclaiming, disseminating, and VALUING Black cultural production.

THE RECLAIM GAME: WHY WE ARE IN THIS INDUSTRY

While our business mission is singular, the benefits of being in this industry extend far beyond our individual benefit. We are engaged in a multi-nodal reclamation campaign, starting with our stories, our things, our value, and our future. As the song goes, it's good to be "seen in green," and we agree; in 2023 alone, the secondhand industry has prevented tons of waste from being thrown into the environment. While neither of us have a formal background in the science and practice of sustainability, it is a major thrust of our work. What is the point of collecting artifacts for the future when the actions we take now have a direct impact on whether the planet survives? Though we have never done formal recordkeeping when it comes to our sustainability efforts or the positive impact on the environment of our reclamation work, every item we have ever sold or currently hold is one less item in the landfills that run along the New Jersey Turnpike. Each item we rent or loan is one less new item created. We pride ourselves in engaging in a business that is kind to our Earth and helps to sustain future generations of all people.

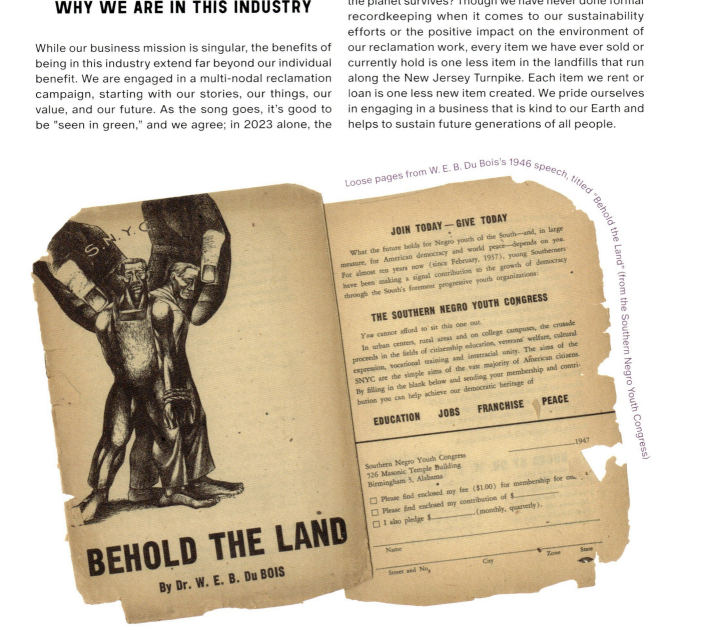

Loose pages from W. E. B. Du Bois's 1946 speech, titled "Behold the Land" (from the Southern Negro Youth Congress)

Staging our custom BLK socks in our backyard (2022)

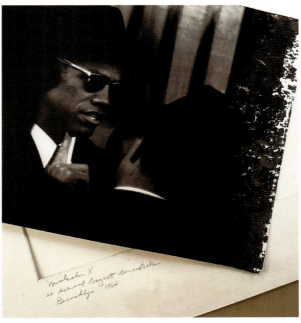

Malcolm X Photograph in Brooklyn by Frank Espada (1964)

We hope that by this point in the book you have a solid understanding of the power of the reclamation of our stories and how it was pivotal in shaping us as individuals and our business journey. Reclamation in the physical sense also shapes how we interact with players in this industry. Unlike some dealers who are only in the business of high-end antiques or museum-quality finds, we collect everything, regardless of condition. We seek to reclaim the "least of these." Our reclamation of pieces in poor condition complicates our understanding of value(s) further. Knowing that the industry standard is the better the condition, the higher the price, we try to rely more on the intrinsic value of items and how value can be added back to them in the absence of being in pristine condition.

museum-quality; adj: Often used as a selling point, museum-quality describes an item that is in pristine condition, is rare, and would be acquired for a museum collection.

We had the opportunity to purchase an original image of Malcolm X, found in a storage unit during the pandemic. The owner of the storage unit was distraught by the water damage to the image, and she stated that she was just going to throw it away because she wouldn't be able to sell or exhibit it in the current condition. We explained that the picture had been taken in Bed-Stuy, where our shop was located. The connection to the image and the meaning behind it gave it great value to us, even if it wasn't worth anything (monetarily). The owner of the storage unit said we could have it and we happily obliged.

In the same vein, we see value in items even when that value is not immediately discernible. Being able to *see beyond* the item in front of you and to the possibilities of upcycling or repair is perhaps the secret sauce of the industry. A vintage Schwinn Tiger bike from the 1950s is just a bike if you don't use your imagination to see beyond, just as worn and tattered magazines are destined for the landfill if you can't find a use for the content past the torn cover or missing pages.

Seeing beyond is a BLK MKT Vintage mantra. See chapter 6 for more.

The internet has enabled us to democratize so many industries that had been at the whim of gatekeepers. As we have already established, those gatekeepers, regardless of the gate, have traditionally been white,

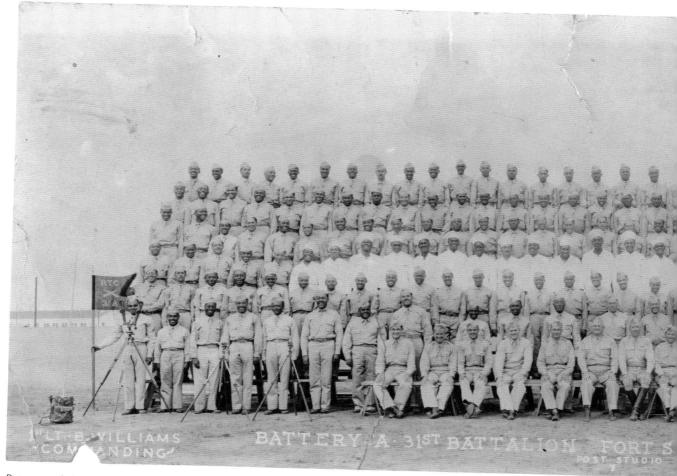

Panorama photograph of US Military Battery A, 31st Battalion, Fort Sill, Oklahoma (May 1942)

cisgender, heterosexual men. Think of how social media networks and online information sharing has democratized the mainstream media, or how the music industry and A&Rs have been democratized by SoundCloud and going viral on TikTok. Similarly, history has also been democratized. More access allows more folks to lay claim to and reclaim space, narratives, and values. We seek to be arbiters of this democratization and make historical material culture accessible and available to folks, regardless of socioeconomic status or identity. Price accessibility is a major tenet of our approach. In our online shop and our brick-and-mortar, our pricing ranges from free (because I give too many things away) to several thousand dollars. We reject the notion that collecting should be relegated to folks with a certain

level of disposable income. Our *for us, by us* approach to the secondhand industry allows us to meet folks where they are and engage them around a space the collective "we" have not traditionally occupied.

The positionality granted by our identities also allows us to go further than the gate to a place of reclaiming the gaze through which our cultural production is viewed. The paradigm of the "white gaze" comes from the prevalence of white supremacy in our society, as well as the assumption that everything cater to white consumption. Single-sided histories (or outright omissions), racist stereotypes, and marginalization all come from the presence of the white gaze. So how does a small business from Brooklyn disrupt that? (If you yelled, mouthed, or thought *reclamation*, then you win the prize!)

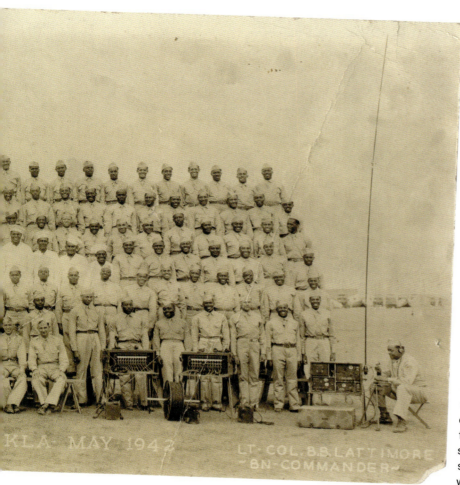

KLA- MAY 1942 LT. COL. B.B. LATTIMORE
~BN-COMMANDER~

for it. I could not fathom how the white gaze around Black people and watermelon of the 1800s could be influencing what Black folks of the twenty-first century were eating. That's a lot of power given to dead white people and their gaze.

Shifting away from the white gaze enables us to get to the true why and how. It is well documented that watermelon is a fruit indigenous to Africa. Brought to the Americas with our enslaved ancestors during the transatlantic slave trade, watermelon was grown throughout the period of chattel slavery. Shortly after emancipation, during the Jim Crow era, newly freed folks used their knowledge of the fruit as a means of economic liberation. Selling a fruit like watermelon enabled our ancestors to provide for themselves and create a sense of freedom outside of the system of enslavement and sharecropping. To denigrate Black people and hurt their sales and economic mobility, white Southerners created the negative depictions of Black folks and their watermelon. The sayings, songs, and portrayals became pervasive. Plainly, the watermelon stereotype was established in an effort to subjugate the formerly enslaved seeking economic freedom.

There is tremendous power in the white gaze. It created these racist depictions; disseminated these images for decades, cementing a racial stereotype; and, now, in the contemporary setting, get to recirculate them in the secondhand industry without proper context. But as we have contended throughout this text, the white gaze obscures and erases the context and full reality of history. The exercise of reclaiming the watermelon is one I have been on from a young age. Outside of my surface-level love of the taste of watermelon, I have always pushed back against the stereotypes associated with the fruit. When friends have stated that they "would never eat watermelon in front of white people," or they don't like watermelon "because it's racist," I would cling tighter to my appreciation

I wonder: If folks knew the truth about watermelon, would it shift their view of the fruit, the world, themselves? Instead of continuing to wonder, I began reclaiming the aesthetic. Watermelon sneakers, socks, and shirts all became staples in my wardrobe. When I became a parent, my daughter was on the watermelon team, too. Baby costumes, bathing suits, floaties all were adorned with watermelon. It became a symbol for the power of reclamation of narrative. Most importantly, it became a beacon of hope as our ancestors were continually seeking freedom for themselves in the face of violence and tremendous opposition.

For us, running BLK MKT Vintage is a refusal to promote the status quo, a rejection and reclamation.

Motorcycle helmets at a vendor's table at a New Jersey flea market (1960s)

Doing this work means pieces of our physical history do not end up in actual landfills or the metaphorical wastebasket of history. It means that we get to empower folks and get them to view pieces of culture and themselves as valuable, even if other gazes or gatekeepers tell them otherwise.

INDUSTRY FAQS

❶ **Why are these old things so expensive anyway?** There are several factors that go into the pricing of antique items. Condition, availability—both to the vendor and the overall market—and past sale price are all in play when it comes to pricing. There is an additional factor that I call the "seek" factor. We travel far and wide to acquire unique and interesting things. We are in basements, warehouses, storage units, garages, attics, and other often undesirable places. A lot of time, effort, and energy go into sourcing vintage and secondhand items. The cost of seeking out these items can be quantified to a degree with gas and tolls expenses, but how does one translate the tremendous effort it takes to find these items through the cost of labor? Lastly, there is the intangible cost of the journey of the item and the stories that came with it. Dealers quantify this cost of antiquity via price as well.

❷ **How do you price your items?** We start by researching what the item has sold for in the past and, at this point in our journey, we have become the price-setters ourselves. When searching the web, our past items will often pop up and become our comps. Condition is the factor that weighs the most in our pricing process. The difference between a $20 book and a $2,000 book can be as simple as the condition.

We base most of our pricing on our acquisition cost. What profit margin are we comfortable with? Did we buy things in a lot and get a reduced price? If so, we factor that into the per-unit cost. In the case of items that are priced lower than they are valued, we consider what some of these items "should" cost. Dealers set the market for these items so there is some responsibility on them to maintain a certain baseline of monetary value.

❸ **Why can't I negotiate the price of an item listed as "firm"?** Technically you can still negotiate; you just may not get very far. There is an important purpose for firm pricing in our space. Having a firm price is usually a marker of higher value(s). Being firm on a price helps to preserve some semblance of consistent market pricing and primes the buyer to put more value on like items. Back to the example of the $20 book and the $2,000 book: I'm more likely to be firm on the $2K to maintain the higher market (monetary) value of like properties in similar condition as the book. Imagining that this book has the original dust jacket or is signed, it's vital that the higher value for these attributes is preserved for the whole market. Firm pricing also comes in when there is a firm margin the seller wants or needs to adhere to. Lastly, since most dealers are collectors themselves, there are items that we waffle between keeping or selling. When we aren't sure if we really want to sell something or keep it, setting a firm price is saying, "I'm keeping this . . . unless you're willing to pay my exact price (see do-not-sell price).

do-not-sell price; n: A BLK MKT Vintage term for the price we place on items we are not sure we want to sell. Putting a higher price on an item helps ease the sting of not keeping it in our private collection.

❹ **Where do y'all find all your stuff?** We travel the world looking for vintage items. There is no single place we seek out to find the goods. In a nutshell we frequent thrift stores, estate sales, flea markets, antiques malls,

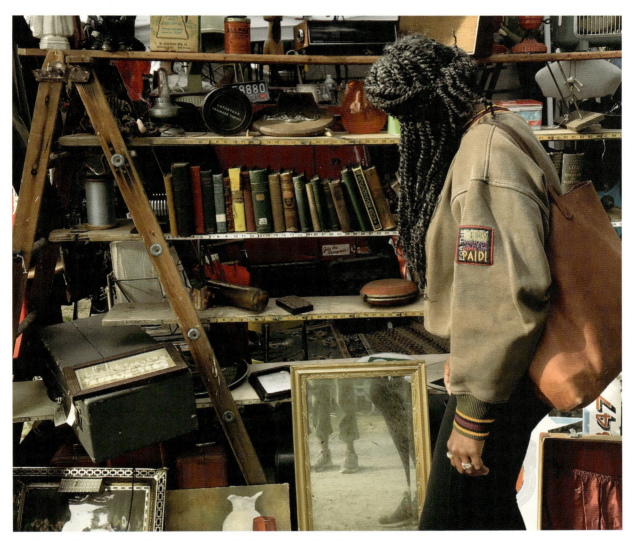

Kiyanna browsing the wares of a vendor at the Brimfield Antique Flea Market

stoop and garage sales, pop-up markets, online sites, book fairs, poster fairs, auction houses, storage units, and private sellers.

ABCs of Vintage (Always Be Checking!); n: We engage the ABCs of vintage as a strategy for always being on the hunt. Whether it be in your hometown or a new city, you *always* have to be *checking* for the latest finds.

❺ **Where is the best place to buy vintage?** This is a tough question because no one place is a honey hole.

I like to go to places where there are multiple vendors. Myriad types of people curating their collections lend more variety and increase the likelihood that you'll find something that speaks to you. Antiques malls, flea markets, and pop-ups are really good for finding diverse items from folks with different types of goods and different types of value, taste, and style.

honey hole; n: A place, store, or location that has a lot of items you are interested in at the price point and margin that is favorable to you as the customer.

THE VAULT

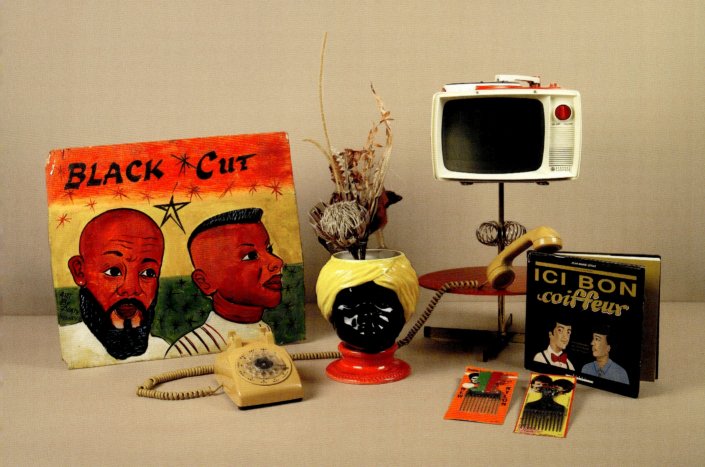

From left → 1. Vintage West African "Black Cut" barbershop sign; 2. Yellow rotary phone (1960s); 3. Vintage ceramic jar; 4. General Electric Show N Tell Phono Viewer & Record Player on stand (1960s); 5. Assorted Afro picks (1970s); 6. First edition of *Ici Bon Coiffeur*, by Jean-Marie Lerat (1992)

WRITTEN BY

Kiyanna

"I can't wrap my head around what y'all keep for yourselves if this is what your inventory **FOR SALE** looks like." We hear this sentiment all the time and it truly reflects one of the most intimate, fun, and **PERSONAL** aspects of our work—building and maintaining a private collection we **BOTH** love. The objects we keep with no intention of selling, trading, or parting with are single-handedly the **MOST** exciting part of our work—at least, for now. With **THOUSANDS** of objects passing through our hands monthly, both the BLK MKT Vintage shop and e-commerce site are **ALWAYS** top of mind. However, there's something more urgent, more foundational, and exponentially more particular about the private collection we keep, steward, and protect within our walls. And **THAT** is the difference between the **ENTIRE** BLK MKT Vintage collection (all the items we acquire for the various arms of our business and our personal interest) and the **STEWART-HANDY** collection. It has a ring to it—doesn't it?

The difference speaks to that personal, intimate aspect of collecting we've talked about throughout this book— our names, our identities, our lives, and our shared livelihood. When I think back to some of our earliest purchases together, a handful have remained with us. An assortment of vintage tins; marble and ceramic vessels and catch-alls; our antique theater seats (the ones I mentioned in chapter 2); a shipping barrel covered with clippings featuring all our favorite public figures, artists, and celebs from the 1970s; a reward notice for an escaped enslaved person; and some well-loved Fela Kuti vinyl records.

These objects have been part of the Stewart-Handy collection for the last ten years. They've been in three moving trucks, traveling with us from our first apartment to our first home, while providing us with an opportunity to time-travel alongside them. Building a private collection that we love is among the most intentional and discerning work that we do. Because of the material limits we contend with (physical space, capital, etc.), we can't keep it all. We actually sell most of what we acquire. A much smaller percentage is kept for our prop rental inventory and special projects and for the vault (our private collection).

Even with two storage units, a seven-bedroom home with a detached garage and a full basement, we don't have the space or capacity to keep all the incredible items that find us. And we don't really want to.

What we want to do is to have as many outlets, uses, and purposes for vintage/antique ephemera, to see Black cultural ephemera out in the world and alive in our cultural consciousness. The items we hold on to speak to our many experiences, interests, and aspirations. We collect for our inner child as well. Little Kiyanna and little Jannah have unique, eclectic, and expensive taste! Sometimes, that means investing significantly in the acquisition of rare, sought-after materials. It might mean spending a few racks on a book, a piece of artwork, or another ephemeral object at a competitive auction or after several charming and coaxing conversations with a private seller. Other objects in our private collection may not yield much at auction or be desirable in today's market, yet they bring fulfillment to little Kiyanna, help Jannah tell a larger story about a subset of items she's found or elicit our curiosity about a time, place, or community. The vault is a mix of these rare, expensive objects and those whose value lies in their familial, aesthetic, and sentimental value for us. We find this to be a very balanced approach to building a personal and private collection that we love.

PRESERVATION AT HOME

We began this business with many skills and areas of formal education and training. Preservation and archiving was not one of those. However, we recognized the level of investment that would be required over the long term to sustain a business like BLK MKT Vintage and the private collection we dreamed of. Caring for the items in our private collection demands regular upkeep, maintenance, and a series of ritualized practices to ensure organization and the integrity of our favorite things. The Stewart-Handy collection includes over two thousand materials of various types. Caring for this many objects, while considering their different uses has been a challenge at times, but we recognize that preserving our collection is a lifelong process

whereby we learn, adapt, and shift what works. Some similar-sized collections may require completely different preservation strategies. A collection of two thousand books is different from a two-thousand-item mixed collection of six hundred books, four hundred garments, two hundred pins, three hundred framed works of art, five hundred magazines, etc. One of the unique aspects of our collection is that it's varied in subject matter, era, and item type—so, we've had to do quite a bit of research and organization, involving trial and error, to figure out what works best to maintain our growing collection. Below are a few best practices from our home-based private collection to yours.

THE WHAT AND THE HOW

As discussed in chapter 5, about Black folks' collecting practices, it can be helpful to consider the goals and intention of your collection, first and foremost. Maybe you collect family photos and intend to organize and store them at home in albums or boxes for safekeeping. Maybe you collect kicks and want to store your collection in an aesthetically pleasing way, while also ensuring that you can access each pair to wear them once (or periodically!). Your goals are rooted in your why and, once determined, should be your anchor in establishing your level of investment, materials and expertise needed, storage method, and ways you can enjoy your collection without compromising the integrity and value of it. Y'all know our why already. Our private collection needed to be one that we could display in our home and shop, wear and live among—not folded up in archival boxes in storage. To each their own, but we've always been interested in a

collection that we could integrate into our daily lives. Because access is key for us, we've invested in framing and storage that will protect our goods in high-traffic and light-filled rooms throughout our home.

LOCATION MATTERS

This is an important one and, to be honest, we're constantly reevaluating location and placement of our collection. Sometimes it feels as if we're acquiring so much and running low on space. We know space is a limited resource, so we've had to be creative. Best practice for storage location is to avoid basements, garages, and attics. Basements and garages tend to be damp, and attics tend to be hot. The lower the temperature, the longer your items will last because cooler temperatures slow the rate of chemical decay, while reducing insect infestation. In terms of temperature, below 75°F is recommended and humidity should be between 15 percent and 65 percent to prevent mold growth. Be sure to store your goods away from sources of leaks and floods, such as pipes, windows, or known roof leaks. Keeping items on shelving and off the floor is an important tip (and one we had to learn the hard way in our early years). Also, we recommend doing your best to keep your thangs out of direct sunlight. Different types of light can cause irreversible and permanent damage to materials. The Library of Congress writes about this in extensive detail in their "Collections Care Guide." If you're like us, and display your collection of framed art and materials on your walls, it's highly recommended to invest in the added protection that comes with UV-resistant and museum glass, both of which filter 99 percent of UV rays. Lastly, as parents of a little human and two large dogs (a Rhodesian and a Doberman), we've had to be mindful of this—keep your goodies raised (on high shelves, surfaces, and mounted) to avoid accidents with the little ones in your lives.

INVEST IN MATERIALS THAT ENSURE THE LONGEVITY OF YOUR COLLECTION

I've heard from customers and clients alike that this can be the intimidating part of preserving a collection at home, and I think it's because of the perceived and very real financial investment required here. We've been investing in the preservation of our wares for years and, luckily for us, our business is thriving in ways that allow us to access these materials, sometimes in bulk for the private collection and those in the public-facing inventory. However, it wasn't always that way. One archival, clamshell box can easily run you $150 to $250. Depending on the size and contents of your collection, preservation materials can definitely start to add up. And we're not talking about leasing space in temperature-controlled facilities or investing in professional preservation or restoration services here. We're talking about caring for your items at home with organizational systems and rituals using industry-recommended materials. Here's a short list of items we use in the preservation of our thangs:

Acid-free polyethylene vinyl record sleeves
Microfiber cloths
Nylon or cotton gloves
Temperature and humidity reader
Acid-free archival boxes
Acid-free folders
External hard drive
Acid-free tissue paper
Acid-free polyethylene sleeves
Cotton twill labeling tape
Archival-quality ink pens
Digital database software
(Microsoft Excel can suffice)
UV-resistant or museum-glass framing

Sawyer Model G No. 2014 Viewmaster

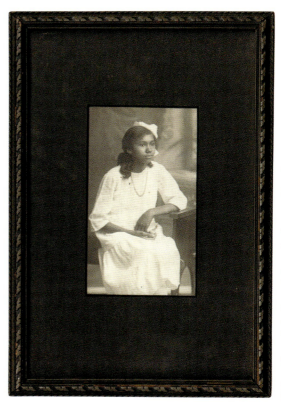

Antique framed photograph from the Stewart-Handy collection

THE REVOLUTION WILL BE DIGITIZED!

There are so many online resources for digitally archiving items in your collection. We recommend digitizing your originals, so you can view and share them without the wear that comes with handling. Purchase an external hard drive and keep a copy of your scans there for a digital record of your collection. Scanners vary by size and quality, but there are incredible at-home portable options that even novice users can get the hang of. Newsprint deteriorates quickly and, depending on your collection, you can use flatbed scanners or sheet-feed options. (Beware of feed-in scanners. They can jam and tear materials every now and then.) Some archivists recommend the ❸-❷-❶ method for collections:

❸ Create one primary backup and two copies of your data. ❷ Save your backups to two different types of media. ❶ Keep at least one backup file off-site, in a different location.

The ❸-❷-❶ method isn't necessarily industry standard, but it is popular and addresses the importance of having more than one digital duplicate in more than one place—to ensure your recordkeeping in the event of a mishap. As a digital tip, we also recommend keeping a database of the items in your collection, which may include names, descriptions of materials, any provenance info, purchase price, age, date purchased, and any additional important info. When scanning your materials, you can add metadata to the scan, making it easier to search on your device. Be sure to label your files consistently, so they're easier to locate when you need them, and keep a copy of that database on your external hard drive as well.

ENLIST THE PROFESSIONALS!

This is an important one. While there's a considerable amount of preservation and collection care that can be done at home with the materials and tips we mentioned above, we think it's crucial to discern what is within your abilities and when it's time to bring in the professionals. Given the unique nature of some historical materials (certain textiles, papers, photography, and some architectural salvage), we can't overstate how valuable expertise can be for objects in your collection. Professional services include binding for books and other paper ephemera, restoration, leasing space at a temperature-controlled storage facility, hiring archivists to manage your collection, and having appraisals done to ascertain value and even for insurance. Each of these services can be a costly investment—particularly if you have quantity (like us) or if you have a very rare, niche specialty—but they are investments in the longevity and overall value of your personal collection.

Vintage memorial paper fan (1960s)

Antique stereoview from the Stewart-Handy collection

THE

As much as writing about personal collections excites us, there's something a bit daunting about sharing the breadth and depth of our vault. There are just too many objects to choose from (about two thousand) and, for years, we've resisted sharing most of these publicly in anticipation of this very book project.

STEWART–HANDY

We've selected a bunch of objects we admire, covet, and are excited about and moved by. You'll see literature, art, pins, clothing, textile art, apparel, décor, and other material objects that mean quite a bit to us. For some, we retell our favorite acquisition stories. For others, we share a bit of interesting history and context for the objects.

COLLECTION

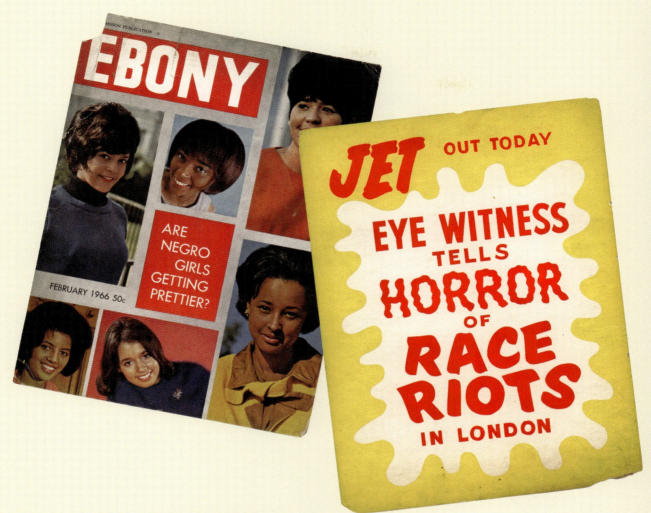

These are two of our favorite display covers in our collection of *Ebony* and *Jet* ephemera. Our collection includes about two dozen of these large-format printouts, which appear to have been used for merchandising/display purposes, possibly in a retail store, for a presentation, for advertising, etc. The *Ebony* cover speaks to the long tradition of colorism and underlining white supremacy within Black communities (and our beloved publishing entities and cultural institutions). The *Jet* cover references the Notting Hill Race Riots in 1958. Both publications were staples in African American households and these two merchandising displays represent a snapshot of the cultural consciousness of the time, as well as the pervasiveness of issues like colorism, racism, state-sanctioned violence, and beauty standards that denigrate Black folks.

Vintage *Ebony* magazine merchandising display cover: "Are Negro Girls Getting Prettier?" (February 1966)

Vintage *Jet* magazine display cover: "Eye Witness Tells Horror of Race Riots in London" (September 1958)

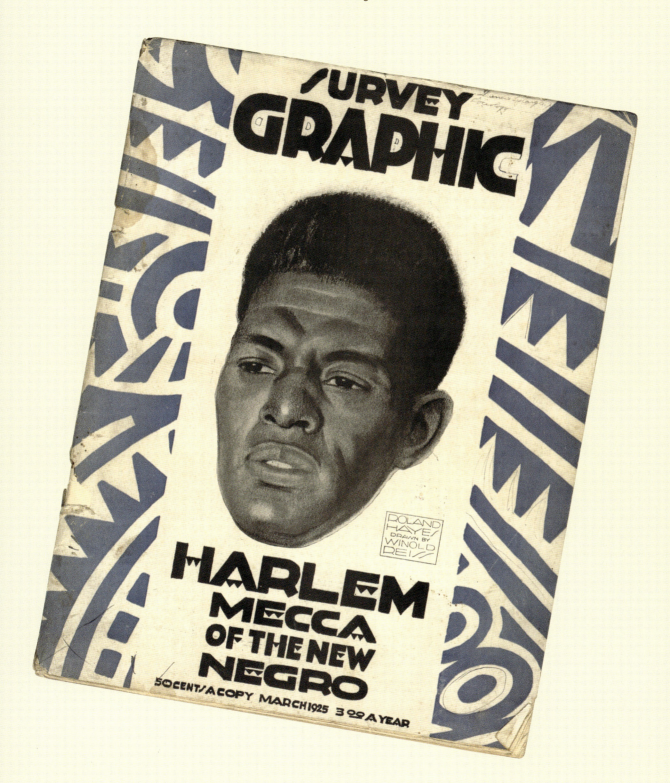

Survey Graphic was the monthly illustrated version of Survey magazine, a social work journal published during the 1920s. During November 1924, the magazine's editor asked Alain Locke to design and edit a special issue devoted to what we now know as the Harlem Renaissance. It's absolutely incredible to flip through this hundred-year-old publication and see the published work of public intellectuals like James Weldon Johnson, Arturo Schomburg, W. E. B. Du Bois, and Countee Cullen in their time.

Survey Graphic "Harlem: Mecca of the New Negro" issue (March 1925)

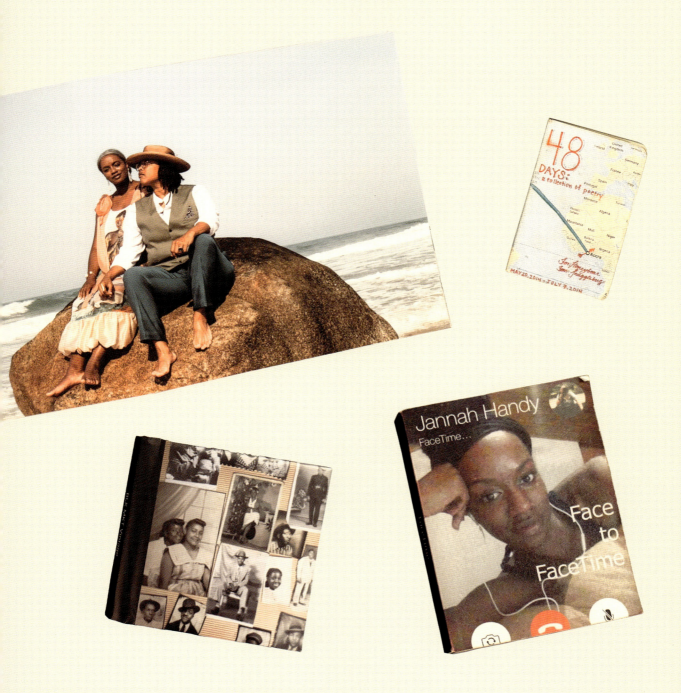

Over the years, we have curated, written, and designed books for one another filled with poetry, love letters, photos, drawings, and reflections. Consider this book, *BLK MKT Vintage*, as an addition to this personal collection.

Collection of personal books
(2014–today)

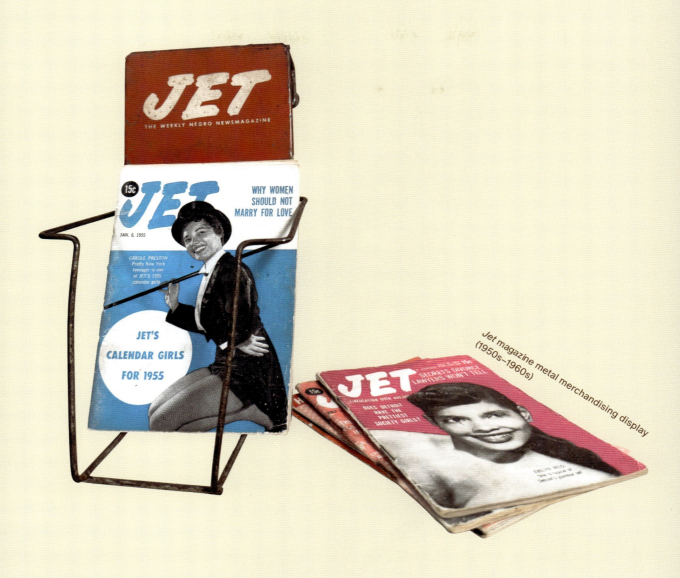

Jet magazine metal merchandising display (1950s–1960s)

Our collection includes two of these metal merchandising displays for *Jet* Magazine, published by Johnson Publishing Company. They're very rare and were uses for wall-mounting or countertop displaying of the small-format *Jet* magazines, before they were expanded in size in the 1970s.

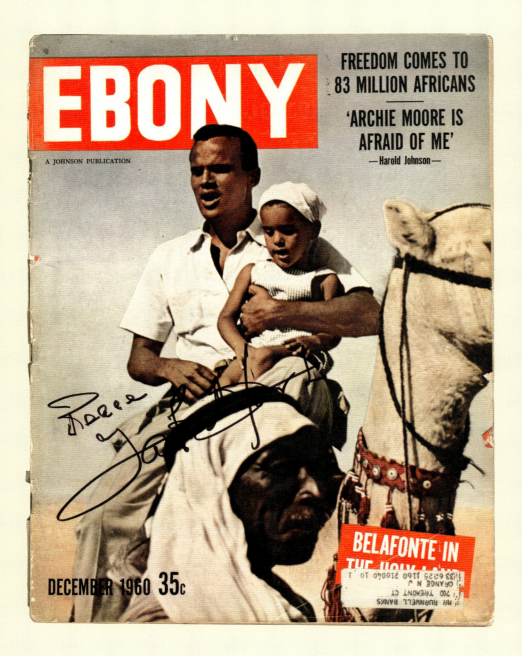

We were both working at Rutgers University in New Brunswick, New Jersey, when Harry Belafonte visited in celebration of Paul Robeson's birthday and the institution's inaugural Paul Robeson Week and

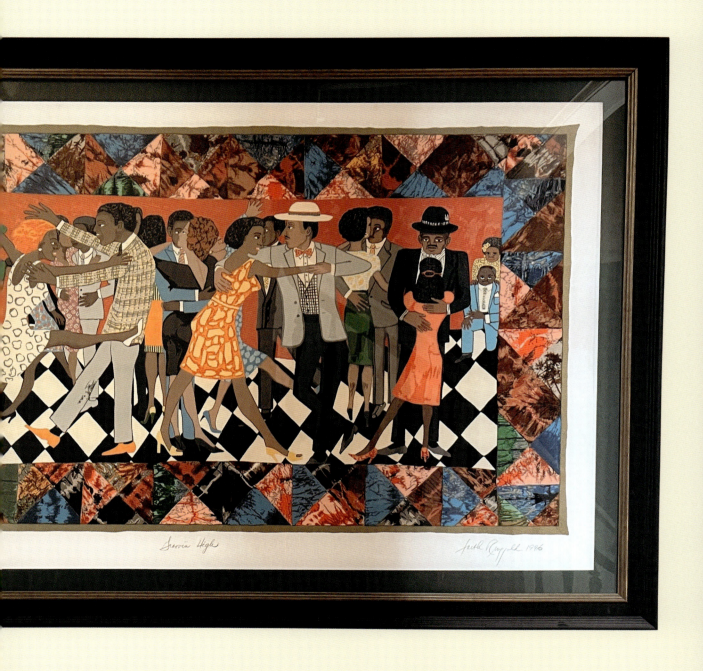

Groovin' High

Faith Ringgold 1996

signature lecture. Kiyanna led that university-wide initiative, alongside the leadership of the Africana Studies Department, and during Belafonte's visit, he signed this issue of *Ebony* for us.

Autographed *Ebony* magazine, by Harry Belafonte (December 1960)

Framed, signed, and numbered lithograph. Faith Ringgold *Groovin' High* (1996)

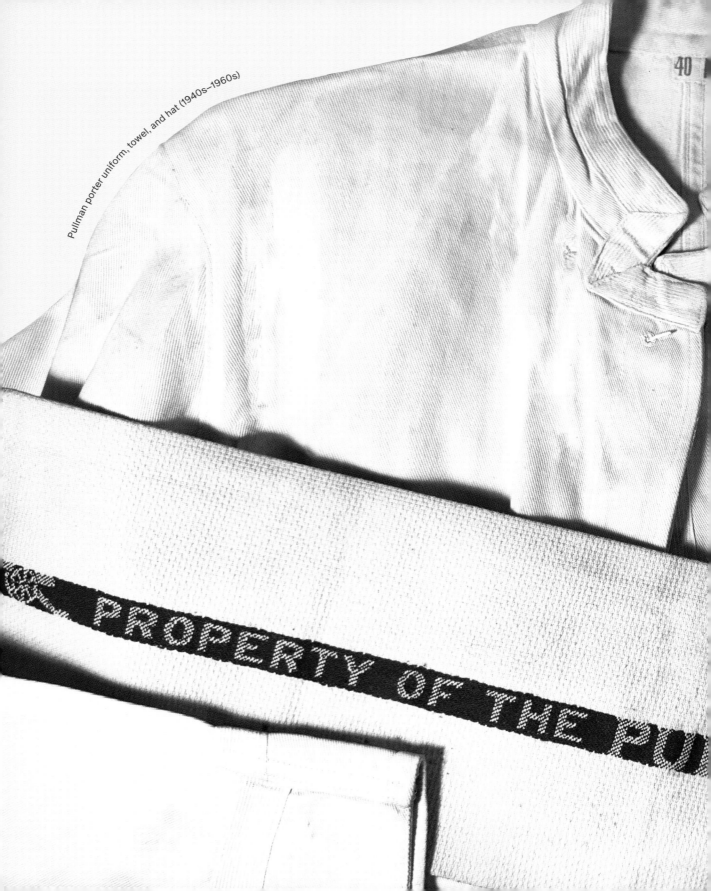

Pullman porter uniform, towel, and hat (1940s–1960s)

PROPERTY OF THE PU

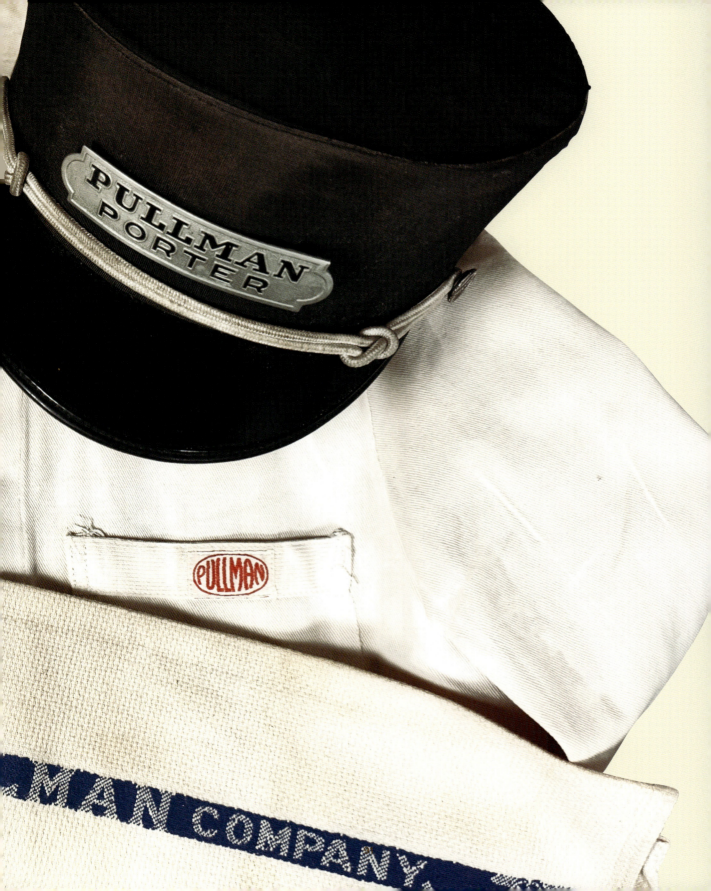

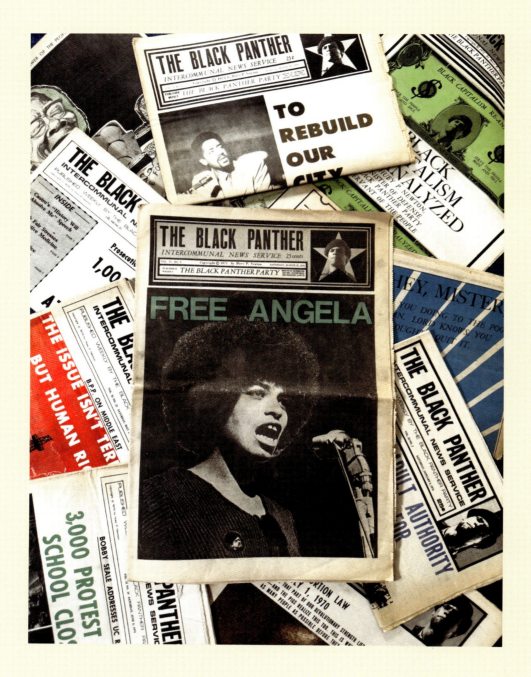

Our private collection includes over fifty issues of *The Black Panther* newspaper, spanning the thirteen years the publication ran in print (1967–1980). These are some of our favorite covers, most of which bear color artwork by the Panthers' minister of culture, Emory Douglas.

Collection of *The Black Panther* newspaper issues

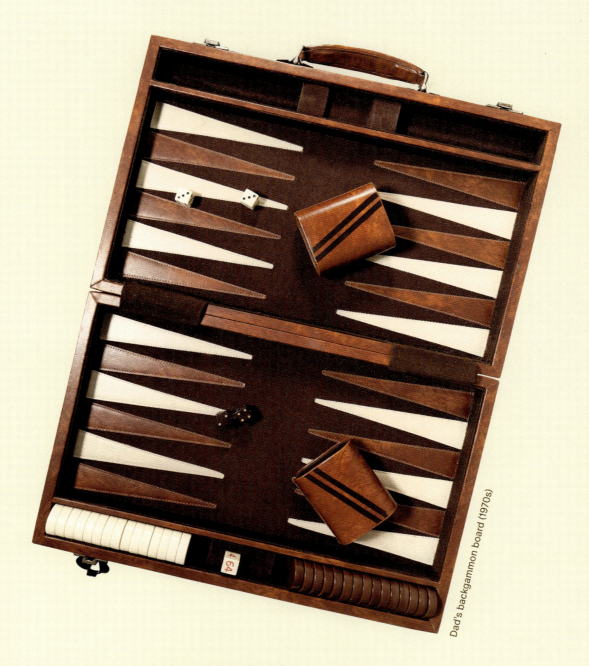

Dad's backgammon board (1970s)

This is a family heirloom and one of the more senti-
mental objects in our private collection. It belonged to
Michael J. Handy, Jannah's father. His backgammon
board is still rockin' in the original leather case, which
makes it easy to bring on family trips, quick jaunts to
the beach, or out in the backyard.

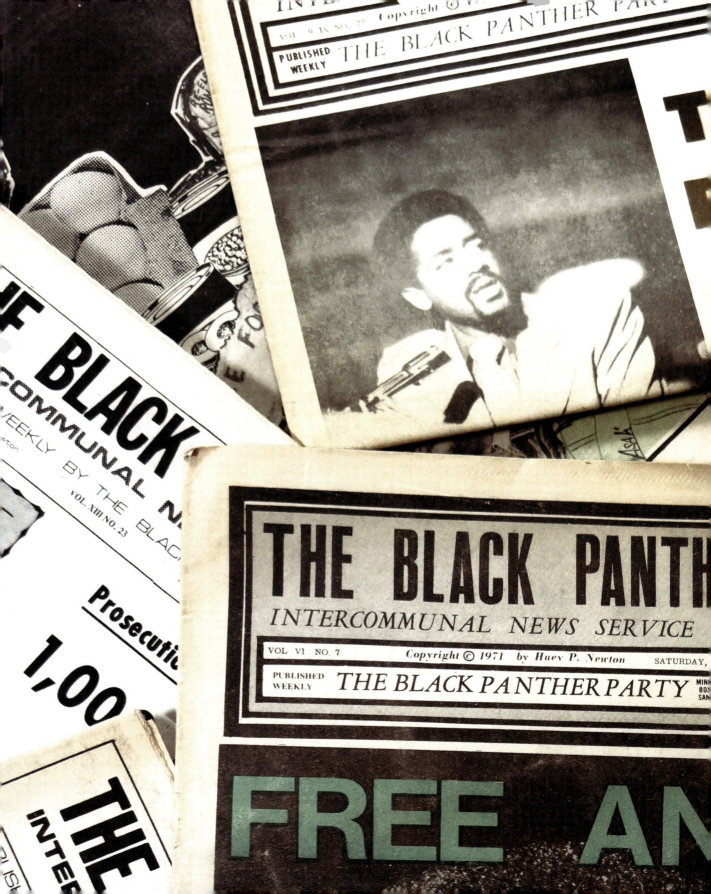

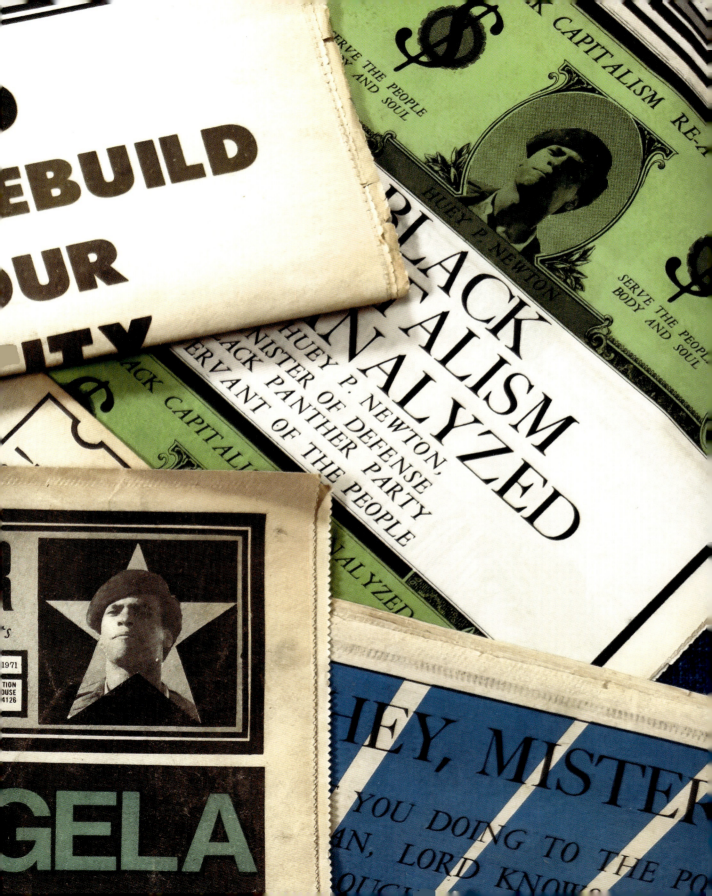

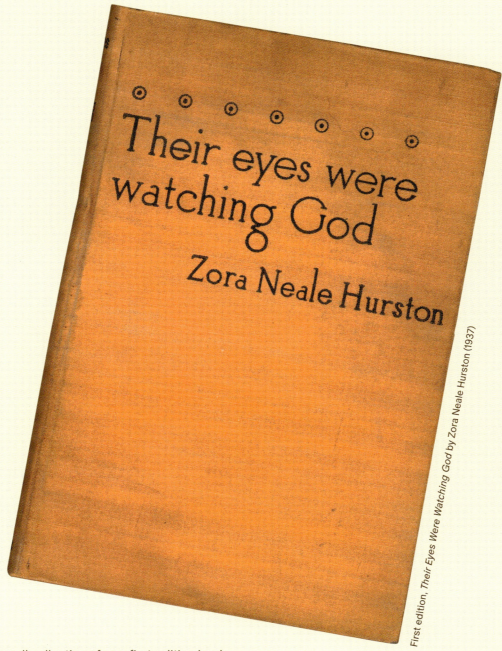

First edition, *Their Eyes Were Watching God by Zora Neale Hurston* (1937)

We have a small collection of rare first-edition books, and this is one of our favorites (and one of our most expensive book acquisitions). It's also Zora Neale Hurston's most famous and widely recognized work of literature.

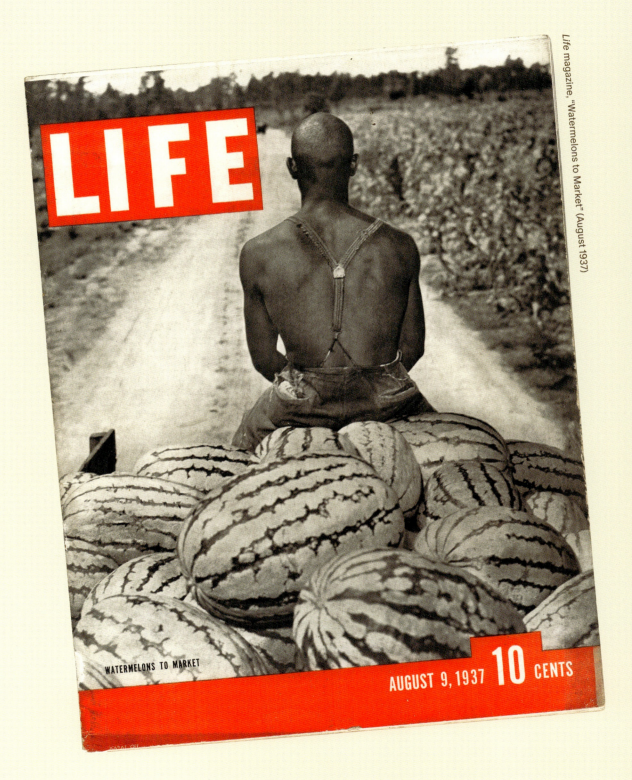

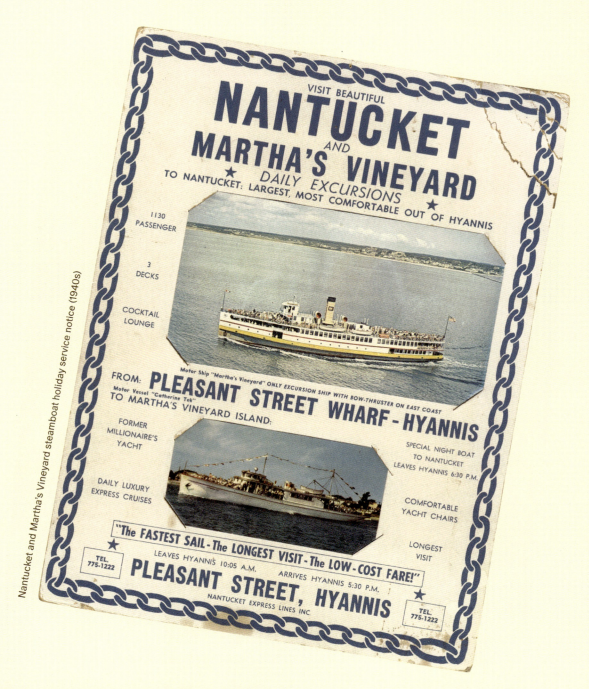

Nantucket and Martha's Vineyard steamboat holiday service notice (1940s)

While this piece isn't expressly Black in nature or ethos, it's a sentimental piece of ephemera representing our personal connection to Martha's Vineyard and its vast, rich legacy of Black leisure, rest, and joy.

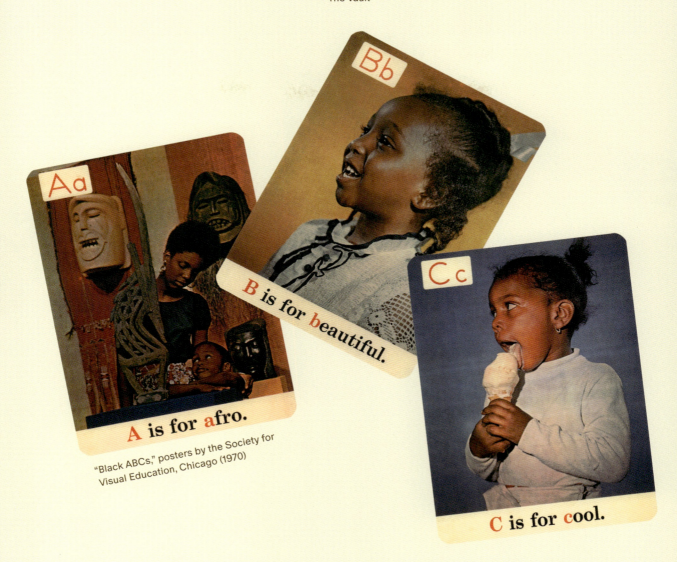

"Black ABCs," posters by the Society for Visual Education, Chicago (1970)

For several years, these Black ABC poster-sized study cards were on our holy grail list. We've been on the hunt for a complete set since we learned about their existence, shortly after our business was founded. Our set includes the original vinyl carrying case and the original booklet that explains the intention for the posters in classroom settings, providing context, activities, and directives for teachers in Chicago during the Black Power era. Thank you again to Kris, a customer/fan from Wisconsin who sent us an email in 2022 about these being available at a small auction house and who didn't want to see them trashed if there was no interest.

In the spirit of naming and acknowledgment, we also think it's important to lift up the two Black woman educators responsible for these iconic images. The Black ABCs set was created by June Sark Heinrich, and consultant Bernadette H. Triplett. Heinrich received her MA in English from the University of Chicago and was an author and editor of programs for early childhood education. Heinrich and Triplett teamed up to produce the Black ABCs in 1970 for the Society of Visual Education. These posters decorated the walls of Chicago schools, inspiring Black pride, self-determination, and community.

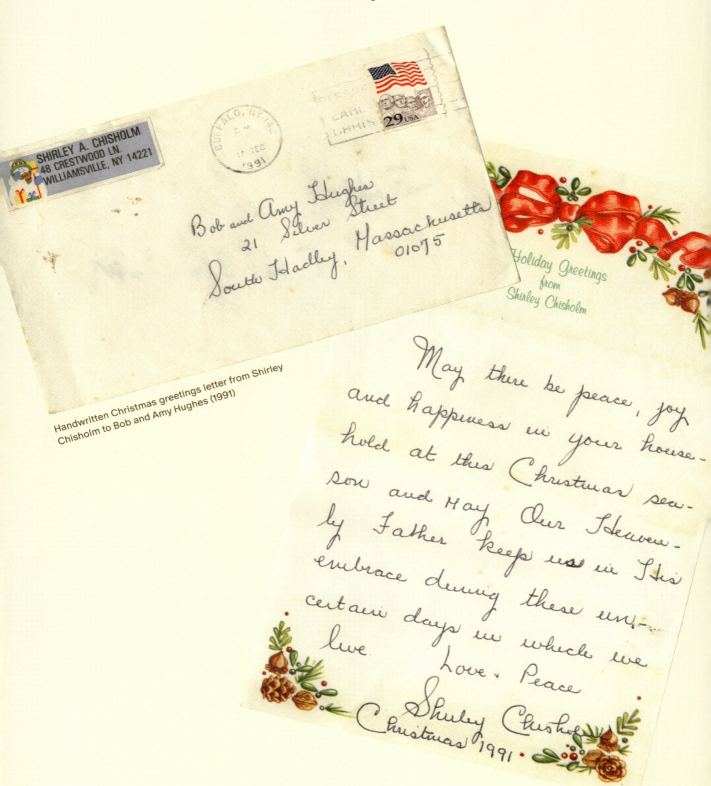

SHIRLEY A. CHISHOLM
48 CRESTWOOD LN.
WILLIAMSVILLE, NY 14221

29 USA

Bob and Amy Hughes
21 Silver Street
South Hadley, Massachusetts
01075

Handwritten Christmas greetings letter from Shirley
Chisholm to Bob and Amy Hughes (1991)

Holiday Greetings
from
Shirley Chisholm

May there be peace, joy
and happiness in your house-
hold at this Christmas sea-
son and May Our Heaven-
ly Father keep us in His
embrace during these un-
certain days in which we
live.
Love & Peace
Shirley Chisholm
Christmas 1991.

Vintage Afro Kola, "The Soul Drink," can, New York City (1970s)

We acquired this original can of Afro Kola drink in 2023 at auction and were immediately drawn to the colors and graphic nature of the label. Afro Kola was a drink distributed in New York City by Frank Mabry Jr., who owned a company called Afro-American Distributors and was a good friend of jazz musician, Max Roach. In our research, we learned that Max Roach wrote a sixty-second jingle for Afro Kola and the Library of Congress holds the original score in their collection of Max Roach papers. Here are the lyrics:

Afro-Kola
The taste of freedom
The soul drink
Right on (repeated 8 times,
accompanied by
a 16-bar piano solo)
The soul drink
Afro-Kola
Right on

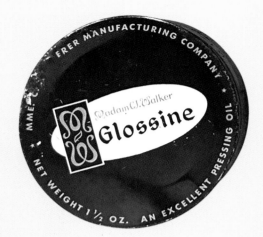

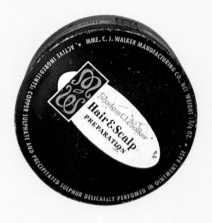

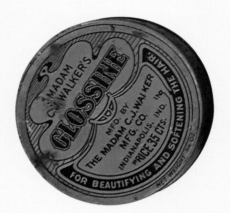

Our collection of Madam C. J. Walker hair products includes five canisters—four of which are filled with product and one booklet for saleswomen. The yellow Wonderful Hair Grower and Glossine tins are dated from the 1910s to the 1920s, and the brown and yellow Glossine and Hair & Scalp Preparation tins are from the era of the 1940s to the 1960s. Years ago, we visited and shopped an estate sale at Villa Lewaro, the mansion in Irvington, New York, built by Madam C. J. in 1916–1918, and it's still one of our most memorable estate sale adventures to this day.

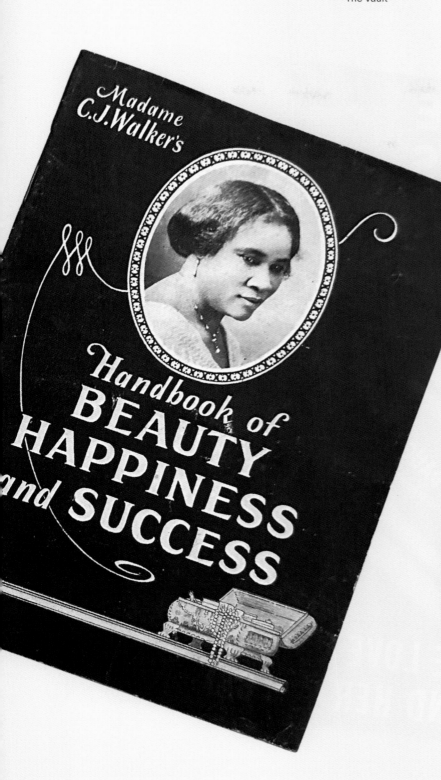

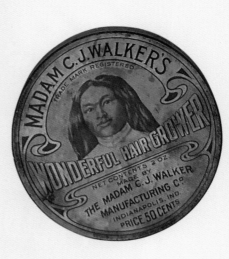

Madam C. J. Walker's hair product tins
and booklet (1910s–1960s)

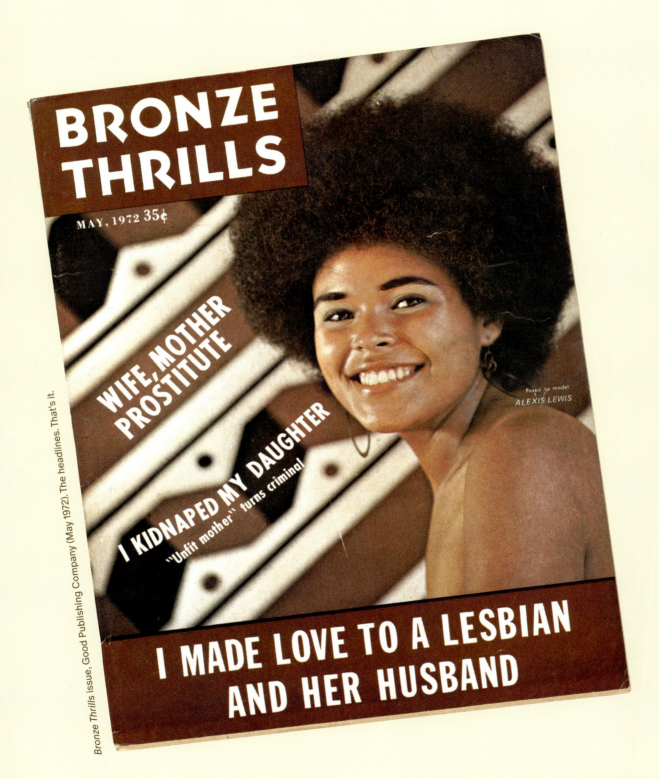

BRONZE THRILLS

MAY, 1972 35¢

WIFE, MOTHER PROSTITUTE

I KIDNAPED MY DAUGHTER
"Unfit mother" turns criminal

Posed by model
ALEXIS LEWIS

I MADE LOVE TO A LESBIAN
AND HER HUSBAND

Remington Starfire typewriter (early 1960s)

Our working Remington Starfire typrewriter is a sentimental object in our collection, gifted to me (Kiyanna) by Jannah in 2021 during the COVID-19 pandemic. It sits in its original case on the built-in shelves in our living room, and we've tapped many a love note on it.

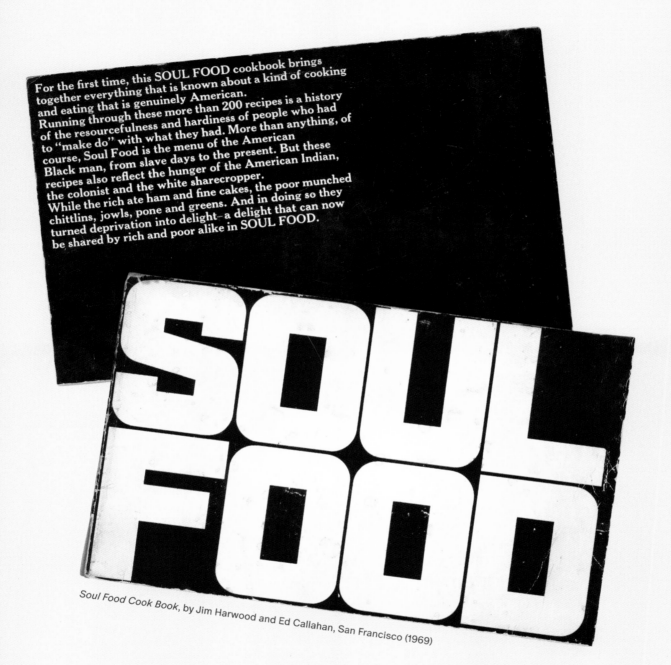

For the first time, this SOUL FOOD cookbook brings together everything that is known about a kind of cooking and eating that is genuinely American.
Running through these more than 200 recipes is a history of the resourcefulness and hardiness of people who had to "make do" with what they had. More than anything, of course, Soul Food is the menu of the American Black man, from slave days to the present. But these recipes also reflect the hunger of the American Indian, the colonist and the white sharecropper.
While the rich ate ham and fine cakes, the poor munched chittlins, jowls, pone and greens. And in doing so they turned deprivation into delight– a delight that can now be shared by rich and poor alike in SOUL FOOD.

Soul Food Cook Book, by Jim Harwood and Ed Callahan, San Francisco (1969)

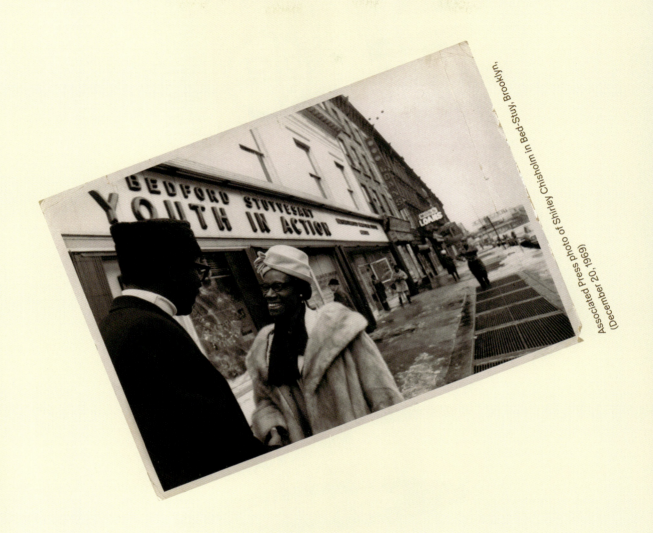

Associated Press photo of Shirley Chisholm in Bed-Stuy, Brooklyn,
(December 20, 1969)

This is an 8-by-10-inch, black-and-white portrait of
Shirley Chisholm in Bedford-Stuyvesant, Brooklyn,
taken by the Associated Press after she was elected to
Congress. According to our research, this was snapped
on Fulton Street and ran on January 5, 1969.

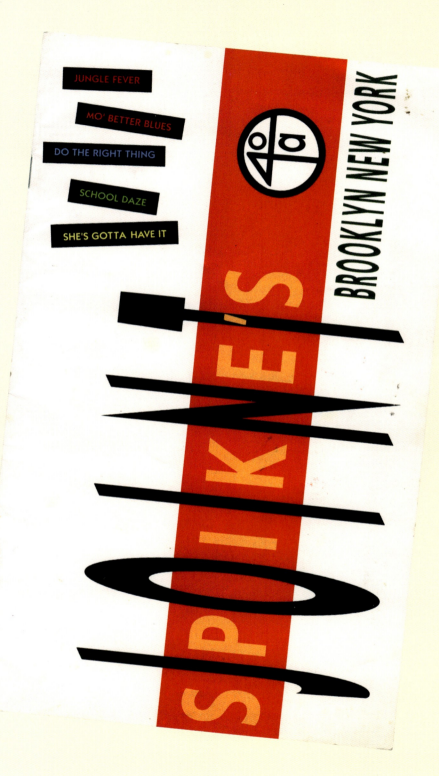

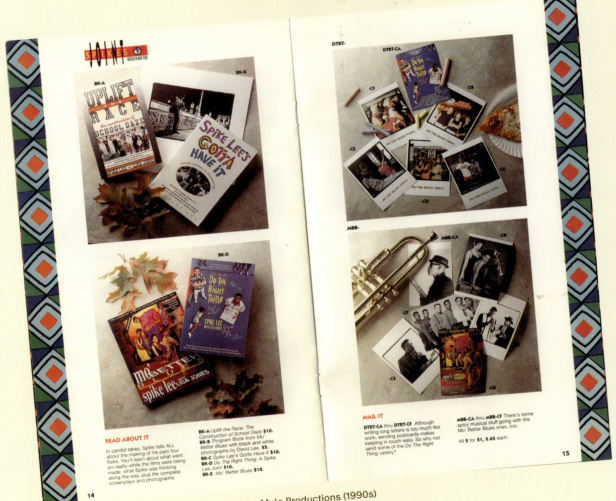

Spike's Joint merch catalogue, 40 Acres and a Mule Productions (1990s)

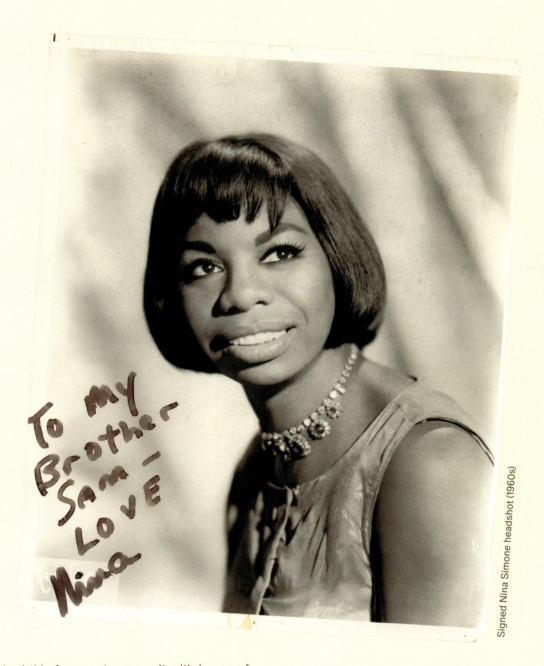

Signed Nina Simone headshot (1960s)

We acquired this from a storage unit with boxes of music-related ephemera. The collection included several signed photos of Nina Simone and dozens of black-and-white press photos. The signed headshot was one of those and extra special because it is inscribed to Simone's brother, Sam Waymon.

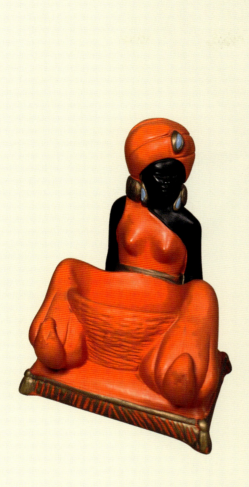

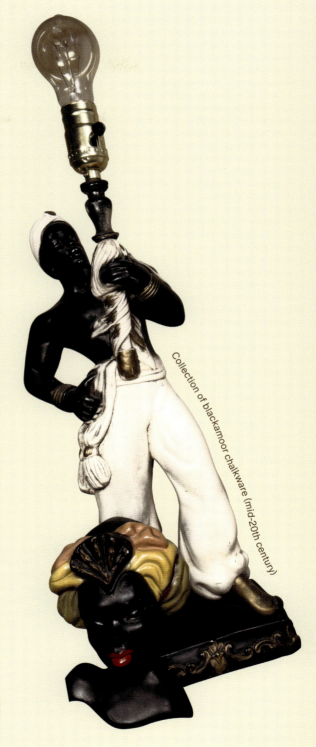

Collection of blackamoor chalkware (mid-20th century)

Blackamoor chalkware decor, including a table lamp, catch-all statue, and wall-mounted bust. Jannah found these at a flea market in our early days.

This beaded art deco clamshell purse was given to
Kiyanna by her grandmother Alda, who wrote her name
on the inner silk lining in pen. Grandma Alda's purse
appears to have been made in the 1970s–1980s and is
preserved today in a dust bag in our closet.

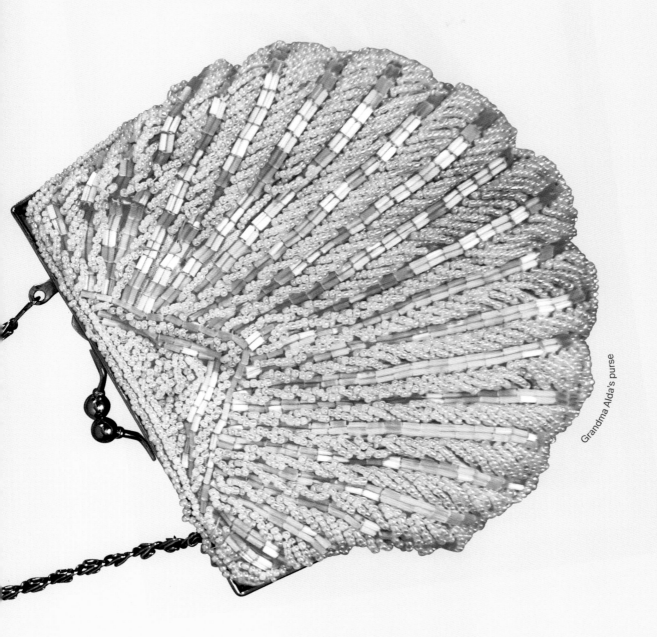

Grandma Alda's purse

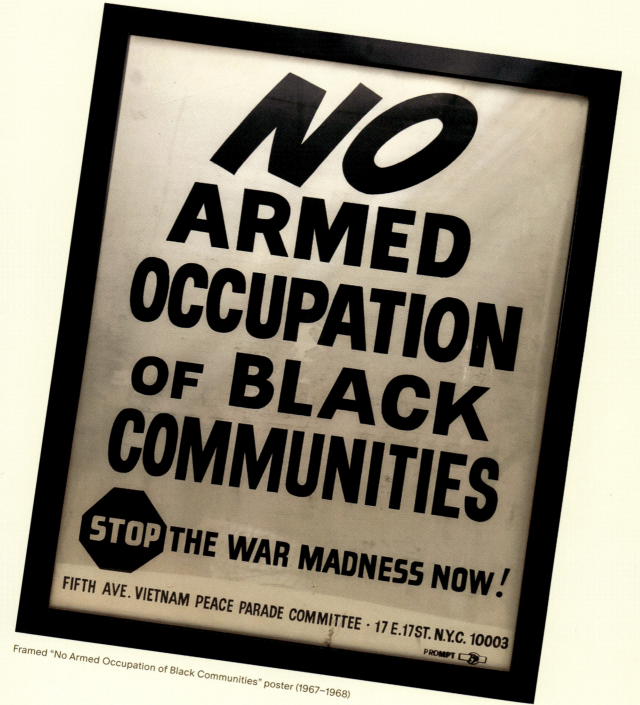

Framed "No Armed Occupation of Black Communities" poster (1967–1968)

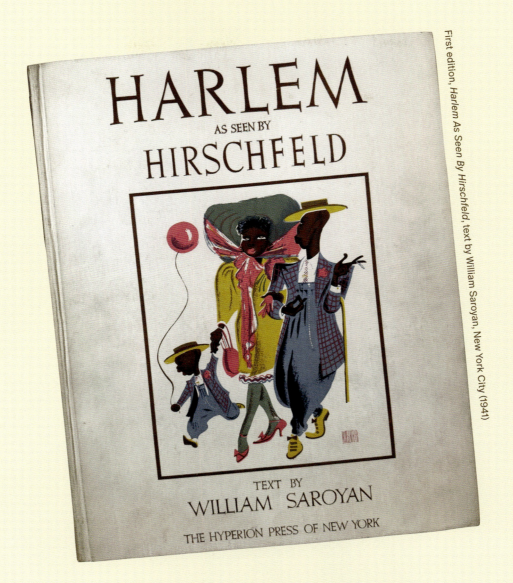

First edition, *Harlem As Seen By Hirschfeld*, text by William Saroyan, New York City (1941)

Neither Al Hirschfeld nor William Saroyan were Black, but we happen to enjoy Hirschfeld's renderings of Black life and families in Harlem in the 1930s. The large-format book includes twenty-four original color lithographs by Hirschfeld, nineteen of which depict Black Harlemites in their Sunday best.

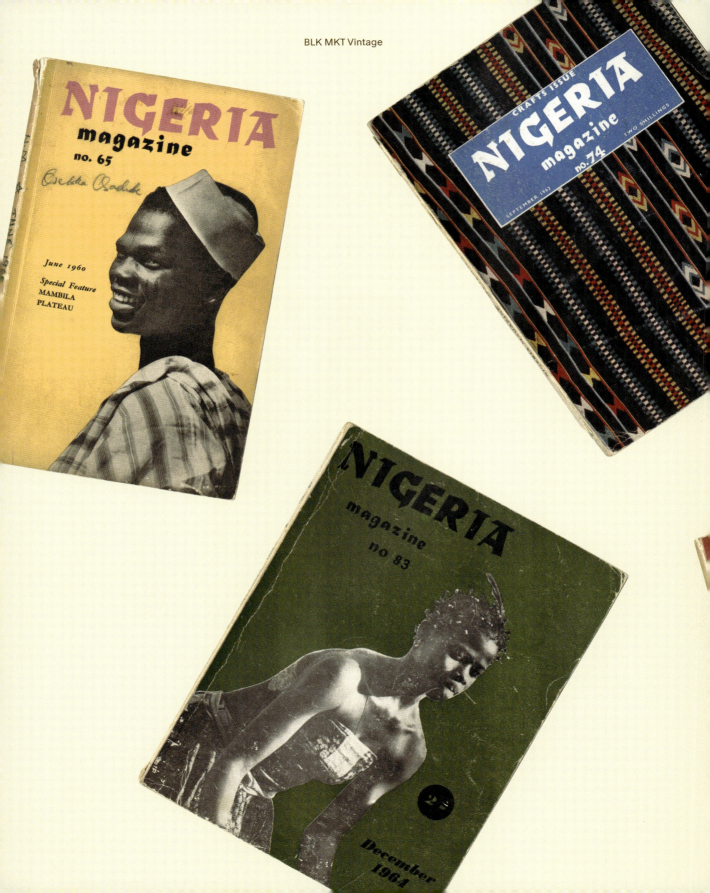

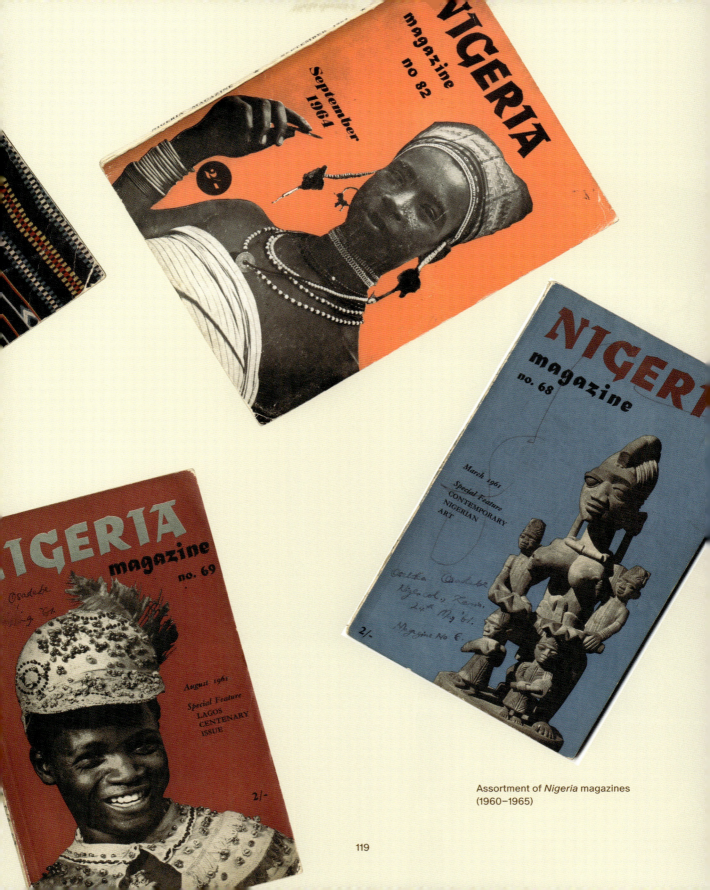

Assortment of *Nigeria* magazines
(1960–1965)

"Blues Suite . . . employs song as well as
dance and it mounts to an exciting pitch."
Harry MacArthur, The Evening Star, 1959

(Continued)

has been with the Company since 1961, when Mr. Ailey first heard
the singer at Folk City and asked him to sing the "blues" in a
ballet now titled *Blues Suite*. He has toured Europe and Australia
with the Company and has performed on Broadway in *Tambourines
To Glory*, off-Broadway in *Black Blues* and has recorded several
albums including *Baptist Shout* and *Big Boat Up The River*. He is
the godson of the late Mahalia Jackson.

Something Strange which serves as the overture to BLUES SUITE
is, like *I Cried*, a traditional lament that acknowledges and bemoans
the presence of the blue devils and the low-down feeling they
always bring. The lyrics are the grieving victim's attempt to spell
out the cause and effect of his affliction. This type of music which
as a rule is performed far more often by itinerant folk style guitar
strummers than by dance beat oriented honky tonk piano players
has unmistakable overtones of the aboriginal chant and the
downhome field holler.

Above: "Sham" with Barbara Alston, Merle Derby, Minnie
Marshall. Photo: Normand Maxon. Top left: "House of the
Rising Sun" with Mari Kajiwara and, "Good Morning" with the
Company. Photo: Susan Cook; Across: "Mean Ol' Frisco"
with the Company, Photo: Lois Greenfield and, "Sham" with
the Company. Photo: Lois Greenfield.

BLUES SUITE, which has been in the repertory of the Alvin Ailey
Company since 1958, opens with *Good Morning Blues*, a traditional
12-bar folk ballad. The time is early morning and the dancers
represent people who are waking up once more into a world of
torment and trouble. The very atmosphere is oppressive. The
specific setting is a honky tonk or jook joint and the opening move-
ments are intended to suggest a very intense human response
to a gloom-ridden environment. There are waking and stretching
movements which express rage, anger, frustration, loss, longing
and also yearning and also determination. These are the actions of
people who are trying to extend their world, to stretch out into
another perception of themselves. It is as if they are fighting
their way free of an entanglement. At first it seems as if each
individual thinks his troubles are unique, but as the dance pro-
gresses there comes an awareness of a common ground of
commiseration. Hence, the ensemble climax.

The music and lyrics of M-
a lost love who has left town
deliverance from one life to
section, however, come out o
childhood in Texas during the
their belongings waited besi
train to Chicago, Kansas, De
being mean (i.e. cruel) becau
But it is also mean because o
the task of snagging or hobo
as huge as a fairy tale drag
as much destructive force as

In the blues idiom (and in
too, for that matter) the freie
phenomenon and a very pro
transportation, but it is also
stretches all the way back to
which the fugitive slave rod
Land of Freedom. Incidental
in church music seems to an
blues music.

The setting for *House of the*
of the sporting house premis
movements of the trio of pros
feelings of lost dreams, feel
another situation where they
instead of having to sell it as

Backwater Blues is a twili
place upstairs over the honk
standing love/hate flirtation
turns out to be a very passio
a bit of time playing games
such is the nature of their de
in each other's arms.

In The Evening is a dance
solitary response to his alon
meaning. The time of this act
the search is not only for ser
for a higher reason for being

Yancy Special, Slow Drag
with the evening festivities.
honky tonk where as the ve
blues are dragged, stomped
away, shouted, strutted, shin
with resolution but also none
All these functions work tow
them at bay at least for the t

The festive atmosphere of
of the opening strains of Goo
completed. The fact that the
yesterday does not mean tha
The blues always come back
which has to be dealt with e
Copyright © 1978 by Albert

CREDITS
EXECUTIVE PRODUCER / G
PRODUCER / DANCE THEA
ALBUM DESIGN / BEA FEIT
ASSOCIATE DESIGNER / GIL
COVER PHOTO / REVELATIO
℗ 1978 DTF, Inc.
Dance Theater Foundation, Inc

ALVIN AILEY AMERICAN DANCE THEATER PRESENTS

REVELATIONS

We purchased this vinyl record from a collector a few years ago and it's a super-clean copy. Many of my (Kiyanna) years dancing were heavily inspired by the legacy of Alvin Ailey and it's really dope to have the score on vinyl, without the visuals.

Opposite and above:
Alvin Ailey American Dance Theatre Presents: Revelations, 33 rpm vinyl record (1978)

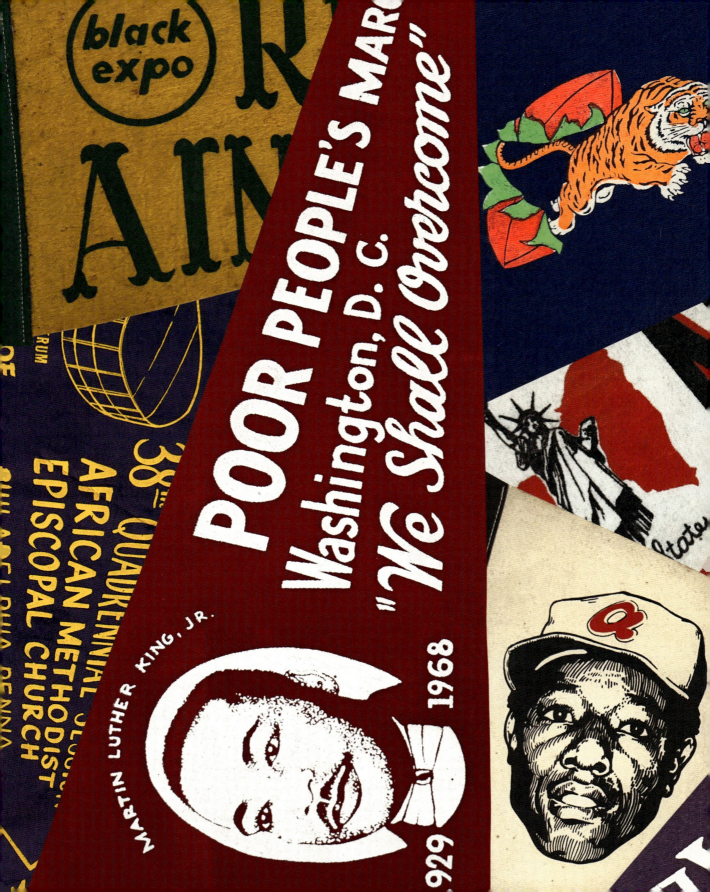

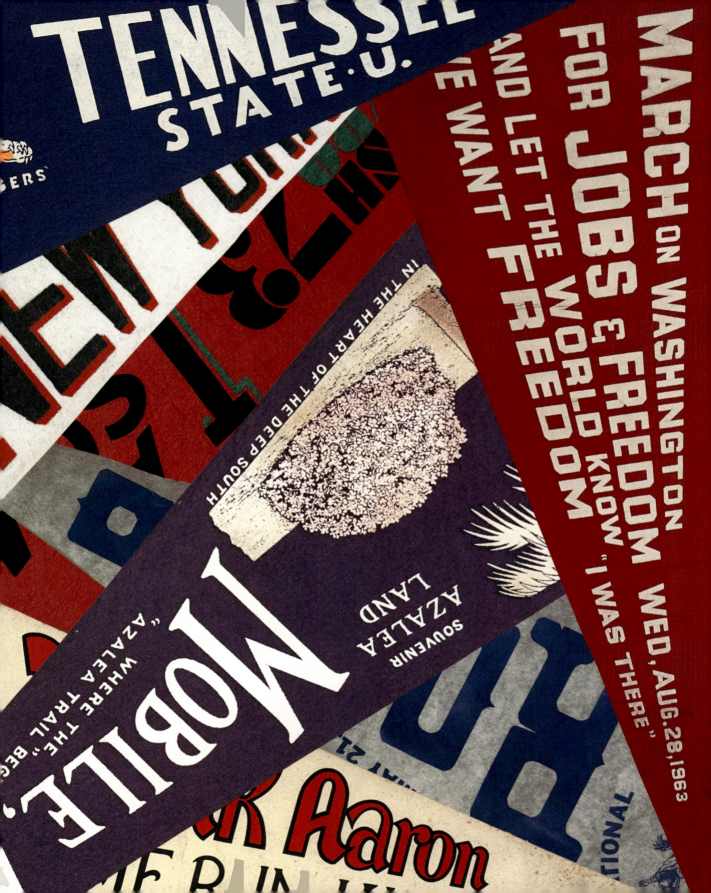

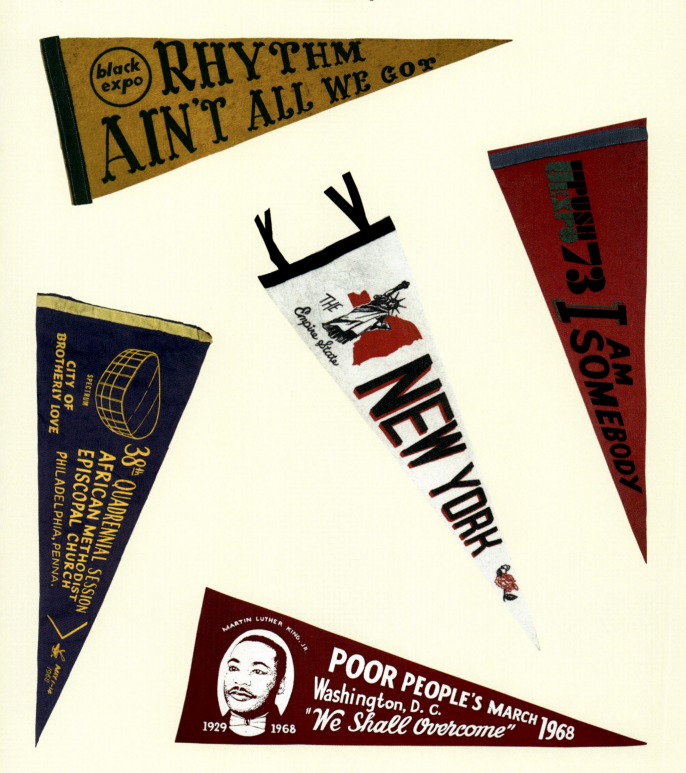

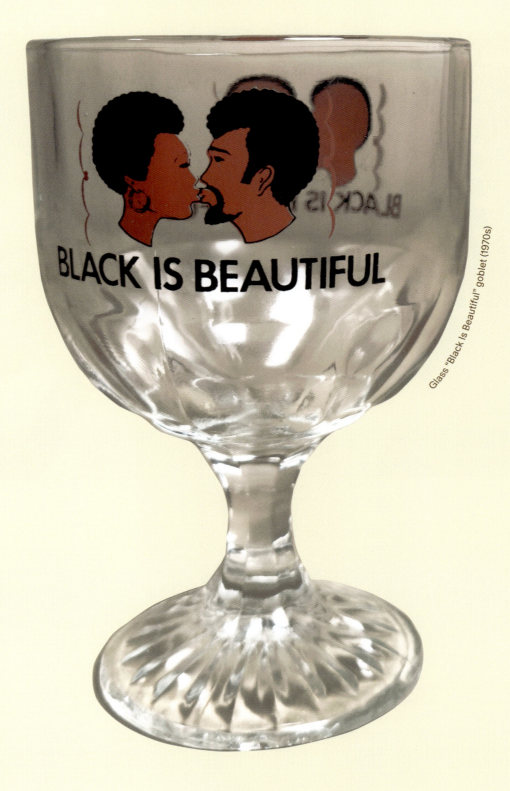

Glass "Black Is Beautiful" goblet (1970s)

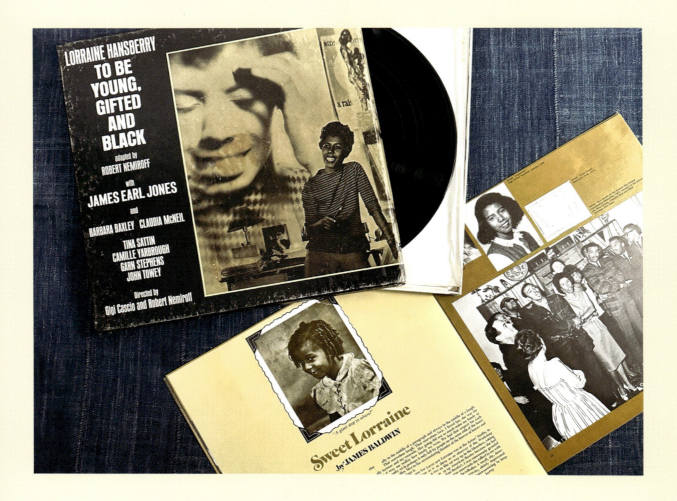

This set includes a beautiful twenty-one-page booklet about Lorraine Hansberry's on-stage productions, featuring photos of cast members and a heartfelt reflection about Hansberry by her good friend James Baldwin, called "Sweet Lorraine."

To Be Young, Gifted and Black by Lorraine Hansberry, three-record vinyl boxed set and booklet, the Theatre Recording Society, New York City (1971)

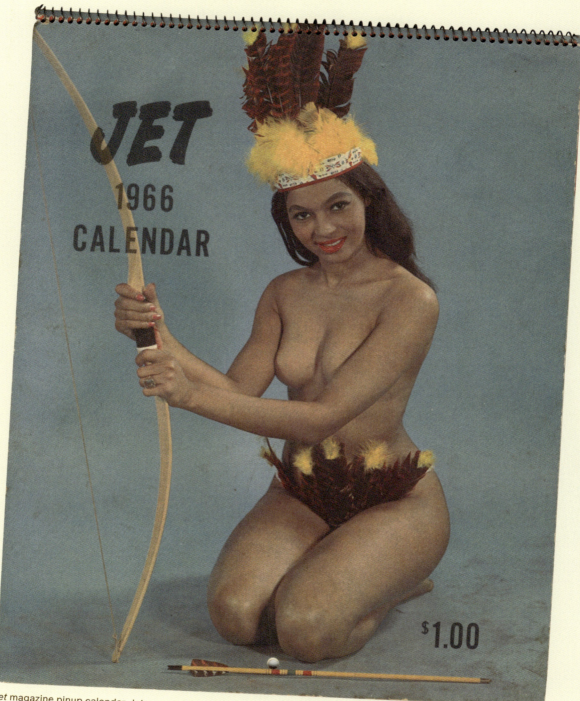

Jet magazine pinup calendar, Johnson Publishing Company (1966)

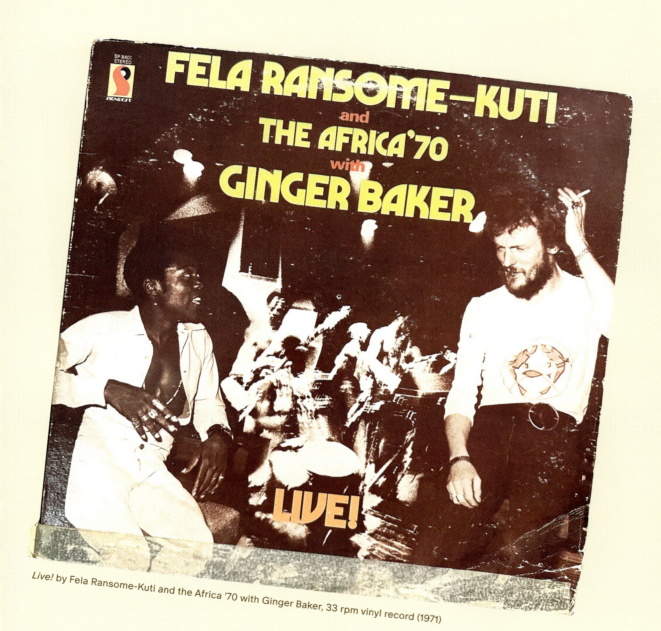

Live! by Fela Ransome-Kuti and the Africa '70 with Ginger Baker, 33 rpm vinyl record (1971)

It's hard to find original pressings of Fela Kuti records in the United States, but we've managed to get our hands on a few of them. This one is in the best condition, even with the split along the bottom. "Egbe Mi O" is our joint!

130

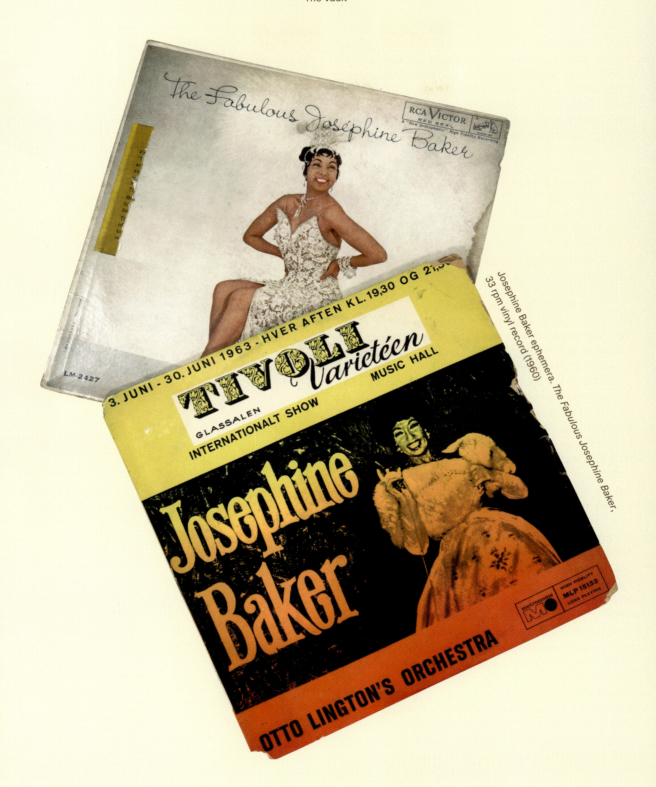

Josephine Baker ephemera. The Fabulous Josephine Baker,
33 rpm vinyl record (1960)

One of our favorite acquisitions of queer ephemera happens to be one of the more tragic and traumatic—a collection of ten 1940s–1950s mugshots of presumed trans women and queer people, all arrested in Cleveland. Most were arrested on sex-work-related charges and they were almost definitely targeted because of their transgressive identities and gender expression:

Ester Mullins
Kenneth Ashton
Duwayne
Quincy Baldwin
Tracy Saunders
Deloris
Clyde Dooley
Cassien

In honor of the spectrum of gender expression and not knowing exactly how these ancestors identified, we've addressed them above with their chosen names and given names when an alternative was not listed on their records.

The glossy mugshot images show them adorned in blingy necklaces, post and chandelier earrings with victory rolls, slicked-back buns, and roller sets. Their listed crimes—faggotry, prostitution, and something annotated as "s.p." (possibly, sexual predator). These mugshot and booking cards tell a story about the criminalizing of queerness in this country and also reveal details about the interior lives of queer folk across the country with laws and policies like the three-article rule (aka "masquerading" or "anti-cross-dressing" laws) and criminalization of sodomy. Beyond those laws, Black queer folks endured violence at the hands of everyday people for their race, presentation, and gender variance. These mugshots speak directly to our broken governing systems of today, revealing a deep-rooted history that has always disdained the courage of queer people to be themselves. There's an overwhelming lack of published work about queer and trans communities pre-Stonewall, so ephemera like this helps us, scholars, archivists, memory workers, and other cultural producers to fill the gaps in our historical memory. This set of mugshots has helped to reorient our storytelling, ensuring that people like Tracy Saunders and Ester Mullins aren't forgotten when constructing the future in which BLK MKT Vintage wants to live.

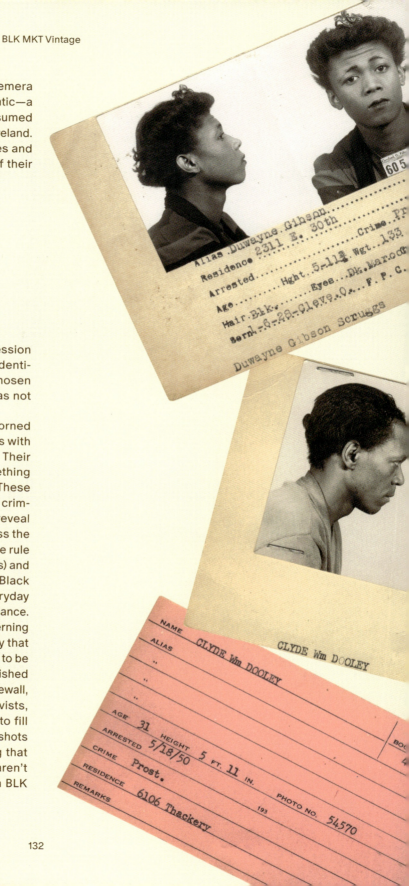

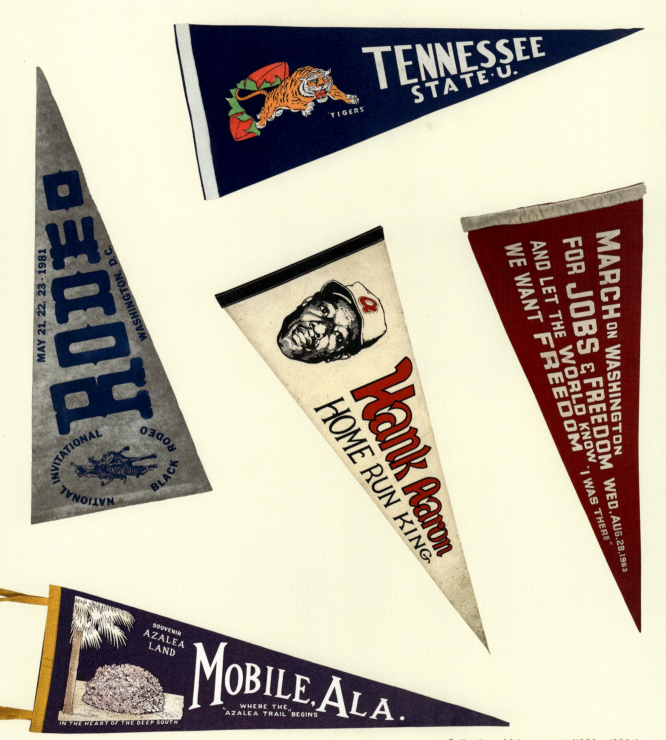

Collection of felt pennants (1920s–1980s)

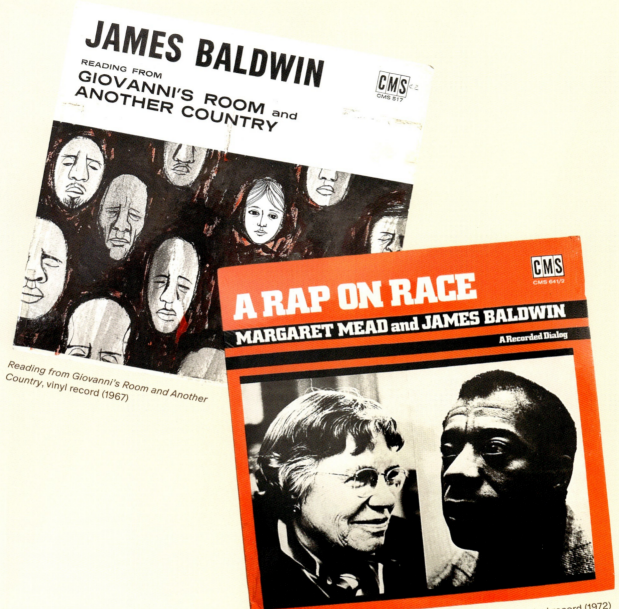

Reading from Giovanni's Room and Another Country, vinyl record (1967)

Sealed A Rap on Race: Margaret Mead and James Baldwin, vinyl record (1972)

We have a soft spot for spoken-word vinyl records, and these two Jimmy Baldwin records are hard to come by. Baldwin has one of those hard-to-forget voices, so being able to listen to his works and dialogues is a gift.

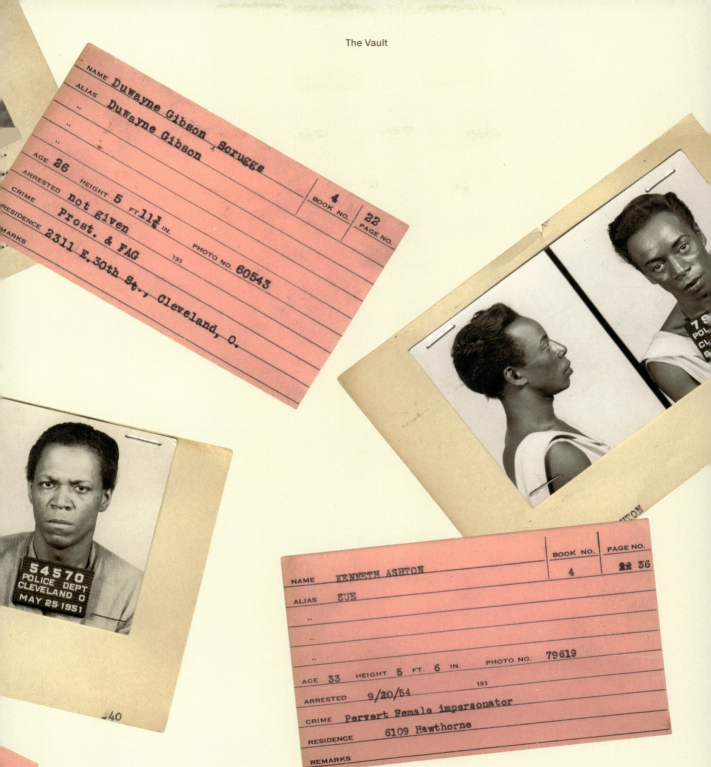

NAME Duwayne Gibson , Scruggs
ALIAS Duwayne Gibson
AGE 26 HEIGHT 5 FT 11½ IN.
BOOK NO. 4 PAGE NO. 22
ARRESTED not given
CRIME Prost. & FAG PHOTO NO. 60543 193
RESIDENCE 2311 E.30th St., Cleveland, O.
REMARKS

54570
POLICE DEPT.
CLEVELAND O
MAY 25 1951

NAME KENNETH ASHTON
ALIAS SUE
BOOK NO. 4 PAGE NO. 36
AGE 33 HEIGHT 5 FT. 6 IN. PHOTO NO. 79619 193
ARRESTED 9/20/54
CRIME Pervert Female impersonator
RESIDENCE 6109 Hawthorne
REMARKS

Mugshots of queer people arrested in
Cleveland (1940s–1950s)

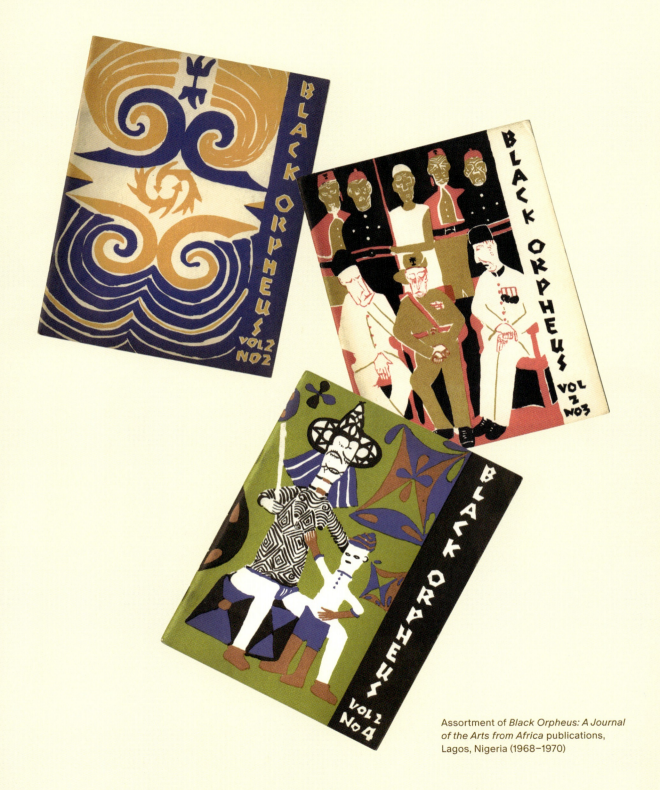

Assortment of *Black Orpheus: A Journal of the Arts from Africa* publications, Lagos, Nigeria (1968–1970)

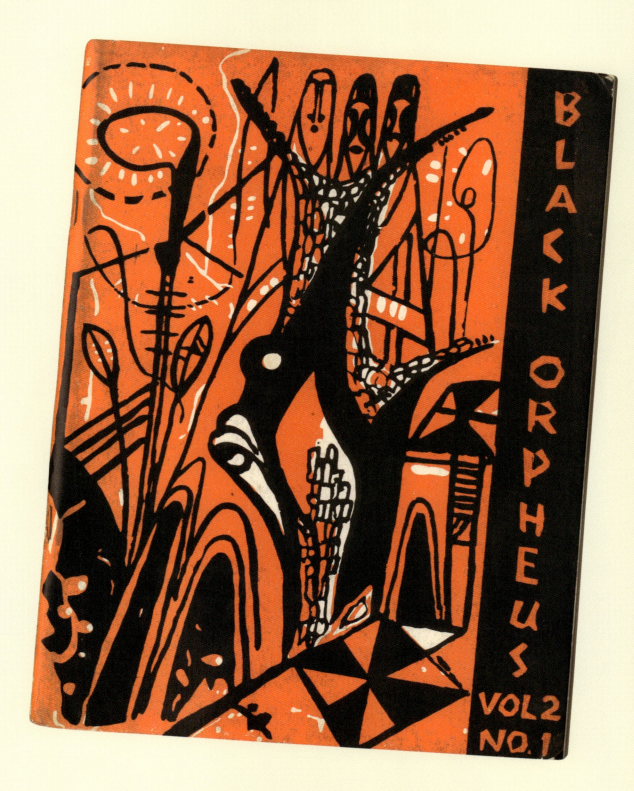

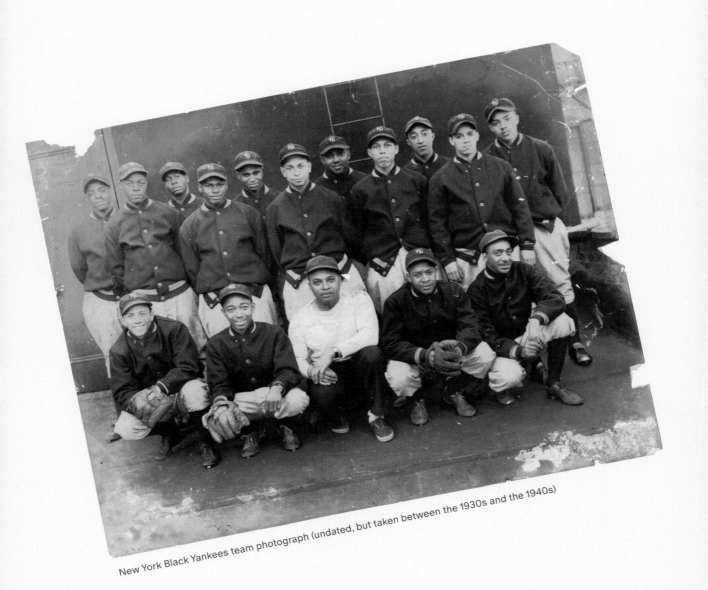

New York Black Yankees team photograph (undated, but taken between the 1930s and the 1940s)

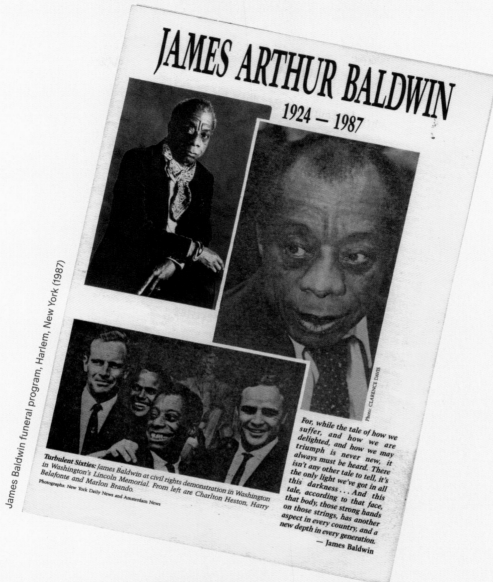

James Baldwin funeral program, Harlem, New York (1987)

JAMES ARTHUR BALDWIN

1924 — 1987

Photo: CLARENCE DAVIS

Turbulent Sixties: James Baldwin at civil rights demonstration in Washington in Washington's Lincoln Memorial. From left are Charlton Heston, Harry Belafonte and Marlon Brando.

Photographs: New York Daily News and Amsterdam News

For, while the tale of how we suffer, and how we are delighted, and how we may triumph is never new, it always must be heard. There isn't any other tale to tell, it's the only light we've got in all this darkness... And this tale, according to that face, that body, those strong hands on those strings, has another aspect in every country, and a new depth in every generation.

— James Baldwin

This is one of our most coveted and cherished pieces of ephemera in our collection. We revere the legacy and work of James Baldwin and this celebration of his life is a touching, sobering reminder of his impact. From Odetta's vocal medley, tributes by Maya Angelou, Toni Morrison, and the ambassador of France, the eulogy delivered by Amiri Baraka, and the procession led by Babatunde Olatunji, we can only imagine the impact his loss had on Black artists and the community at large. May he continue to rest in abundant peace and power.

The Cathedral Church of St. John the Divine

DECEMBER 8, 1987

12 O'CLOCK NOON

A Celebration

of the Life of

James Arthur Baldwin

Presiding

THE VERY REVEREND JAMES P. MORTON, DEAN

REVEREND CANON LLOYD S. CASSON, SUB DEAN

The Order of Service

ORGAN PRELUDE

PROCESSIONAL — "A Drum Salute" Babatunde Olatunji Ensemble

THE ANTHEMS and COLLECT The Very Reverend James P. Morton
The Reverend Canon Lloyd S. Casson

PSALMS 23 and 121 *Anglican Chant* The Cathedral Choirs

THE PRAYER The Reverend Samuel Joubert

THE SCRIPTURE LESSON — The Reverend Doctor Rena Karefa-Smart
The Revelation of St. John the Divine 21:1-5, 5:11-14

The Order of Service

A SUITE OF PRAISE — Odetta
 "Motherless Child"

 "Glory, Glory, Hallelujah"

 "Let Us Break Bread Together"

THE ECOMIUM/TRIBUTES —
 Maya Angelou

 Toni Morrison

 His Excellency Emmanuele de Margerie
 Ambassador of France

THE HERALD — "A Horn Salute" Jimmy Owens, Trumpet and Flugel Horn
 Danny Mixon, Piano

THE EULOGY Amiri Baraka

"PRECIOUS LORD," A PRAYER James Baldwin
 A Recording

THE CHOIR ANTHEM

THE PRAYERS and LORD'S PRAYER Dean James P. Morton
 Canon Lloyd S. Casson

THE BENEDICTION The Reverend A. Knighton Stanley

THE COMMENDATION KANTAKIOM Catherdral Choirs

THE RETIRING PROCESSON —
 "Continuum Drums" Babatunde Olatunji

Writer, Poet, Essayist, Advocate, Quintessential

Black Panther Party

FEDERAL BUREAU OF INVESTIGATION
UNITED STATES DEPARTMENT OF JUSTICE
JOHN EDGAR HOOVER, DIRECTOR

MARCH 1971

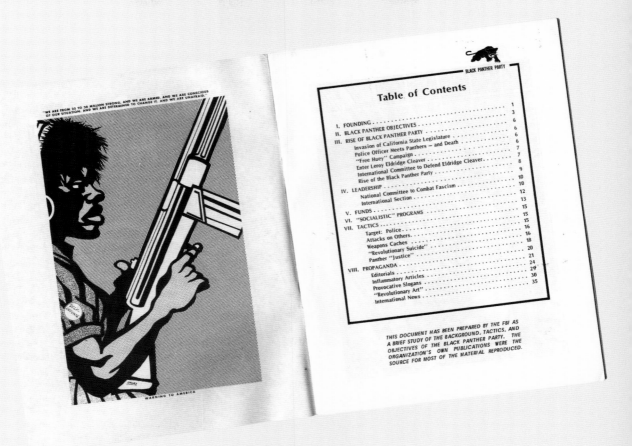

According to the interior page, "This document has been prepared by the FBI as a brief study of the background, tactics, and objectives of the Black Panther Party. The organization's own publications were the source for most of the material reproduced."

FBI study on the Black Panther Party, booklet (1971)

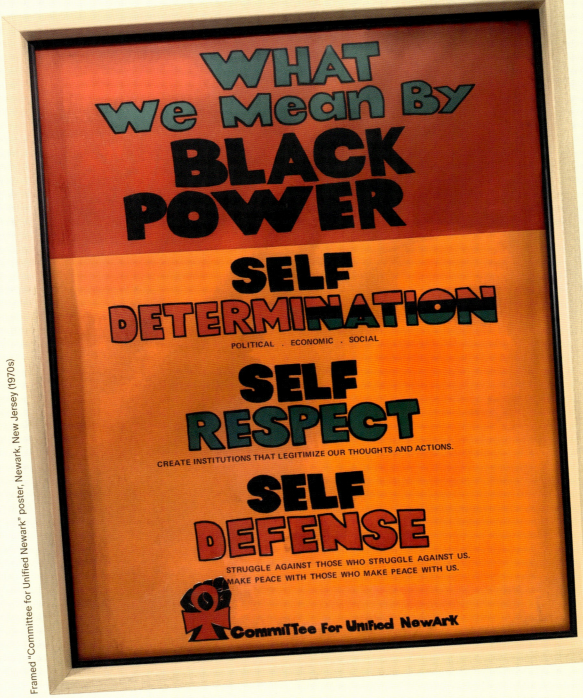

Framed "Committee for Unified Newark" poster, Newark, New Jersey (1970s)

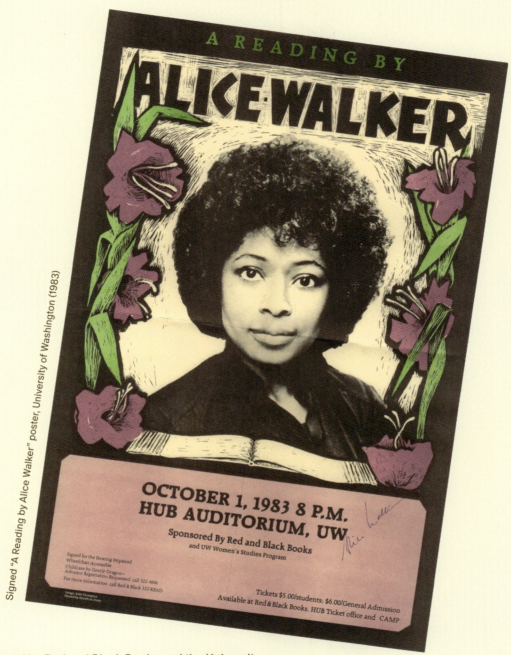

Sponsored by Red and Black Books and the University of Washington Women's Studies Program, this Alice Walker reading took place on October 1, 1983, just a few months after she was awarded her Pulitzer Prize for Fiction for *The Color Purple* (the first awarded to a Black woman). It was signed by Walker in purple marker on the bottom right.

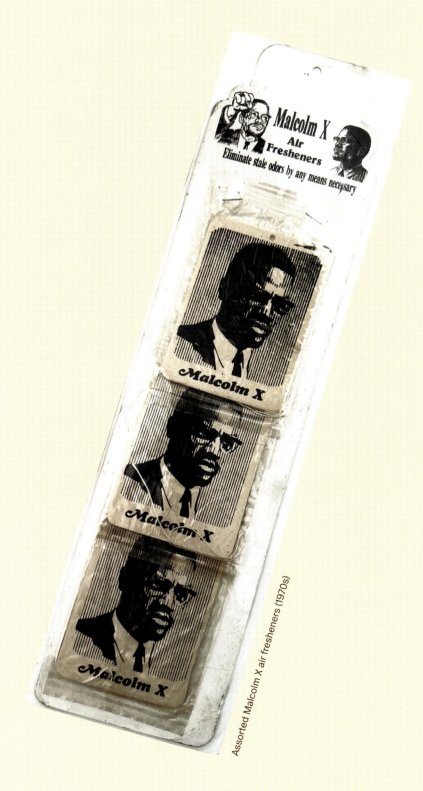

Assorted Malcolm X air fresheners (1970s)

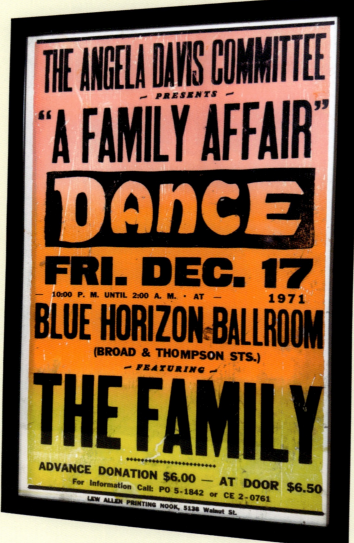

Framed Angela Davis fundraising benefit poster, Philadelphia (1971)

We purchased this poster at auction during the pandemic and its boxing/concert graphic style spoke to us. The poster is advertising a benefit being held a year into the imprisonment of Angela Davis. The venue, the Blue Horizon Ballroom in Philadelphia, was best known as a boxing arena. We have quite a bit of consciousness-raising and fund-raising ephemera in our collection and the imagery looks similar—bold fonts, raised fists, portraits of Angela Davis and her comrades, illustrations of pigs (seriously!), and this one stands out in its simplicity.

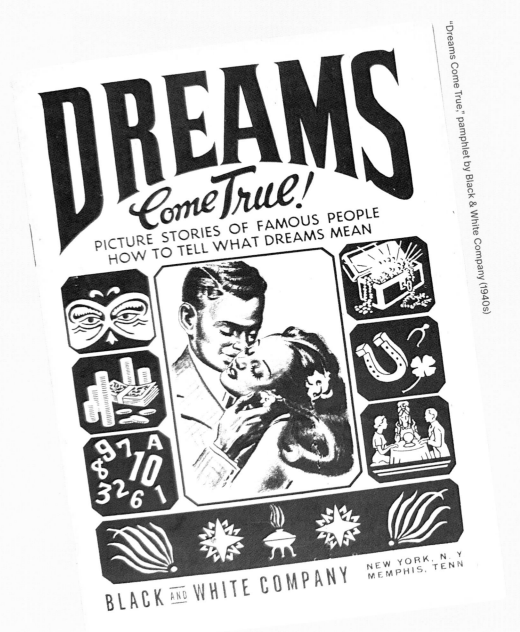

"Dreams Come True," pamphlet by Black & White Company (1940s)

The booklet was produced as marketing for the Black and White cosmetics brand. We have a collection of a dozen cosmetic jars in varying condition. Most infamously, the Black and White brand was known for its skin bleaching creams.

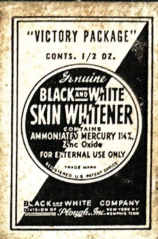

"VICTORY PACKAGE"
CONTS. 1/2 OZ.
Genuine
**BLACK AND WHITE
SKIN WHITENER**
CONTAINS
AMMONIATED MERCURY 1¼%.
Zinc Oxide
FOR EXTERNAL USE ONLY
TRADE MARK
REGISTERED U.S. PATENT OFFICE
BLACK AND WHITE COMPANY
DIVISION OF Plough, Inc. NEW YORK N.Y.
MEMPHIS TENN.

Genuine
Active Ingredients:
Ammoniated Mercury
1¼%, Zinc Oxide,
Bismuth Subnitrate
CONTS. 1/2 OZ.
**BLACK
and
WHITE**
BLEACHING CREAM
BLACK AND WHITE COMPANY
DIVISION OF Plough, Inc. NEW YORK N.Y.
MEMPHIS TENN.
MADE IN U.S.

Genuine **BLACK and WHITE**
7/8 OZ
AV. NET
CLEANSING CREAM
BLACK AND WHITE COMPANY
NEW YORK N.Y.
Plough, Inc. MEMPHIS TENN.
MADE IN U.S.A.

Genuine
**BLACK AND WHITE
OINTMENT**
USE EXTERNALLY FOR
PIMPLES, RASHES AND
ECZEMIC CONDITIONS
OF THE SKIN
TRADE MARK REGISTERED
A PRODUCT OF
BLACK AND WHITE COMPANY
CHICAGO

1 1/5 OZS.
Genuine
**BLACK
and
WHITE**
SKIN SOAP
BLACK AND WHITE COMPANY
NEW YORK, N.Y.
Plough, Inc. MEMPHIS, TENN.

TAN TAN TAN TAN

VOL. 8
T. 1957-
T. 1958

VOL. 5
NOV. 1954-
OCT. 1955

VOL. 7
NOV. 1956-
OCT. 1957

VOL. 6
NOV. 1955-
OCT. 1956

Bound volumes of *Tan* magazine, 1960–1967

Bound volumes of *Sepia* magazine, 1960s

1969
VOL. 18

1976
VOL. 25

1971
VOL. 20

32
NOV. 197
APR. 19

31
MAY-OCT.
1976

29
NOV. 1973-
APRIL 1974

29
MAY-OCT.
1974

Bound volumes of *Ebony* magazine, 1960–1987

Bound volumes of *Our World* magazine, 1962–1967

SEPIA

SEPIA

SEPIA

OUR
WORLD

VOLS. 6-10
JAN. 1951-
AUG. 1955

INCOMPLETE

Signed Allegheny Airlines pamphlet by Muhammad Ali

Surprisingly, this is the only signed Muhammad Ali ephemera in our private collection, and we purchased it from a collector of sports memorabilia around 2017 in Massachusetts. Muhammad Ali's signature is in pencil along the right side, and it's on an Allegheny Airlines pamphlet dated 1969. Muhammad Ali owned a home in Mt. Lebanon in Allegheny County, Pennsylvania and Allegheny Airlines was the local, now-defunct airline servicing Pittsburgh and its surrounding areas.

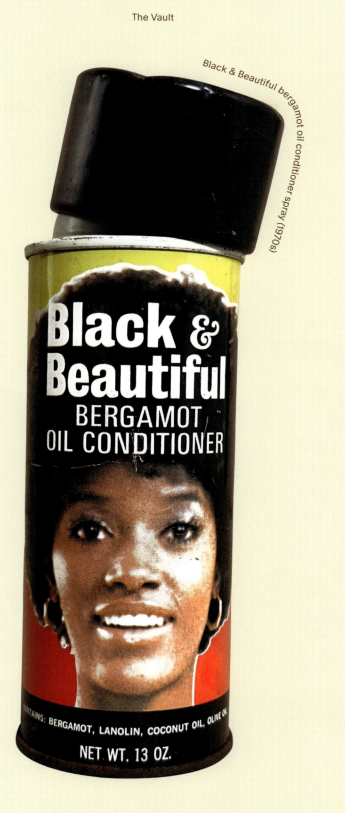

Black & Beautiful bergamot oil conditioner spray (1970s)

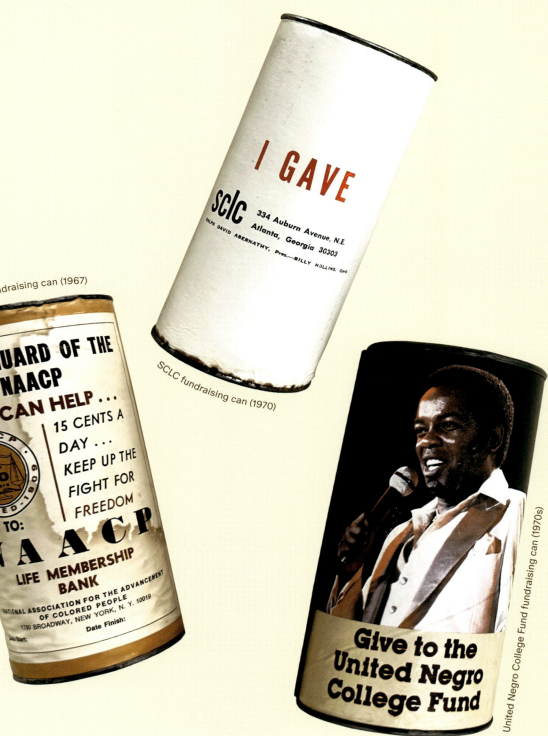

NAACP fundraising can (1967)

SCLC fundraising can (1970)

United Negro College Fund fundraising can (1970s)

Speakin' O' Christmas, by Paul Laurence Dunbar, Dodd & Mead (1914)

This hardcover first edition copy is our favorite Paul Laurence Dunbar book in our collection. As a 110-year-old book, it's in excellent condition and normally brought out during the holiday season as part of our décor. Jannah collects Black Christmas and Kwanzaa ephemera, so this is part of that mini collection.

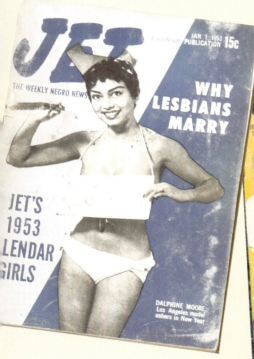

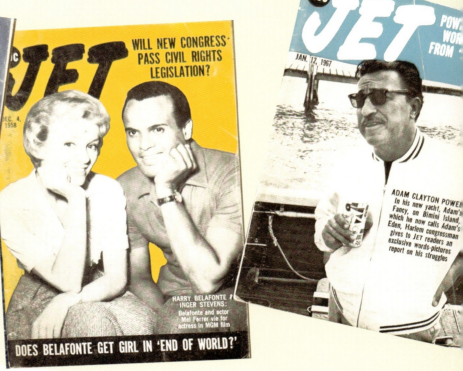

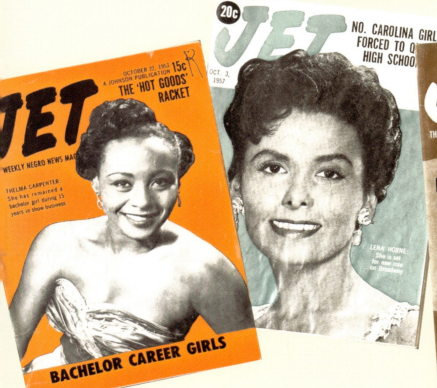

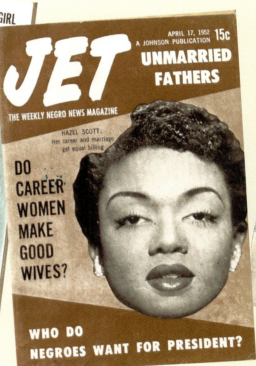

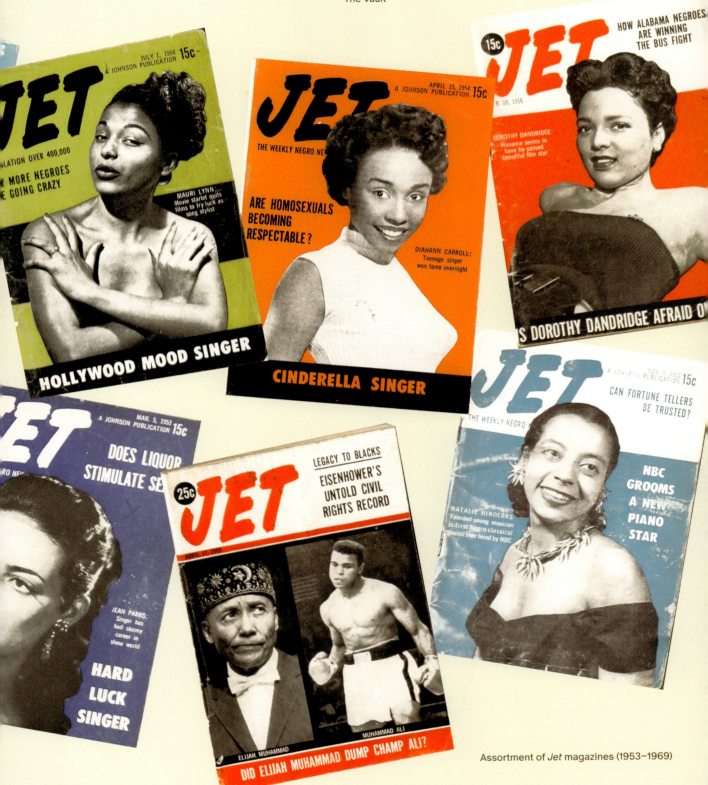

Assortment of *Jet* magazines (1953–1969)

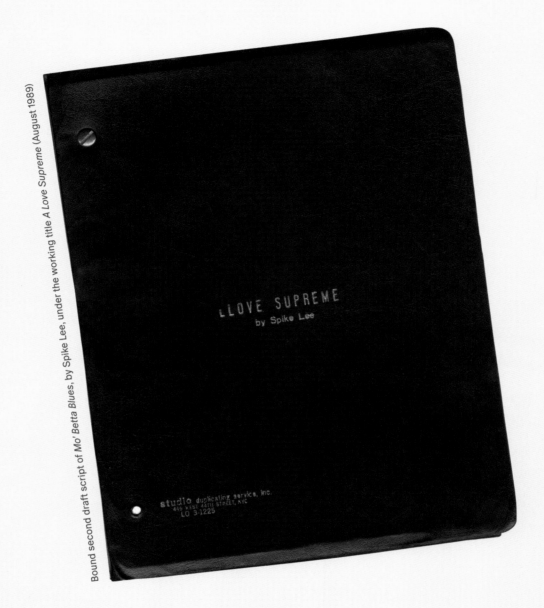

Bound second draft script of *Mo' Betta Blues*, by Spike Lee, under the working title *A Love Supreme* (August 1989)

This is a super-special piece of film history that found us by way of a consignee. She was looking to sell this for a family friend who inherited it and instead of consigning, we purchased it directly to keep it for our collection. Spike Lee has seen the script and jokingly grilled us about how we came upon it. We especially love that the title changed, as it was a work in progress. Brooklyn, stand up!

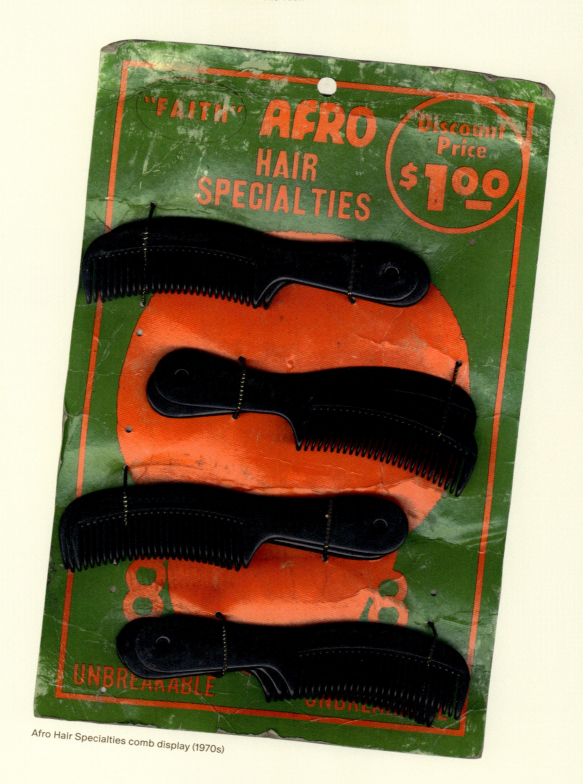

Afro Hair Specialties comb display (1970s)

1941

1936 EST.

EDITION

THE
NEGRO MOTORIST
GREEN=BOOK

Hotels
Taverns
Garages
Night-Clubs
Restaurants
Service-Stations
Automotive
Tourist-Homes
Road-Houses
Barber-Shops
Beauty-Parlors

Prepared in cooperation with
The United States Travel Bureau

Victor H. Green — Publisher
938 St. Nicholas, Ave. New York City

Price-25¢

The Holy Grail List

❶ THE NEGRO MOTORIST GREEN BOOK
❷ AUDRE LORDE LITERARY PROOFS OR NONBOOK EPHEMERA
❸ NEGRO LEAGUES BASEBALL JERSEY
❹ MARCUS GARVEY BLACK STAR LINE EPHEMERA
❺ LOÏS MAILOU JONES WATERCOLOR PAINTINGS
❻ GORDON PARKS CAMERA
❼ ARETHA FRANKLIN CAMCORDER
❽ ANTIQUE PHYSIOGNOTRACE
❾ THE WIZ TAXI PROP

Every now and then, folks express interest in learning about the objects and materials we've yet to acquire but are actively looking for. There are thousands of items we'd love to acquire for the collection and to offer via our props inventory; however, there's a very small subset of items we'd consider to be holy grail materials, otherwise known as the most desirable or sought-after Black cultural ephemera. This is our short list and if you (or your mama) have any leads on acquisitions, you know how to reach us!

COLLECTING WHILE BLACK

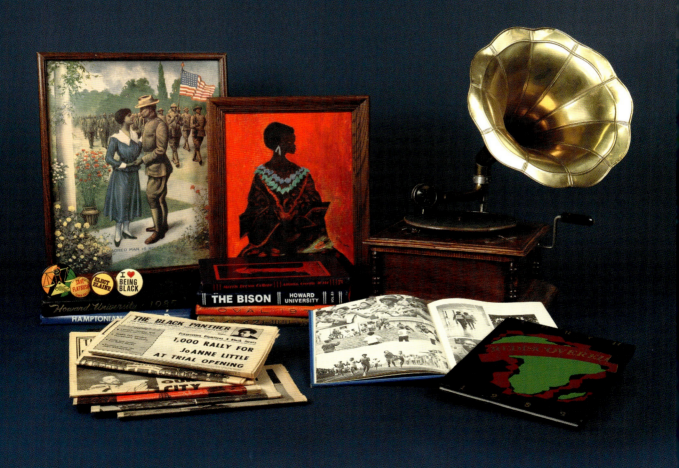

From left → 1. Antique *Colored Man Is No Slacker* lithograph (1918); 2. Vintage framed oil painting (1960s); 3. Black Veterans for Social Justice pinback (1970s); 4. Save Flatbush pinback (1970s); 5. Elect Elaine pinback (1970s); 6. I Love Being Black pinback (1970s); 7. Howard University yearbook (1985 and 1970s); 8. Assortment of *Black Panther* newspaper issues (1970s–1980s); 9. Morris Brown College yearbook, Howard University yearbook, and Fisk University yearbook; 10. North Carolina Agricultural and Technical State University yearbook; 11. Howard University and Morehouse College yearbook; 12. Antique phonograph

WRITTEN BY

Kiyanna

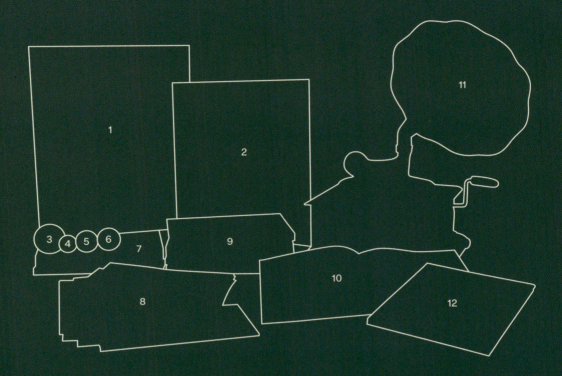

BOY, do we have **THINGS**. Lots of things. There are tintype photos, cast-iron hot combs, chenille patches, five-foot-tall colon statues from the Ivory Coast, antique reading lamps, walnut shoe trees, Malcolm X air fresheners, vintage New York Public Library cards, FBI Wanted posters, leather Moroccan poufs, Black Panther Party consciousness-raising pamphlets, Sister Rosetta Tharpe vinyl records, 1950s-era erotic magazines, original March on Washington pennants, Dance Theatre of Harlem letterman jackets, Air Jordan kicks, signed Audre Lorde works, beautifully weathered Senufo stools, 1930s and 1940s Tuskegee Institute photographs, Faith Ringgold signed prints, funeral home fans, Magnavox shoulder-bound boom boxes, FREE ANGELA DAVIS pins, dance-hall reggae posters, photo-booth portraits, Willi Smith blouses, tourism postcards from Selma, Alabama,a signed and mailed Christmas card from Shirley Chisholm, oil paintings, Madame C. J. Walker hair pomade tins, a Junior's Cheesecake advertising sign, wicker peacock chairs, and **THOUSANDS** of other wares.

Antique found photograph, Booker T. Washington at the "Lifting the *Veil*" monument at Tuskegee Institute (undated)

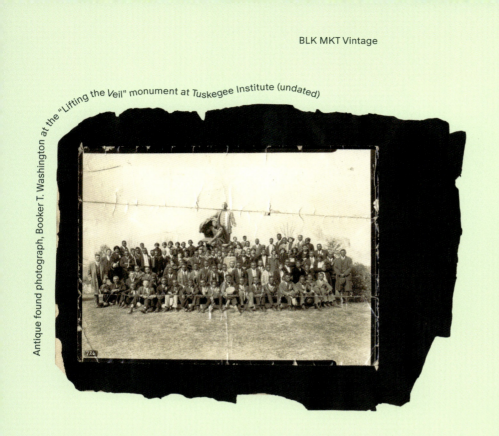

Found antique photograph

From a Land Where Other People Live, by Audre Lorde (1973)

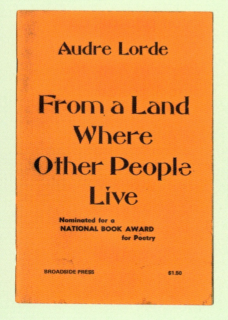

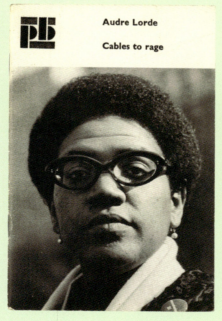

Cables to Rage, by Audre Lorde (1970)

The New York Head Shop and Museum, by Audre Lorde

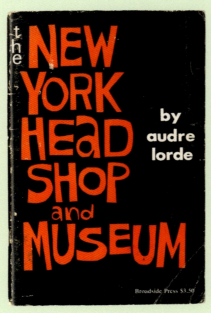

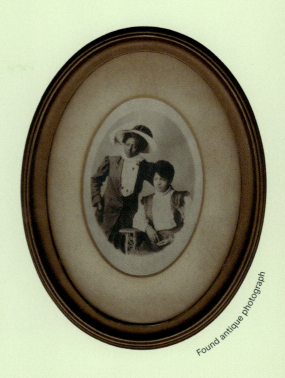

Found antique photograph

The Cancer Journals, by Andre Lorde (1980), Interior page of *Cables to Rage*, signed by Audre Lorde in ink

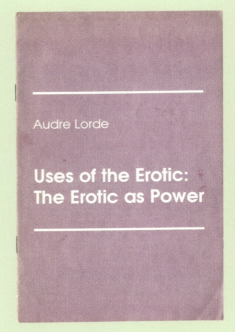

Uses of the Erotic, by Audre Lorde (1978)

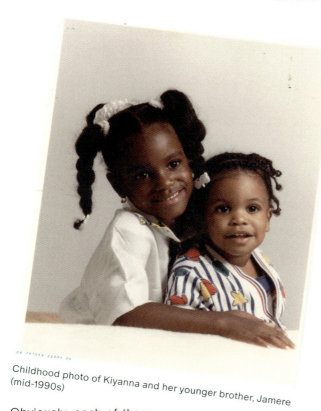

Childhood photo of Kiyanna and her younger brother, Jamere (mid-1990s)

Obviously, each of those things are their own . . . thing. Object. Material. Ware. Item. Artifact. Boy, do we have an abundance of language, too. There's a phrase we use often in this work that merits some exploration and positioning—*material culture*. We've used it throughout this book, in every chapter, but we recognize that while it's commonly used in our work and home, it may not be all that common in the zeitgeist. *Material culture* is a phrase used among vintage/antiques purveyors like ourselves, historians, collectors, archivists, cultural critics, anthropologists, librarians, semioticians, sociologists, and psychologists to explore objects and their relationship to people, cultures, and entire societies. There are plenty of multidisciplinary writings on material culture, thanks to the extensive research in various fields like the aforementioned, as well as the rise of mass consumption and industrial production. However, there's less research and writing specifically about Black material culture that is grounded in a semiotic, anthropological, psychoanalytic analysis. Maybe that's our second book—who knows? But as two former academics who wear multiple hats as entrepreneurs,

we don't ever really take off the academic hat. We just turn it to the back, most times.

We couldn't walk through the rest of *BLK MKT Vintage* without a quick grounding in material culture. The term *material* comes from the Latin, *materia*, or "matter," and suggests a corporeal, tangible object. Defining *culture*, the latter part of the phrase, is a more difficult task. Stuart Hall is one of the founders of cultural studies in the UK and has made significant contributions to the study of media, race, politics, culture, and postcolonialism since the 1960s.

According to Hall, "The word 'culture' is used to refer to whatever is distinctive about the way of life of a people, community, nation or social group . . . Alternatively, the word can be used to describe the shared values of a group or of a society." Basically, *culture* speaks to the ways we construct a relationship with the world around us. Material culture takes it one step further in its quest to excavate the space between us, the objects we make, trade, collect, and leave behind in the world we live in. What's the reciprocal relationship between these entities—us, our things/objects, and our world? Material culture studies explore this intersection.

ON COLLECTING

For a long time, I was reluctant to call myself "A Collector." (Note the capital A and C here.) I'd always felt that there was something self-serving, pretentious, ego-centered, and even gluttonous about collectors. I was an artsy child of the '90s, who grew up in New York City frequenting museums and cultural institutions, both of which regularly invoked the language of private collections and art collectors. It was intimidating and, as I grew up, I easily discerned the connection between collecting and wealth, collecting and resources (be it physical space, intellectual prowess, access to individuals and institutional entities), collecting and cachet, and, finally, collecting and whiteness. As a young person, I didn't know any collectors personally, and in my Black interior world, I thought collectors must have been white. My younger brother Jamere had an extensive collection of diecast toy cars in their

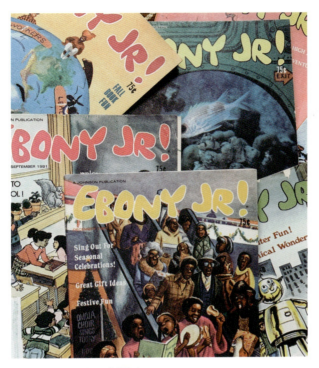

Ebony Jr. magazines (1970s)

most adult collectors began the practice as a child and shared similar underlying motivations. The Association for Consumer Research completed a study in 1996 about this very topic and they found that "children are motivated to collect because they enjoy the process of collecting as it allows them to escape boredom and sometimes reality, learn or satisfy curiosity about their collecting domain . . . want to differentiate themselves from others, and desire to associate with others, especially family and friends."

As I reflect on my own journey collecting as a little girl, the motivations above resonate deeply. While some of the motivations remained the roots of my personal practice as I aged, they're now part of a much more complex web of desires and values. This adult is motivated by different things as the collection has evolved from contemporary Barbie dolls to Bayard Rustin ephemera.

This chapter explores Black folks' relationship to collecting, archiving, and recordkeeping rituals to situate "collecting" as a democratized, accessible continuum, on which we have always been. For those of

original boxes, which lined the walls and shelves of the bedroom we shared. I remember his collection of stamps and rocks (excuse me, "gemstones") also being meticulously placed along the shelves adjacent to my bunk bed ladder. He also collected currency—from Sacagawea dollar coins and $2 bills to coins from all fifty states. I, on the other hand, collected Black special edition Barbie dolls and kept them in their original boxes, unopened and untouched. Then, there was the collection of Lil' Bow Wow memorabilia and ephemera. I had Bow Wow T-shirts, bandanas, books, magazines, poems (I had feelings!), and posters—all of which were taped, pinned, and tacked to my bedroom walls from floor to ceiling, like wallpaper. I also had a small and seasonal collection of seashells and stones I'd found on the beach during summer trips to Jones and Rockaway Beaches or vacations. Collecting a handful of shells on beach vacations is a ritual of appreciation I continue to this day. Jannah was also a diligent, young collector, holding on to her screen-printed travel T-shirts, currency (bills and coins), and video games. In our anecdotal experience and research, we've found that

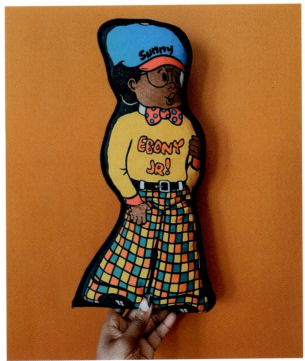

Vintage "Sunny" *Ebony Jr.* doll (1970s)

us who don't consider ourselves archivists, collectors, or record-keepers, this chapter hopefully characterizes our multitudinous relationship with the materials of our lives—our things—while, contributing to the cultural conversation about how and why we reclaim said things. I started with my younger self because I know and understand my own relationship to objects and materials best. And because my memory and my body are my own living, breathing archive. While I didn't identify as a collector, despite collecting throughout my life, I've always been fantastically curious about people's relationship to different objects. Founding BLK MKT Vintage with Jannah in 2014 represented the convergence of our interests, as discussed in chapter 2, but also a complete embrace of our fascination with Black folks and Black things. Codifying our business and thinking through the kind of business and cultural institution/space we wanted to build together, we've found countless ways to center our own curiosity about how and why Black folks collect.

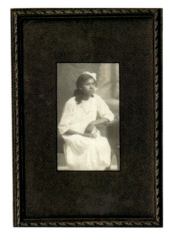

Today, we call ourselves collectors, among many other titles. Our work has forced us to examine the ways we internalize and express a single definition of collecting, all while dismantling the very elitism and anti-Blackness that underpins many of our collective understandings. We also call ourselves stewards, entrepreneurs, cultural workers, curators, vintage enthusiasts, and so much more. Language matters and so do the practices, beliefs, rituals, and behaviors that substantiate, even bolster, the language we use. How do you define *collecting*? As we talk about collecting as a process and collectors as individuals, who and what do you see? Where are the lines between collecting and amassing, collecting and hoarding? Are these actions and processes synonymous? What motivates Black folks to collect, and why? These are some of the questions we've been asking ourselves since before our business was formalized and we've set out to explore the answers in this chapter, alone, with each other, and in conversation with a curated rolodex of Black folks who have their own, unique relationships to cultural ephemera and vintage materials.

For us, *collecting* can be defined as "the meticulous selection and amassing of objects, materials, and goods to meet a need or substantiate a belief or value system." Black folks collect objects and materials for many different reasons. While characterizing the relationships between us and our things, we've been mindful of the roles that generalizations can play, as well as how easy it is to speak on behalf of the collective. Those of us whose work involves exploring and explaining human behavioral patterns often rely on generalizing/grouping in order to make sense of all the data that constitutes those behavioral patterns. We humans singularize and universalize often. Think about the term the *Black community*. There are so many communities that make up the Black diasporic community, yet singular language is often a go-to for its accessibility, establishing of continuity between individuals with shared experience, and sometimes for its avoidance/rejection of nuance. We've done so for the first two reasons. We understand that each of our relationships to people, things, memories, etc. are vast, abundant, and disparate. Black folks aren't a monolith, yet there are some throughlines in our conversations with Black folks about the why, how, and values that undergird their relationship to their things. We're interested in how those throughlines came to be and liken them to the popular sentiment on social media "Why are we like this?" about common reactions, trauma responses, interior

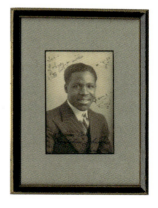

aesthetics, language like AAVE (African American Vernacular English), and so much more. So—*why are we like this, y'all?*

While conducting research for this book, we interviewed countless folks about their collections, their relationships to collecting/archiving, their ritualized processes, and their motivations. It was fascinating to expand a conversation we often have with each other to reach more folks in various lines of work and with different interests. As much as we love talking about our work and our approach with one another, it sometimes feels like an echo chamber. Despite our differences, we are most definitely preaching to the choir.

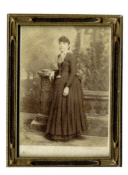

Rather, we're an ensemble and are thrilled to introduce you to new voices in this chapter. We ensured that our rolodex of interviewees was diverse in age, sexuality, geographical location, socioeconomic status, gender expression, and profession in order to present a sampling that is representative of our community. As stated above, we're certainly not a monolith. However, there are three common motivations we've identified across our Collecting While Black sampling, and anecdotally in our conversations over the years with Black folks who collect various objects and materials.

Preservation. Black collectors preserve materials/objects as a counter to ubiquitous, structural marginalization and erasure. We amass collections as vindicating evidence of our robust existence.

Counternarratives. Black folks build collections to demonstrate our investment in specific subject matter. We see the value (financial, cultural, intellectual, etc.) of a well-rounded collection and embark on the journey to create generational wealth for those who will come after us.

Value. Many Black folks see their collecting practice as akin to an archival practice, in the motivation to ensure that people, moments, and cultural work important to us live on forever.

PRESERVATION: GIVING ONE ANOTHER LIFE

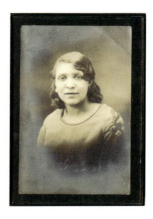

In chopping it up about personal collections, we were touched by how much of our conversation was rooted and grounded in intention for familial, ancestral, and spiritual connection and preservation. For the majority of the folks we spoke to, collecting and archiving practices were as much about preserving the spirit and legacy of objects, people, and defining, formative moments, as they were about the specific materiality of the object. We know that Black folks are a deeply spiritual people, raised by guardians, parents, elders, and community members who were reared with a specific communal, interdependent responsibility and sense of belonging to one another. It's embedded in the closing quote from our introductory chapter—Gwendolyn Brooks's "We are each other's magnitude and bond," which echoes throughout our exchanges about material ephemera. I hold that particular Gwendolyn Brooks quote like a meditation. As if it were, in and of itself, an ephemeral material. And, in a way, it absolutely is. We like to believe that words live forever. Certainly, published words live infinitely. But widespread cultural amnesia, book banning, and other coordinated efforts to erase our very existence

Found antique framed photographs

demonstrate the importance of retelling, speaking the names, words, and histories of our ancestors as a duty. This is how many Black collectors feel about the spiritual work of preserving and ensuring the livelihood of material ephemera. In many ways, we are keeping one another alive and in the face of ubiquitous, intergenerational, repeated, coordinated, state-sanctioned violence, it's a heavy, yet necessary responsibility.

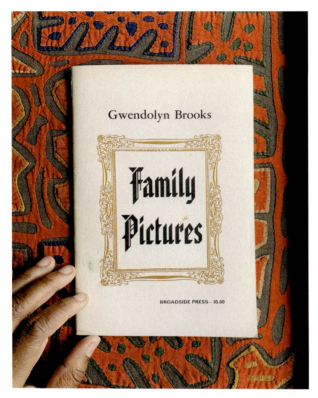

Paperback edition of *Family Pictures*, by Gwendolyn Brooks (1970)

We talked to Syreeta Gates, founder of the Gates Preserve, who was born, raised, and still resides in Queens, New York. She's an OG customer/client-turned-friend and has been rocking with us since 2015 or 2016, shortly after we founded our business. The Gates Preserve specializes in hip-hop and other music ephemera and the archive consists of over 100,000 materials, including a first-edition copy of Zora Neale Hurston's *Their Eyes Were Watching God* in the original dust jacket (1942), a complete run (every single issue) of the *The Source*, *VIBE*, *XXL*, and *Ego Trip* magazines, 1990s Versace silk shirts, Moncler jackets, Coogie sweaters, and a collection of press photos from *Love Jones*, *Do the Right Thing*, *Love and Basketball*, and so much more.

During our two-hour conversation, Syreeta talked emphatically about her late grandmother Jessie Mae Jones Doherty and her spirit, her hustle, her jiggy persona, her Pink Cadillac, her influence, and her voice. We talked about how Jessie Mae was pivotal in Syreeta's foray into archival practices because she wanted to immortalize her and her legacy in the most intentional ways.

What I'm clear of is that my entry to preserving the culture stems from my grandmother, Jessie Mae Jones Doherty. She passed away three days after my twenty-first birthday, and so from there I've been figuring out how I can chase her in the ancestor realm . . . I feel like once she passed away, I didn't have enough information. And I knew all of these stories—right—like, I knew the stories. Aunt Jessie at three in the morning. In Brownsville. Fur, mink coat on. Diamonds on every finger, shooting dice cause her car broke down in the projects. I'm sure this had to be 1970s, 1980s. That shit was not safe ever, but to be a Black woman of a certain age in that space, wow. I fuck with my grandmother heavy, so when she passed away I started the journey of trying to find more information about her. I went back to college 'cause she was a sharecropper-turned-scholar. So, I'm like—my grandma could go get her master's degree with three ass kids and a whole ass husband. Syreeta Gates has zero excuses. I'm wilding. I was like, I want to figure out how I can ensure that this nigga lasts forever. Ever and ever and ever. She was an ill motherfucka, a bad mamma jamma, right? . . . We played that at her funeral 'cause that was her favorite song. Preserving her memory was my entrance into archiving and preserving the culture via a personal collection.

COUNTERNARRATIVES:
AIN'T NOBODY HERE BUT US CHICKENS

Carla Williams is a writer, editor, collector, archivist, photographer, and entrepreneur from California, currently living in New Orleans. We were introduced to Carla's work via the digital presence of her shop called Material Life, which specialized in Black housewares,

artist editions, commissioned work, and vintage popular culture ephemera. As two young and budding business owners in NYC, we were enamored by Carla's work in New Orleans. It was one of the first independent brick-and-mortars that focused exclusively on Black material culture—vintage and contemporary. It was absolutely a possibility model for us in the early stages of BLK MKT Vintage. Material Life is now closed, but Carla has found other means to continue her work in service of archives, the preservation of Black stories, and acquiring collections of photographic Black life. We covered so much ground in our conversation with Carla—from the ways her collection has expanded and changed over the years to the obligation she holds as a Black and queer person to be a "keeper of things," both in her family and out in the world. Carla shared a bit about the ways marginalized people can be further marginalized and invisibilized in collections/archives and the importance of curating a collection as a record of our existence, a form of visual history.

Promotional poster for "She's a Bad Mama Jama (She's Built, She's Stacked)," single by Carl Carlton (1981)

Yes—I totally feel an obligation in my family, because no one else has an interest in being the keeper of these images, and that kills me. I cannot get the younger generation really interested. I keep preserving and holding on to these materials, thinking . . . well, it's here. Like, it'll all be someone else's job when I go, but I'm doing my part. And being a queer woman, too—for years we were told that we didn't have any visual history. Like it was taboo. We were told, 'There are no pictures of your love. There are no records. You didn't exist' . . . And that was bullshit. I worked very early in my career in the archive. I worked at the Schomburg Center for Research in Black Culture and . . . was sort of always drawn to nudes and subject matter that was labeled as taboo . . . I took over for Deborah Willis when she left to go to the Smithsonian. So, I was the curator of the Photographs and Prints Division and, prior to her departure, she shared with me a common trend about collections that she'd encountered over the years. For images that included private or sensitive images of subjects, one of two things would happen. The

images would be stolen or some librarian would systematically remove them from the archive. Think about all those parts of our history that were removed from this trusted archive. That always stuck with me because I thought, 'The fuck?' It doesn't surprise me because of human nature, but the sadness of it, like the limitations. Like why would you want to assume that Black people don't have all of that in their lives as well as any other subject? And why would you rob someone else of knowing the fullness of our story? . . . It's our full humanity.

So, for example—one of the collections I have that I'm super excited about and hope to publish over time belongs to jazz musician Louis Jordan and his third wife, I believe. He photographed her everywhere topless,

Material culture explores objects and their

Vintage hair tools

Vintage Dutch cocoa tin (1950s)

Vintage Exa film camera

Vintage Stokely Carmichael pinback

Vintage Martin Luther King Jr. pinback

ELAINE BROWN
Vintage pin

Oxtail soup recipe mug

Vintage baby powder bottle

Brownn Sugarr
Powder
Net wt. 4 oz. (112 g)

Crocodile head taxidermy, New Orleans

Vintage pin

Hand-painted NAACP parade float sign

relationship to people and cultures.

Vintage anti-Vietnam pinback

Free Angela Davis fundraising sticker (1970s)

FREE ANGELA DAVIS AND ALL POLITICAL PRISONERS

Vintage "peace Brother" patch

NAME Duwayne Gibson , Scruggs 4 BOOK NO. 22 PAGE NO.
ALIAS Duwayne Gibson

AGE 26 HEIGHT 5 FT 11½ IN. PHOTO NO. 60543
ARRESTED not given
CRIME Prost. & FAG
RESIDENCE 2311 E.30th St., Cleveland, O.
REMARKS

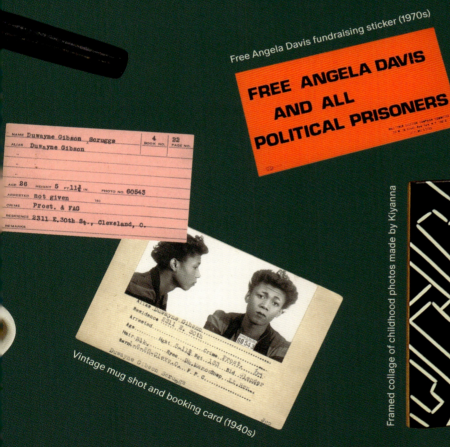

Vintage mug shot and booking card (1940s)

Framed collage of childhood photos made by Kiyanna

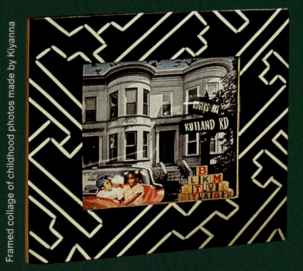

OVER 66 YEARS of SERVICE

everywhere they went. Sometimes, she was fully nude and in some of the photos, he's photographed with her. She passed away in the early 2000s and was living in Las Vegas. Her estate eventually got liquidated and the liquidator was selling the collection of photographs on eBay. I bought as many as I possibly could, and it's such an amazing record of their intimacy and their relationship. As she ages into her senior years, he's still photographing her. There were even some small-format laminated photos, which I'm convinced he must have taken on tour with him—like, slipped in his pocket since they're about this big. Why else would you laminate a few of the duplicate images? It's just to have them with you . . . Every time I look at this collection of photos, I think, had this been in a public archive, it might be gone. It might have disappeared . . . I feel a total responsibility, and only because I have the privilege of having access to these materials.

This thread was woven throughout several of our interviews with Black collectors and stewards who were grappling with notions of invisibility and their agency. Folks often assume that, because something isn't visible and isn't accessible, it doesn't exist. Black folks like us, who collect material culture understand that that is a false equivalence and create collections we love as a testament to our expansive existence. In a world committed to rendering Black people silent, invisible, and dehumanized, it's a profound responsibility and joy to hold the evidence of our fullness in our homes, institutions, and family archives. In the words of bell hooks, we may "live on the margins," but we're living and thriving, nonetheless.

ON VALUE: SOLANGE SAID, "BE THE GOLD YOU WANNA HOLD, MY G'S"

The final motivation we see as a common thread among Black folks who collect objects and materials is about investment, value systems, and creating generational wealth for those who come after and with us. When

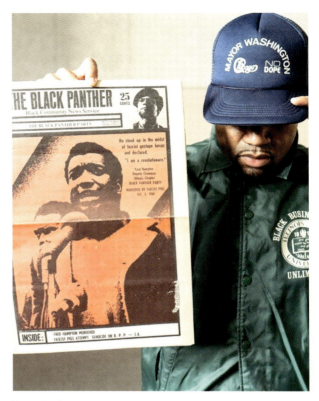

Dwamina Drew with *Black Panther Newspaper*, purchased from BLK MKT Vintage

we talk about generational wealth here, think back to the value systems we explained in previous chapters. Financial/monetary is only one form of wealth and investment. The others are just as important (depending on the collector) and can impact collection-building decisions and practices. Another collector we spoke with in our research was longtime customer/client, designer, creative, and Chicago native Dwamina Drew. He's the founder of the Enstrumental brand, also based in Chicago, and has been collecting Black art and cultural ephemera since 2009–2010. His motivations are clear:

I think it's an exciting time to be a Black collector right now. Thinking back to the Black Arts Movement in places like Chicago, Oakland, and New York City, there was a strong desire to articulate a Black aesthetic, put our lived experiences in the works,

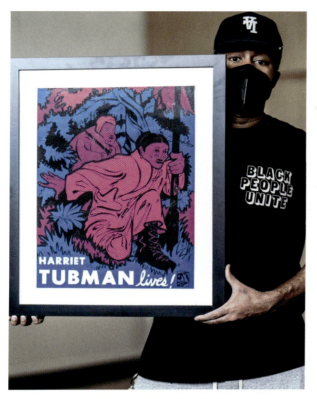

Dwamina Drew with Harriet Tubman Black Workers Congress poster, purchased from BLK MKT Vintage

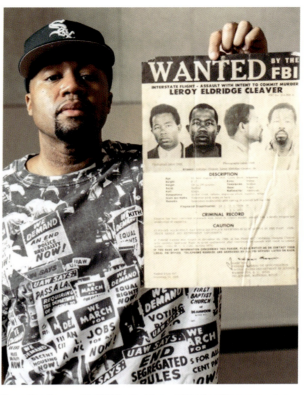

Dwamina Drew with FBI Wanted Leroy Eldridge Cleaver poster, purchased from BLK MKT Vintage

and communicate unapologetically to the world. Respectfully, I'm not sure how much thought and intention went into collecting and archiving the works of the time. Like, 'Hey—not only are we creating this material, but we're collecting, keeping, and preserving this material, too.' But, I really want to see that conversation and intentionality continue through the present and future. We have an abundance of 'creators' of the culture; however, we don't have an abundance of 'owners' of the culture. We need to reclaim more of our things. It's not necessarily a 'cool' conversation to have, but an important one, nonetheless. It's kind of like talking about life insurance. We should invest in the collecting and preserving of materials (in my case, art and ephemera) because we see value in it . . . I didn't have any art passed

down to me. No one told me, 'You should collect this' or 'You should collect that.' I know plenty of collectors who've inherited things from family members and I think that's great. I know that the legacy starts with me, so I'm collecting with the hopes that if I have a kid, I can pass that down to them, or to my niece or nephew. I'm trying to show them all different types of value a collection can hold. There was a time I was begging Black folks around me to collect work, and I'm talking about individuals whose work is now priced at $40K, $50K. Back then, the work was going for $1,000 or $1,200, but something has shifted in our consciousness when it comes to the value of Black art/ephemera from a cultural and economic standpoint. So, I think we are doing our part to carry that intention forward.

COLLECTING

Now that we understand some of the motivations,
we wanna see the goods.

WHILE BLACK:

Where they at?

A SERIES

Megan Dorsey

OWNER AND SHOPKEEPER,
EVERTHINE ANTIQUES

176

Steven D. Booth

ARCHIVE MANAGER, JOHNSON PUBLISHING ARCHIVE,
AND CO-FOUNDER OF THE BLACKIVISTS

179

Carla Williams

OWNER OF MATERIAL LIFE AND HOUSE
OF BLACK STYLE

183

Renata Cherlise

MEMORY WORKER AND FOUNDER,
BLACK ARCHIVES

188

Matthew Jones

ARCHIVIST, SOUL PUBLICATIONS

192

Syreeta Gates

COLLECTOR, ARCHIVIST, AND
CULTURAL WORKER

196

INTERVIEW WITH

Megan Dorsey

Racine, Wisconsin
Owner and Shopkeeper,
Everthine Antiques

BLK MKT VINTAGE: Tell me a little about how you describe yourself and your work with Everthine Antiques?

MEGAN DORSEY: I describe myself as a collector and dealer who retrieves and reclaims Black antiques and ephemera. So, there's—of course—the dealer and commerce side. That's how I make my money. It's also my passion but, other than that, I'm actively building a collection that is focused on Black ephemera, particularly photos, but also ads, trade cards, letters, and stuff like that.

BMV: How did you come to the vintage industry?

MD: I'm from the South Side of Chicago and I have so many memories visiting my grandmother. Y'all probably know what they look like because they're so dominant in Chicago and New York. Those historic, stately brownstone homes. They're really gorgeous, and she lived in one of those. Every time I visited . . . the wood really captivated me. Doors were so heavy and ornate. Her home just had such a presence. I noticed it even as a young person. She also had closets full of

costume jewelry, big hats. Just a world of things, and I loved going through her closet . . . She had a lot of jewelry, pocket watches, trinkets, and she would always let me bring one thing home with me. That was the start of my curiosity about material items and ultimately, collecting.

BMV: What is collecting for you?

MD: Collecting is a way to time-travel to the past and experience history through material goods. There's nothing like seeing and feeling the ephemera and the items. I romanticize objects from the past...but I also find it very unsettling and sad because I have to constantly confront and reconcile—in the industry—our history as Black Americans. I love collecting material culture because it's a more accurate and tangible way to look back at our history. There's a lot of propaganda historically, but when you hold a photo in your hand of a Black business owner from the 1930s, it just hits different.

BMV: How do you take care of the items that you've collected over the years?

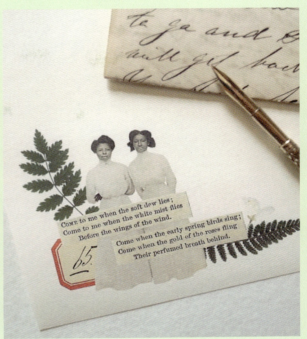

Everthine Antiques stationery, reimagined by Megan Dorsey

Everthine Antiques stationery, reimagined by Megan Dorsey

MD: I like the world to see my things, and I like to see them throughout the house. A lot of images in my collection are tucked into the frame of my mirrors. I like to have vintage magazines sitting on my tables for guests to read. Some of them are framed for preservation and put into a gallery wall. Some, I even keep with me just to look at just as a reminder . . . I recognize that my collection being out and about—livable—isn't technically the best way of taking care of them, but I just love seeing them and living amongst my things.

BMV: Do you have a favorite item in your collection? Anything you hold sentimental?

MD: So, I found a Black Victorian-era photo album at an auction online. This is back when I was teaching and not making a lot of money. We know how costly it can be to buy back our own stuff. Black material culture is not cheap, especially as the materials get older and more rare. This album was actually one of my holy grail finds. As I was bidding, it was a weird experience because I was present to the reality that that, too, was how Africans were bought, sold, and ultimately

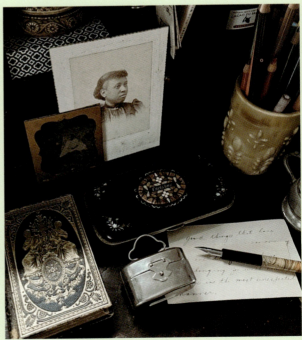

Megan Dorsey's desk

enslaved. I felt oddly complicit in the buying and selling of people. Something clicked amidst all that, and I was like, "This is mine and I need it." As the price was going up and I was starting to get angry, I assumed it was probably a white person trying to purchase. Then, I was like, "I don't have any money for this. What am I going to do?" But I kept bidding up and I won it. I won't say I paid too much for it, but I will say that I did not, by any means, have the money to buy it. I don't regret it, though. It was full of cabinet cards and tintypes. I looked at it when I first got it in the mail and I kept it in a really safe place. It's weird, but I didn't open it for almost like a year. I almost felt like I didn't deserve to. Recently, I went through it again, and it's truly a sacred piece of history.

BMV: How do you see valuation as a Black dealer and collector?

MD: It's really hard. I just buy what I love, even if it's more contemporary and more common—like a '70s *Jet* magazine. I still buy them. People think that age means everything. I buy stuff from the '80s, even the '90s, because I see the value in some of those materials . . . I think the notion of valuation is annoying, particularly for my niche and interests. It tends to be based on rarity—which, think about the social conditions across generations that made it so that these objects are hard to find, determine provenance, cross-reference, etc. I do buy from white folks and have to deal with their sense of price, value, and cost. That brings an additional element of frustration into the process because, historically, they are part of why these materials were displaced, stolen, burned, lost, etc. in the very first place . . . I wrestle with this often. A lot of Black antiquities are priceless to me and sentimental value is just as important and persuasive as monetary value.

BMV: Lastly, do you have any advice or thoughts for non-Black people who collect Black cultural ephemera?

MD: I've thought a lot about this. I think it's important for non-Black collectors and dealers to remember that objects they collect mean something completely different to Black folks. Sometimes, I come across antique Nazi memorabilia. While my first thought is "Wow, this is insane and I can't believe I found this," I also recognize that it likely means something different to a Jewish or German person. Context means so much. The context of your own identity and the context of our objects. For non-Black dealers and shop owners, be more mindful of how you name your items. I've seen some wildly offensive descriptions at antiques shops and in online auctions. I know there's argument about whether non-Black people should be selling these items at all. I say yes because I want to be able to buy them. I just want those folks to conduct their business with more sensitivity and respect. I want as much of our material history out in the world, accessible, so we can learn from it. We've all heard the saying about what happens when you don't know where you come from, right?

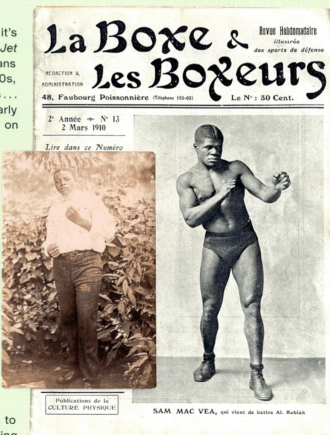

Boxing ephemera, from the collection of Megan Dorsey

INTERVIEW WITH

Steven D. Booth

Chicago, Illinois
Archive Manager, Johnson Publishing Archive
& Co-founder of the Blackivists

BLK MKT VINTAGE: Can you please tell us about yourself, Steven?

STEVEN BOOTH: My name is Steven De'Juan Booth, and my pronouns are he/him. I am a native Chicagoan, born and raised in Humboldt Park. I've been a professional archivist, pretty much all my life, but my background is in performing arts. I was a choir kid growing up and I attended Morehouse College, where I majored in music.

BMV: How did you come to your work?

SB: I'm a second-generation archivist. It was only after I went to library school that my mother revealed to me that she had worked in an archive for a health insurance company. So it's in my blood, if you will. During my senior year at Morehouse, I knew I didn't want to pursue a career as a performer. A professor of mine suggested that I go to library school. I've always been interested in libraries and books and history. I just didn't know that there was an actual career path for it.

BMV: Can you tell us about your work with the Johnson Publishing Company archive?

SB: I'm part of a team at the Getty Research Institute that manages the publishing history of Johnson Publishing Company from when they were founded in 1942 up until maybe 2014, I'll say. The collection consists of about 2.6 million photographic items, which we are estimating will be more like 4.5 million images once the archive is fully digitized. In addition, we also have about ten thousand audio and video recordings from their television shows, award segments, and radio broadcasts.

We also have a full run of all the magazines. The most notable, of course, *Ebony* and *Jet*, but there's also *Negro Digest*, *Hue*, *Tan*, *Tan Confessions*, *Copper Romance*, *Beauty Salon*, *Black World*, *Black Stars*, *Ebony Man*, *Ebony Jr.*, *Ebony Africa*, and *Ebony South Africa*. I was reading Mr. Johnson's memoir, and what stood out the most was that he was very adamant about the "rainbow of Blackness." So that's how he came up with these titles like jet, ebony, tan. You know, colors that represented Black people in our shades. Right now it is closed to the public, because there is work to be done.

This is a seven-year project and, as we rehouse the materials and catalog them here in Chicago, they will be digitized. Then, the materials will be permanently stored at NMAAHC [National Museum of African American History and Culture, also known as the Blacksonian] in DC, and the content will be made accessible via a designated online platform.

BMV: What importance does the JPC archive hold for collective memory?

SB: I think what the collection does is it shows the vastness of the Black experience. Mr. Johnson and the staff covered all types of topics related to us. From LGBT rights to civil rights to various industries. We've done it all, and JPC is the evidence to show that.

BMV: Do you have a favorite item in the archive?

SB: Well, I don't have a favorite yet, but I'll tell you what's been the most surprising to come across is a head X-ray of Muhammad Ali. Why it's in the collection I don't know.

BMV: Something that has always stood out to us as Black queer women is that Johnson did publish coverage about the LGBTQ+ community, but the language and framing was sensationalized. How do you rectify visibility and simultaneous stigmatization?

SB: It's a double-edged sword. Mr. Johnson sent photographers to these drag balls in New York and Chicago. We have folders of thousands of photographs from these events. You're absolutely right in everything that you said, but I think the fact that there was some intentionality there means a lot. I'm saying this as a queer person, too. It gives me a sense of calm and a hunch there was a level of respect there that he had for queer people.

BMV: Do you collect, yourself?

SB: I do collect. Having been a choir kid, going to Morehouse, and being part of Glee Club, I've acquired a collection of HBCU choir vinyl recordings. I started acquiring when I was at Morehouse and the vinyl collection grew. My favorite choir of all time is Morris Brown.

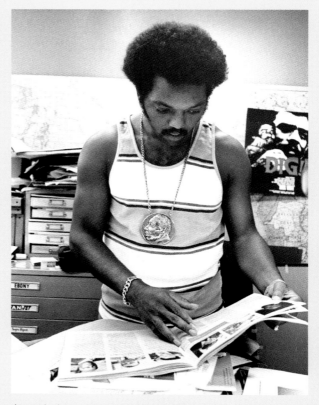

Jesse Jackson visiting Johnson Publishing Company archives, J. Paul Getty Trust and Smithsonian National Museum of African American History and Culture (1971)

I think everybody is an active collector, though. They might not see themselves as such, but everybody is collecting something.

BMV: You know that Black folks—our elders and ancestors—have archived, preserved, and collected, but didn't necessarily have the same language as we do. So how have we devised, created, and passed on archival and preservation practices and rituals?

SB: I think in every Black family, there's an archivist. Someone who has been designated by an elder, or someone who's just taken on the responsibility of being a person to keep all the photographs, keep Grandma's recipe book, and the family Bible. I think these are all examples of the ways that we've preserved materials. Also, oral history traditions like telling stories and

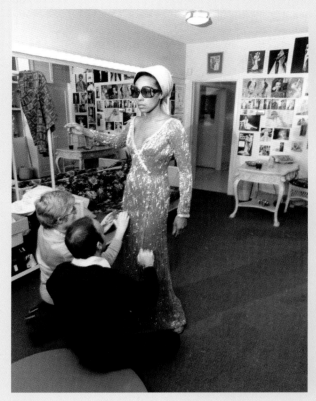

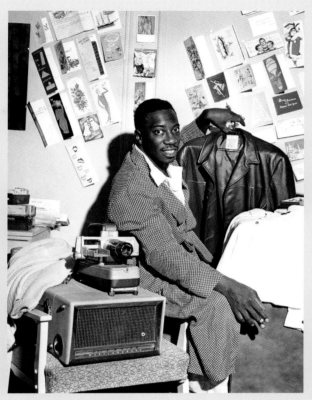

Noted designers Ray Aghayan and Bob Mackie make adjustments to Diahann Carroll's cape and dress for the Academy Awards, J. Paul Getty Trust and Smithsonian National Museum of African American History and Culture (1975)

Joe Williams selects his outfit for a night on the town, J. Paul Getty Trust and Smithsonian National Museum of African American History and Culture (1958)

singing songs over and over again. That's a form of preservation that I think many of us have experienced in our own families. There's a misconception that archives are just a collection of material. But the crux of archives is preservation so that items live in perpetuity and are accessible. Without preservation, do you really have an archive? Some might say yes. But I would say no.

BMV: Let's stay on access. Sometimes we witness tension between institutions and individual collectors, where private collections are made out to be "black holes" where materials will never be seen again by the public eye.

SB: I think you are right. I think it's also how people and institutions approach one another. Institutions must change how they approach personal collectors. I think

for personal collectors there must be an understanding that just because an institution has materials, it doesn't always mean that they are always well resourced and well funded. Oftentimes, archival programs within institutions are the least-funded and resourced department. So, I think we have to find a better way of assisting one another to uphold access.

BMV: Are there ethical implications or issues that you think Black collectors, Black dealers, collectors of Black material culture, regardless of how they identify, should be mindful of when building a collection or archive?

SB: Yeah. You know, I think for me the biggest ethical issue is access. I fully support community archives, documentation projects, private collectors, and all that. It's all necessary and very important. But is it

accessible? And by access, I mean not just to you and your homies. What's the purpose of what you're doing? Is it just for you or is it for the community? Is it for the culture? I think access is so key.

BMV: What does your experience managing such a vast and important collection reveal to you about the Black imagination?

SB: We literally are dope and there's nothing that we cannot do. I can't wait for folks to really dig into this collection. I think it's going to spark so much creativity, ingenuity, and innovation that we haven't seen before. At least that's my hope that somebody will come across something on the website and it just unlocks

something for the greater good of Black people and the Black experience.

BMV: Anything you wanted to talk about that we didn't get to?

SB: Yes, because this will be a book and I think it'll have a huge reach. So, I'll just say this—especially for my Black people. Social media is not an archive. These apps are proprietary software, owned by a company and more than likely a person, right? And if it goes down tomorrow . . . everything that you put up there is gone. And so, while your online archive is very important, I would encourage folks to make sure that they're also preserving content outside of these platforms.

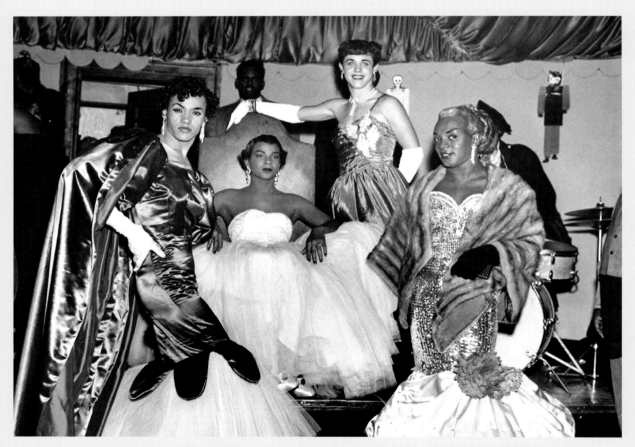

Female impersonators participate in the annual Funmakers Ball; the ball would attract crowds of over two thousand and was held in major cities such as New York and Chicago. J. Paul Getty Trust and Smithsonian National Museum of African American History and Culture (1950s and 1960s)

INTERVIEW WITH

Carla Williams

New Orleans, Louisiana
Owner of Material Life and House
of Black Style

BLK MKT VINTAGE: Carla, can you start by telling us a little bit about how you describe yourself, your pronouns, and your work?

CARLA WILLIAMS: I describe myself as a writer, editor, archivist, and photographer—although I'm having to reintroduce that last one into my vocabulary. My pronouns are she/her. I'm from California, but in terms of my familial roots, my mom is from New Orleans, which is what brought me here. New Orleans feels very much like an ancestral place.

BMV: Wow. Okay. So how did you arrive at or come to your work? Who led you there—if anyone in particular?

CW: Well, I think I came to it by birth. My father was a collector from a family of thrifters. In fact, one of my great-aunts owned a thrift store and so they were always people who collected things. And so, I think it's partly bred in the bone for me. One of my most vivid memories from childhood is of me going to bed at night and insisting that every object I touched that day was piled on top of me on the bed. If something

fell off, I'd pitch a fit until one of my sisters got up and put it back. It didn't matter what it was—I had to have those things on top of me. I don't do that anymore in a literal sense, but figuratively, I surround myself with the things I collect.

BMV: What does your collection include?

CW: At the moment, I collect in three areas. I collect vintage pinups of Black women, vintage images of Black burlesque dancers, and images and ephemera of Black circus and sideshow performers.

BMV: Why those specific areas?

CW: Well, as a photographer, I always took self-portraits and I was nude in virtually all of them. I just feel a kindred spirit with those women in the labor of posing. For a long time, I didn't know that they existed. Of course, theirs was created as titillation; mine wasn't, but it's virtually the same rendering. From my perspective, it's sort of women projecting a particular image of themselves through their bodies for a camera. It was

me seeking a visual precedent that made me start with the pinups. That lead to burlesque dancers because so many dancers also posed. The circus performers interested me because of the history of human display.

As sideshows became a more popular form of entertainment in the nineteenth and twentieth century, a tradition of Black dancing girls emerged and they were often accompanied by a Black band. Certainly not all of their stories were positive, but I'm really interested in the choices of their labor and also the spectacle of their performance. When you collect, you've got to narrow it down at some point. So, I thought, I'm going to stick with this subject matter. It's not an overwhelming amount of material, but it's enough to keep me constantly going and learning.

BMV: Yes. And you identify as an archivist as well?

CW: Yes.

BMV: Where does archival work fit into your personality, your rituals, your practice, your business? How does it fit into your life?

CW: It actually really fits in at the top. I'm a much better archivist than I was a businessperson and shop owner. Given my love of collecting, I thought it would be much harder to sell items I'd acquired. But, I had the satisfaction of acquiring and felt okay moving on. My impulse to create an archive is, despite all the inherent flaws in an archive, the intention for it to be shared with others as a record of sorts. Material Life was very much an archive and as objects were redistributed, and sold, there was a record

that it existed here, with me. I think that comes out of my academic background. But archives are tricky because, depending on who's administering them and what their intentions are, they can really work for good or ill.

BMV: Something we tasked ourselves with for this very book project was democratizing archival work, collecting and kind of demystifying what it's like to be in relationship with objects of old. Something you mentioned about your role as shopkeeper and archivist makes me think about gatekeeping access and information. Can you talk a little bit more about your work to open the gate for others?

CW: The vintage materials I collected and sold in Material Life were such a great gateway because they were nostalgic for so many people. I could easily start a conversation with Black folks about looking in their own homes. You have some stuff already. And if you don't, ask an elder because they likely do. In doing that assessment, value what you have, what you have lived with, what your family has lived with, what has mattered to you. That's where you start. It shouldn't be someone else telling you "Hey! This is important." It's you looking and thinking, "Well, of course, this is important because this shaped my childhood, my identity, family, etc." I had a lot of customers who just looked and talked. That was such a fun part of the business because I was perfectly happy if they went away not buying anything but instead said, "I'm going to ask my mother where that is." Because then, they were starting to think very differently about the value of their own lives and the material culture that helped them along in their memory.

BMV: Let's talk a bit about non-Black folks who buy, deal in, and collect Black material culture. How does this sit with you?

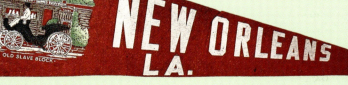

Vintage New Orleans pennant

184

Assortment of Cajun food and beverage books

that because those objects are not representative of our lives. That is their perception of what we do and who we are . . . It's so lazy.

BMV: How do you negotiate different types of value as you traverse this industry as a Black person?

CW: I have a budget. So, if it goes beyond—even if it's something I would love to have—if it's out of my price range, it's just out of my price range. Although, I had a young woman who contacted me recently to share an acquisition. For the longest time, I mean years, there was a photograph listed online for sale of two Black women kissing in a hot-air balloon.

BMV: Yes! In Danville, Illinois.

CW: Yes! It was like $3,500 or something like that. The price was never reduced, so the buyer took a second job to buy it. It's one of the earliest representations of romantic affection between two Black women. It's an outstanding image, and I just commend her commitment to acquisition. There's one photo on eBay that I would do that for today. It's a photograph of Thomas Dilward, a performer whose stage name was Japanese Tommy. He was a Black little person who cross-dressed. There are reproductions of him in a suit, but there's an original

CW: I rarely had non-Black customers buy anything from me that was specifically representational, so I never felt like I had to talk somebody out of something like, "You're going to put that on your wall?" Although, that's my general feeling when it comes to our stuff.

BMV: Give it back.

CW: Right, and you won't be compensated for giving it back. You're just going to have to rely on your conscience for that. This is tangentially related, but a pet peeve of mine—the phrase "Black Americana." That is not our stuff. That is white Americana and every time I see a vendor online selling with that title, I think immediately, "This is yours." I often buy from white people because—the market. The tension sets in immediately. I want them to stop calling it

Antique found photograph of Ringling Brothers and Barnum & Bailey Circus Side Show Band, Brooklyn (1938)

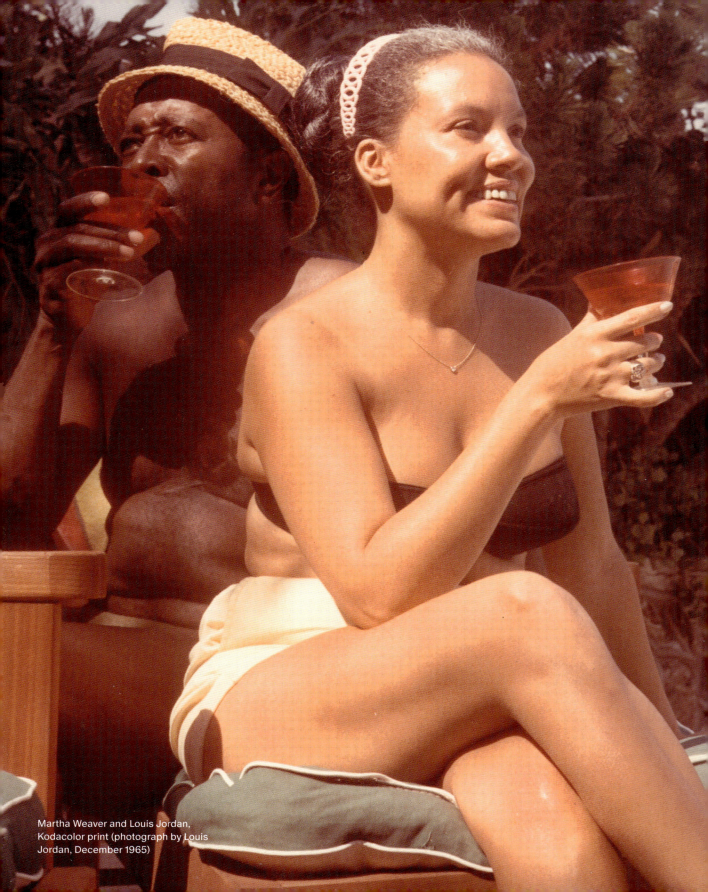

Martha Weaver and Louis Jordan, Kodacolor print (photograph by Louis Jordan, December 1965)

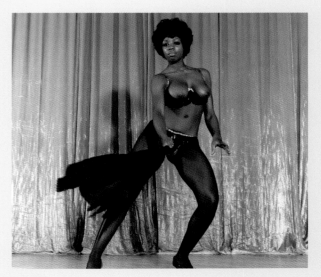

Yvonne Carothers, gelatin silver print (photographer and date unknown)

photograph where he's in a dress. I really want it, but it's $2,400 . . . It's been for sale for years and sometimes, the price is just the price. Sometimes it's flexible; sometimes it's firm. I'm always working toward trying to get the most representative piece in the best condition for the best price—that's ideal. Valuation and budget are really a balancing act, as a seller and a buyer. Both ends.

BMV: Are there any other holy grail pieces that you would love to acquire for your collection?

CW: Yes. Original photographs of LaWanda Page as the Bronze Goddess of Fire when she was a burlesque dancer. Any originals of LaWanda Page in that era. I've gotten a couple of reproductions and I have even acquired a still from the Sanford and Son episode where she performs as the Bronze Goddess. That is my holiest grail. LaWanda Page originals during her burlesque career. Aunt Esther, her character on *Sanford and Son*, was the constant butt of "ugly" jokes, but when she appeared on talk shows she was always so beautiful, regal, and self-possessed—you truly couldn't call her ugly if you tried. I was fascinated by how she embodied elegance, especially in contrast to Esther. When I found out that she had been a burlesque dancer I was done, like, "Okay, this is my queen." I have never seen an original, but I'm determined to find one!

BMV: Do you have any thoughts about what the future of collecting looks like in general, or specifically for your practice and your collection?

CW: For my personal collection, the future looks like continuing to collect in the areas in which I specialize until I have "enough" material. Overall the future for us is to wrest our culture out of the hands of people who'll mishandle it. I think that the future of collecting (more broadly) is demonstrated by the fact that you and your shop exist. When I started Material Life, there wasn't really an equivalent. Now, my work has morphed into something else and y'all still exist. There are multiple places/shops that exist today, where people can go to see vintage and antiquities, buy them, and learn more about them. I think that can only be for the best and I'm very hopeful. I mean, you two are the future. I mean, literally in the work that you do...and finding different ways to discuss and center Black vintage—like writing this book—that is the future.

BMV: And speaking of the future, we're always talking to folks about what tomorrow's vintage will be. What will folks be collecting in the next fifty to a hundred years, particularly in a world that is becoming so much more in the cloud, digital, blockchains, Web3, NFTs, fill in the blank. What gives you hope about evolving technologies, and what also gives you trepidation about it?

CW: Well, the trepidation is easy. It's the loss of material culture. People don't produce tangible things. The internet is the best invention since photography, basically. Technology has democratized access in a way that is unprecedented. But the danger as archivists or artists is overrelying upon technology driven by a commercial market, like photography. It moves so quickly without reflection that, as new technologies are brought on, there's little consideration given to what's lost. In the short term, there will be a couple of generations who are lacking a significant amount of material culture—they never printed anything out, and the software they once used is obsolete. As someone who relies upon these little scraps of paper, it's hard to reconcile that such an enormous archive of culture won't exist. But hopefully someone will figure out a way to retrieve it, though who knows what form that will actually take?

INTERVIEW WITH

Renata Cherlise

Atlanta, Georgia
Memory Worker and Founder,
Black Archives

BLK MKT VINTAGE: Let's jump right on in, Renata. Tell me a bit about how you describe yourself and your work with and for Black Archives.

RENATA CHERLISE: Yes. Well, I'm an artist, memory worker, and now a newly published author. Black Archives was birthed for me through an artist's lens. It's this creative umbrella where I get to engage with archives, you know, through various projects in community, through services, and collaborations. And it's through that that I'm able to sort of tap into the role of memory worker. There, I get to work your memory through time and space, specifically through Black images.

BMV: Mm-hmm. I love that title. How does that title, memory worker, serve you, and where did that come from?

RC: At the family level, I consider myself a family archivist, right? But professionally, I'm not really working with a lot of materials, like physical materials. And I know there are digital archivists. But my approach is that, I'm here to work you through remembering, and

I'm here to sort of, like, hold your hand through these moments. So, memory worker for me feels a little more personal and, yeah, that's how I show up. At a family level, of course, with my family archives, I'm holding on to things. I'm preserving physical copies of photographs, ephemera, and any tangible items. But professionally, I kind of live in this artistic memory working space. I feel like I'm pointing you to the collections. I'm pointing you to the work of archivists who are actively working in different spaces. I'm pointing you to those collections and highlighting their bodies of work that illustrate how Black folks live.

BMV: Yes, and you mentioned not working with a ton of physical materials, but also having tangible physical copies of photos and other family-related ephemera. Does anything resonate with you when you look back to your childhood or young adulthood about your relationship to materials?

RC: Yeah, of course. And I think that's how images came into play for me because the family photo album, like in many families, is sort of like our first entry into our family

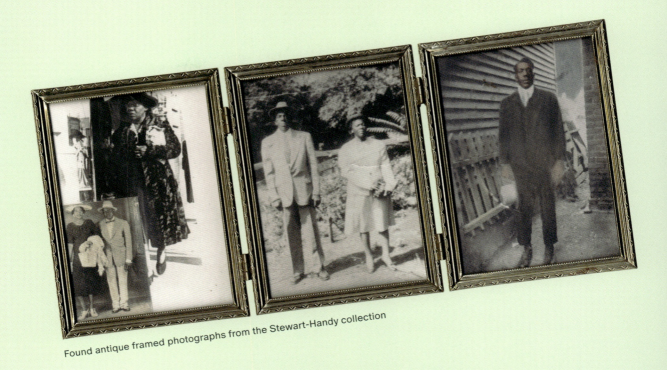

Found antique framed photographs from the Stewart-Handy collection

history, right? And it starts with this tangible thing . . . I think that's one of the things that's so powerful about the work that I do. I, as an adult, get to expound upon those memories of me being really excited and curious as a child. I was actually just thinking about this earlier. I remember the first scrapbook that my grandmother showed me. I was probably somewhere around nine years old. And prior to that, I had always had access to the family photo albums. But one day, I remember her pulling out this other book. And I was just thinking, "What is this?" She sat down with me, opened it, and it had these newspaper clippings. There was a story about Vanessa Williams being stripped of her crown. And I was just like, "Oh my goodness." And I kept those memories with me. She was so intentional about those things—books and records—but I don't know what happened to that book. I wish I had access to it.

BMV: I was about to ask you.

RC: Yeah, I wish I had access. I can't even put it into words. At that time, I was overwhelmed because I thought I knew everything in my grandmother's house,

right? I'm so nosy. And I was like, here she is with this other thing, right? [laughs]

BMV: Yes. Yes. And your family, what do they think about your work? How do they engage with or receive your work? What's that like?

RC: They love it. It's so funny because a few days ago I came across an archive of photographs from St. Augustine, Florida, where my great-grandmother was born in the '20s. We don't have pictures of my family prior to the '60s. And so, I'm always imagining what they looked like when they were younger. And when I came across this archive, I shared it with my older cousin and I shared it with my mom, asking, "Is this Great-Grandma? Could this be her when she was a baby?" And it's like the closest thing that I have. My mom said that the years were a little bit off and this little girl would've been a bit older. In my family, the women have pretty much been the primary ones who have carried the stories and our history. And so, I find it really cool when I can kind of get them engaged in the storytelling to figure out who is who. They'll say,

"Just keep up the good work," and that's really affirming for me.

BMV: That's such a gift. Let's move into a little bit of collecting of ephemera and materials. And as we're talking about materials, in this conversation we can be thinking about digital as well. I'm thinking about your family photo albums, the photos, the archive. Do you identify as a collector at all, and do you have a collection of photographs?

RC: So, that's interesting because I have a collection of prints. But they're more so prints of my peers who are actively making work. I think the intention behind this collection is to create a future archive of people who are doing the work and living, like, during the same time that I'm living. Some of them are framed, some of them are not. But outside of my family photos, no. I don't have a collection of photographs.

BMV: When did you start this collection of print photography?

RC: Maybe around 2012. I was living in Chicago at the time and there was a photographer, Malcolm Jackson, who was documenting my hometown of Jacksonville, Florida. He was always shooting these images, and it reminded me of home at a time when I missed home, right? And so I started purchasing prints to make me feel as close to home as I could. Then, I started buying the prints of other living Black photographers—

folks like Texas Isaiah, Andre Wagner. I bought their print photography, and the collection started there. I don't really consider myself an avid collector, but I am intentional that when I see something, I'll grab a print.

BMV: You talked about this collection of contemporary photography, like folks who are living the same time as you are, documenting in this moment, creating this future archive, etc. Was that intention there in the very beginning, or was it more of an interest or curiosity?

RC: Just a supporting. I wanted to support my peers who were making work. Every now and then they'll have a print sale. And then before you know it, I've collected. The only other things that I really collect are vinyl records . . . I've always loved record stores. So, for a while I was purchasing vinyl records, but I didn't have a record player to play them on.

BMV: That's how we started off our record collection, too. Those records are the gateway! [laughs]

RC: So, one day, I got a record player as a gift, and with that, I became much more intentional. Early on, I was just like, I want a vinyl collection and I'm picking up every vinyl that I can find at the flea market, you know? The intentionality made me curious with myself. What does this record, this thing, mean to me? I also started looking at older photographs of vinyl records, like my family photos where there were vinyl records in the background . . . And I'd try to find those vinyl records and then incorporate them into my collection.

BMV: Mm-hmm. Are there any records, or any photographs in either collection that are particularly sentimental to you?

Vintage Jacksonville, Florida pennant (1940s–1950s)

RC: Yes.

BMV: Can you tell me about one?

RC: Yeah. One time my aunt from Jacksonville came to visit Chicago. We all went to the record store with my mom. And I remember coming across this one vinyl—it was the New Birth's *It's Been a Long Time*. As soon as I saw it, my mom was like, "Oh, I'll take that. Thank you." And I said, "Wait a minute." Then my aunt, who is a couple years older than my mom, pulls, like, the big sister card. And she says, "No, I'LL take that." My mom hands it over to her and, of course, that was the only copy in the record store. So, I lost out. [laughs] Well, my aunt goes back home to Jacksonville a couple of weeks later, and then . . . I wish I didn't pick up the phone, so I'd have a voicemail recording. But she calls me one day and she's got the record spinning in the background. It was so funny because I'm answering and trying to talk to her, but she's not saying anything. She's just playing the song "Wild Flower" from the album. Like, come on, Auntie. Why are you doing this . . . like, we're trolling now? And she was just laughing. She passed away in 2015, and while I don't have that actual record, I think my cousin has it. I did buy a replacement, and anytime I hear that song, I kind of have that memory attached to it.

BMV: Let's shift back to Black Archives. How does the platform and your personal practice benefit the Black collective?

RC: I want to be clear that people have, on a regular basis, reached out to me and told me how much the work I'm doing of curating these collections and making them . . . accessible is inspiring them to do things with their family photos and inspiring them to think about their photography if they are a photographer. What I find so cool about our community is that it's made up of so many different people. You have your filmmakers, documentary makers, your visual artists, producers, and I think they lean into Black Archives—at least from our Instagram account—as a source of inspiration. It's profound.

Then, you have your contemporary photographers who are thinking about the future of their archives and the possibility of there being a Black Archives component in the future that will find and exhibit their photos. I think many of them are considering the kind of intention they need to embody now in order to have a legible archive in the future. Also, I think about people who don't really have a professional relationship to Black Archives, image-making, or the arts, but just really love engaging with photographs. That's one of the strengths about cultivating community, where there's a shared interest in learning more about the Black experience.

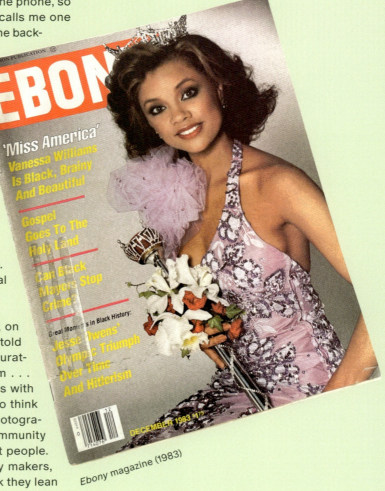

Ebony magazine (1983)

INTERVIEW WITH

Matthew Jones

Los Angeles, CA
Archivist, SOUL Publications

BMV: We've been waiting to connect with you for a minute, Matt! Let's jump on in. Tell us a little about yourself.

MJ: My name is Matt Jones. I am the grandson of Ken and Regina Jones who were the publishers of *SOUL*, a Black music and entertainment [magazine] that was published from 1966 to 1982. I'm a Los Angeles native, third generation. My grandparents and parents are from here. Before that Texas and Louisiana. I went to school at UC Santa Cruz and ended up getting a degree in American studies, so a lot of what I'm doing with the publication now is pretty directly linked to the stuff that I was learning in my undergrad career.

BMV: And let's jump right into how you acquired the *SOUL Newspaper* archive.

MJ: For reference, I was born in 1983 and SOUL ceased publication in 1982. The long and short of how the SOUL Publications came into my possession is that the publication kind of disappeared—in part, because the people who had a lot of the archives at the time were holding on to them. It really was a treasure trove of information and didn't resurface until 2002 when my grandmother was asked to do an interview on Michael Jackson for *VIBE* magazine. One of our family friends went to the person who was holding on to all this stuff and requested it all be returned. So my grandmother got the archive, prepared for the interview, did the article, and it was published. Fast-forward six years to 2008, I moved back to Los Angeles and my grandmother asked me to clean out her garage and discard a bunch of stuff that was in there. There were stacks and stacks of the newspapers and photographs—and [she] wanted it all gone. Here I am coming from Santa Cruz with this American studies background and I'm witnessing this archive in its fullness for the first time. I convinced her to sift through it and pick out some of the better material that survived the garage. Fortunately, most of the damage happened at the top and the bottom. We ended up preserving the issues in the middle. We initially made a donation to UCLA that included a near full run of the publication, as well as some images and negatives. There was still an incredible amount of material left, and so I sat on it. It got to the point where I started feeling frustrated

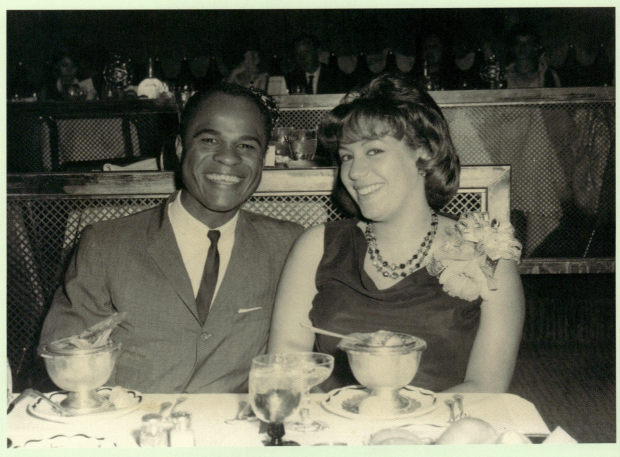

Ken and Regina Jones, founders of SOUL Publications

about the lack of awareness about *SOUL* and I felt like more folks needed to know about and access the contributions of the publication.

During the pandemic, I got laid off. I had a bunch of equipment already, so I created this in-home office and started archiving and digitizing the collection. From there, I started the website, started the Instagram, and, since then, have just been learning from different people that I've met. I feel very alone in a project like this because it's my family's thing and it just disappeared. I feel very protective of it, too. I bring all of that to my archival work for the collection.

BMV: Wow, so you mention being protective of the collection and feeling lonely in the work. That's something we've heard other archivists—family, community, and

institutional—reflect on as well. We're really curious about these feelings you have, being that there's a familial connection to the actual material and to the labor that has been done here. How does that exist within your family, and what's that legacy been?

MJ: There really weren't any conversations about *SOUL* within my family that I was privy to for a long time and the way that the paper ended really coincided with the dissolution of my grandparents' marriage. My grandfather was one of the first Black nightly news anchors in Los Angeles after his radio coverage of the Watts Rebellion, but, in a lot of ways, my grandmother was the person who turned his ideas and ambitions into something tangible. My grandmother ran a PR agency when I was growing up; she actually ran Jesse

Jackson's PR for his presidential campaign in the '80s. She worked for Solar Records and had a lot of life after *SOUL*. I didn't really know about it until she had this *VIBE* magazine interview, so I was removed from a lot of their work until later in their lives. They had five kids together when the paper folded in 1982. My grandmother named her sixth child SOUL and I think the newspaper took precedence over their actual children at times. I understand that there's been animosity and some jealousy about how much . . . space the newspaper took up in their lives, relationship, and family unit . . . My grandfather passed away when I was about nine, so archiving and reading the newspaper today feels like conversations with him in ways that it's hard to articulate. So many of the conversations with my grandmother have really been trying to reveal to her how important *SOUL* was and is in terms of legacy and history—not just for our family but for the culture. Like, having to persuade her about her own cultural impact. A big part of why I'm stewarding this collection is to have a legacy so that my siblings, cousins, kids, and, hopefully, grandkids can look back and have an easier route than I did. I really had to fight to find out about our family legacy.

BMV: I think you're tapping into something about our work being intergenerational and how sometimes our older generation don't realize how dope they were. How do you grapple with the dissonance of that? Needing to convince your grandma that her cultural production is an important part of history. In our case, that her material culture was and is necessary.

SOUL newspaper (1977)

SOUL newspaper (1978)

SOUL newspaper (1967)

MJ: Yeah, I think there's a lot there, especially her being a Black woman. She got married at fifteen, had her first kid at sixteen. I think she had impostor syndrome and still does. But, when I think about the cultural messages Black folks were inundated with at that time, it really makes sense. She feels like she was just paying the mortgage. She knows it's super important and she knows that it was unique but, to your point, she doesn't hold that history with the same weight. She casually tells me stories sometimes—"We were in the office one day and we had this really bad sound system and you know Stevie walks into the office and he says, 'Change that; the sound's too bad.' And so the next day he walks in and has a brand-new sound system for us." And, I'm like, "Are you talking about Stevie Wonder?" [laughs] She's got amazing stories about all these legends and, to her, they were just people. *SOUL* was one of the first publications to really interview them and put them on the cover, including huge celebrities like, the Jackson 5. I'm always reminding her that this is a big deal and I fully recognize that there's trauma that's tied up in there. There's a humility that exists in our elders and ancestors that was 1,000 percent necessary back then in that time. I feel like it's dope to be a little unhumble sometimes and recognize what they've created for us. Especially for Black women.

BMV: What would you say is your most prized or coveted vintage item from your personal collection and from your *SOUL* collection? They could be the same thing.

MJ: I mean, I think in terms of the publication, this legal seal/stamp in the case means a lot to me and I think because it's symbolic in a lot of ways. The fact that they still have it is super weird because they don't have a lot of materials that aren't paper. So, this heavy, metal object in a case with the publication name printed on it, that means a lot. It's so official. The other thing is the bound volumes of *SOUL* that were at my grandmother's house growing up. I was never allowed to touch them as a kid, but now I touch them all the time. [laughs]

BMV: Is there anything else that you want to share about your collection that we didn't get a chance to cover?

MJ: I want to encourage folks to take a look at THEIR grandmother's garage—both in the literal and figurative sense. When I was growing up, there was a lot of talk about us being "kings and queens" and I think that's cool, but you don't have to be a king or a queen to be important. Or to have done something worth passing down or preserving. I think that us knowing the truth of our histories and stories is important enough. Our elders and family members were both regular and extraordinary. Like, something I have to mention about *SOUL* is that although it was founded by my grandparents, it was run primarily by women. Women were writing all the articles, editors, photographers, etc. Some of the photographers were men, but grandmother and a team of women built that plane and flew it. In one of the first issues, you see a man's name credited for something, but it's a pseudonym for one of the women. And it was multicultural. They were Black, white, Asian, a very diverse team of people who were committed to specifically documenting Black music in the twentieth century. Just makes me think about the kind of culture shifting we can do when we center Blackness and band our resources together to keep a record of it and share it. Personally, I'm committed to a practice of appreciation for old things and leaning into creating new things, too. I'm not stuck in the past, though. I think I'm able to create new things because I understand the past. I consult with my past regularly, and I'm better for it.

SOUL newspaper (1968)

SOUL newspaper (1970)

INTERVIEW WITH

Syreeta Gates

Queens, New York
Collector, Archivist, and
Cultural Worker

BLK MKT VINTAGE: Let's do the damn thing, sis. How do you describe yourself these days?

SYREETA GATES: I've been thinking about descriptions a lot lately. I think in true Black folk fashion, I'm a proud multi-hyphenate. I'm like Brenda Annette Gates' daughter and Jessie Mae Jones Doherty's granddaughter and Malvina Mayo Jones Chance's great-granddaughter. And I'm an Aquarius and a native New Yorker (South Side Jamaica, Queens, to be specific), an archivist, LEGO artist, and an artist period. Also, I'm a collector and a Black memory worker and whatever else I decide to be tomorrow.

BMV: I want to jump right into your collecting practice. Were there specific items, objects, or materials that you collected as a child? For example, we collected rocks, shells, stamps, and T-shirts. What about you? Take us back.

SG: Yeah, I collected sneakers. I was definitely a sneaker girl growing up. I was a fashion girl, in particular. Mad Polo Ralph Lauren! I don't even know how I was

getting the money to do that shit because my moms, Brenda, never said, "Here's $400 to go spend on some sneakers." I remember going to my grandma's house with some new shit. Maybe I was working at Jones Beach at the time and I used to pull up like, "Oh, I got the new Bathing Apes." Grandma was like, "If you don't go and get the fuck out of my face with that. Like buy something that will appreciate in value." I'll never forget when I bought my first mink coat. I had to put that joint on layaway. My youngest uncle, Du, took me to the fur spot that he'd been going to and I, as a teenager, was putting $100 on it like every two weeks. My mother got my fur out for Christmas, and when I took it back to my grandmother Jessie, she was like, "That's what the fuck I'm talking about. Get a fur. You never got to buy another coat again." [laughs]

BMV: Yo, what kind of kid were you, putting furs on layaway? We're New York heads over here, too, but this is a little too old New York for us. [laughs]

SG: Listen, I was collecting sneakers and shit. I was collecting cash. I was probably dating like mad d-boys

at the time. I loved the idea of touching paper. Give me $2 bills; give me the $50 bills; the original $100 bills. I wanted them all. I was collecting mad receipts and still have 'em, too. I have receipts from Apollo Express when I bought my first American Cup Prada's before Ashanti had them shits on in the "Be Happy" video. I even have the receipt from the first time I took my crew to the Chinese restaurant and I paid for it. It wasn't exorbitant or anything, but I kept it. My mother's old books. I held on to her old copies from the '60s and '70s—the Malcolm X work, Toni Morrison, Black women writers, etc.

BMV: I know how important your mother, Brenda, and your grandmother Jessie were to your arrival at the work of collecting. Can you tell us a bit more about them?

SG: Every day, I'm so grateful for the ways my mother had the foresight to keep all the mementos I would have thrown away. Like cards from my dad that would have been heavy in the trash—like, I would have thrown them shits out. My mom kept a note she wrote to me back in/around 1994. She went to vote, and I was at my grandmother's house after school. The note says something to the effect of: "I'm going to vote because our ancestors didn't have the opportunity to, and it is our duty and right to ensure that we play in this political space and that's what I'm doing right now. That's why your ass is after school at your grandmother's house." I wouldn't have been old enough to grasp why that was important to keep, but because she had the foresight, I now have—to my knowledge—every Post-It note my mother left for me growing up. My mother was like the first archivist in my world.

BMV: And how did they inspire the Gates Preserve, your personal collection?

SG: I haven't shared this often, but the word *preserve* is in there as a nod to my grandmother Jessie. The ancestors were definitely making some preserves; y'all already know. Some shit was going in the jar, right? Like them, I, too, want to ensure that some things last forever. Gates is my mother's last name, and I registered it in 2015. I don't know 100 percent what led me to create an entity where my collection could

be formalized and structured, though. I feel like the gods, the ancestors, [were] just like, Do the thing. And this is gonna sound morbid, but I'm actually excited for folks to see my personal collection and archive after I pass. We got some fire ass niggas in that shit! [laughs] #TeamUs in the flesh, literally. Every note y'all have given or left for me is in there. I still have it. There are so many folks I've worked with and met that I've found ways to document their work and our relationship. The archive also documents them just being Black, being great, being themselves. And I think that is more than enough reason to keep it as a record. I mean, it may be a whole book at some point.

BMV: For you, where are the lines of hoarding, collecting, and accumulating?

SG: For me, hoarding feels like a dirty word, but I think the bridge between hoarding and collecting is curation. I don't have everything in the history of everything, right? And I'm an archivist, so I be telling niggas don't throw

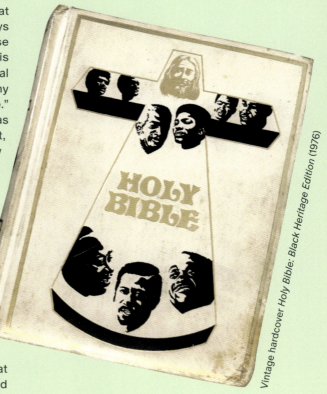

Vintage hardcover *Holy Bible: Black Heritage Edition* (1976)

anything away. [laughs] So, there's a line, but it's not exactly a thin line. I don't want mice, roaches. I mean, I just started letting ladybugs live. Collecting feels like there's a level of intention. Like, you're on a mission and you are not doing it alone. There's community to be found in collecting, in my experience. Hoarding feels lonely, which is why I don't want any parts.

BMV: Let's talk about the goods. What's your favorite item you've purchased from us for the Gates Preserve?

SG: Remember when I reached out to y'all. "Check this out—I'm looking for a Zora Neale Hurston first edition. Ideally, signed"? I don't know when I sent that message, but months later you hit me and said—we got it and it's twelve bands unsigned. Original dust jacket included. I had to sit with it, check my coin, and make sure I was willing to make the investment. I had no idea when another might come around, so I jumped on it.

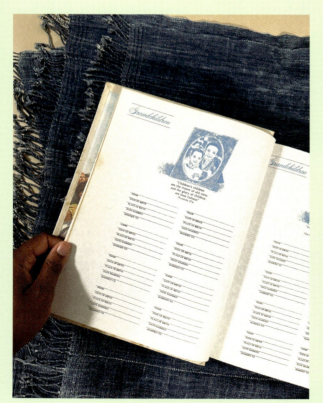

Interior of *Holy Bible: Black Heritage Edition* (1976)

The math just mathed for me. I had a conversation with my mom about the book, too, because we weren't rich, but I needed to let her know that if all else fails and business is messed up, "sell this book, bro." And she knows the extent of the collection—we have Baldwin's. We have Toni's. We have Hughes's. For my grandmother, it might have been, "If we're down bad, sell this fur. Sell that diamond." But, a book? That's my first edition. *Their Eyes Were Watching God* for me and mine.

As an aside, I think some collectors often like looking down on niggas who spend money on sneakers, like a Black, hood aesthetic. It's really just anti-Blackness, racism, and straight up hating . . . but I'm very much the girl who blew a bag on the fucking Gucci bag. I done blew the bag on Evisu jeans. I done blew the bag on Bathing Ape. I've walked into many a store, many an exhibition, etc., and folks ain't think I had the paper. Bamboo earrings on. I'm walking in with a red lip. When I pull out that Amex, it's all the same. And when I start asking about condition, about provenance, then there's a switch-up. I'm a Black woman, so the audacity of me to have leftover paper to collect something . . . How dare I have the space or resources to care for those things?

BMV: Yes! Yes! How does it make you feel now seeing material culture from that Black hood, hip-hop aesthetic being recognized for their value?

SG: Archiving is a statement of value—you feel me? So, when we talk about hood material culture, that shit brings me immense joy. It's us. It's me and my home-girls. My aunties and cousins. Like that Moncler coat I just put in the Hip-Hop 50 exhibition at FIT in NYC. Mary [J. Blige] had that joint on in 1994. The objects and goods I really care about, I love to see them pulling it in at auction. I love that it's ran up. Let's run it up even more because the culture deserves it. Honestly, it's a lot of white tech bros buying up Black ephemera for their own satisfaction, but I truly care about what we say is valuable and how the market reflects that. When I think about Avirex, Vanson's, name belts, name chains, X and O chains, and all of that material culture, I recognize that the reason it's not ran up is because white people don't know how lit it is yet. We've always known. And I grapple with what is lost when these items sell for what I know them to be worth—culturally. Aesthetically. Historically. Who's left out? Who has to

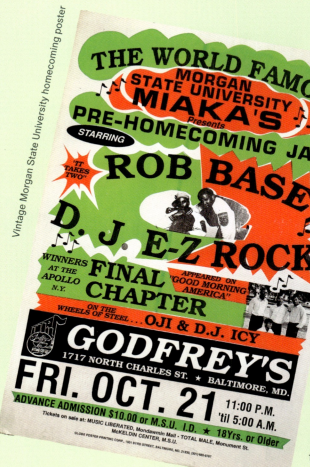

Vintage Morgan State University homecoming poster

catch up? Who's setting the price and according to whose historical memory? All of those questions come into play for me.

BMV: What is your favorite thing, item, object? Is there one?

SG: Damn. It's not going to be what you think, which is hilarious. I'm pulling it up because it's not tangible, either. [plays audio on phone] It's the last voice mail that my grandmother left my mother, and it's the most important thing to me. I feel it in my bones, and as a collector, I know the importance of a tangible thing—a letter, a Post-It note, a book. All the things we've spoken about today. But, the voice of someone you know, love, and respect? I just texted y'all the voice note, too, and

I've done this before with other folks. I send it to my people because, God forbid something happens to me, I need that shit to still exist. We don't realize how important material is until people, spaces, communities are no longer here. In full transparency, I probably would not value this voice mail if my grandmother was here. The loss and the grief is the difference. The fact that this data, this audio file gives me access to a part of my grandmother (her voice) when she died in 2009 is wild. That's the value. That's what these materials, collections, and archives do. They transport us and give us access to our own memory.

My forever unc Greg Tate is a perfect example of this. To me, this dude was supposed to last forever, forever ever, FOREVER EVER. I'm grateful to have been alive at a time when he was. And he birthed a generation of writers. Listen, I'm an archivist and I'm in community. So, I went back to my text messages immediately after I learned that he passed. Part of my archive, right? I found the first interview I did with Tate, and it was several hours' worth of audio. I was so grateful; still am. I often think about the opportunities that the ancestors give us, but we feel as if we're not worthy and/or we're not ready. Someone asked me to direct a Greg Tate documentary, and I thought, "Why me? Oh—because I have everything. I have hours of Tate on film. I have audio. I have video. I have receipts. Which leads me to my last point on this: Keep your receipts. I request that of the legendary designer, stylist, and my good sis Misa Hylton damn near every week. Create some shit to keep. Create a voice note, record your conversations (with permission). Write on some paper. Back up the files on a hard drive. A whole generation will literally be lost because you didn't think about the future archive—or spend time thinking about how technology, which we use every single day, can advance your future collection or future archive.

BMV: Do you have advice for folks who are interested in building a collection or being a collector? Black folks specifically.

SG: Black folks specifically? When are we not talking about Black folks? Just get shit that you love. Don't try

to keep up with the Joneses. Don't try to buy entirely based on the projected value. Even the first edition that I bought from y'all, I didn't get it because I thought it was going to be worth something. I bought it because it was Zora and Zora has value today, and yesterday and the day before that. Start with what kind of objects you find value in today. Buy the shit you love. Be in conversation with people; like build a tribe and community around collecting because it makes life easy. The tribe that you create around collecting is very much a family tribe. I'm telling y'all because I appreciate and care about you both in real life, not solely because y'all are BLK MKT Vintage. I have so much respect for you both as humans. Two other Black women. I would say, save your coins because you never know when you find some shit. If you're caught off guard, you're either going to have to find some coins or have great credit. Start working on that shit now. And it doesn't have to be crazy exorbitant. Niggas always think, you gotta have the $100 million Kerry James Marshall. No, you could have the family Bible. The value is the same. Lastly, talk to your family members. Just be interested, just be curious and see where it leads you.

BMV: So what, specifically, is collecting to you, a Black woman?

SG: To me, collecting unlocks access to all of the things your grandma said, "No, don't touch," when you were not ready. Collecting happens in that readiness phase. I'm thinking about, like, family photos, in particular. I remember going to my grandmother's house asking to borrow the photo album. "No." But when I was ready, she said yes. And I don't know what I had to do to get ready, but listen, she knew. I also believe that collections will come to you when you're ready. I would not have been ready for y'all to have entered my life when I was twenty-two. No, sir, I would not have been able to financially afford a $12,000 book or a $30,000 piece of art. Collecting means taking a risk in public. Collecting means ensuring legacies are preserved. Collecting means we get to dictate the narrative.

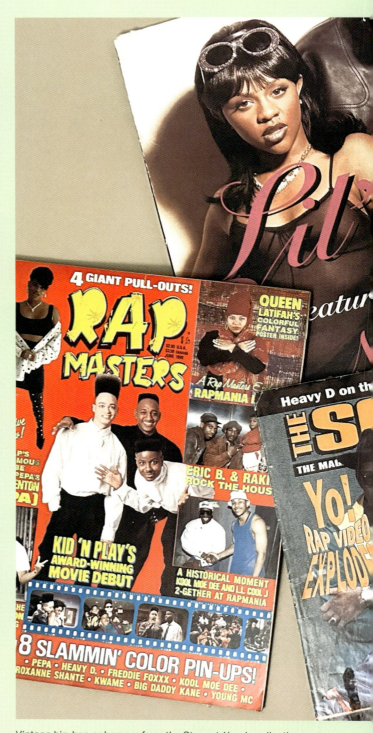

Vintage hip-hop ephemera from the Stewart-Handy collection

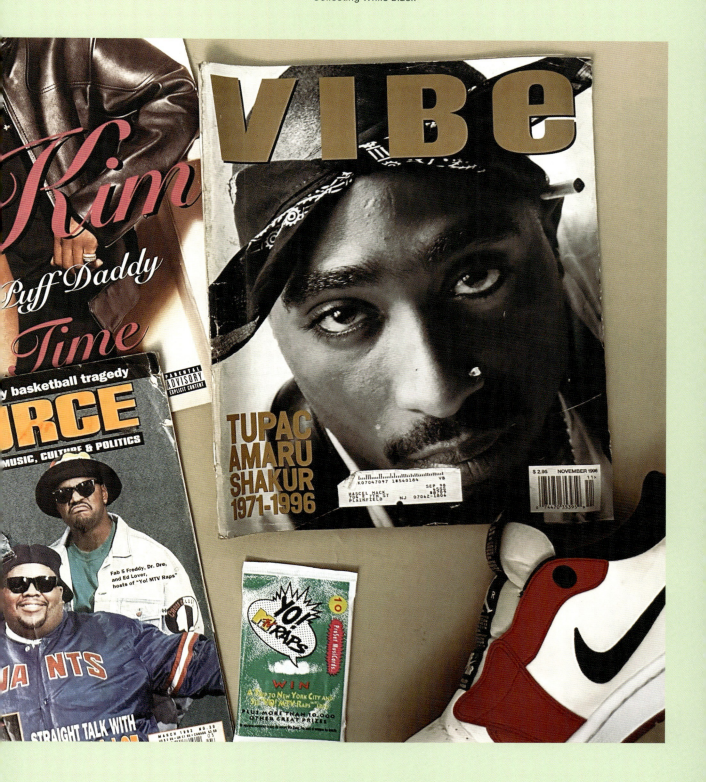

SEEING BEYOND

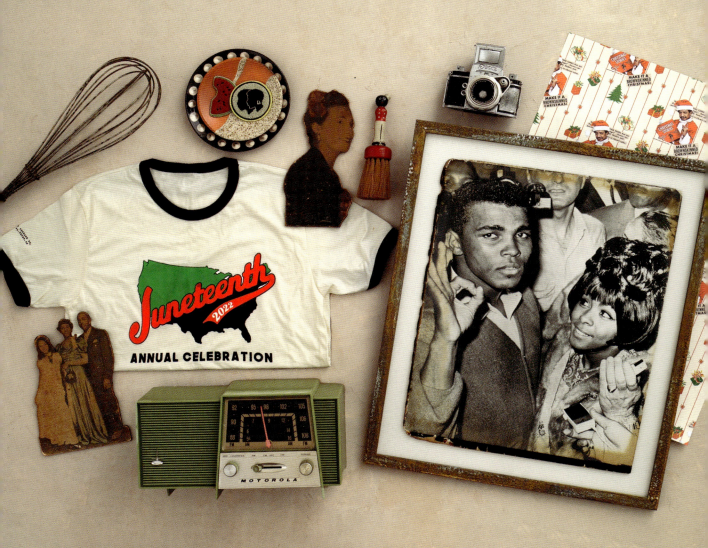

From left → 1. Antique wire whisk; 2. BLK MKT Vintage Juneteenth ringer tee; 3. Vintage cork cut-out; 4. Motorola radio (1950s);
5 and 6. BLK MKT Vintage chenille cameo and watermelon patches; 7. Assorted stoneware saucers; 8. Vintage cork cutout;
9. Midcentury crumb brush; 10. Exa camera (1950s); 11. Vintage framed portrait of Muhammad Ali and his wife, Sonji Roi; 12. BLK MKT
Vintage Sherman Hemsley holiday wrapping paper

WRITTEN BY

Jannah

SEEING BEYOND; v: The act of engaging your imagination when considering material culture. Being resourceful and considerate of other forms of value and function.

The concept of Black **IMAGINATIVE** genius, repackaged and recontextualized as **SEEING BEYOND**, fits squarely within the continuum of Black folks having to "make a way out of no way." From the dawn of time, the Black imagination has enabled us as a people to "see beyond" environment, circumstance, doctrine, legislation, and informal (and formal) caste systems. In many ways, the American project is an **EXERCISE** in imagination; operating in a society that is based on contradictions, hypocritical notions, oxymorons (actual morons), and boldface **LIES**.

More specifically, Black imagination has been pivotal in seeing beyond oppression—racism, sexism, xenophobia, and anti-LGBTQIA hate. For us, seeing beyond has been about survival—on the micro and macro level. Black survival, in a society that continually affirms the notion that we live in a country built by us but not for us. The survival of self, family, or community has often propelled our imaginations to unthinkable heights in the face of very real depths. Black imagination amounts to a personal rebellion; rebelling against what capitalism, patriarchy, and white supremacy offer up to pacify the masses as a means for us to stay in our respective stations. And while Black imagination can be engaged as forms of survival and liberation, it also functions as sites of creative improvisation that challenge tacit form and function and lead to innovation, art, and beauty. Tapping into Black imaginative genius is an experience of remixing, upcycling, or seeing beyond what is in front of us as an avenue to create different realities.

Seeing beyond is one of the most fundamental aspects of our business. It enables us to draw from the lineage of imagination. Reconsidering the function, purpose, history, and condition of a piece allows us not only to understand the item in its original context, but to visualize it in new and reimagined forms. In this chapter we unpack what imagination and, specifically, what Black imagination is and how it functions in the BLK MKT Vintage multiverse.

WHAT IS IMAGINATION?
THE SCIENCE OF SEEING BEYOND

What exactly is imagination? After speaking with Dr. Shari K. Moore, psychiatrist, neuroscientist, and fellow Smith College class of 2008, I was able to gather a much more robust understanding of the word and the process. Using a mixing bowl as an analogy, our imaginations are the result of all the ingredients we placed in the bowl prior to mixing. Our imaginations

are basically the synthesis of the world around us and the experiences we have lived. Since imagination does not originate from a singular region of the brain, there are a number of inputs (ingredients) that go into the bowl to get to our output.

SENSE + MEMORY + PATTERN
= IMAGINATION

What this all boils down to is that what we think, feel, see, and experience over the course of our lives are all the drivers of our imaginative process. Our individual stressors, triumphs, traumas, and skills all influence our ability to imagine. Or, as Dr. Shari puts it, "Unique experiences lead to unique imaginative processes." Taking this one step further, it's reasonable to assume that Black imagination comes from the Black experience. You cannot have the dopeness that is Black cultural production without Black struggle and triumph; the science (and the doctor) says so.

LOOKING BACK TO SEE BEYOND:
VINTAGE AS INSPIRATION

We aim to both draw from and contribute to the concept of the Black aesthetic in all we do. From the curatorial choices we make to the suppliers and vendors we choose, the centering of Blackness is the point of it all here at BLK MKT Vintage. In order to give you more concrete examples of how we achieve this goal, we have outlined four projects that illustrate how we use Black historical objects, aesthetics, and narrative to propel and ground our imaginative process.

Assortment of political pinbacks in the Stewart-Handy collection

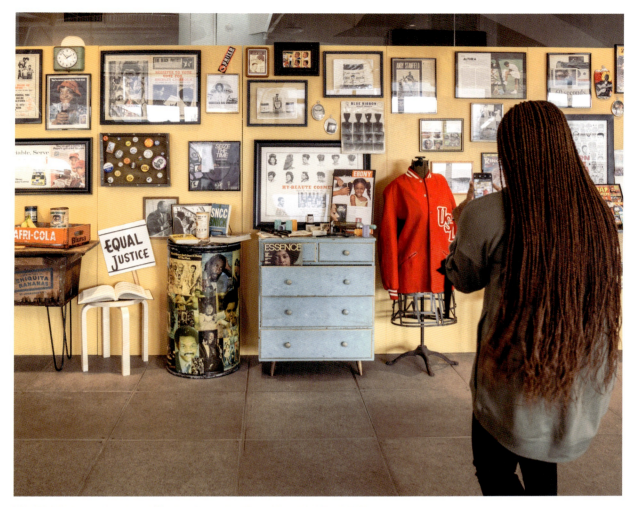

BLK MKT Vintage activation at Wieden+Kennedy offices, New York City (2020)

BRAND PARTNERSHIPS
AND CONSULTING PROJECTS

As discussed in chapter 2, one of our business arms is creative brand and corporate collaborations. When folks are looking for creative and authentic ways to express messages or appeal to African American consumers, they reach out to us to collaborate on the promotion or branding for a given initiative or activation. These projects bring our work out of the garages and thrift stores and allow us to engage our imagination around the Black aesthetic in new and different ways. Our collaborative work has run the gamut with projects as simple as

panel discussions to the creation and dissemination of limited-edition merchandise and collectibles. Out of the litany of companies and projects we have worked on, two of the most popular and imaginative ventures were with HBO's *Lovecraft Country* and a presentation we did at the advertising firm of Wieden+Kennedy.

After some brainstorming and negotiating back and forth, we landed on the final direction for this collaboration with Wieden+Kennedy: an exploration of Black advertising. We focused on the staging and curation of items to help tell a fuller story not only about Black advertising but about the Black people the ads were geared toward. An additional aspect of the collaboration was a

Draft sketch of Josie's Juke Joint NYC Pride Parade float (2023)

Founded in 2019 by Nina Chanel Abney, Jet Toomer, and Racquel Chevremont, the Josie Club is a social organization aimed at centering the experiences of queer Black women and femmes. Named after Black, queer icon Josephine Baker, the Josie Club hosts events and opportunities for the queer community, as well as offering fellowship and promoting activism across the country and virtually.

The Josie Club

206

panel discussion where Kiyanna expertly brought to life the nuances of Black life and aesthetics from contemporary and historical perspectives. The parting charge to the event attendees was to consider different sources of inspiration in order to spark their imaginations. Kiy challenged folks listening to create with the expressed purpose of shining a light on folks who are often marginalized and left out of larger societal conversations.

We are both huge fans of HBO's *Lovecraft Country* and the folks involved both in front of and behind the camera, so the opportunity to collaborate with this groundbreaking show was a dream come true for us. The show itself, through creator, director, and showrunner Misha Green, was a testament to the thrust of this chapter: using Black aesthetics to ignite our imaginations.

REIMAGINING COMMUNITY: CURATE THE FUNCTION

The idea of curation of and creation from vintage sources is not solely relegated to material objects. We can also be intentional about curating the time we spend with community.

In 2023, BLK MKT Vintage partnered with the Josie Club to create their first annual NYC Pride Parade float. It was not only a dream partnership but a dream project, thinking back to the parades I had been to as a teen and in my wayward twenties. Drawing inspiration from queer luminary Josephine Baker and the juke joint establishments of the 1930s and '40s, we decided on the theme of Josie's Juke Joint. We set out to create the Black, queer visibility we wished we had seen when frequenting the parades in our youth and to have an amazing time. More than a hundred queer folks came to march and ride with us for an unforgettable display of pride. With the rallying cry of "Black . . . Queer . . . Been Here . . ." we treated the float and experience as a piece of performance art and moving ephemera, bringing us full circle from the quest for the NAACP parade float signs (see chapter 3).

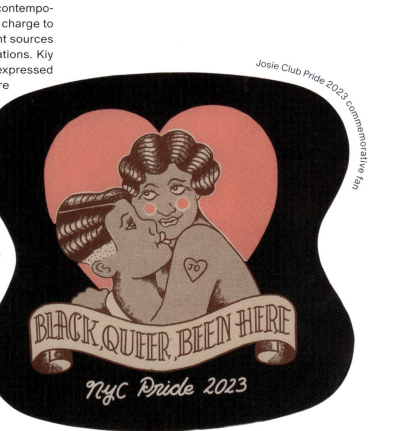

Josie Club Pride 2023 commemorative fan

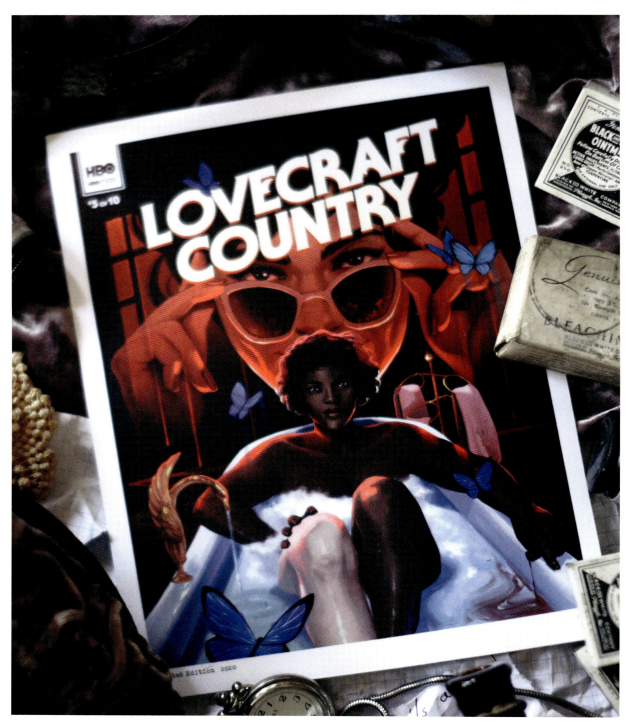

Limited-edition print from the BLK MKT Vintage x HBO *Lovecraft Country* collaboration (art by Salena Barnes, 2021)

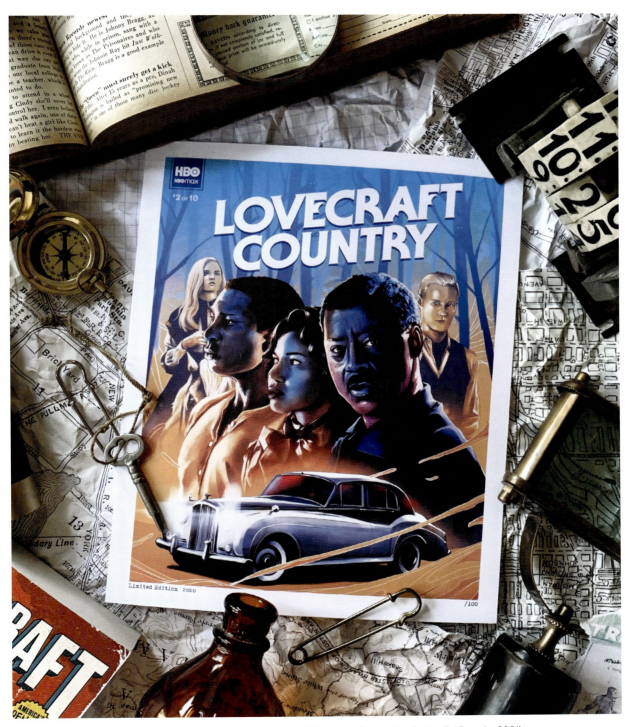

Limited-edition print from the BLK MKT Vintage x HBO *Lovecraft Country* collaboration (art by Taj Francis, 2021)

Seeing beyond isn't just about imagination, but about

Vintage hair tools

Soul cards by SoulMar (1973)

Store display for Sepia magazine

JAIL FOR Joe Louis

BECAUSE OF HIS INCOME TAX TROUBLES **???**

READ ABOUT IT IN THE JUNE SEPIA AT NEWS STANDS - 30¢

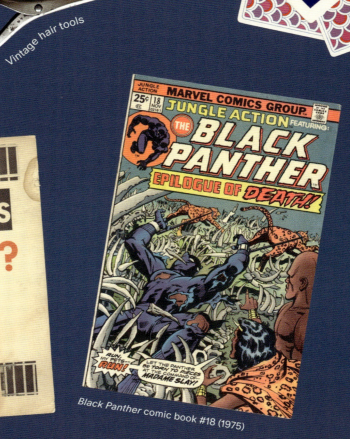

Black Panther comic book #18 (1975)

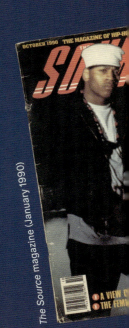

The Source magazine (January 1990)

FREEDOM IN '63

ELDRIDGE

Vintage pin

Vintage can of Negro Head Oysters (1940s - 1950s)

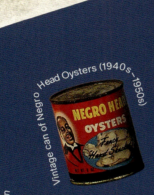

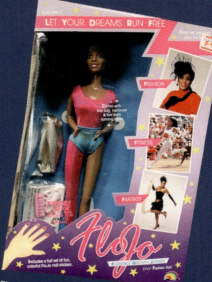

LET YOUR DREAMS RUN FREE

FASHION

FITNESS

FANTASY

FloJo
FLORENCE GRIFFITH JOYNER

Soul cards
by SoulMar (1973)

Antique Ole Vir-gin-a baking pan

The Real Model Collection: Beverly
Johnson doll (1989)

I ♥ BEING BLACK

Vintage pin

POLITICS VOL. I NO. 5

$1.95

LL COOL J

'can 'that type of guy'
re-claim the street'

RAP INDUSTRY
ON HIP-HOP

creating something new from the well of Blackness.

JUNETEENTH

I really can't put my finger on why,
but I love a good T-shirt.

CAPSULE

Whether it's something goofy, touristy,
or event-based or celebrity stanning, I've rocked
with tees for a minute.

COLLECTIONS

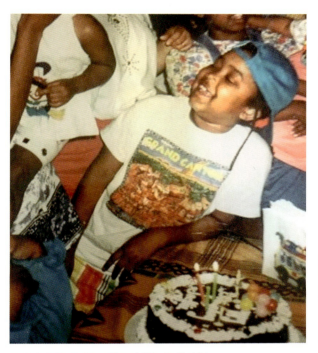

Jannah in her vintage Grand Canyon T-shirt

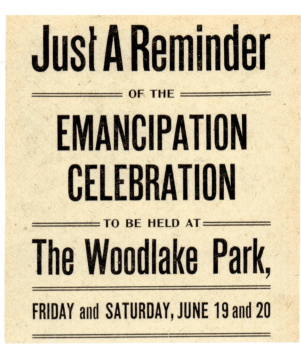

Juneteenth ephemera for sale at Swann Auction Galleries (2023)

I thought I was being slick. As a tomboy I really didn't fit into any of the aesthetics offered up in girls' juniors or in boys' husky sections. Going through the nuances of all that is a completely different book. But I knew then that T-shirts were usually unisex. I didn't have to choose a boys' or a girls' tee when I bought that 1990s Yankees Championship shirt. I didn't have to worry about that when my family would bring home the obligatory souvenir travel tees, in youth sizes, not boys or girls. And, strangely enough, I didn't have to worry about it at the church picnic. Although every Sunday I was chided and reprimanded for not wearing a skirt or a dress to church, everyone wore the same tee to the church outings.

Beyond the comfort T-shirts offered me, I loved how they became their own time capsules. Family reunion tees, high school Senior Week shirts, freshman orientation tees all became physical freeze frames of the times of my life. In my work, I still hold this rather simple item in high regard. This makes searching for them and collecting them even more special. Like most of the items we interact with, it's thrilling to find vintage items that resonate with us on a personal level.

Having lineage migrating from Texas on my mother's side, from a young age my sisters and I had an understanding and appreciation of Juneteenth. While our celebrations for the holiday were not annual or grand by any means, I can recall acknowledging it as it passed on the calendar and family members commemorating it with the pouring of libations at the July 4th family reunion. It's a rather surreal feeling to have seen in my lifetime the nationalizing (and commercializing) of a Juneteenth holiday from somewhat of a niche and lesser-known obscurity. As a result of that and it's hyper-regionality, finding and collecting Juneteenth ephemera is rather hard. Items are scarce, and it is a rarity to find pieces not already in library or museum collections. For us, the most accessible pieces of Juneteenth ephemera are commemorative tees.

It became evident quickly that finding Juneteenth tees out in the field—IRL at thrift stores, estate sales, and bulk clothing importers—was going to be a once-in-a-Black moon occurrence. Searching online or buying directly from clients was the way to go. Early on in our adventures in picking, we decided to change that. Just as we are writing the

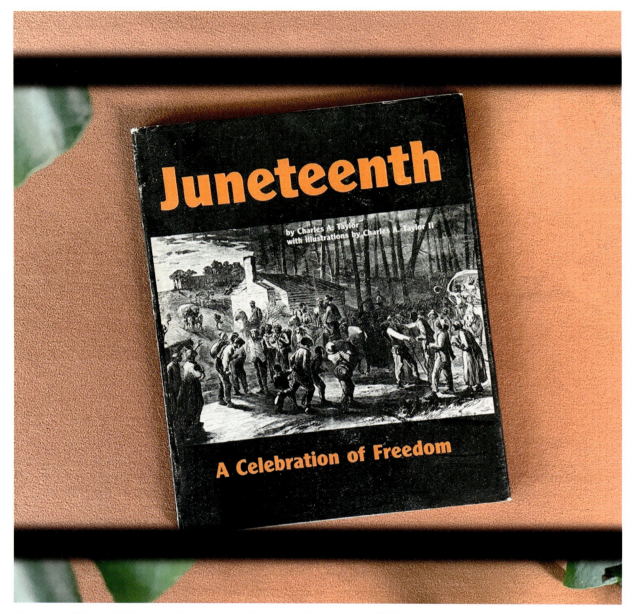

Hardcover edition of *Juneteenth: A Celebration of Freedom*, by Charles Taylor (1995)

book we wish we had to read, or opening the vintage store we wish we could have frequented, we decided to create the vintage tee we hoped to find in the future. In 2019 we offered our first annual Juneteenth Celebration tee. When creating anannual commemorative tee, the why and the how are directly rooted in our imagination and interpretation of the Black aesthetic.

From the design to the supplemental information in descriptions and promotional materials, to our annual philanthropic donation, taken from a portion of the sales, we strive to honestly practice what we preach.

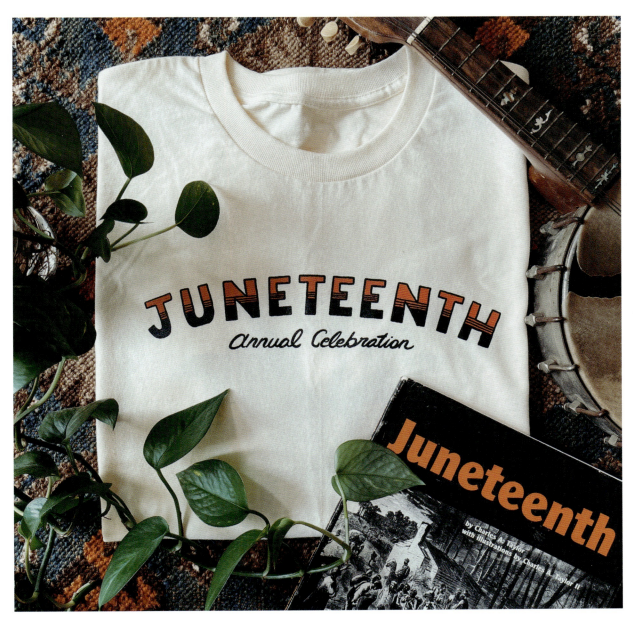

2021

To date, we have sold over three thousand Juneteenth tees since 2019. That brings us tremendous pride in knowing that something that stems from our imagination resonates with so many folks. Additionally, those three thousand–plus shirts that are now in people's closets will be the tees that will populate future collections.

I hope in another twenty years, when someone comes across a BLK MKT Vintage Juneteenth tee in a thrift store or estate sale, they see that the holiday was significant. And they, in turn, come to find import, or at the very least intrigue, in the Black holiday and the Black folks behind it.

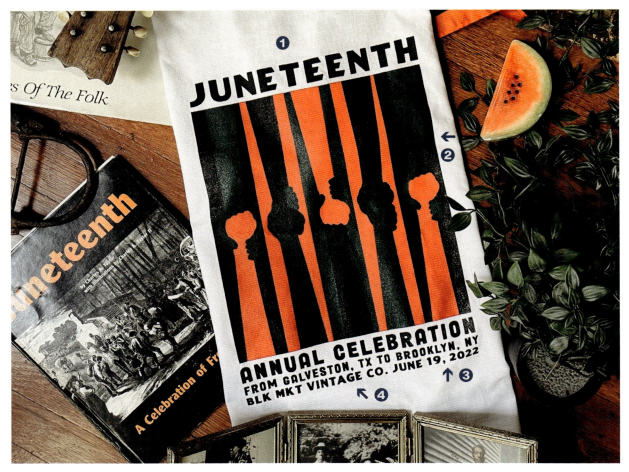

2022

❶ Our tees are either tan or off-white to mimic the early signs of age and patina. Tan shirts conceal armpit staining and other random stains and discoloration that come with wear. The tan shirt also gives the new creation an old feel right from the start. (There have been two exceptions to this as disruptions in the supply chain and manufacturer availability have made stark white the only option.) ❷ Wear and patina are already worked into the design. We try to go for an heirloom feel by adding some light character and texture to the graphic ❸ More often than not, our tees are dated. This is pivotal as a collector who often struggles to establish provenance of an undated item. Making the year part of the design helps with the identification process in the future. ❹ Lastly, something we have recently started doing is branding the tees with BLK MKT VINTAGE. This is important for the same reason as establishing provenance, with the additional benefit of establishing authenticity. Don't want folks in fifty years trying to ascertain if they have an authentic BLK MKT Vintage Juneteenth tee or a bootleg!

Design Throughline Through the Years

2019 and 2020

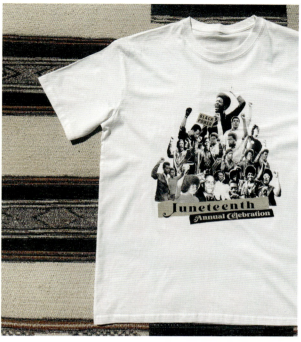

2023

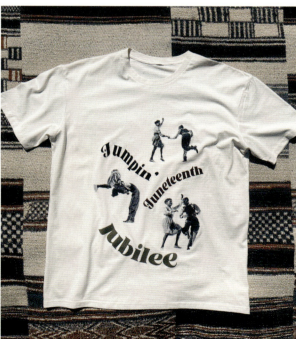

2023

Jannah and Kiyanna's gift wrapping competition poll (2021)

Vintage *The Black Panther* newspaper (December 1972)

HOLIDAY WRAPPING PAPER

I'll do anything to win a competition. Kiyanna and I are very competitive about things that you would least expect. Who can find the coolest item at the thrift store for under $20? Spontaneous foot races to see who can make it from the driveway to the front door the fastest. Most notably, our annual holiday wrapping challenge with social media voting for Christmas and Kwanzaa. The latter is where we find our next foray into flexing our imagination and the Black aesthetic.

Something so simple as holiday greeting cards and wrapping paper are mediums that are invariably subjected to the white gaze. Finding Black figures on holiday cards and wrapping paper was a hopeless task that would lead you to DIY it or spend exorbitant amounts of money on niche products. As a lover of all things Christmas, I often sought out wrapping paper and cards that had imagery that resonated with myself. Fussing over an issue such as not being represented in holiday wrapping paper or greeting cards seems childish. Much ado about something that is going to be torn to shreds and thrown away should be a non-issue, right? I had to confront the voice of white supremacy telling me I was being dramatic. There is nothing dramatic or childish about seeking representation for something that is sentimental and personal. Well, actually, maybe it is childish because the inner child in me still gets excited by seeing reflections of myself in small, mundane ways and large, sweeping displays.

Enter the centering of the Black gaze and the establishment of the Black holiday aesthetic. Following

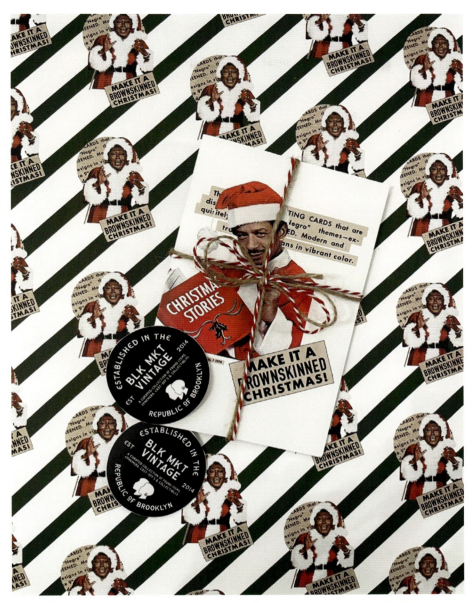

BLK MKT Vintage holiday wrapping paper, featuring Sherman Hemsley and Esther Rolle

in that same tradition, I set out to smash the competition in the holiday wrapping contest of 2020. What started out as a collage on brown shipping/butcher block paper, has morphed into a highly anticipated BMV annual offering like our Juneteenth tees. Using our collection of Christmas and Kwanzaa ephemera, including magazine covers, newspaper clippings, vinyl records, and deadstock gift wrap, we began to craft what the BLK MKT Vintage Black holiday aesthetic would be. Starting off with Christmas wrap in 2021, we then expanded our offering to include Kwanzaa papers and greeting cards as well. We are excited by the prospect of further expansion in order to serve and center our community.

CREATING

We asked some of our favorite artists, creatives, and co-conspirators about the impact primary sources and historical material culture have on their practice and process. The following group of folks are beacons of light and exemplify how the Black imagination is not only thriving, but a source of commerce, reclamation, representation,

FROM THE

and subversion. There is not enough room in this book for the full conversations we had, but these gems should be just enough to pique your own imaginative process and encourage you to create from the source as well.

SOURCE (MATERIAL)

WHY IS IT IMPORTANT FOR YOU TO PULL FROM VINTAGE SOURCES TO SPARK YOUR IMAGINATIVE AND CREATIVE PROCESSES?

You can make stuff up, but for me, I like facts.

AYA BROWN

Aya Brown is a noted contemporary artist from Brooklyn. She is a staple in the art world as someone who pulls from early aughts imagery and centers the Black, queer, femme, lesbian aesthetic.

AB: [Pulling from vintage sources] makes the work more genuine. I think that's why I'm so connected to my personal family's archive. I do really want to work with other people and their families eventually. I think storytelling has to come from facts at some point. You can make stuff up but, for me, I like facts. I like being able to be like, "Yo, this is a real thing" and relatable to a variety of people. I love going to the source to tell stories.

Of course, I have my go-to sources Whether it's BLK MKT Vintage or eBay or my grandmother's or family's archive. When I'm in my studio, I watch VHS tapes. I was just watching Janet Jackson's HBO concert right before we got on the phone. I think there's something about these things I've gotten from BLK MKT Vintage, specifically. They're not just sitting around, but still have function. Through my art [and imagination] I give new life to them.

"Sexy Love" T-shirt by Aya Brown (2023)

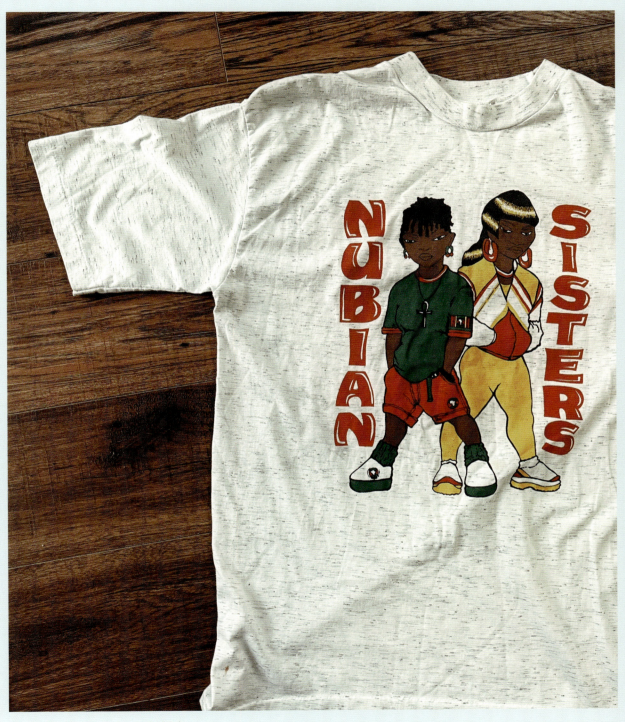

Vintage Nubian Sisters T-shirt (1990s)

You can't be innovative without deeply observing history in order to carve your own path for the future.

NINA CHANEL ABNEY

Nina Chanel Abney is a prized, artistic luminary of the twenty-first century whose work is displayed in museum collections, public murals, and basketball courts around the world. Outside of her larger-than-life collage and spray-painted works, Nina has become a champion of using form and medium as expressions of the Black aesthetic. From clothing, sneakers, Uno cards, NFTs, and parade floats, she doesn't shy away from trying something new, different, or risky.

NCA: I think it's critical to pull from the past as a reference. I like to use individual and collective memories as a guide for the present issues that I might be considering in my work. You can't be innovative without deeply observing history in order to carve your own path for the future.

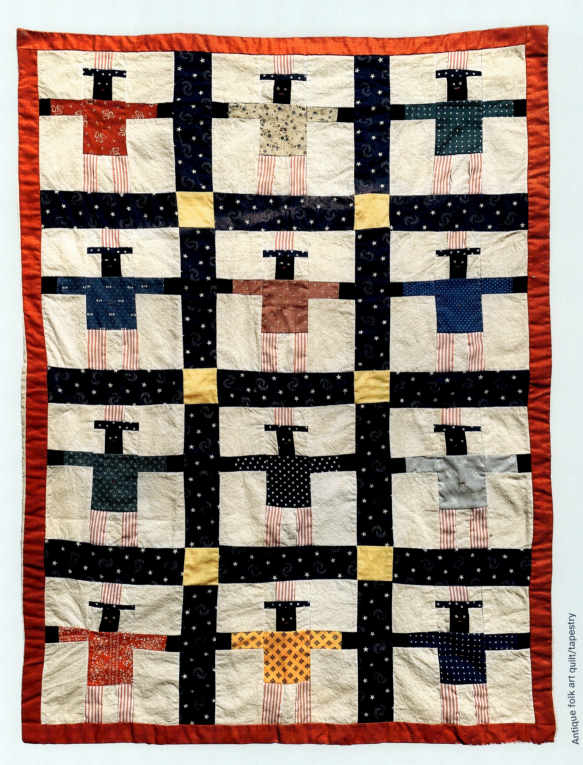

Antique folk art quilt/tapestry

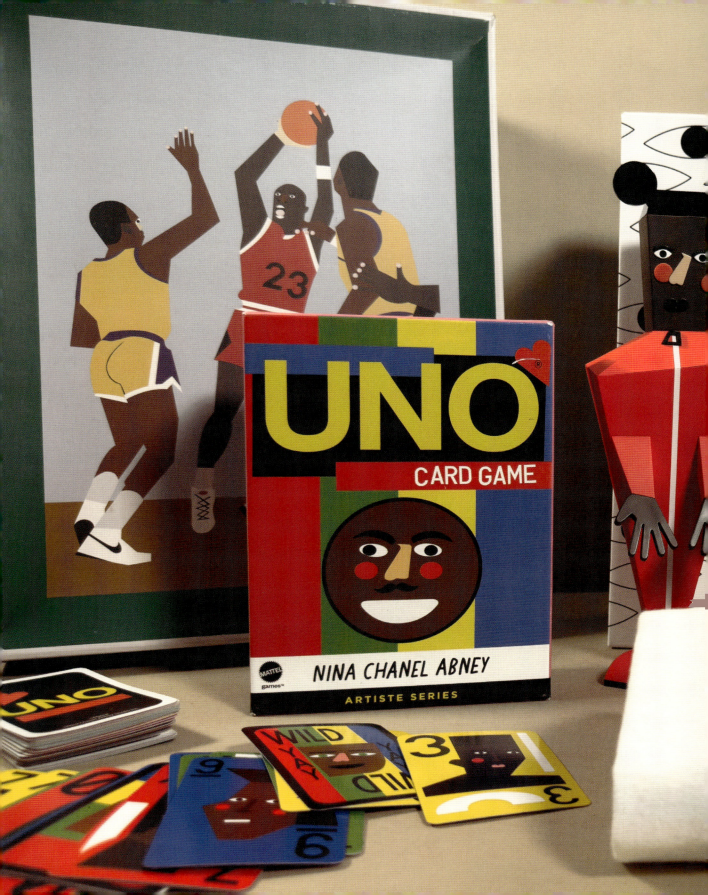

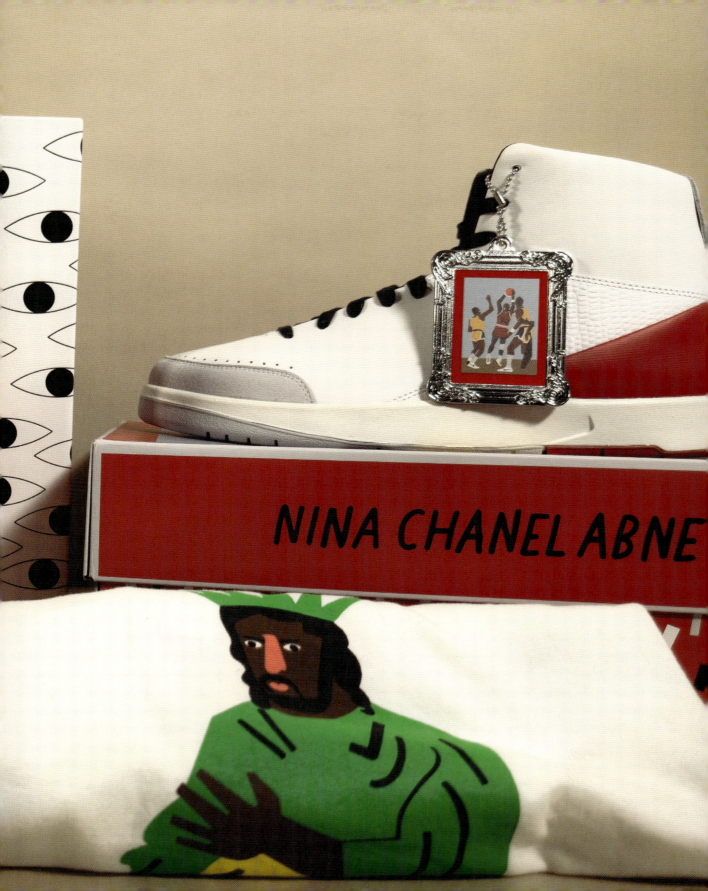

NINA CHANEL ABNE

But I have to say that my love for history is deep . . . I don't know a feeling stronger than nostalgia.

JERALD COOPER

Jerald Cooper is the creator and curator of the Instagram-based cultural archive, @Hoodmidcenturymodern, where he centers Black Modernism, architecture, and preservation in the everyday. Jerald's work deals with the interior and the built exterior world, how we exist in it, and how it impacts Black culture.

JC: Well, I often find myself in this space of nostalgia. My dad was an OG, and my mother is one of the matriarchs of the family. She has lived in the house that I was raised in, in Cincinnati, Ohio, for the last forty-something years. Currently in her living room is a bench my grandmother sat on in church for sixty-plus years. She keeps everything! The space reminds me of my childhood, so it's almost like being home is nostalgic in itself.

I didn't connect that until I came back to the "Nati" and the Ohio River. Back to the source. I mean, talk about spaces [and sites of Black history]. That is where the North and the South essentially exist together, the Ohio River is right in this intersection, one of the major routes of the Underground Railroad. I came home seeking space, the river, ancestral energy, prayer, and I ended up finding this Hood midcentury modern narrative within that.

I have to say that my love for history is deep. People talk about love being a strong feeling, but I don't know a feeling stronger than nostalgia. I feel like I'm stuck there, but it's progressive. It's alive and breathing.

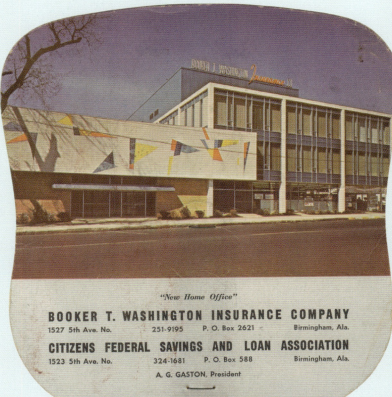

"New Home Office"

BOOKER T. WASHINGTON INSURANCE COMPANY

1527 5th Ave. No. 251-9195 P. O. Box 2621 Birmingham, Ala.

CITIZENS FEDERAL SAVINGS AND LOAN ASSOCIATION

1523 5th Ave. No. 324-1681 P. O. Box 588 Birmingham, Ala.

A. G. GASTON, President

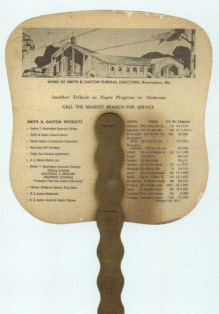

Church advertising fans featuring
midcentury building in Alabama (1960s)

That photograph acted as a bit of a portal, permission to explore my own interiority.

SHEFON TAYLOR

Shefon Taylor is a visual artist who is known for her striking collage work and themes of "re-memory" and nostalgia. Pulling directly from archival and source materials, her works center the Black experiences and recontextualize elements of the Black aesthetic. Her work resonates so deeply with us as it leans on the very material culture we interact with on the daily. It is also a testament to the many nontraditional uses of the physical materials and imaginative approaches to personal and familial storytelling and legacy building.

ST: In my work, I focus a lot on themes of re-memory, the sharing of interiority, and the intimate pursuit of belonging. In 2017, I was visiting a great-uncle in Portsmouth, Virginia. He has this massive archive of family photographs, and there was a Polaroid of my grandmother and her youngest sister dated August 1967. They would have been in their mid- to late twenties, and at that moment, their interior lives developed into a kind of obsession for me. Nearing thirty at the time, I remember deeply contemplating myself and becoming

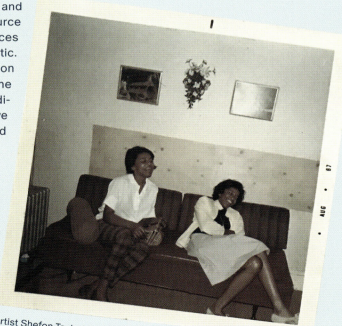

Artist Shefon Taylor's family photo (August 1967)

curious about their dreams, desires, fears, and everything I could not access about these women I had watched my entire life. The encounter with the image, the two of them, twenty-somethings, legs crossed, hands clasped at their knees, heads thrown back in laughter, I remember thinking to myself, "Who are these women? Like, who were you really, Mom Mom?" That photograph acted as a bit of a portal, permission to explore my own interiority. The casual haphazardness of that moment became the catalyst for what my artistic practice is today.

I have discovered over time that this work is always about little Shefon trying to get home and attempting to see more of herself as an entryway to the present and what it means to imagine her future.

Looking back on my grandmother's history and her sisters as a collective group, I delight in reimagining their lives individually and using it as a way to interrogate and define femininity, womanhood, motherhood, and daughterhood for myself. I suppose by holding the women with whom I share blood, I ultimately take pleasure in holding myself.

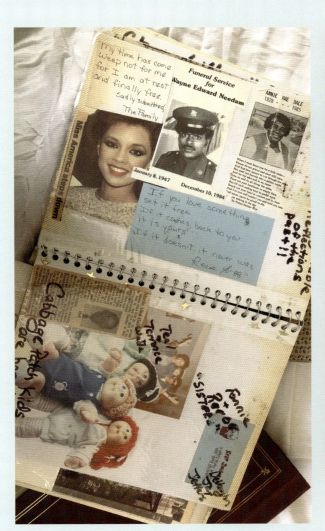

Artist Shefon Taylor's family scrapbook

Interior project, featuring Shefon Taylor's "Can You See Us Now" collage, New York City (2022)

TAPPING INTO YOUR BLACK IMAGINATION

Now that your imagination is primed and ready for creating, we want to give you some ideas about how you can see beyond some of the items that you may encounter in your own spaces. We encourage you to actively work to strengthen your ability to see beyond, as that is the only path to undoing the harms of the past and working toward a better future.

TIPS ON UPCYCLING AND DIYS

Gallery Wall DIY: Collage walls have been all the rage since their humble beginnings as "salon walls" in seventeenth-century France. The gallery wall is a useful tool in curating a space and adding personal touches to your walls.

❶ Start with a plan. It's best to have all of your items laid out ahead of time, as spacing is crucial. ❷ Be open to incorporating nonframed items. Mirrors, paintbrushes, hand-painted signs, and small collectibles can add texture and make your gallery wall more dynamic. ❸ Only you can decide what is too much! Gallery walls get a bad rap for belonging to the maximalist aesthetic by default. Gallery walls are not predicated on a number of items, but on a way of arranging them. A gallery wall can be made with five or fifty pieces: You get to curate

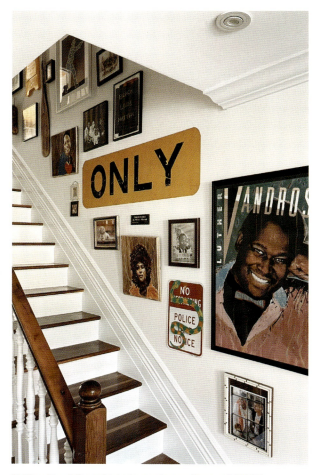

"A Very Good Home" interior project gallery wall (2022)

A number of studies have codified and scientifically established the fact that listening to music stimulates divergent thinking and spurs creativity and imagination. Here are some songs that encourage our creative thinking and help us get in the groove of imagination. Next time you swing by the shop, see how many you recognize setting the vibe!

"O.P.P." by Naughty By Nature, cassette tape

Black Imagination Playlist

a wall that fits your style, whether you lean toward maxi or minimalist vibe. ❹ Incorporate shelving into your gallery to gain the extra benefit of storage. Don't be afraid to work large furniture into your gallery wall. Don't just let the gallery stop where the credenza starts; build a story from floor to ceiling. ❺ Lastly, when it comes to flat screens and mounted televisions, seeing beyond does not include seeing your TV wires. Please, for the love of the Black aesthetic, use cord covers. Covers are easy to install and can be painted or even worked into a funky pattern or accent. Please cover up!

Add Legs to That Thang!: Go on enough picking trips with us and you will frequently hear the refrain "We could put hairpins on it!"

❶ Beautiful live-edge black walnut wood slab? "Put some hairpins on it!" ❷ A 1920s steamer trunk with original hardware and hand-painted monogram? "Put some hairpins on it!" ❸ Large 1950s valve radio? Sand it, restain it, then "put some hairpins on it!"

Yes, there are other options for legs, but we love a good hairpin. Adding legs to a random object can take it from cumbersome to functional in no time. The radio on hairpins (fourteen inches tall) sits in the kitchen as décor and another surface to use or to style. The steamer trunk on four-inch hairpins can be used as a coffee table or a plant bench, with the extra functionality of storage inside. Creating levels and hidden storage are always a plus, so legs of any kind are an easy and inexpensive way to add to your interior aesthetic. This also holds true for casters or small wheels. In our shop we have a small seat for perusing record crates that is legit an eight-inch stump of wood with four casters screwed to the bottom. Adding casters to coffee tables and large furniture allows spaces to become convertible and multifunctional.

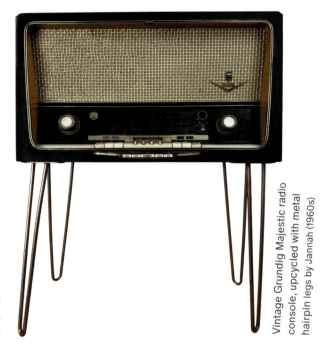

Vintage Grundig Majestic radio console, upcycled with metal hairpin legs by Jannah (1960s)

▶ "It'll All Be Over"	Supreme Jubilees	3:05
▶ "Liberated Brother"	Weldon Irvine	6:29
▶ "Morning Sunrise"	Weldon Irvine	3:19
▶ "Pure Imagination"	Lou Rawls	3:41
▶ "Just My Imagination"	The Temptations	3:48
▶ *Voodoo* (album)	D'Angelo	1:18:00
▶ "Imagination"	Earth, Wind & Fire	5:15
▶ "Fantasy"	Earth, Wind & Fire	4:37
▶ "If I Ruled the World (Imagine That)"	Nas, (feat. Ms. Lauryn Hill)	4:42
▶ "Imagine Me"	Kirk Franklin	5:18

Unconventional Furniture Usage: Be unconventional with your furniture and storage! Use your imagination to rethink the functionality of the pieces of furniture you have at your disposal. A shabby chic clothing dresser is currently being used as storage for pieces of our private collection. Equipped with compartments and dividers, we saw past the intended purpose and made the piece work for our unique needs. Similarly, a vintage Singer sewing machine table functions as our kitchen island. A deep clean and restaining made this piece a fun and functional addition to our space. If you're really adventurous, look for unique statement seating. In our first apartment, we had a beautiful 1940s mustard velvet and wood settee. In our second space, the living room was accented with a light teal 1960s salon styling chair. Our current living room is accented by a salmon-colored salon dryer chair, which is staged in front of our built-ins. For your space, try leaning into the Black aesthetic with an early 1900s porcelain barbershop chair à la Spike Lee's *Crooklyn* living room, or a peacock chair featured at a Black function near you.

Centering You in the Yule Log—Custom Holiday Ephemera: There are a number of phone apps that allow you to easily edit, animate, and meme-ify your photos. Make a collage on your own or via one of those apps and print it as your next holiday, birthday, or "just because" greeting card or gift wrap. Customizing gifts with custom paper, cards, or stickers make receiving it that much more special. Custom cards are great because the recipient is more likely to hold on to it

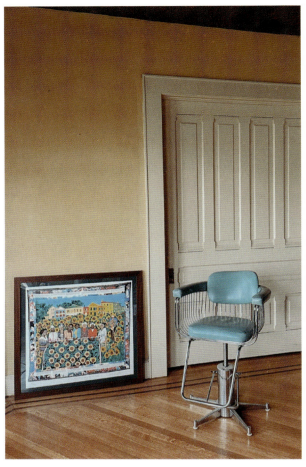

Vintage leather mint salon chair

▶ *Organic Dreams* (album)	Wendell Harrison	35:30
▶ "Untitled (How Does It Feel)"	D'Angelo	7:10
▶ "Pyramids"	Frank Ocean	9:52
▶ "She's Leaving Home"	Syreeta Wright	1:18:00
▶ "Night in Tunisia"	Miles Davis	4:20
▶ "Take Five"	Quincy Jones	3:29
▶ "I Shall Be Released"	Nina Simone	3:53
▶ *Seat at the Table* (album)	Solange	51:55
▶ "Things I Imagined"	Solange	1:59
▶ "Umi Says"	Mos Def	5:05

Black Imagination Playlist

than store-bought cards, as the love is in the time and effort it took to create.

Make It Last Forever: Picture books are becoming a great option for gift giving. Everyone has at least a thousand images on their phone nowadays, so give the gift of curation. A ten- to twenty-page photo book is both an inexpensive and a thoughtful way to materialize the digital images we may take for granted. Bonus points for adding text, a letter, or a poem to make it especially tailored and more dynamic. Weddings shouldn't be the only time you order a photo book. They are a lot more practical than loose photographs and allow you to keep the memories protected and contextualized for future generations.

Remix Your Threads: One really easy way to add some juice and new life to your aesthetic is to be creative with your clothing. From buttons and patches, mends and personalization, to hand-done embellishments and accents, there is no shortage of ways you can upcycle, reimagine, and remix the things you wear. The idea of hand-painting clothing was introduced to me recently with some pretty dope results. Client, friend, and artist Aya Brown's creative approach knows no bounds, we should all try to get like her . . .

BLK MKT VINTAGE: When you dropped in the shop a couple of weeks back, you had the leather jacket on and it was still red, white, and blue. How did the jacket evolve and come to be in its current iteration?

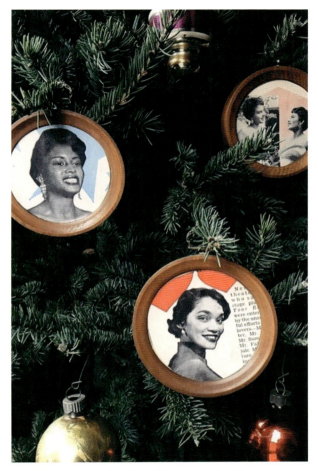

DIY holiday ornaments, collaged by Kiyanna (2019)

▶ "On & On"	Erykah Badu	3:46
▶ "Mystery of Iniquity"	Ms. Lauryn Hill	5:10
▶ "I Gotta Find Peace of Mind"	Ms. Lauryn Hill	9:18
▶ "Fight the Power"	Public Enemy	4:42
▶ "Mango (Freestyle / Process)"	Orion Sun, Mulch	4:50
▶ "Vibe (If I Back It Up)"	Cookiee Kawaii	1:23
▶ *The Wiz* movie soundtrack	Various Artists	1:19:00
▶ *The Music of Revelations* (album)	Alvin Ailey American Dance Theater	29:31
▶ *Songs in the Key of Life* (album)	Stevie Wonder	1:45:00
▶ *Black Radio (album)*	Robert Glasper	1:05:00

The jacket in question is a 1980s Michael Hoban, leather bomber jacket. Known for his striking designs and bolds colors, Hoban, a white man from Queens, New York, made a name for himself when his jacket was shown in an episode of *Seinfeld*. Better known for the 8-Ball jackets that were a staple in New York streetwear and gang culture, Hoban's aesthetic is recognizable to a large number of Black folks, even if they don't know his name.

AYA BROWN: Literally, that week I saw you at the shop it just came into my fucking mind . . . every other day I'm on eBay not buying shit—lol. I was just on the site where I could sit in this archive of sorts and find inspiration to tell stories. And in a similar way to hip-hop and even eras before, remixing shit and sampling stuff [was a way of life and art]. You know there's [a specific aesthetic] culture behind this leather bomber jacket stemming from the '90s. A [singular] style of jacket can sometimes connect the whole tribe, [community, block, gang, or clique].

I think in a way these jackets have told our stories before or given us the reason to define ourselves [or our community]. Thinking about painting the jacket I'm like this [interpretation] will be crazy. Like this shit says USA and has an American flag but this jacket is Black! IDGAF who made it, it's Black. Like I've come to know these jackets not when the white guy made them, but I've seen the jacket in the hood [context], so how can I make this more Black? More ours? In the same way that I play around with other clothing, it's like, How can

I define myself more through this? How can I remix this even more so it sounds like us, so it looks like us? That's how I imagined it.

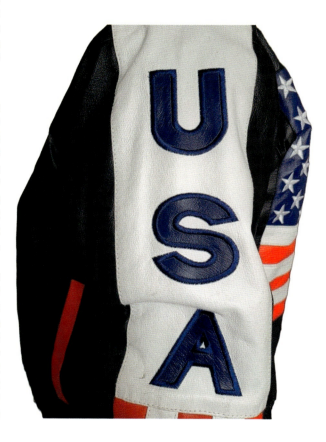

Black Imagination Playlist

▶	*Black Radio Recovered* (album)	Robert Glasper	37:23
▶	"Don't Worry"	The Roots	4:19
▶	"Optimistic"	Sound of Blackness	5:18
▶	"Viva Nigeria"	Fela Kuti	3:47
▶	"Whitney on the Moon"	Gil Scott-Heron	1:59
▶	"Silly Games"	Janet Kay	3:53
▶	"Love Is the Message"	MFSB	5:13
▶	"Black Maybe"	Syreeta	4:34
▶	"Les Fleurs"	Minnie Riperton	3:19
▶	"P-Funk (Wants To Get Funked Up)"	Parliament	7:39

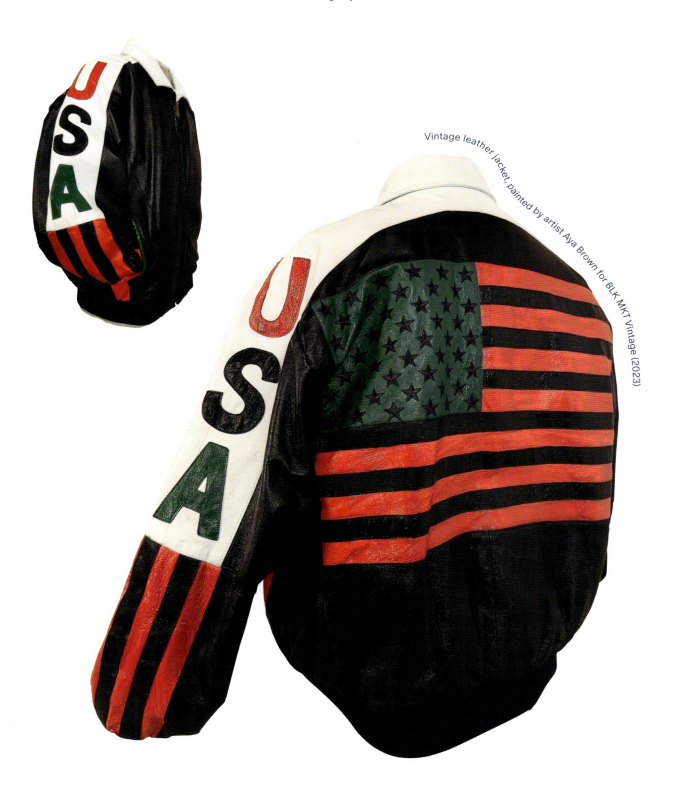

Vintage leather jacket, painted by artist Aya Brown for BLK MKT Vintage (2023)

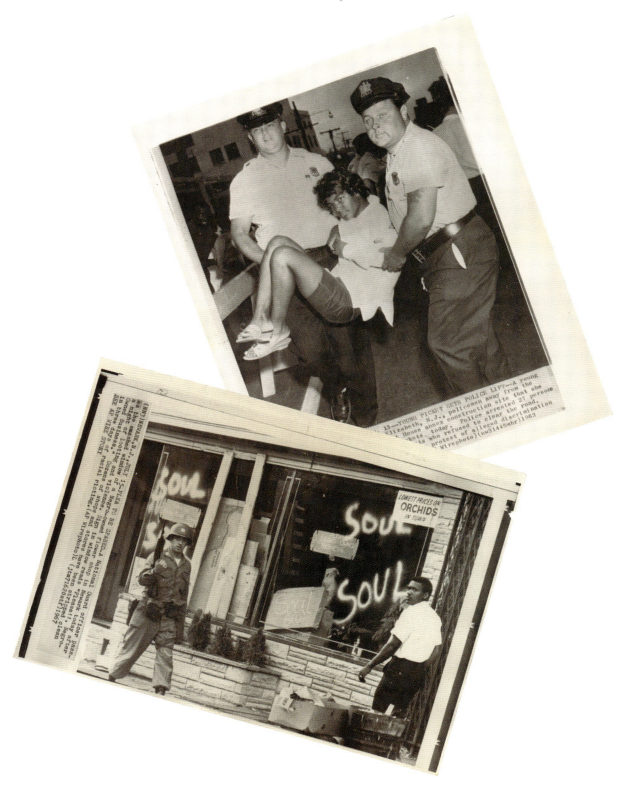

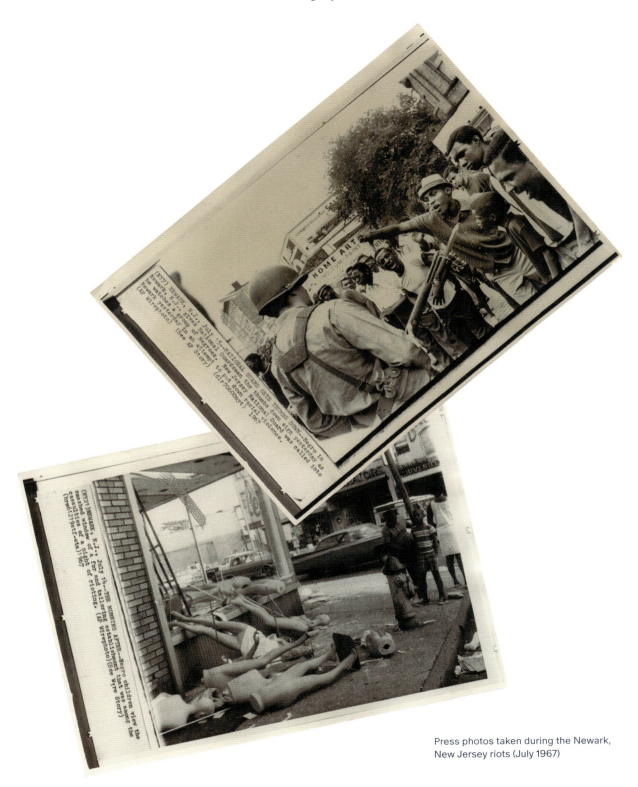

Press photos taken during the Newark,
New Jersey riots (July 1967)

WHAT'S NEXT

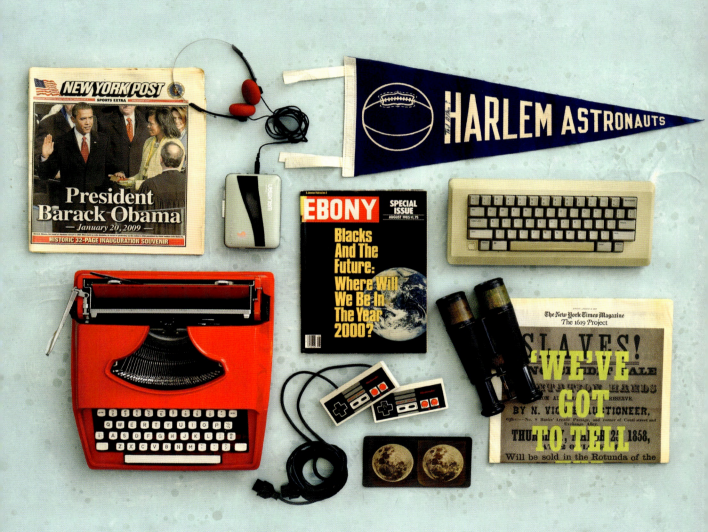

From left → 1. *New York Post* (2009); 2. Sony Walkman (1990s); 3. Harlem Astronauts felt pennant (1960s–1970s); 4. Remington Starfire typewriter (1950s); 5. *Ebony* magazine (1985); 6. Vintage Nintendo controllers; 7. Antique stereoview card; 8. Vintage Apple keyboard; 9. Vintage binoculars; 10. *New York Times* 1619 Project Special Edition (2019)

WRITTEN BY

Jannah

At about **3:00 A.M.** EST or 7:00 a.m. UTC, I was scrolling on an NFT app called OpenSea. A big art collection drop just happened, and I was caught up in the frenzy of the **"MINT AND REVEAL"** process to get the one I really wanted. Kiyanna was awakened by the consistent jolts of my swiping and the glow of the phone screen. She asked what I was doing. I explained that an **NFT DROP** had just happened and I was trying to secure the best one. Half annoyed and half still asleep, she reminded me that I had to be up early to open our shop later in the morning. I assured her that I was going to sleep soon as she rolled back over. I laughed to myself that my **NON-FUNGIBLE** (digital) collectibles were getting in the way of my **FUNGIBLE** (physical) ones.

As I tried to get back to sleep, I pondered: Will there be a point in my lifetime when all human life is lived in the cloud and blockchain? If so, are the NFTs I'm buying going to be groundbreaking and valuable in their relative newness to the technology?

I let my imagination speculate about the ways technology and the space of antiquities will evolve after I am long gone. Will all official documents be web-based, so the days of finding paper birth certificates or marriage licenses be gone?

As the creation of content shifts to artificial and machine-based sources, will the days of tracking down movie props like the *Wiz* taxi be obsolete because the taxi in question was just CGI or created through some type of machine learning and was never real or material to begin with?

One critical question arose as I finally put my phone down after securing the perfect Black Astronaut from the Auktar NFT collection—What will tomorrow's vintage be? And, more importantly, how can we all participate in making sure it's preserved and accessible, so, if for nothing else, we are remembered for having been here.

This chapter looks to the future, which really starts today. Rooted in the theories of Afrofuturism, we will talk about what the future can look like with intentionality. As two Black, queer women, we know

Akutar #8474, NFT digital art (2022)

that our presence is not always accounted for when plotting out the future. How do we ensure our representation in the future and inclusion in a world we are helping to build and shape?

On the industry level, we know there will be natural shifts, not only in the items we will be encountering but also in the means through which we do business. We talk about how technology will shift the collecting and documenting landscape and how we plan to adapt and overcome.

If the previous pages haven't done enough to convince you, we will end with a charge and some homework.

We encourage you to take account of Black cultural ephemera in your immediate circles—what's in your aunt's, mama's, and great-granddad's basement? Do you have a will? How are your family's photo albums being preserved? Can you talk to your grandmother and record (with her permission) conversations about her

The Black Astronaut, by Stu Gilliam, vinyl LP (1960s)

upbringing and gain insight into the context she grew up in? In one last-ditch effort, we encourage you to invest somewhere in the vintage/antiques ecosystem, consider legacy building, and close this book inspired to see the valuable history and material culture that's all around you.

LOOK OUT, SHORTY! AI'S GON' GET YOUR MAMA!

With new technology comes new fear. With an increasingly online and digital world, the reality of increased surveillance, cyber aggressions and attacks, and regressive forms of eugenics and algorithmic stereotyping are not relegated to a far-off future. We are feeling the effects of it now. Every time a touchless faucet in a public restroom doesn't recognize my brown skin and refuses to turn on, I am reminded of how the assumption that tech is race-neutral and data-driven is utterly wrong. Additionally, with the onslaught of machine learning and AI (artificial intelligence), there are fears about the future of content creation and

authorship, rouge (and, worse, vindictive) computer overlords, and the blurred concept of what is real and fake in the media.

Despite the noted drawbacks, machine learning is being touted as the next big technological advancement, ushering in a computational renaissance unlike anything we've experienced before. As someone interested in tech, I understand how the democratization of machine learning and generative software is groundbreaking. But as a Black person and an antiques collector, I can't fully embrace the inauthenticity. The content generated is not coming from a real place. I value things that are real. That are fact. Spend enough time on Audre Lorde's internet and you start to spot the telltale differences between machine-generated and human-generated content.

For me, AI and machine learning take human living and experiencing out of the equation. Remove the "brain" from the function. As a person who occupies a number of marginalized identities, I have a robust understanding of the ways my personhood and lived experience are devalued and erased. I see machine learning as an extension of that paradigm. The person is literally taken out of the equation.

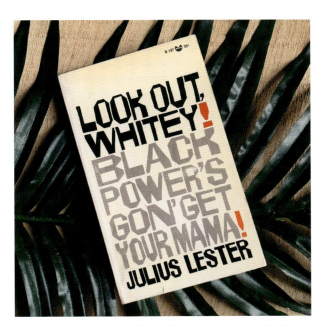

Paperback edition of *Look Out, Whitey! Black Power's Gon' Get Your Mama!*, by Julius Lester (1969)

RAP MUSIC – BLACK PEOPLE ——— AI RAPPERS	TELEVISION – HUMAN WRITERS ——— MINI-WRITERS' ROOMS AND AI-GENERATED SITCOMS	CUSTOMER SERVICE – HUMANS ——— PRETTY MUCH THE SHIT WE HAVE NOW

We encourage you to create! To document and to bear witness to the world around you as there is no replacing the real thing. We are nowhere near the extinction of material culture. The space we occupy now is one of asking how we see technology fitting into the world we live in. While technology can do a lot and has the potential to address some of the most pressing issues facing the human race, computers and machines will not replace us. Talk to your family, your friends, and your contemporaries to document their stories.

Give it a try yourself! How does a conversation with AI stack up against a conversation with your mother?

TOMORROW'S VINTAGE

In a world of fast fashion, the cloud, metadata, and evolving (and in some cases devolving) social media platforms, we are faced with a real question in our line of work—*What will tomorrow's vintage be?* Not solely in a rhetorical way, but in a very practical way. Will all physical forms of information and data be uploaded into the cloud? Will the days of finding old photo albums or scrapbooks be nothing but a memory?

The short answer is no. Regardless of how digital the world we occupy may become, we will always have physical manifestations of our humanity. Our culture. Barring natural disasters or cataclysmic events, humans are tactile creatures. We respond to things we can see, feel, hear, touch, and experience. Regardless of what my anxiety tells me when I'm late or have to miss an auction or market, we will not run out of vintage material culture.

The items of my youth are quickly becoming vintage, and that is a rather surreal experience. The obsolete and antiquated technologies of the past are a reminder that time and technology march on. Being in the vintage space allows me to take account of and document the progression of time. As such, I have a collection of vintage tech: televisions, radios, computers, camcorders, and video game consoles. Some of which I have vivid memories of using and others are just referenced in history books. To see the items together offers a very humbling perspective on the progression of technology over a time continuum.

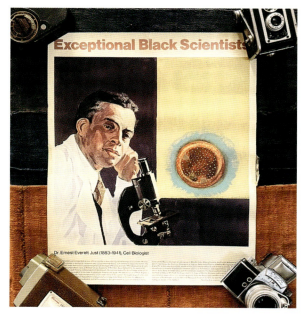

Exceptional Black Scientist poster (1970s)

So what will tomorrow's vintage be? Simple—the things we put intention into saving and documenting. Our old iPhones when we get an upgrade. The newspapers that commemorate a big event—yes, you must find the one remaining newsstand to accomplish this. The program from your niece's college graduation, the one who was born in the 2000s! The things we find important and integral to our lived experience will be the items that outlive us.

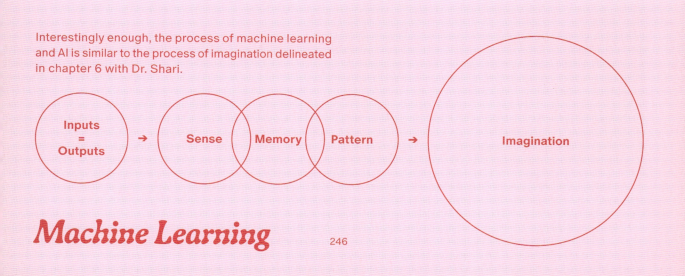

Interestingly enough, the process of machine learning and AI is similar to the process of imagination delineated in chapter 6 with Dr. Shari.

Inputs = Outputs → Sense · Memory · Pattern → Imagination

Machine Learning

246

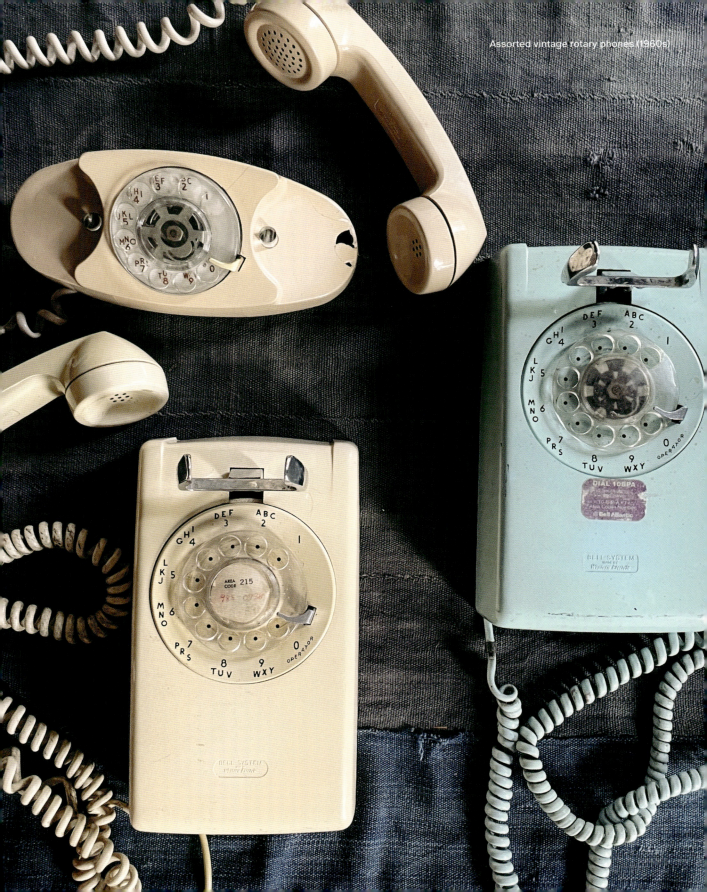

Assorted vintage rotary phones (1960s)

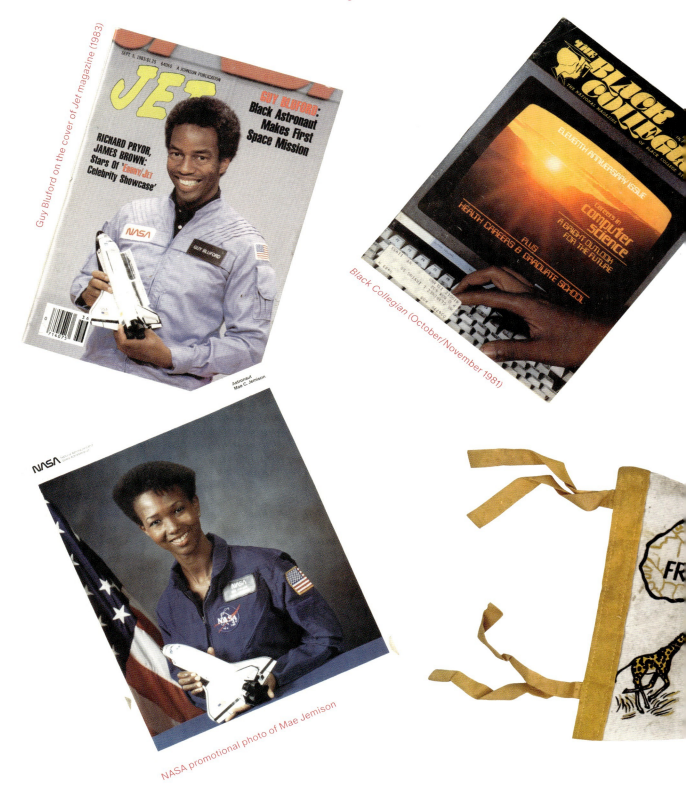

Guy Bluford on the cover of Jet magazine (1983)

Black Collegian (October/November 1981)

NASA promotional photo of Mae Jemison

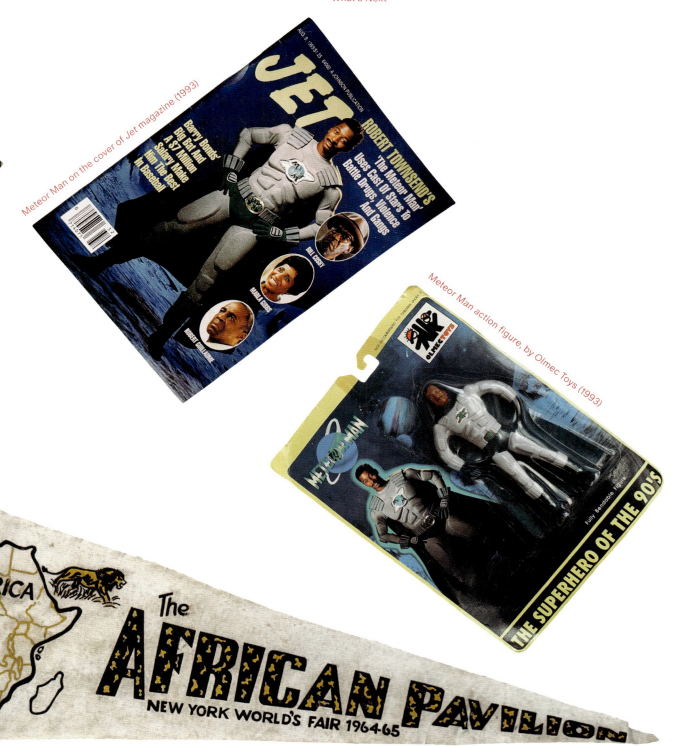

Meteor Man on the cover of Jet magazine (1993)

Meteor Man action figure, by Olmec Toys (1993)

African pavilion at the New York World's Fair felt pennant (1964)

WHEN YOUR THINGS OUTLIVE YOU

Having a curated collection while you are living is more than half the battle, but what did you put in place to safeguard your items once you are gone?

Ensuring your legacy through:

Intentional documentation. Documenting the present with the future in mind is an imperative. Taking account of your current-day experiences, major events, societal shifts, and familial or communal ties becomes a personal time capsule for future generations to glean insight from, be encouraged, or affirmed in.

Curated collecting. Create a collection with a point of view, a throughline that helps the next owner understand the goals of the collection. That info is important in figuring out the next steward or location of your collection.

Contextualized archiving. The homie Syreeta Gates sums this up perfectly: "Years ago, my good sis Renata [Cherlise] was collecting material for her genius *Black Archives* book, and there's a page with two pictures on it—one photo with my mother and two cousins. The other photo is of my grandmother. I wrote "Grandma Q" in the email because I was rushing. When the book dropped, I realized I fucked up. Grandma Q? What does that even mean? My grandma's name doesn't even start with the letter Q. So labeling things and giving materials context is important in the long run. You've gotta take your time. My archivist and conservation friends would probably be mad at me for saying this, but even more than preserving materials and ephemera is giving it all context. Because who the fuck is Grandma Q, bro? It's Jessie Mae Jones Doherty till the end; tell a friend!"

Preservation for longevity. Preservation is not only relegated to the white glove crew with degrees and institutional resources. At the individual level, it's important to take care of the items we are investing in. Take the time to learn best practices for expanding the life span of your ephemera. If resources permit, at the bare minimum invest in archival boxes or sleeves and backing for your paper ephemera. Another way to safeguard condition of an item is to invest in framing.

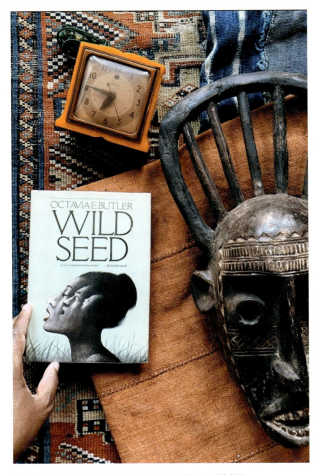

First edition of *Wild Seed*, by Octavia Butler (1980)

Estate planning. Some folks don't want to engage in estate planning because they believe it will jinx them. Me—I am some folks. However, we compiled a list of questions that could be helpful in beginning the conversation:

❶ Are there things I can do today to safeguard my collections or effects? ❷ Is signing a note expressing your wishes enough? ❸ How do I create plans for my estate, keeping my cultural identity and traditions in mind? ❹ What websites, apps, and digital/local resources exist to help with the undertaking of estate planning? ❺ Look up "last will and testament" and consider how it might assist you in clearly defining the ownership of your material possessions.

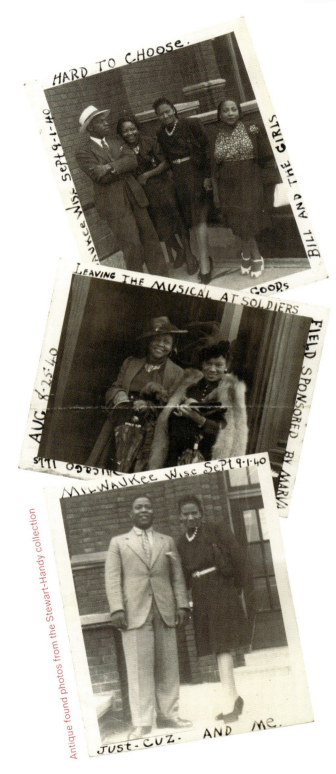

Antique found photos from the Stewart-Handy collection

HARD TO CHOOSE.

Milwaukee Wise Sept-1-40

BILL AND THE GIRLS

LEAVING THE MUSICAL AT SOLDIERS GOODS

AUG 8.25.40

FIELD SPONSORED BY MARVA

Chicago ILLS

MILWAUKEE WISE SEPT 9·1·40

JUST·CUZ. AND ME.

AT THE END OF THE DAY . . .

As we noted in the introduction, our goals in writing this book included the following:

Democratize Black cultural ephemera. There's value here for everyone.

Peel back the curtain on our process and share a bit about ourselves.

Provide a theoretical and contextual grounding for our work.

Reveal some wild stories and encounters from our picking adventures.

Introduce and highlight the community that makes this industry go 'round.

Dish industry tips and tricks, so you can engage in this work in your own lives, spaces, and communities.

A cell phone timer goes off, and from the dining room Kiyanna says with a laugh, "Pencils down, session is all done." We've reached the end of another timed writing stint and it is time for a break. As I write this during our "mandatory" stretch break, I am left trying to decide, if, in fact, we are "all done." Have we completed the tasks we set for ourselves at the outset of this text? Is it enough? Is it too much? At the very least, if folks don't get it, they'll like the pretty pictures, right?

▲▲▲▲▲

This book was not meant to be a definitive text on what Black material culture is and how it functions in our sociopolitical world. *BLK MKT Vintage* is an attempt to document our story thus far as partners in life, love, and vintage™. A contemporary account of how we came to be, the ways we interact with the constellation

of stakeholders in the secondhand industry, and the tremendous amount of work and intention centered around how we value and make accessible Black history. We hope this book adds context, both in the present and the future, to the tens of thousands of items we sold and that currently occupy space in folks' homes and collections. In addition to that, we hope this book adds value to the pieces our clients have acquired from us in the last ten years. Contributing to the story of provenance for their acquisitions and casting light on the vintage market from 2014 to 2024.

Perhaps more selfishly, we wrote this book with the main purpose to be found. Reclaimed. Claimed or bequeathed. We place our material culture, the items of mundane Black life, in such high regard that we put the incredible amount of time and effort into writing this book so it can be experienced, engaged with, and provoking. Whether it be right after publication or a hundred years from now, we hope folks will allow themselves to go down the wormhole of history and discover something about themselves through these evocative pieces.

jaleelwhite ✔

Liked by **19,845 others**

jaleelwhite People do clumsy stuff around me ALL the time ☀️ BUT U LET ME DROP MY DAMN SMOOTHIE ON THE FLOOR AS SOON AS THEY HAND IT TO ME ONE TIME... JUST ONCE... and everybody leans in wanting me to say it... DID I DO THAT?????? 👆😝👆 Can't believe y'all out here still reselling these dolls 30 years later @blkmktvintage 🤯 🙏 Why Hasbro make my butt so flat tho? 🤔 No shaping at all 🍊 I was a nerd with a bootie. Y'all need to know 😏 Photo Cred: @kyleshevrin 📸

View all 700 comments

March 20, 2021

Jaleel White on BLK MKT Vintage Instagram account selling Steve Urkel dolls (2021)

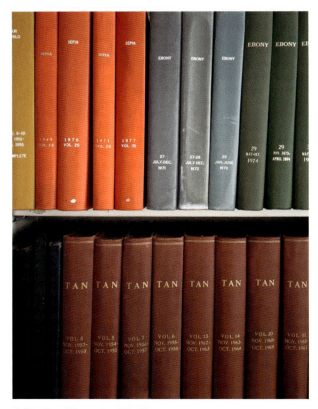

Collection of bound publications

A CHARGE FOR YOU

Self-discovery and articulation are processes we engage in every time we consult the archive. What are the things we see and what do they tell us about ourselves? Our contemporary existence? In one final push to fully convert you to the church of BLK MKT Vintage, we have a charge for you. Well it's more than one charge, but the Donny Hathaway reference would've fallen flat . . .

Join the ecosystem. This is a charge to engage in the secondhand industry as a buyer or seller. It is imperative to our environment, preserving our stories, and supporting local and small businesses. Having more people engaged in this industry, namely Black folks, will allow for the proverbial net we cast to get bigger, and more pieces of history to be saved. More importantly, more people engaged in the space is a collective statement of value and investment.

Create and document. What you make today is tomorrow's vintage. Document your stories and take steps to preserve them. Do dope shit with your dope friends. Add to the tapestry of material culture with accounts of your day-to-day life. Don't forget to add context; don't be like "Grandma Q."

Pass the mic. Take account of your privilege and pass the mic to those who don't hold the same.

Be intentional. Donate and sell us your things.

Imagine. It would be simple enough for this charge to be, "Go imagine something," but that's easy. We hope you leave this text open to inspiration. Open to actively and intentionally engaging your imagination in your daily life. Don't relegate creative thinking only to your job or your career—imagine worlds and lives other than your own. Use history to spark your imagination through an investigation of material culture.

BLK MKT VINTAGE FUTURE

What's next for us is utterly exciting. We are grateful we get to live a passion-driven life. It is a tremendous privilege and we do not take it lightly. In our great quest to reclaim ALL of our things, we see expansion in the future. A bigger spot . . . another shop . . . We have

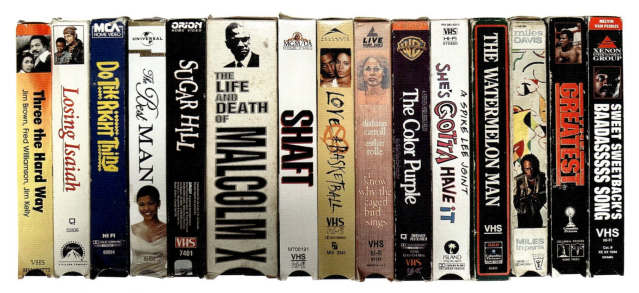

Assortment of vintage VHS tapes

growth on our minds to facilitate a deeper and more far-reaching impact. At the time of publication, we will have opened our new location, as our current lease is up in July 2024. Additionally, we are exploring other mediums and outlets in order to engage in imaginative storytelling around the history and experiences we have at BLK MKT Vintage.

Expansion also looks like reclaiming land and space. We are new homeowners and have given clients a glimpse into the interior design and renovation process. In the future, we hope to take you into other spaces our work has taken us—museums, private collections, and clients' homes. Book two is already on the horizon and we have some fun conversations and threads to explore. Additionally, we have always pontificated about what a BLK MKT Vintage bed-and-breakfast would be like or a dedicated living space that offers folks a different way to engage with Black material culture and the Black aesthetic. Lastly, expanding the Stewart-Handy collection, our private collection and archive, is always at the forefront of our minds. What are the items we can uncover and the stories we can share? Where are the new places the Black history wormhole will take us?

BLK MKT

VINTAGE BLACK CURIOSITIES, CASTOFFS, AND COLLECTIBLES.

VINTAGE

▲▲▲▲▲

Nine years ago, while we may have wavered around the name or logo of the business in its first iteration, our tagline was consistent:

We'd hoped then, as we hope now, that the pieces of Black history we collect spark curiosity in folks. Makes them reconsider why certain items are cast off to begin with and encourage them to engage with collectibles for future generations. The last couple

Jannah and Kiyanna at the Weeksville Heritage Center (photograph by Adreinne Waheed, 2022)

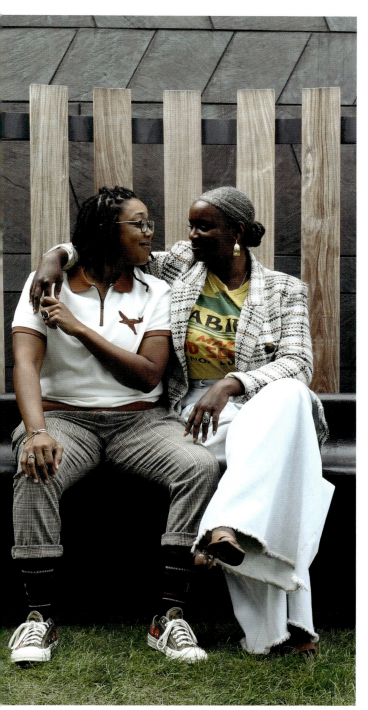

hundred pages really boil down to being receptive to the inspiration that's all around us. We just so happen to do this through vintage and material culture. Others in this book do it through art or architecture, through leaning in and preserving the record, or by not engaging with vintage materials at all.

Regardless of your point of entry, in numerous ways we have illuminated the importance of documenting and investing in the representation of marginalized identities. We hope this book stands as a testament to the vision we had for BLK MKT Vintage in 2014. Creating a space where we could be seen as individuals but also as an institution committed to the valuing of the Black experience. In this very specific way, the seeking out of Black material culture, we are able to honor those who have come before us, inspire those who are our contemporaries, and represent for the future generations. Intention around our things has a direct impact on the intention with which we choose to live. Planning for a future is only possible if you can imagine yourself in the future.

As bell hooks says, "Since decolonization as a political process is always a struggle to define ourselves in and beyond the act of resistance to domination, we are always in the process of both remembering the past even as we create new ways to imagine and make the future."

For us, there is no better way to put it, ". . . remembering the past as we create new ways to imagine and make the future." This isn't a call to be essentialist and myopic about considering life along the time continuum, just a suggestion to consider the past and future context as a means of understanding more deeply the world you occupy today.

INTRODUCTION

xxii *That we can be in the words of Gwendolyn Brooks: The Essential Gwendolyn Brooks* (Ypsilanti, MI: Library of America, 2005

CHAPTER 1

13 *nostalgic*; adj: *longing . . . past time or condition*: Merriam-Webster.com, https://www.merriam-webster.com/dictionary/nostalgic.

13 *dissonance*; n: *lack of agreement . . . mingling of discordant sounds*: Merriam-Webster.com, https://www.merriam-webster.com/dictionary/dissonance.

13 *cognitive dissonance; n: the mental conflict . . . Leon Festinger: Encyclopedia Britannica* (August 7, 2023), https://www.britannica.com/science/cognitive-dissonance.

13 "*peculiar sensation*" *. . . dark body*: W. E. B. Du Bois, *The Souls of Black Folk: Essays and Sketches* (Chicago: A. G. McClurg, 1903), p. 98.

16 "*[G]ifted with a double vision . . . same time*": Richard Wright, *The Outsider* (New York: Harper and Row, 1953), p. 129.

18 *The American Negro . . .* "*repair and offset*": Arturo Schomburg, "The Negro Digs Up His Past," *Survey Graphic* (March 1, 1925).

18 "*It occurred to me then . . . acts of concrete reclamation*": bell hooks, *Art on My Mind: Visual Politics* (New Press, 1995), p. xv.

CHAPTER 2

24 *Lastly and earliest . . . by a white, racist mob*: David Ruggles Center for History & Education, https://davidrugglescenter.org/david-ruggles.

25 *Joshua Clark Davis writes about . . . National Negro Business League*: Black Perspectives, https://www.aaihs.org/black-owned-bookstores-anchors-of-the-black-power-movement.

25 *42 percent of new women-owned businesses*: Ruth Umoh, "Black Women Were Among the Fastest-Growing Entrepreneurs—Then Covid Arrived," Forbes.com, October 26, 2022, https://www.forbes.com/sites/ruthumoh/2020/10/26/black-women-were-among-the-fastest-growing-entrepreneurs-then-covid-arrived/?sh=77ac117a6e01.

CHAPTER 3

47 *value*; n: *. . . and independence:* Oxford English Dictionary, 2nd ed. (Oxford, UK: Oxford University Press, 2004), s.v. "value."

48 *rarity*; n: *. . . morning off was a rarity*: Oxford English Dictionary, 2nd ed. (Oxford: Oxford University Press, 2004), s.v. "rarity."

48 *scarcity*; n: *. . . a time of scarcity:* Oxford English Dictionary, 2nd ed. (Oxford, UK: Oxford University Press, 2004), s.v. "scarcity."

52 *On a real level . . . business as usual*: NY1, October 6, 2021, https://ny1.com/nyc/all-boroughs/health/2021/10/06/u-s--covid-deaths-in-2021-top-2020-total.

53 *The resale industry, across the globe*: Jia Wertz, "Rise of the Resale Business in the Retail World," Forbes.com, October 31, 2022, https://www.forbes.com/sites/jiawertz/2022/10/31/rise-of-the-resale-business-in-the-retail-world/?sh=cfab1187796e.

68 *more than twenty thousand auction houses in . . . 2021*: "Used Goods Stores in the US," IBISWorld, March 1, 2023, https://www.ibisworld.com/united-states/market-research-reports/used-goods-stores-industry/#IndustryStatisticsAndTrends.

68 *provenance,* n: *. . . authenticity or quality*: Oxford English Dictionary, 2nd ed. (Oxford, UK: Oxford University Press, 2004), s.v. "provenance."

CHAPTER 4

101 *The Library of Congress holds the original score*: Library of Congress, https://www.loc.gov/preservation/care/light.html.

CHAPTER 5

164 *We couldn't walk through . . . this intersection*: Stuart Hall, ed. *Representation: Cultural Representation and Signifying Practices* (London: Sage Publications & Open University, 1997), pp. 1–11.

165 *The Association for Consumer Research . . . especially family and friends*: Stacey Menzel Baker and James W. Gentry, "Kids As Collectors: A Phenomenological Study of First and Fifth Graders," in Kim P. Corfman and John G. Lynch Jr., eds., *NA—Advances in Consumer Research* 23 (Provo, UT: Association for Consumer Research, 1996), pp. 132–137.

NOTE: Page references in *italics* indicate illustrations and captions.

A

Abney, Nina Chanel, *58*, 206, 226, 227–229
activations, 36–37
aesthetic value motive, 60
Africa '70, *130*
African National Memorial Bookstore, 22, *25*
Afri-Cola crate, *xxiv*
Afro Hair Specialties comb display, *157*
Afro Kola, 101, *101*
Afro picks, *39*, *76*
Afro-American Distributors, 101
Afrocentric schools, 8, 9
Afrofuturism, 244
Afropunk, 37
AfroTech, 37
Aghayan, Ray, *181*
AI (artificial intelligence), 245
Ailey, Alvin, 121
air fresheners, *144*
Akutar NFT collection, 244, *244*
Ali, Muhammad, *59*, 150, *150*, 180, *202*
Allegheny Airlines, 150, *150*
Alvin Ailey American Dance Theatre Presents: Revelations, 121
American Pickers, 50
Angelou, Maya, 137
Apollo Theater, 37
Apple keyboard, *242*
architectural salvage, 52
Art on My Mind (hooks), 18
Ashton, Kenneth, 132
Association for Consumer Research, 165
auction houses/listings, *67*, 68

B

baby powder bottle, *170*
backgammon board, *xxiv*, *93*
Baker, Ella, 35
Baker, Ginger, *130*
Baker, Josephine, *xxiv*, 10, *10*, *11*, *19*, *64*, 65, *131*, 206, 207
Baldwin, James, 126, *126*, 128, 137, *137*, 138–139
Baldwin, Quincy, 132
banjo-playing figurine, *44*
Baraka, Amiri, 137
barn finds, 52

Barnes, Salena, *208*
baseball cards, *ix*
Beacoup Hoodoo, 29, *30*, *34*, *35*
beer advertisement, *15*
"Behold the Land" (Du Bois), *70*
Belafonte, Harry, *viii*, 88–89
binoculars, *242*
Black & Beautiful conditioner, *32*, *151*
Black & White Company, 146, *146*, *147*
Black ABCs set, 99, *99*
Black Archives, 188, 191
Black Arts Movement, 172
Black Astronaut, The (Gilliam), *244*
Black Betty Boop, 31
Black bookstores, 24–27
Black Chamber of Commerce, 27
Black Collegian, *248*
Black community (term), 166
"Black Cut" barbershop sign, *76*
Black Heritage paperbacks, *xiv*
"Black Is Beautiful," *58*, *127*
Black Orpheus: A Journal of the Arts from Africa, *vi*, 134–135
Black Panther, *209*
Black Panther Newspaper, 92, *92*, *94–95*, *160*, *172*, *220*
Black Panther Party, 140–141, 141
Black Poetry (Randall), *vii*
Black Stars, *xvi*
Black Veterans for Social Justice, *160*
blackamoor chalkware decor, *113*
Blacks & Whites board game, 62–63
BLK socks, *71*
BLK: The National Black Lesbian and Gay News, *xiv*, *54*
Blue Horizon Ballroom, 145
Bluford, Guy, *248*
books, handmade, *xiv*, *11*, *86*
bookstores, 24–27
Booth, Steven D., 175, 179–182
boxing ephemera, *178*
Braille sheet music, *54*
brand partnerships, 36–37, 205, 207
Brimfield Antique Flea Market, *75*
Bronze Thrills, *104*
Brooklyn Civic Council, *37*, *38*
Brooklyn Museum, 37
Brooklyn-Manhattan Transit Line, *xxiv*
Brooks, Gwendolyn, *xxii*, 167, *168*
Brown, Aya, 224, *224*, 237–238, *238–239*
Brown, Nakeya, *xxii*
bumper sticker, *65*
bundling, 65
Butler, Jerry, *15*
Butler, Octavia, *250*
buyer's premium, 68–69

C

Cables to Rage (Lorde), *162–163*
cajun food and beverage books, *185*
Callahan, Ed, *106–108*
cameo patch, *202*
cameras, *xiv*, *xxiv*, *170*, *202*
"Can You See Us Now" (Taylor), *233*
Cancer Journals, The (Lorde), *162–163*
Carlton, Carl, *169*
Carmichael, Stokely, *170*
Carothers, Yvonne, *187*
Carroll, Diahann, *181*
Cassien, 132
casters, 235
catch-all, ceramic, *59*
Chance, Malvina Mayo Jones, 196
Cherlise, Renata, 175, 188–191, 250
Chevremont, Racquel, 206
Chisholm, Shirley, *65*, *100*, 109, *109*
Civil Rights and Wrongs, *vii*
Clayton, Mayme, 24
cleanouts, 51
Cleaver, Eldridge, *173*
clothing, creativity with, 237–238
cognitive dissonance, 13
collage/collage walls, *xxiv*, 234–235
collecting, 164–166
collection
 care of, 78–79
 curation of, 26–28
 digitization and, 81
 location of, 79
 longevity of, 80
 motivation and, 79
 starting, 28–29
"Collections Care Guide" (LOC), 79
colon statue, *xiv*
Color Purple, The (Walker), 143
Colored Man Is No Slacker lithograph, *160*
Columbus, Christopher, 17
"Committee for Unified Newark," *142*
communal value motive, 60
compass, *58*
condition, price and, 74
contextualization, 40–41, 250
Cooper, Jerald, 230
cork cutout, *202*
corporate spaces, 55
costume rental, 35–36
Côte d'Ivoire, *xiv*
counternarratives, 167, 168–169, 172
crab paperweight, *xiv*
Craigslist, 57
crocodile head, *170*

crumb brush, *202*
Cullen, Countee, 85
cultural criticism, 24
culture, definition of, 164
curation, 26–28, 207, 250
customizing, 236–237
cut-paper silhouettes, 52

D

Damon, Cross, 16
Dark & Lovely T-shirt, 36
Davis, Angela, 36, *36*, 145, *145*, *171*
Davis, Joshua Clark, 25–26
decanter, *44*
Deloris, 132
democratization, 71–72, 187
design philosophy, 28–31
Dilward, Thomas, 185, 187
disclaimer, 57
DIY tips, 234–235
documentation, 250, 253
Doherty, Jessie Mae Jones, 168, 196
dolls, 27, *28*, 165
dominoes, *14*
do-not-sell price, 75
Dooley, Clyde, 132
Dorsey, Megan, 175–178, *177*, *178*
double consciousness, 13, 16–17
double vision, 16–17
Douglas, Emory, 92
"Dreams Come True," *146*
Drew, Dwamina, 172–173, *172*, *173*
Drum and Spear Bookstore, 24
Du Bois, W. E. B., 13, 16–17, *17*, *70*, 85
duality, 16–17
Dunbar, Paul Laurence, 153, *153*
Dutch cocoa, *170*
Duwayne, 132
Dynamic Design Industries, *62–63*

E

eBay, 56, 57
Ebony, xvi, *22*, 29, *40*, *41*, *44*, 68, 83, *83*,
 88, 89, *148–149*, *191*, *242*, *252*
Ebony Jr., *165*
Enstrumental brand, 172
environmental value motive, 60
ephemera, definition of, 56
Espada, Frank, *71*
Esquire, *xxi*, *xxii*, xxii, *xxiii*
estate planning, 250
estate sales, xv–xvii, *xvii*, *xviii*, 51, 52

Etsy, 56, 57
Everthine Antiques, 176, *177*
Exceptional Black Scientist, *246*
experiential marketing, 36

F

Fabulous Josephine Baker, The, *131*
Face to FaceTime (Handy), *xiv*
Facebook, 37
Facebook Marketplace, 57
family photos, *xxiv*
Family Pictures (Brooks), *168*
fans, *vi*, *vii*, *14*, *41*, *55*, *80*, *207*, *231*
FBI, *140–141*, 141, *173*
female impersonators, *182*
Festinger, Leon, 13
firm prices, 63, 74–75
Fisk University, *160*
Flame of Paris, The, *65*
40 Acres and a Mule Productions, *110–111*
48 Days: A Collection of Poetry
 (Stewart), *xiv*
Francis, Taj, *208*
Frank and his junkyard, 48–55
Free Angela Davis (Steiniger), *ix*
Freeman's auction house, 68
From a Land Where Other People Live
 (Lorde), *162*
fundraising cans, *152*
Funmakers Ball, *182*
furniture, unconventional usage of, 236

G

gallery walls, 234–235
gatekeepers, 71
Gates, Brenda Annette, 196, *197*
Gates, Syreeta, 168, 175, 196–200, 250
Gates Preserve, 168
generational wealth, 172
gentrification, 30
Geraldine, 27, *28*
Getty Research Institute, 179
Gill, Johnny, *36*
Gilliam, Stu, *244*
Givhan, Robin, 24
globe, *44*
Green, Misha, 207
Groovin' High (Ringgold), *88–89*

H

haggling, 61, 63–65
hair products, 27, 102, *102–103*
hair tools, *26–27*, *170*, *209*
Hall, Stuart, 164
Handy, Michael J., 8–9, 93
Hannah-Jones, Nikole, 17
Hansberry, Lorraine, 128, *128*
Harlem as Seen By Hirschfeld
 (Saroyan), *117*
Harlem Astronauts pennant, *242*
Harlem Renaissance, 85
Harriet Tubman Black Workers
 Congress, *172*
Harwood, Jim, *106–108*
Heinrich, June Sark, 99
Hello, Dolly, 18
Hemsley, Sherman, *202*, *221*
"Herbs of the Orisa, The," *65*
hip-hop ephemera, *200–201*
Hirschfeld, Al, 117
historical/educational value motive, 60
Hoban, Michael, 238
holiday ornaments, *59*, *237*
Holy Bible: Black Heritage Edition,
 197, *198*
Holy Grail list, 159
honey holes, 75
hooks, bell, 18, 255
How to Eat to Live (Muhammad), *68*
Howard University, *160*
Hughes, Amy, *100*
Hughes, Langston, *44*
humidity levels, 79
Hurston, Zora Neale, *22*, 27, 96, *96*, 198
Hylton, Misa, 199

I

Ici Bon Coiffeur (Lerat), *40*, *76*
imagination, 204, 234, 246, 253
In Our Mothers' Gardens, xviii
informal spaces, 54
Insecure, 36
institutional spaces, 55
interior design work, 34–35
Isaiah, Texas, 190

J

Jackson, Jesse, *180*
Japanese Tommy, 185, 187
jars, ceramic, *76*

Jemison, Mae, *248*
Jet, *xiv*, 83, *83*, 87, *87*, *129*, *154–155*, 178, *248–249*
Johnson, Beverly, *210*
Johnson, James Weldon, 85
Johnson Publishing Company, 87, *129*, 179–180, *180*
Jones, Ken and Regina, *193*
Jones, Matthew, 175, *192–195*
Jordon, Louis, 169, *186*
Josie Club, 206, *206*, 207, *207*
Juneteenth: A Celebration of Freedom (Taylor), *214*
Juneteenth T-shirts, *202*, 213–216, *215*, *216–217*, *218*

K

King, Martin Luther, Jr., *170*
Kings County Clubs, *22*
Knicks NBA, 31

L

Las Noches Rojas de Harlem, *32*
Lawson, Jennifer, 24
Lee, Spike, x–xiii, 156, *156*
legacy, ensuring, 250
legs, adding, 235
Lerat, Jean-Marie, *40*, *76*
Les Ballets Africains, *51*
Lester, Julius, *245*
Lewis, Shantrelle, xviii, 29
Liberation Bookstore, 24
Library of Congress, 79, 101
Life, 97
"Lifting the Veil" monument, *162*
light, avoiding direct, 79
Liston, Sonny, xxii
Live! (Ransome-Kuti), *130*
Locke, Alain, 85
Look Out, Whitey! (Lester), *245*
Lorde, Audre, *162–163*
Louis, Joe, *55*
Lovecraft Country, 205, 207, *208*
Luzianne tins, *60*

M

Mabry, Frank, Jr., 101
machine learning, 245, 246
Mackie, Bob, *181*
Magic Lantern glass slide, *56*

map of Africa, *49*
March on Washington, *5*, 210
marginalization, 169
Martha's Vineyard, *xiv*, 36, *98*
material culture, 164, 172
Material Life, 168–169, 184, 187
Mayme A. Clayton Library and Museum, 24
Mays, Willie, *ix*
Mead, Margaret, *126*
memory worker, use of term, 188
metadata, 81
Meteor Man, *248–249*
Michaux, Lewis, 24, 26–27
Miseducation of the Negro (Woodwon), 8
Mo' Betta Blues (Lee), *156*
Monaco, Louis Lo, *5*
monetary value, 48, 60
Moore, Kenya, xx
Moore, Shari K., 204
Morehouse College, 31, *160*
Morgan State University, *199*
Morris Brown College, *160*
Morrison, Toni, 1, 137
motivation, 60, 167
motorcycle helmets, *74*
mug shots/booking cards, *33*, 132, *132–133*, *171*
Muhammad, Elijah, 68
Mullins, Ester, 132
Mulzac, Una, 24
Muse, Daphne, 24
museum glass, 79
museum-quality, definition of, 71
music, 234–238

N

NAACP, *64*, 66–69, *66*, *152*, *170–171*
Nantucket, *xiv*, 98
narrative-driven design, 31
NASA, *248–249*
National African Memorial Bookstore, 24
National Association of Negro Business and Professional Woman's Clubs, Inc., *22*
National Beauty Culturist League, *19*
National Memorial African Bookstore, 27
National Negro Business League (NNBL), *18*, 22
Naughty by Nature, *234*
negotiation, 61, 63–65, 74
Negro Digest, 18
Negro Digs Up His Past, The (Schomburg), 17–18

Negro Head Oysters, *22*, 210
Negro History Bulletin, 8
Negro Motorist Green-Book, The, 158
Negro Music Festival, *viii*
Negro please, 39
New York Black Yankees, *136*
New York Head Shop and Museum, The (Lorde), *163*
New York Post, *242*
New York Times, *242*
New York World's Fair, *xiv*, *58*, *248–249*
Newark (New Jersey) riots, *240–241*
newspaper clippings, 189, *240–241*
NFS (not for sale), 54, 55
NFT digital art, 243–244, *244*
Nigeria, *32–33*, *118–119*
Nintendo controllers, *242*
"No Armed Occupation of Black Communities," 116
North Carolina Agricultural and Technical State University, *160*
nostalgic dissonance, 11, 13, 17
Notting Hill Race Riots, 83
Nubian Sisters, *225*
NYC Pride Parade, *206*, 207

O

Odetta, 137
Ohio Arts Council, 1
oil painting, *160*
Olatunji, Babaunde, 137
Ole Vir-gin-a cake pan, *32*, *209–210*
Olmec Toys, *248–249*
OpenSea, 243
"O.P.P." (Naughty by Nature), *234*
Orji, Yvonne, 36
Our World, *149*
Outsider, The (Wright), 13, 16
oxtail soup mug, *xxiv*, *170*

P

Page, LaWanda, 187
pandemic, 51–52, 105
"Peace Brother" patch, *171*
Pee Wee, *55*
Peeples, Edna Wells Handy, 9
peer-to-peer sites, 56
pennants, *xiv*, *58*, *122–125*, 184, *190*, *210*, *242*, *248–249*
personal value motive, 60
Philadelphia Odunde Festival, *22*
phones, *76*, *247*

photographs, antique found, *viii, 13, 19, 40, 54, 55, 57, 69, 81, 112, 162–163, 166–167, 185, 189, 202, 251.* See also *individual subjects*
pickers, 50
picking process, 37, 39–41
pictures, gifts using, 236–237
pinbacks, *59, 69, 160, 170–171, 204*
pinup calendar, *129*
Plato's Closet, 50
playbills, *18, 51*
playlist, 234–238
political pins, *viii, ix, 14, 15, 32–33, 160, 170, 204, 210*
Poshmark, 50
pre-auction estimates, 69
preservation, 80, 81, 167–168, 250
pressing oil, *22*
pricing, 74
profit margins, 60–61
Progressive Labor Party (PLP), 24
prop rentals, 35–36
provenance, definition of, 68
Pullman porter uniform, towel, and hat, *90–91*
purse, art deco clamshell, *114–115*

R

radios, *202, 235*
Rae, Issa, 36
Raisin in the Sun, A, 51
Ransome-Kuti, Fela, 130, *130*
Rap on Race: A, 126
rarity, 48–49, 74, 178
"Reading by Alice Walker, A," *vi, 143*
Reading from Giovanni's Room and Another Country, 126
Real Model Collection: Beverly Johnson, *210*
RealReal, The, 50
reclamation, 17, 18–19, 69, 70–74
records, *22, 45, 46, 47, 47, 69, 120–121, 126, 126, 128, 131, 190–191*
Red and Black Books, 143
Remarkable Advancement of the Afro-American, The, 64
re-memory, 232
representation, 17–18, 69
Richardson, Judy, 24
Ringgold, Faith, *88–89*
Ringling Brothers and Barnum & Bailey Circus, *185*
Roach, Max, 101
Robeson, Paul, 88–89

Roi, Sonji, *202*
Ruggles, David, 24
Rutgers University, 88–89

S

salon chairs, 236, *236*
Sanford and Son, 187
Sano, Mustafa, *61*
Saroyan, William, 117, *117*
Saturday Night Live, 36
saucers, stoneware, *202*
Saunders, Tracy, 132
Save Flatbush pinback, *160*
scanners, 81
scarcity, 48–49, 74
Schomburg, Arturo, 17–18, 85
Schomburg Center for Research in Black Culture, 169
School of Hard Knocks, 31
SCLC fundraising can, *152*
scrappers, 60
seashell necklace, *22*
secondhand industry in digital age, 56–57
 FAQs for, 74–75
 haggling and, 61, 63–65
 layperson and, 51–53
 locations for, 53–55
 motivation and, 70–74
 NAACP sign and, 66–69
 players in, 49–51
 profit margins and, 60–61
 value and, 47–49, 57, 60, 69
seeing beyond, 71
"seek" factor, 74
Sepia, 148, 209, 252
set design, 35–36
sheet music, *xxi, 54*
"She's a Bad Mama Jama" (Carlton), *169*
Shindana Toys, 28
shoe polish, *59*
shoeshine box, *xxiv*
Show N Tell Phono Viewer & Record Player, *76*
silhouette portrait, *44, 52, 53*
Simone, Nina, 112, *112*
1619 Project, *242*
skin bleaching creams, 146
Slick Black Hair Dressing, *25*
sneakers, *41*, 196, 197
social media, 182
Society for Visual Education, 99, *99*
Solange, 36, 172
Sony Walkman, *242*
soul cards, *xiv, 14, 15, 209, 210*

Soul Food Cook Book (Harwood and Callahan), *106–108*
SOUL newspaper, 192–193, 194–195, *194, 195*
SoulMar, *14, 15, 209, 210*
Souls of Black Folk, The (Du Bois), 13, *17*
SoundCloud, 71
Source, The, 209–210
source/sourcing, 52–53, 222–233
Southern Negro Youth Congress, *70*
Sparks of African Genius School, 8, 9–11, *9, 11*
Speakin' O' Christmas (Dunbar), 153
Spike's Joint, *110–111*
Spirituals in Rhythm (Tharpe), *22*
sporadic spaces, 54
Steiniger, Klein, *ix*
stereoviewers and cards, *44, 81, 242*
Steve Urkel dolls, *252*
Stewart, Jemere, 164–165, *164*
stool, antique, *22*
storage, 79
store, physical, 30–31, *30, 31, 34, 52*
Student Nonviolent Coordinating Committee (SNCC), 24
sunlight, 79
"Sunny" doll, *165*
Super Soaker water gun, *33*
Superman vs. Muhammad Ali, vi
Survey Graphic, 16, *84, 85, 85*
sustainability, 70
Swann Auction Galleries, *67*, 68–69, *213*

T

Tan, 44, 148, 252
Tate, Greg, 199
taxi, *xvi–xx, xviii, xix*
Taylor, Charles, 214
Taylor, Shefon, 232–233, *232, 233*
technology, 245, 246
temperature, 79
Tharpe, Sister Rosetta, 22
Theatre Recording Society, *128*
Their Eyes Were Watching God (Hurston), *22, 27, 96*, 198
Third World Ethnic Bookstore, 24
thredUP, 50
3-2-1 method, 81
TikTok, 71
Time for Laughter, A, vii, viii
To Be Young, Gifted and Black (Hansberry), *128*
toilets, 51
toolbox, *xvii*

Toomer, Jet, 206
Totius Africae Accuratissima Tabula, *49*
traffic light, 52–55
Triplett, Bernadette H., 99
T-shirts, *22*, 31, 36, *36*, *202*, 213–216, *213*, *215–219*, *224–225*
Turini, Shiona, 36
Tuskegee Institute, *162*
TWA mini luggage, *xiv*
typewriter, 105, *105*, *242*

U

United Negro College Fund, 36, *152*
Uno card game, *58*, *228*
upcycling, 234
US Military Battery A, 31st Battalion, *72–73*
USA jacket, *238–239*
Uses of the Erotic (Lorde), *163*
UV-resistant glass, 79

V

value, 47–49, 55, 167, 172–173
values, 48
"Very Good Home, A," *234*
VHS tapes, *253*
Vietnam War, *171*
Viewmaster, *80*
Villa Lewaro, 102

W

Wagner, Andre, 190
walkaways, 65
Walker, Alice, vi, 143, *143*
Walker, Madam C. J., 27, 102, *102–103*
walk-in sales, 31
Washington, Booker T., *162*
watermelons, *xxiv*, *44*, *59*, 73–74, *202*
Waymon, Sam, 112
Ways of White Folks, The, 44
"We Are the World," 31
"We Shall Overcome," 5
Weaver, Martha, *186*
Weeksville Heritage Center, *254–255*
Western States Black Research Center, 24
White, Jaleel, *252*
white gaze, 72–73, 220
Wieden+Kennedy, 37, 205, *205*
Wild Seed (Butler), *250*

Williams, Carla, 168–169, 175, 183–187
Williams, Joe, *181*
Williams, Vanessa, 189
Willis, Deborah, 169
Wilson, Flip, 27, *28*
Winfrey, Oprah, *68*
wire whisk, *202*
Wiz, The, *xiv*, xvi–xx, *xviii*, *xix*, *xx*, *xxi*
Woodson, Carter Godwin, 8
wrapping paper, *202*, 220–221, *220*, *221*
Wright, Richard, 13, 16–17

X

X, Malcolm, *15*, 71, *71*, *144*

Y

yearbooks, *160*
Young, E. F., Jr., *22*

PHOTO CREDITS

ACKNOWLEDGMENTS

My wife and I dedicate this book to our village; it took you all. We're grateful to those who planted before us, those tilling the soil alongside us and those who will bear the fruit. May this book be an abundant offering of love and appreciation to our familial ancestors, Daddy Michael J. Handy, Nanny Ruth Matthews, Grandma Gladys Wells, Nana Elloise Ingram, Grandma Alda Stewart, and Pop Charles Peeples. May you all continue to rest well and watch over us. Asé.

ABOUT THE AUTHORS

Jannah Handy and Kiyanna Stewart are the co-founders of BLK MKT Vintage, a Brooklyn-based vintage/antique concept shop that specializes in collectibles and curiosities, representing the richness of Black history and lived experience. Their passion for material culture and found objects has led them to interior design projects, personal sourcing, set design, prop rental, museum loans, and other curatorial projects in media/entertainment, education, the arts, and philanthropy. Jannah has a background in business and education, with a B.A. in Economics from Smith College, and a M.Ed. in Higher Education from UMASS, Amherst. Kiyanna has a background in fashion and education, with a B.A. in Journalism and Africana Studies and a M.A. in Women's Studies, all from Rutgers University. The two have over fifteen years in collecting and sourcing experience combined, managing a flagship retail location in their hometown Brooklyn, New York, and an e-commerce shop.

www.blkmktvintage.com
blkmktvintage

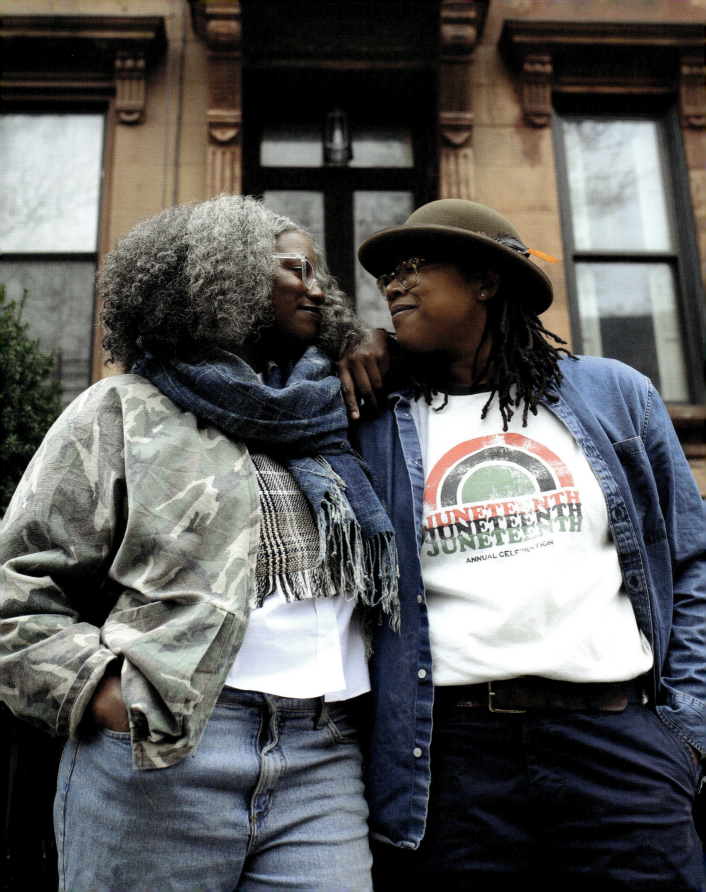

Black Dog & Leventhal Publishers
Hachette Book Group
1290 Avenue of the Americas
New York, NY 10104
www.blackdogandleventhal.com
 BlackDogandLeventhal
 @BDLev

First Edition: October 2024

Published by Black Dog & Leventhal Publishers, an imprint of Hachette Book Group, Inc. The Black Dog & Leventhal Publishers name and logo are trademarks of Hachette Book Group, Inc.

Black Dog & Leventhal books may be purchased in bulk for business, educational, or promotional use. For more information, please contact your local bookseller or the Hachette Book Group Special Markets Department at Special.Markets@hbgusa.com. The publisher is not responsible for websites (or their content) that are not owned by the publisher.

Additional copyright/credits information is on page 261.

Print book cover and interior design by Morcos Key

Library of Congress Cataloging-in-Publication Data

Names: Stewart, Kiyanna, author. | Handy, Jannah, author.
Title: BLK MKT vintage : reclaiming objects and curiosities that tell black stories / Kiyanna Stewart and Jannah Handy.
Description: First edition. | New York, NY : Black Dog &Leventhal, 2024. | Includes bibliographical references and index. | Summary: "BLK MKT Vintage: Reclaiming Objects and Curiosities That Tell Black Stories is a visual exploration into the world and work of the highly successful vintage/antique concept shop and growing brand, BLK MKT Vintage, that expands upon the founders' vision to center, preserve, and make accessible vintage objects that tell Black stories"—Provided by publisher.
Identifiers: LCCN 2023039796 (print) | LCCN 2023039797 (ebook) | ISBN 9780762484034 (hardcover) | ISBN 9780762484041 (ebook)
Subjects: LCSH: Black people—Collectibles. | African Americans—Collectibles. | BLK MKT Vintage (Firm)
Classification: LCC NK839.3.A35 S74 2024 (print) | LCC NK839.3.A35 (ebook) | DDC 704.0396073—dc23/eng/20240108 LC record available at https://lccn.loc.gov/2023039796 LC ebook record available at https://lccn.loc.gov/2023039797
ISBNs: 978-0-7624-8403-4 (hardcover) 978-0-7624-8404-1 (ebook)

Printed in China
1010
10 9 8 7 6 5 4 3 2 1

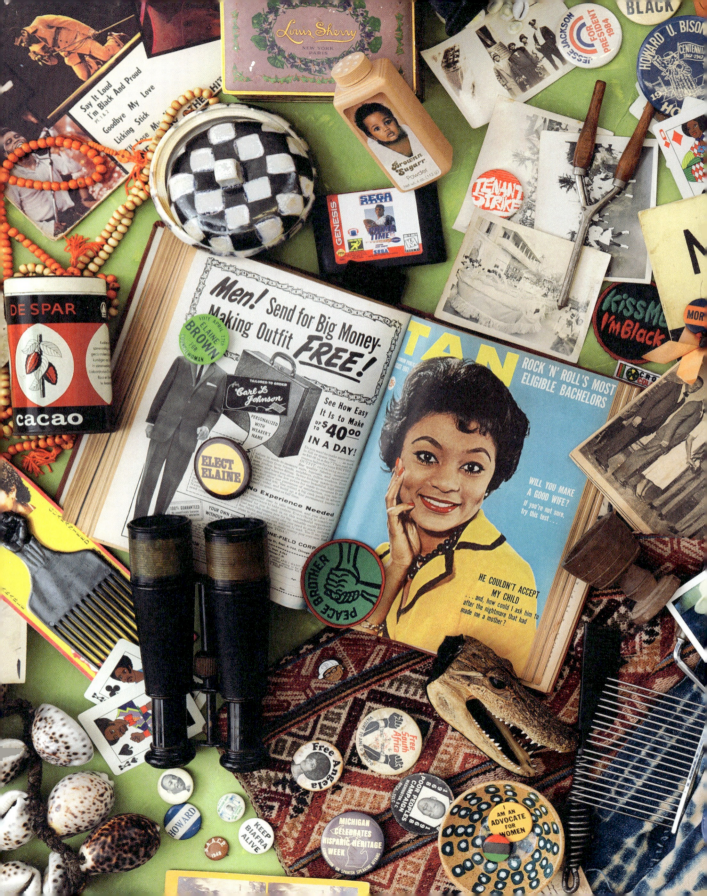